BATAVIA

IN NINETEENTH CENTURY PHOTOGRAPHS

BATAVIA

IN NINETEENTH CENTURY PHOTOGRAPHS

SCOTT MERRILLEES

edm EDITIONS DIDIER MILLET

EDITOR

GOH GEOK YIAN

DESIGNERS

TAN SEOK LUI
NELANI JINADASA

PRODUCTION MANAGER

SIN KAM CHEONG

Front cover photograph, junction of Rijswijkstraat, Rijswijk and Molenvliet West;
Woodbury & Page, mid-1870s, albumen print, size: 17.9 x 22.8 cm.
Collection of the author, Melbourne.
Back cover photograph, see page 25.

Maps on pages 18, 36, 50, 68, 76, 94, 120, 150, 160, 188 and 236 are from the *Kadastrale
overzichtskaart der afdeeling Batavia*, 1874-6, collection of the Algemeen Rijksarchief, The Hague.
Map on page 248 is from *Batavia en Omstreken* by J. Vos, 1887.
Collection of the Algemeen Rijksarchief, The Hague.

Text © Scott Merrillees, 2000

First published in 2000
Second edition published in 2001
Reprinted 2004, 2006, 2010
by Editions Didier Millet
121 Telok Ayer Street, #03-01,
Singapore 068590

www.edmbooks.com

Colour separation by Classic Scan Pte Ltd
Printed in Singapore by Star Standard Industries (Pte) Ltd

ISBN 978–981–3018–77–8

For my mother and father

CONTENTS

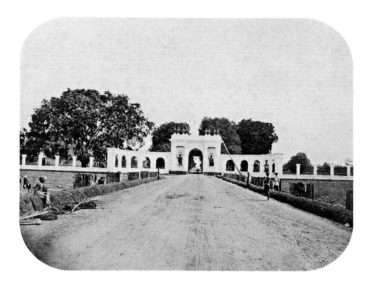

The Amsterdam Poort ("Amsterdam Gate") was the only part of Batavia's old castle to survive into the second half of the 19th century. A prominent landmark for many years, it was located on the road connecting the centre of "downtown" Batavia with the old port. See also pages 38-41.

FOREWORD

This book grew out of my fascination with examining old photographs of Batavia (as Jakarta was known from 1619 to 1945) and researching their contents as well as trying to date them and identify the location from where they were taken.

In essence, the photographs became my personal "time machine" or "window" into the Jakarta of another age that spanned the period from the late 1850s to the mid-1890s. It was an age which is now long gone and there is little left today to remind us of its former existence and yet, in a sense, it didn't feel completely out of reach to me. I can still remember as a teenager being with my great-grandmother, who was born in 1878 and already well into her nineties by that time, and who therefore belonged to the era depicted in many of the photographs in this book. Although she never visited Batavia herself, I still perhaps felt that she provided me with a personal link to the period I was researching.

I naturally wanted to take my "time machine" back as far as I could, but I knew that only photographs would provide a truly clear window into Batavia. This meant that I was limiting myself to going back no further than the late 1850s when the first topographical photographs of Batavia were taken. Of course, we can catch a glimpse of Batavia in the 18th century from the fine engravings of J. W. Heydt and the beautiful drawings of Johannes Rach. However, from a personal perspective, the 18th century seemed too remote an era and, furthermore, drawings and engravings did not provide the objectivity and clarity I was seeking.

Only photographs would satisfy me and I completely shared the sentiments of renowned Scottish photographer John Thomson (1837–1921), when he wrote of photography in his *Illustrations of China and its People* (1873–74) that:

> the faithfulness of the pictures affords the nearest approach that can be made towards placing the reader actually before the scene which is represented.[1]

After taking my "time machine" back to the second half of the 19th century I naturally had to understand the Batavia I found there. I therefore needed to have a feel for the economic, political and social factors which influenced Batavia's development. It was also important to research the specific places, buildings, churches, infrastructure, monuments, landmarks, organisations and commercial firms which appear in the photographs to help bring them to life and to understand why they were important at the time. I wanted to reach out and touch them and feel the "buzz" of Batavian life around them as the photographs were taken.

This book focuses only on topographical photography of Batavia, which began in the late 1850s. I have, therefore, ignored the first two decades of photography in Batavia (and in the Netherlands Indies in general) during the 1840s and 1850s, when the emphasis was on portraits and on photography as a means to assist the documentation of archaeological discoveries and antiquities. Other published works have already dealt with these earlier aspects of Indonesia's photographic history.[2]

This book unavoidably presents a European perspective of 19th century Batavia. This has not been deliberate, but is just a reflection of the fact that the earliest topographical photographs of Batavia were taken by Europeans whose customers were also predominantly European. Nevertheless, I sincerely hope that my "time machine" can be shared and enjoyed by people of all nationalities and all ethnic backgrounds including, of course, the people of modern Jakarta.

Although this book draws upon photographs from some of the leading libraries, museums and academic institutions in the world that hold photographs of Indonesia, I am certain that there must be many more early photographs of Batavia which have not yet been "discovered" and which lie forgotten in attics or old family photograph albums, particularly in Holland. These will hopefully come to light in the years ahead. There is also much more research to be done to better understand the contents of many of the photographs. It is my dearest hope that this book will help stimulate this research and help uncover more "lost" photographs so that any similar publications in the future can be more comprehensive than this one. Correspondence from readers is very welcome, either to *scott@bataviabook.com* or to the address shown below.*

SCOTT MERRILLEES

Melbourne, Australia

June 2000

*Scott Merrillees, Robinson Road Post Office, P. O. Box 1284, Singapore 902534

PREFACE TO THE SECOND EDITION

It came as a pleasant surprise to be asked by the publisher to write a preface to the second edition of *Batavia in Nineteenth Century Photographs* only a year after the first edition was published.

When this book was initially being prepared for publication, only a small print run was envisaged. It was felt that the rather specialized focus of its subject and the luxurious nature of its production would somewhat limit the size of the market. It has therefore been most gratifying to see a higher level of interest than was originally anticipated and, accordingly, this second edition has been made possible.

Batavia in Nineteenth Century Photographs seems to have found an audience among a variety of readers, from the older, more nostalgic residents of Jakarta who have said "I used to live near there or I still remember that building", through to the younger inhabitants who can see and appreciate a Jakarta they never knew first-hand themselves. The book also appears to be enjoyed by foreign residents and visitors to Jakarta seeking to catch a glimpse of part of the long and fascinating history of this great city. In addition, I have been very grateful to receive correspondence and news of additional photographs from readers in Europe (particularly in Holland and France) whose grandparents or great-grandparents lived in Batavia during the period covered by the book.

I would like to express my sincerest thanks to the people who have provided additional input or new material, or have made corrections, since the publication of the first edition. Most especially, my gratitude goes to Mark Hanusz, Geoff Edwards, Tjandra Ghozalli and Hans Groot of Jakarta, Norbert van den Berg of Welsum, Karel A. van der Hucht of Utrecht and Sven Verbeek Wolthuys of Huizen. Thanks are again due to Leo Haks of Amsterdam, whose support and encouragement have been so important and so greatly appreciated since the beginning of this project in 1994.

There have been a few changes to the text where new information has become available (and small corrections have been made to two of the maps); but the book is substantially the same as the first edition. No photographs have been added or deleted. We have however used slightly heavier paper, 150 gsm Gardapat paper this time instead of the 125 gsm Canaletto Liscia used for the first edition.

Once again, I wish to invite correspondence from readers and would also dearly love to learn about the existence of other 19th century photographs of Batavia that do not appear in this book. To make communication easier this time, correspondents may now use an e-mail address – *scott@bataviabook.com* – in addition to the Post Office Box address that appears in the Foreword.

It has been a great thrill for me that already so many people have shared my "time machine" journey back to 19th century Jakarta through the first edition. I now also invite new readers to make the trip through this second edition.

SCOTT MERRILLEES

Jakarta

August 2001

INTRODUCTION
"Downtown" and "Uptown"

To gain a proper appreciation of Batavia in the second half of the 19th century as revealed in the photographs in this book, it is important to try and see the city from the perspective of a resident or visitor of that era. It is, therefore, necessary to be familiar with the concepts of "downtown" and "uptown" Batavia.

Although "Batavia" was the official name for the entire of the capital city of the Netherlands Indies, in daily usage in the 19th century, "Batavia" generally meant the old city in the north around Kali Besar, the town hall, the old port and the "Chinese Camps" at Glodok. In other words, it was what we now call the "kota". This area was known as *benedenstad* ("downtown"), or often as the *oude stad* ("old town"). The old town remained the centre of trade and commerce until as recently as the early 1960s, but had ceased to be one of the main European residential areas by the end of the 18th century.

By contrast, the newer districts of the south around what are now Jalan Juanda, Jalan Veteran, Lapangan Banteng and Medan Merdeka were developed in the late 18th and early 19th centuries. They were known as *bovenstad* ("uptown") and Weltevreden ("well contented") after a large private estate of that name which existed near Pasar Senen until 1820. This area was the "new city" of Batavia.

With the creation of the Batavia City Council in 1905, the "downtown" and "uptown" distinction was formalized, with the northern half of the city being called the Batavia district and the southern half Weltevreden. However, in the 19th century, "downtown" and "uptown" were still only informal concepts in Batavia although they were widely understood. The photographs in this book span the period from the late 1850s until the mid-1890s, and are arranged geographically in a manner that would be meaningful to a resident of Batavia in the second half of the 19th century.

Batavia's "downtown" was originally the Batavia of the VOC (Vereenigde Oost-Indische Compagnie or the "Dutch East Indies Trading Company"), whose brash and energetic fourth governor-general, Jan Pieterszoon Coen (1587–1629), founded Batavia in 1619. The VOC maintained total dominance over the city until its charter was not renewed by the Dutch government in 1799.

The heyday of "downtown" Batavia was from the 1620s until the 1730s when great profits were made from the spice trade between Europe and the "spice islands" of the Moluccas in what is now Eastern Indonesia. This wealth helped finance the "Golden Age" of Dutch history in the 17th century.

When Coen founded Batavia, the VOC had no vision of creating a large and important city. Batavia was just intended to be a supply station to provide the VOC's ships engaged in the spice trade with food, water and repairs. Furthermore, Batavia was established in hostile territory. The Dutch feared attacks from the sultanates of Bantam (now Banten, West Java) and Mataram (Central Java) as well as from marauding bandits until at least the mid-1680s. It was these fears that led the Dutch to build a castle at the mouth of the port and also walls and fortifications around the rest of their little settlement, turning Batavia into a walled city.

From the 1730s until the end of the 18th century, Batavia went into decline and became known as "The Graveyard of Europeans" because of the hideous mortality rates among citizens living within the walled city. This sorry state of affairs was due to low standards of hygiene and poor quality water and was exacerbated by the silting and stagnation of Batavia's canal network and the building of fish ponds near the city which attracted malarial mosquitoes. Also contributing to the decay of the old city and the VOC itself were the collapse of monopoly profits from the spice trade and large-scale corruption among senior officials of the VOC.

From the early decades of the 18th century, people who could afford to live outside the walls moved to the supposedly healthier environs of Jacatraweg (now Jalan Pangeran Jayakarta) and then to Molenvliet (now Jalan Gajah Mada and Jalan Hayam Wuruk), when Jacatraweg also proved to be a health hazard. Drawings from the second half of the 18th century show that there were many grand private residences along Molenvliet with palatial grounds and elaborate gardens, one of which (the Gedung Arsip) still survives to this day in almost its original form (although on smaller grounds). Images of such luxury and splendour gave Batavia the title "Queen of the East".

If "downtown" Batavia was the creation of Coen, then the "uptown" was the inspiration of Marshal Herman Willem Daendels (1762–1818) whose short term as governor-general from 1808 until 1811 had an enormous impact on

Batavia in 1853. Collection of the Algemeen Rijksarchief, The Hague.

the development of Batavia in the post-VOC era. His influence is still felt in the design of Jakarta as we know it today.

France under Napoleon Bonaparte subjugated Holland in 1806. In the same year, Napoleon made his younger brother, Louis, the King of Holland. It was Louis Bonaparte who appointed Daendels governor-general of Java with the instructions to defend it from a feared British invasion. Arriving in Batavia in 1808, Daendels realized immediately that the old and decaying castle and walled city of the VOC could not possibly withstand a British attack. Daendels then issued an order to demolish these structures. After initially considering relocating the capital to Surabaya, he finally decided to keep it in Batavia but move it southwards further inland. From 1809, the new administrative heart of Batavia became the area now known as Lapangan Banteng (then part of the large private estate known as Weltevreden). It was also from this time that what are now Jalan Juanda (Noordwijk) and Jalan Veteran (Rijswijk) became elite European residential districts, only to be surpassed by the Medan Merdeka area (Koningsplein) in the 1850s.

Daendels was actually not the first governor-general to reside at Weltevreden. Jacob Mossel (governor-general from 1750 to 1761) had owned the Weltevreden estate and ran his government from there in order to escape the unhealthy conditions of the castle further north. (Most of Mossel's subordinates were not so fortunate and had to continue toiling away in the castle at great peril to their lives.) However, it was Daendels who decisively and symbolically demolished the old castle and the walls of the old city and moved the entire administration of Batavia to the "new city" in the south, where much of it continues to be located today.

By the middle of the 19th century, the heart of Batavia had very clearly moved "uptown" where one could find the governor-general's residence, key government buildings, the fine houses of the European elite, most of the major churches, the two main social clubs, the museum, the Freemasons' lodge, the European shopping districts and the major hotels.

"Downtown" Batavia still housed the trading firms, the insurance and shipping agents and brokers of various kinds. Indeed, many European men commuted in the mornings along Molenvliet to their offices "downtown" and then back again to their homes "uptown" in the early afternoon when a day's work was done. However, for residents of Batavia and visitors in the second half of the 19th century, most life centred on the new city of the south "uptown". It is thus not surprising that when topographical photography of Batavia began in the late 1850s, photographers would more frequently focus their lenses on the sights "uptown" than anywhere else in Batavia.

The distinction between "downtown" and "uptown" was very clear in the second half of the 19th century, and descriptions of "downtown" Batavia were never flattering. People who had read of the glorious days of the past when Batavia was the "Queen of the East" were invariably disappointed.

> Of the splendour and magnificence which procured for this capital the title of the "Queen of the East", little is now to be found. Streets have been pulled down, canals half filled up, forts demolished and palaces leveled with the dust. The stadhuis [town hall], where the supreme court of justice and magistracy still assemble, remains; merchants transact their business in town during the day, and its warehouses still contain the richest productions of the island, but few Europeans of respectability sleep within its limits.[3]

> About the old European city [old Batavia], little can be said. It lies entirely open and flat, part of its former canals are filled in, and it has a very abandoned outlook. Only in the quarter where the trade offices and some shops are situated, some liveliness exists. Here and there tall and spacious houses are still seen, remnants of the glory of the former East-Indies Company. Staying there is unhealthy. The largest enemy is the Batavia fever, which according to me is mainly caused by the vapour that rises from the alluvial grounds, and which I can clearly see at night. Europeans do not live there; only a few descendants of Portuguese are found.[4]

> Most Europeans escape it [old Batavia] as soon as their activities have ended and they do not like to spend the night there.[5]

> After sundown Batavia is silent and empty; not only the offices and large warehouses of the merchants but even the shops are closed; no carriage is heard anymore and the few indigenous people who move along the streets, make no noise at all on their bare feet, and if the police had not ordered them to carry torches, they would wander there as dark shadows.[6]

However, descriptions of "uptown" Batavia were almost always complimentary:

> But New Batavia! I had heard so much about it. New Batavia looks airy and cheerful, but I do not call it a city. It is a chain of country seats, of which the houses are mostly built in the same not ungraceful style.[7]

> Only after one had driven through the Buiten Nieuwpoort street that looked less pleasing, and continued his way along the friendly Molenvliet, where one could observe the attractive residences with the beautiful gardens in front of them, did the feeling of disappointment make way for more agreeable impressions. Once arriving at Rijswijk, one soon felt convinced that Batavia wore its grandiloquent title "Queen of the East", not altogether unjustly.[8]

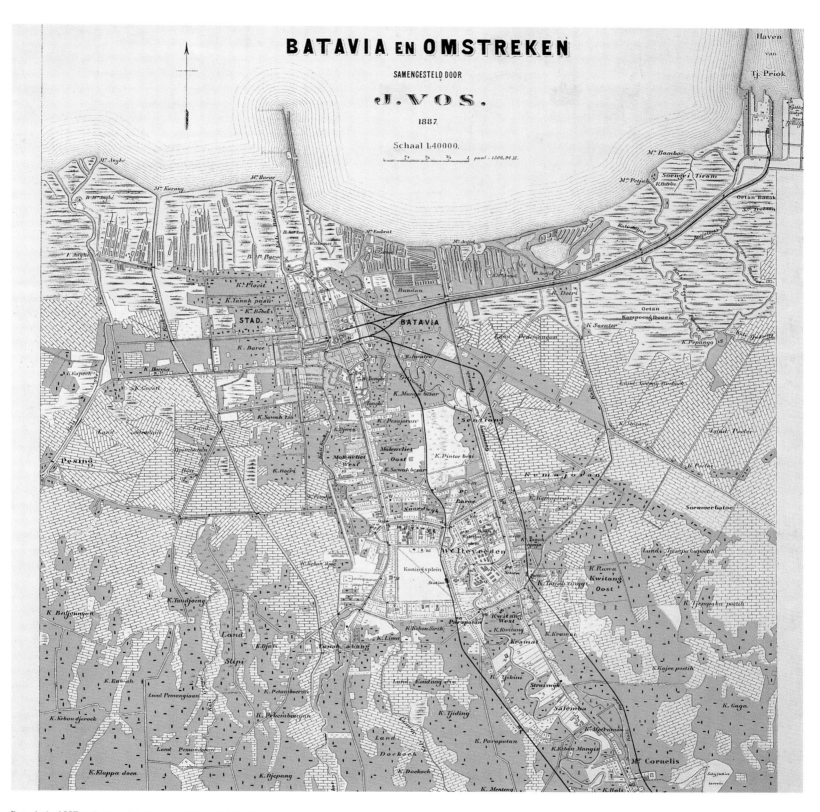

Batavia in 1887. Collection of the Algemeen Rijksarchief, The Hague.

The further we came along the Molenvliet canal, the more we found houses occupied by Europeans. These houses became larger and more decorative and then after we left Molenvliet behind and arrived in Rijswijk, we could see nothing but very beautiful villas.[9]

We have now reached new Batavia, of which the centre lies about one hour away from the old city. I will try to give you a picture of this beautiful region, that as a city, spot, or whatever you will call it, still earns the name "Queen of the East".[10]

Weltevreden, the upper town of Batavia, is unquestionably the finest of the Indies towns, and quite worthy of being well known.[11]

Whilst Batavia proper—the lower town with its counting-houses and shops, its native and Chinese population, its canals and moats, its dust and dirt, and old-fashioned mansions—makes anything but a charming impression, the upper town, to which all Europeans return in the evening, reminds one of a gigantic park, in which villas are built in rows, and great trees shade the broad and gravelly paths, and spacious squares bring air and wind.[12]

The "downtown" and "uptown" distinction lasted into the early decades of the 20th century and as late as 1924, one observer noted that:

It is usual in Batavia to speak of going uptown and downtown; at first it sounds strange; one thinks that it is mistakenly expressed, but it very rightly pictures the reality.[13]

This same writer also commented that the distinction was more than just geographic. When one has gone downtown:

One has not only gone down, but has also gone back. One has gone back to the canals and the small streets with the old façades of the past, where the simple citizens lived in their small two storey houses with high roofs according to old Dutch ways, enjoying a little air in the evenings on the bench at the doorsteps in front of their homes. The dignified families in the large houses with the broad façades along the canals had brought all their customs of stately dignity from the fatherland; they lived their typical Dutch lives in the high dark rooms with the beamed ceilings, the white painted walls and the red tiled floors.[14]

Slowly one went uptown; . . . the dignified people went to live in houses according to the Indies building trend, houses of one storey with large gardens, with front and back galleries and high and wide halls; houses with hanging roofs where shade, air and coolness were the dominant privileges. The new city of Batavia became like one large park, with squares, lanes, lawns and forest-like gardens, where as if by accident among the flowers and greenery, the spacious houses were hidden; where one could live away from the eye of the world, with the luxury of the freedom that came with having one's own grounds.[15]

The second half of the 19th century was a peaceful period in Batavia's history characterized by stable government, expansion of the economy through the opening up of Java and the outer islands as well as the absence of any major military conflicts. Admittedly, the Aceh War began in 1873 and continued for three decades and there were also military campaigns in Lombok in the mid-1890s, but the impact of these events on the daily lives of people in Batavia hardly went beyond following events in local newspapers.

This was unlike the first half of the 19th century, which witnessed the aftermath of the VOC's demise and saw political power change from the hands of the Dutch to the French to the English and back to the Dutch again in less than a decade before the Java War of 1825 to 1830 placed a major strain on the government's financial resources.

The period 1850 to 1900 also saw Batavia benefit from the advances in technology that were improving living standards in Europe. The first telegraph line was installed between Batavia and Buitenzorg (Bogor) in 1856 while Batavia's first international telegraph connection to Singapore began in 1859, even though there would not be a permanent line in place until 1870. Telephones arrived in 1882. Batavia's first gas works were completed in 1861 and gas lighting for public roads commenced in 1862. A horse-drawn tramway was introduced in Batavia in 1869 to be replaced by steam trams in 1882. Electric trams would follow in 1900. Work on Batavia's first railway link with Buitenzorg commenced in 1869 and the line was officially opened in 1873. The first ice works in Batavia started in 1870 and would have been greatly welcomed in the tropical climate of the Indies.

The so-called "liberal policies" pursued by the colonial government from the second half of the 19th century sought to go beyond the narrow objective of economic gain by promoting social institutions which would improve the quality of life and introduce more opportunities for education and medical care for the wider population. A free press was also allowed to develop from the 1850s.

Batavia's "new" port at Tanjung Priok port was completed in 1885 and replaced the old port that had been in use for more than two and a half centuries and had been regarded as inadequate for almost as long. There was a critical need for the new port given that the opening of the Suez Canal in November 1869 had significantly reduced travelling times from Europe to the Indies, and thereby made Batavia more accessible for both commerce and tourism.

The economic complexion of the Indies changed considerably during the

second half of the 19th century. Prior to 1870, opportunities for European private capital were generally limited to the wholesale and retail trades, the importing of goods for consumption by the relatively small European population and the operating of shipping, insurance and commission agencies. Control of the larger economy was firmly in the hands of the colonial government and state-owned trading companies and financial institutions. However, the passing of the Agrarian laws in Holland in 1870 phased out the cultivation (or culture) system of forced deliveries (mainly sugar and coffee) to the government and paved the way for a greater role for private enterprise in the Indies.

This in turn ushered in a period of economic growth and prosperity during the 1870s as fortunes were made from a surge in private sector investment in sugar, coffee and tea plantations and the rapid growth of supporting services such as refining, trading, shipping, banking, broking and insurance. This wealth increased the small number of European elite who were able to enjoy lavish lifestyles in grand houses in the best parts of Batavia around Koningsplein (Medan Merdeka), Prapatan, Tanah Abang, Gang Scott (Jalan Budi Kemuliaan) and the southern end of Molenvliet. This "new money" joined the senior government and military officials, plantation managers, wealthy shopkeepers and commission agents at the top of Batavia's social pyramid, while the old elite land-owning families whose wealth could be traced back to the VOC era gradually went into decline as their political influence waned.

But the good times could not last forever. The collapse of international sugar prices in 1884 created an economic crisis from which the Indies would not completely recover until early in the 20th century. Nevertheless, most of the photographs in this book are from the 1860s and 1870s when the mood in Batavia was generally one of optimism and confidence in the future.

This book unavoidably presents a European perspective of Batavia, given that early commercial photography in Batavia from the 1850s until the 1880s was dominated by Europeans whose clientele was also predominantly European. This perspective is, therefore, a distinctly minority image of the city because Europeans were never more than a tiny proportion of Batavia's population. Official statistics from the period show that there were only 6,253 European residents in Batavia and its environs in December 1866, representing only 1.2 per cent of Batavia's total population of 530,018 at the time (excluding military personnel).

Nearly three decades later in 1895, the population of Batavia and its environs had more than doubled to 1.27 million (excluding military personnel) but the proportion of Europeans remained only 1.0 per cent of the total.

Nevertheless, the photographs in this book present fascinating historical insights that not only enable us to experience life in Batavia in the second half of the 19th century, but also help us to gain an appreciation of how modern Jakarta as we know it today has developed from earlier times.

POPULATION OF BATAVIA AND ENVIRONS

DECEMBER 1866*		DECEMBER 1895*	
Europeans	6,253	Europeans	12,429
Indigenous	472,301	Indigenous	1,169,678
Chinese	50,583	Chinese	82,510
Others	881	Others	3,426
Total	530,018	Total	1,268,043

Source: Regerings-Almanak voor Nederlandsch-Indie, Batavia, Landsdrukkerij, 1868. Source: Regerings-Almanak voor Nederlandsch-Indie, Batavia, Landsdrukkerij, 1900.

DOWNTOWN BATAVIA

The Old City of the North

THE OLD PORT ■ INSIDE THE WALLS ■ KALI BESAR ■ OUTSIDE THE WALLS ■ CHINATOWN AT GLODOK

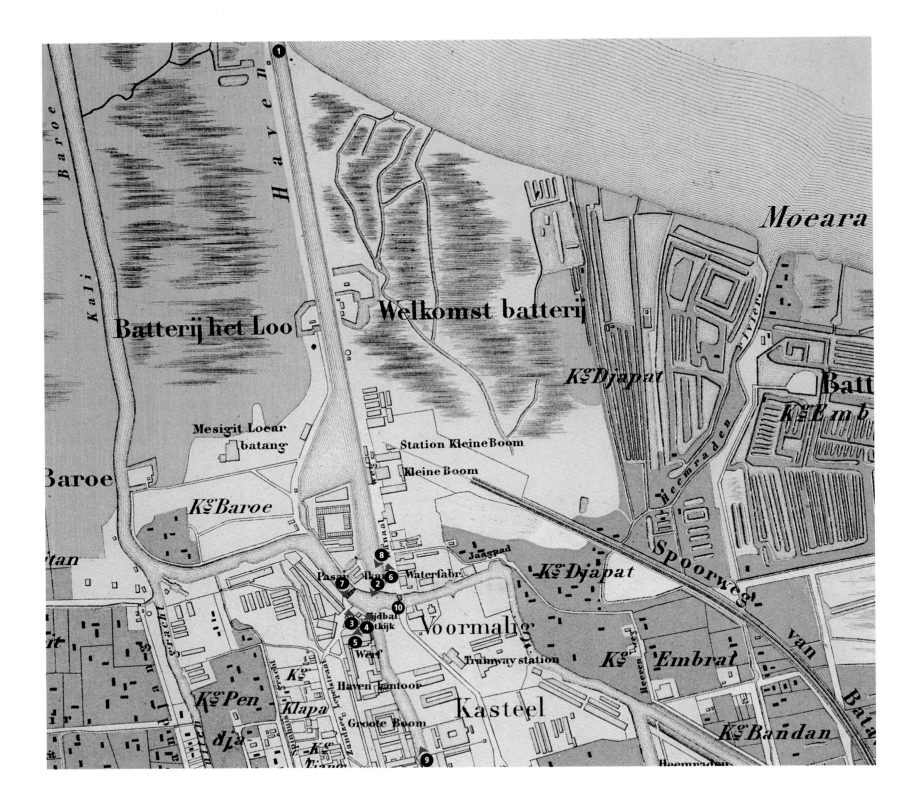

THE OLD PORT

The old port of Batavia, also known as the Haven Kanaal ("Harbour Canal"), the "Roads of Batavia" or "Batavia's Roadstead", is now the port of Sunda Kelapa. It was the main point of entry to Batavia for visitors arriving by sea for over two and a half centuries, from the founding of Batavia by the Dutch in 1619 until the new port of Tanjung Priok was completed in 1885.

During Batavia's early years in the 17th century, small ships could sail from the sea along the canal through to Kali Besar (*see pages 50-67*), where goods could be loaded and unloaded and ship repairs made at the VOC shipyards opposite the old castle. However, even by the late 17th century this had almost ceased to be possible. A combination of the narrow width of the canal, sand banks building up at its mouth and the larger size of vessels created considerable difficulties. For a time during the 18th century, horses and slaves located on the eastern bank were used to tow dredges along the canal but they were still not able to maintain a sufficient depth for ships to pass. This also caused considerable loss of life under the miserable, hot and unsanitary conditions.

Larger ships, therefore, had no choice but to anchor out at sea off the northern end of the canal. Cargo and passengers were unloaded into smaller vessels, known in the 19th century as "lighters", that were able to manoeuvre in the canal. The lighter business was very profitable for the local operators, but the unloading was a time-consuming chore for crew and passengers and could be treacherous in rough weather.

The journey from a newly arrived ship to the safety of dry land could be a long and even traumatic experience for passengers despite the relatively short distance, as was noted by one visitor in 1862:

We were waiting in our ship anchored near the mouth of the canal, and soon afterwards we saw a small steam ship leaving the roadstead with difficulty through the bars, to collect the passengers and take them to Java's shore. This little boat, called the "Ciliwung", was a very small, very shallow iron steam ship that belongs to a private company, and carries out the service to and from the roadstead. Formerly this happened only with large rowing boats, so the little steam ships are an improvement. Despite the shallow draft of the Ciliwung, as soon as it entered part of the canal, it ran aground. The steam was turned up and then it drove straight into the back of a Buginese junk, which was moored at the stone quay, so that everything went to pieces. The passengers of the junk groaningly escaped to shore, and our anchor fell overboard. It took about an hour before everything was in order and we could steam up the canal again with the greatest cautiousness. I admit that through this experience, I formed a poor opinion of the accessibility of Batavia's harbour, of which trade had so long complained about in vain.[1]

Batavia's lighthouse

Since early in the second half of the 19th century, the lighthouse in this photograph was the northernmost point of Batavia and was strategically located just north of the mouth of the old port. Certainly built before 1862, the lighthouse still stands today, but is no longer in use and the surrounding buildings are gone. The lighthouse was the first man-made object seen by visitors arriving at Batavia by sea, and was noted in two accounts from the 1860s:

> The arrival at the roadstead of Batavia, which several times fell to my lot, at first shows much beauty. Already from a distance one sees anchored there many large merchant vessels, a waiting navy ship and usually a few steam boats. But as one approaches closer to Java's coast, all illusions tumble down. As far as the eye can see, there is nothing but very low land in front, covered with palms and other green trees. Very far off into the distance, one can see during clear weather, the high mountains of the Priangan, but usually only early in the morning. Of Batavia itself, nothing but a white chalked lighthouse is visible, then a small fortress hidden behind earthen walls and at the end of a small canal, a few stone houses. So the first glance from the sea of Batavia gives nothing pleasing, but rather gives a painful impression, especially when one has last seen Singapore, Bombay or Alexandria.[2]

> The next evening we came to the Batavia road, a shallow bay where ships lie at anchor partially sheltered from the sea by the many islands scattered about its entrance. The shores of this bay form a low, muddy morass, but high mountains appear in the distance. Through this morass a canal has been cut. Its sides are well walled in, and extend out some distance toward the shipping, on account of the shallowness of the water along the shore. At the end of one of these moles, or walls, stands a small white lighthouse, indicating the way of approaching the city, which cannot be fully seen from the anchorage.[3]

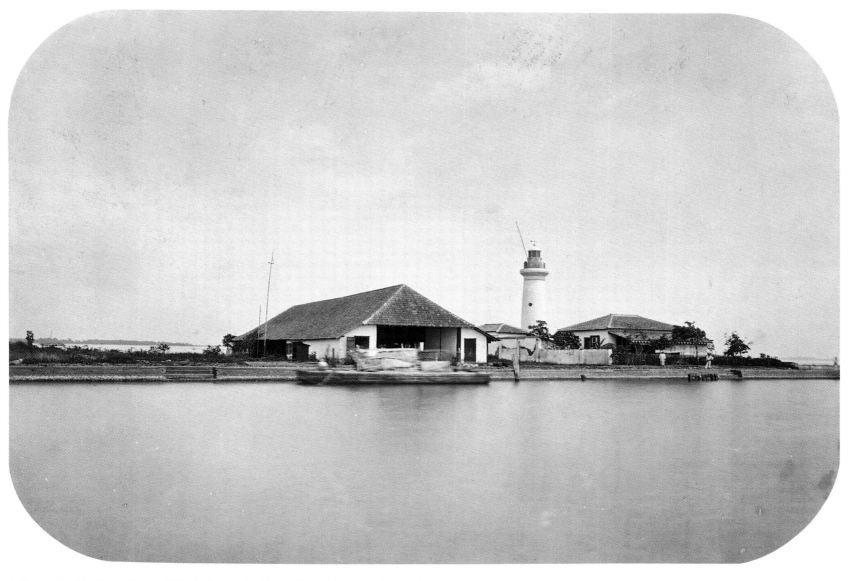

1. Photographer: **Woodbury & Page**, c. 1870 ■ albumen print ■ size: 18.1 x 23.3 cm ■ collection of the author, Melbourne.

The Culemborg lookout

The Culemborg lookout is the tall tower on the right-hand side of this photograph and it still stands today on the west bank of the mouth of the Ciliwung River in the Pasar Ikan area on the north coast of Jakarta. The mouth of the river is visible here just to the left of centre of this scene between the white-painted wall on the right and the stern of the small sailing vessel on the left.

The lookout was built in 1839 to be a watch post for ships arriving at the port and provide signals to the ships when they were sighted. A blue flag, for example, signalled danger and meant that ships were not permitted to bring their passengers and crew to the roadstead. The lookout replaced a tall flagpole that was used for the same purpose until 1826 and which was located only a few metres away on the grounds of the VOC shipyards. On the smaller building to the left of the lookout we can see a circular dish placed on top of a long pole which was used for meteorological purposes.

The name "Culemborg" was taken from the Culemborg bastion built in 1645 near where the lookout is located and which formed part of the old walled city of Batavia. Culemborg was the birthplace in Holland of Antonio van Diemen, the governor-general of Batavia from 1636 to 1645, when the

Culemborg bastion was built. The bastion was demolished along with most of the rest of the walled city in 1808/9 under the orders of Governor-General Daendels.

For several years prior to the founding of Batavia in 1619, the Muslim Prince Jayawikarta or Wijayakarta had a customs post on the point where the Culemborg lookout now stands. The location was chosen, no doubt, because this was the northernmost point of his city of Jayakarta at the beginning of the 17th century and strategically guarded the entrance to the Ciliwung River.

The warehouses visible behind the lookout on the left-hand side were part of the former VOC shipyards and were demolished in 1981 to permit the digging of the canal which runs parallel to Jalan Pakin. Some of the old VOC shipyard buildings still remain and can be seen from the southern side of the lookout along Jalan Kakap.

Jalan Pakin, which now crosses over the Ciliwung and runs between the lookout and the old warehouses, did not exist when this photograph was taken and, therefore, small vessels could still travel from the mouth of the Ciliwung through to Kali Besar further south. After Jalan Pakin was built (probably in the late 1930s or early 1940s) this ceased to be possible.

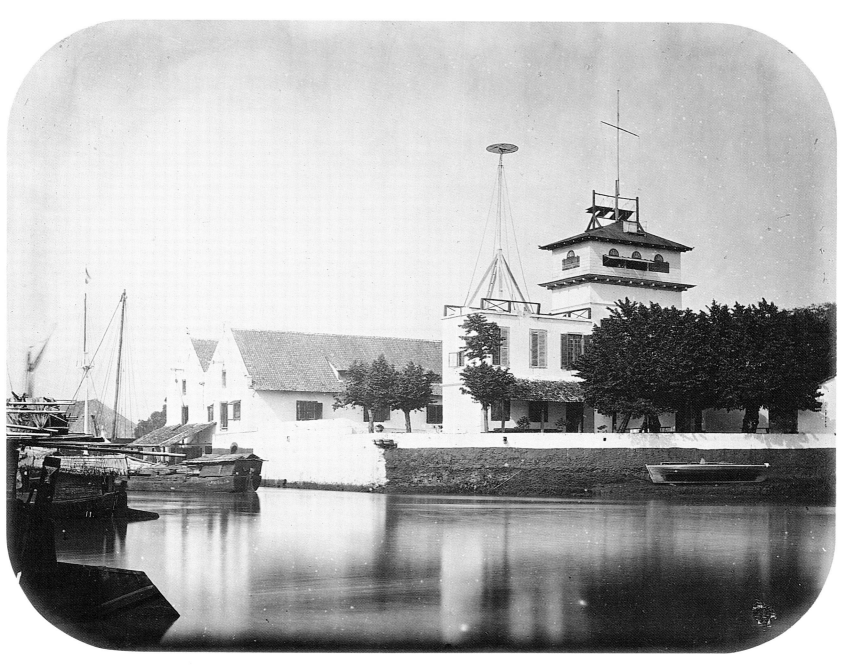

2. Photographer: **Woodbury & Page**, c. 1864–5 ■ albumen print ■ size: 18.9 x 23.9 cm ■ collection of the author, Melbourne.

THE HAVEN KANAAL

In the photograph on the opposite page, we are looking in a north-easterly direction across the Haven Kanaal ("Harbour Canal") towards the ocean in the distance. Customs offices and port administration buildings can be seen on the canal's eastern bank on the right-hand side. The canal changed considerably over the more than two and a half centuries during which it was used as Batavia's main entry point from the sea. In 1619, when Batavia was founded, the entire area shown in this photograph was still open ocean. The Dutch first built a fort or castle on the eastern bank of the mouth of the Ciliwung River and then gradually reclaimed the areas to the north which we can see here.

The large white building in the centre of the photograph is the Pasar Ikan ("Fish Market") which was built in 1846. It no longer exists but the area is still known as Pasar Ikan today. This photograph was taken from the Culemborg lookout (*see pages 22–23*) and was one of the most famous and popular views of Batavia in the second half of the 19th century. It appears in numerous old albums belonging to former residents of Batavia and visitors who passed through the city.

The Vierkantsbrug ("Square Bridge") visible in the lower left-hand corner of this photograph and incorporating a drawbridge was demolished towards the end of the 19th century. The bridge itself was not square, but took its name from the long-gone Vierkant ("Square Building") which existed just to the west of the Culemborg lookout during the VOC days.

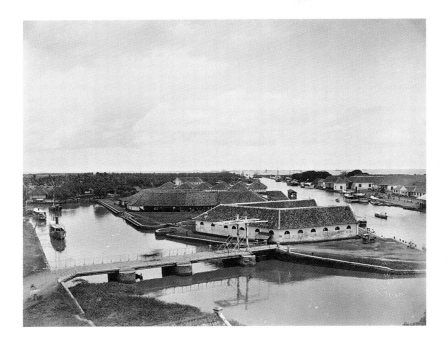

3. Photographer: **Woodbury & Page**, c. 1870 ■ albumen print ■ size: 18.9 x 24.0 cm ■ collection of the author, Melbourne.

Another view of the old port also taken from the Culemborg lookout, but this time with a wider-angle lens; this makes it possible to see another canal which for many years existed to the west (*left*) of the fish-market building. The section of this latter canal north of the bridge has been filled in and many small stalls and shops now exist on the site.

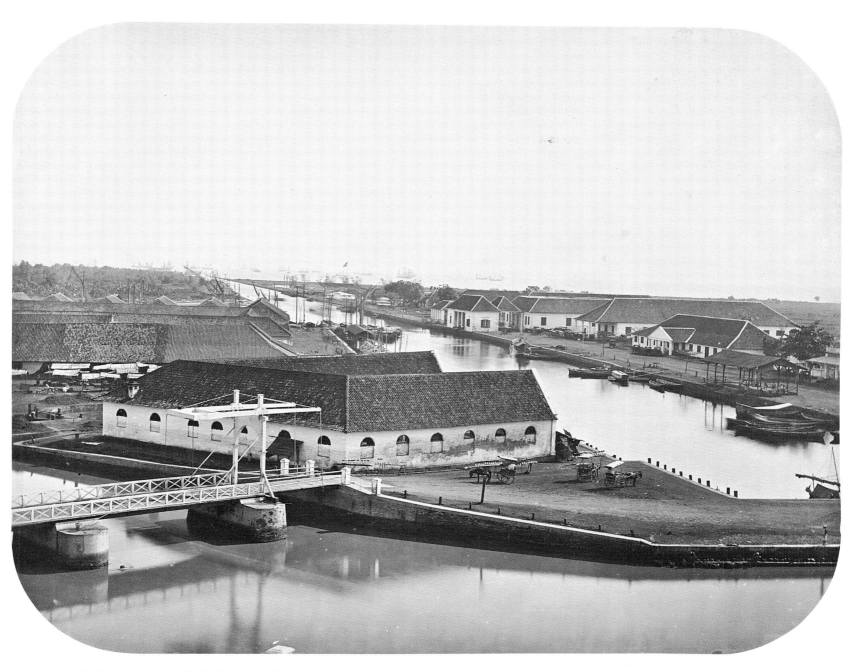

4. Photographer: **Woodbury & Page**, late 1860s ■ albumen print ■ size: 18.7 x 23.8 cm ■ collection of the author, Melbourne.

The southern end of the Haven Kanaal

This close-up view of the southern end of the Haven Kanaal ("Harbour Canal") of the old port of Batavia was also taken from the Culemborg lookout and enables us to have a clear picture of the buildings on the eastern side (the far side) of the canal. On the far right-hand side we can see the Stads Herberg ("City Inn") with its distinctive white columns. More details on the Stads Herberg are given on pages 28 and 29. The next building along to the left of the trees is the "toll house" or "customs house" which probably dates from the late 1840s. Beside the toll house is a group of warehouses belonging to the Groote Boom ("Large Customs Post") where ship cargoes were cleared and customs duties paid. The Groote Boom was relocated to this site on 1 June 1852 after having been situated from 1834 in a building at the very northern end of the west bank of Kali Besar (*see pages 32-33*).

The building partially obscured in the bottom left-hand part of the photograph is the Pasar Ikan ("Fish Market") on the western bank of the canal.

Another important but rather unimposing building was the open-walled structure with the pitched roof on the edge of the eastern bank of the canal, seen here between the Stads Herberg Inn and the toll house. This was the Landingplaats ("Landing Place") and the Kleine Boom ("Small Customs Post"). It was from here that people would disembark from the small steamers or "lighters" and clear themselves and their luggage through customs before continuing their journey into Batavia or further inland.

The word *"boom"* (tree or barrier) dated from Batavia's earliest days when a wooden beam was placed over the entrance of the Ciliwung River by the VOC as both a customs post to collect tolls and prevent smuggling and also a military checkpoint for the collection of weapons from visitors to the city. Smuggling, in particular, was a persistent problem.

The Kleine Boom had earlier been situated on the western bank of the canal, but was moved to this location on 1 February 1848 because of the opening of the Pasar Ikan building on the western bank in 1846.

An American visitor to Batavia, Albert Bickmore, described his experiences with the Kleine Boom in the 1860s:

> When a ship arrives from a foreign port, no one can leave her before she is boarded by an officer from the guard ship, a list of her passengers and crew obtained, and it is ascertained that there is no sickness on board. Having observed this regulation, we rowed up the canal to the *boom* or tree, where an officer of the customs looks into every boat that passes. This word "boom" came into use, as an officer informed me, when it was the custom to let a tree fall across the canal at night, in order to prevent any boat from landing or going out to the shipping.[4]

The canal was dammed in the early 1830s, as can be seen in the bottom right-hand corner of this photograph, in order to prevent silt and mud flowing into it from the Ciliwung River and making it too shallow to use. The shallowness of the canal was a problem which had plagued Batavia's port from its earliest days in the 17th century.

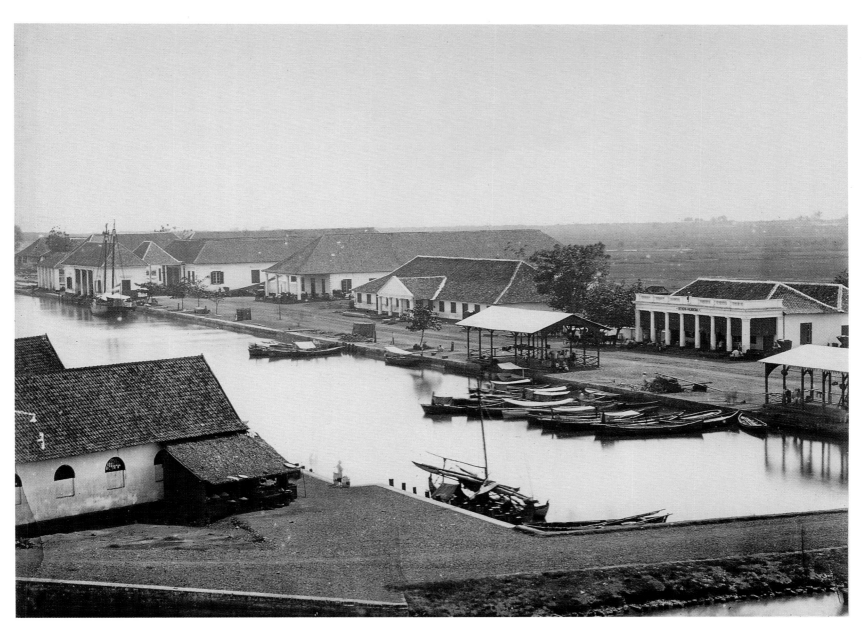

5. Photographer: **Woodbury & Page**, c. 1864–5 ▪ albumen print ▪ size: 17.5 x 23.5 cm ▪ collection of the Tropen Museum, Amsterdam.

The Stads Herberg

A ground-level view of the Kleine Boom ("Small Custom Post"), which is the open-walled structure on the left and the Stads Herberg ("City Inn"), which is the white-columned building on the right. The Stads Herberg was built in 1849 and was a popular place for refreshments for people newly arrived in Batavia or those who were about to depart. Many a joyful reunion or tearful farewell would have been seen at this inn. New arrivals coming late in the day could also spend the night there before travelling into Batavia the following morning.

The Stads Herberg was the initiative of H. S. van Hogezand who sensed a business opportunity with the relocation of the Kleine Boom from the western bank of the canal to the eastern bank on 1 February 1848. Van Hogezand had owned and run a smaller inn near the same location since 1820 and obviously realized that all passengers arriving or departing through the Kleine Boom would be passing right in front of his door. He therefore applied to the government for permission to build larger premises and received a temporary building permit in a letter dated 24 July 1849. Final approval was granted just over a month later on 2 September.

Van Hogezand's business sense served him well and the City Inn prospered. From 1850, he also earned an additional 200 guilders a month from his new premises by leasing out a small room on the north side of the building (left side) to an Englishman J. Parker, who operated a ship supplies business. The "Marine Stores" sign of Parker's enterprise can just be seen in this photograph above the awning on the left-hand side of the building. The Stads Herberg seems to have been so lucra-tive for van Hogezand that by 1852 he had sold it to J. F. Tentee and was able to use the proceeds to buy the much grander Hotel der Nederlanden (*see pages 130-131*).[5]

Tentee's timing was also opportune. The Groote Boom ("Large Customs Post") was relocated to the eastern bank of the canal on 1 June 1852 and the warehouses associated with it were built from that year. This meant more traffic passing by the front door.

The golden years for the Stads Herberg were from 1849 to 1885. Faster steamships, the opening of the Suez Canal in 1869 and the greater opportunities for private enterprise in the Indies after 1870, all meant more passengers passing through the Kleine Boom in front of the Stads Herberg. So strategic was its location, that Batavia's first letterbox was placed in its immediate vicinity in 1863.

However, the good years came to an end in 1885 with the completion of the new port at Tanjung Priok, which marked the end of the passenger traffic through Batavia's old port. By 1914, the once popular Stads Herberg was owned by Ong Tek Hin, but was used as a warehouse. The building still existed in 1949, 100 years after it was constructed, but has since been demolished.

Note in this photograph the many horse-drawn carriages called *delmans* or *sados* outside the inn waiting to take passengers into Batavia. Van Hogezand's original building permit in 1849 also allowed for the operation of a carriage hire business from the Stads Herberg, and it would appear that this activity was keenly pursued.

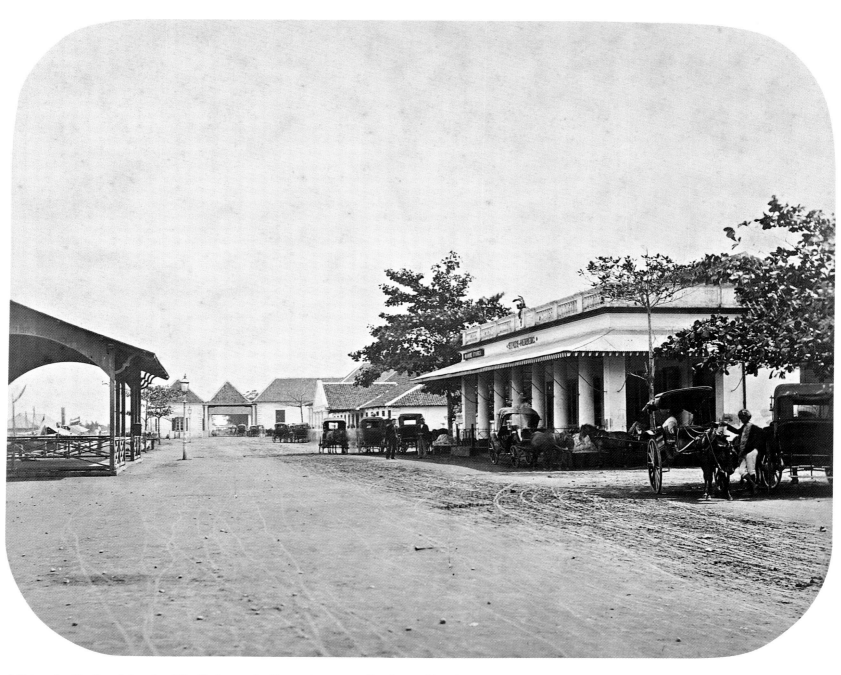

6. Photographer: **Woodbury & Page**, late 1860s ▪ albumen print ▪ size: 19.0 x 23.5 cm ▪ collection of the author, Melbourne.

The Westzijdse Pakhuizen

In this view taken from behind the Pasar Ikan ("Fish Market") building we can see some of the Westzijdse Pakhuizen ("West Side Warehouses") on the far right-hand side behind the masts of the small sailing boats which are moored on the west bank.

The Westzijdse Pakhuizen were built by the VOC to store their valuable commodities, particularly spices. They date back to 1652 although numerous additions and alterations were made during the 17th and 18th centuries. Since 1977, the Westzijdse Pakhuizen have been used as the Museum Bahari or Maritime Museum. The front walls of these warehouses with their small sentry posts are the only significant surviving remains of the wall which was built around Batavia between the late 1620s and the 1640s and remained until demolished by Daendels in 1808/9.

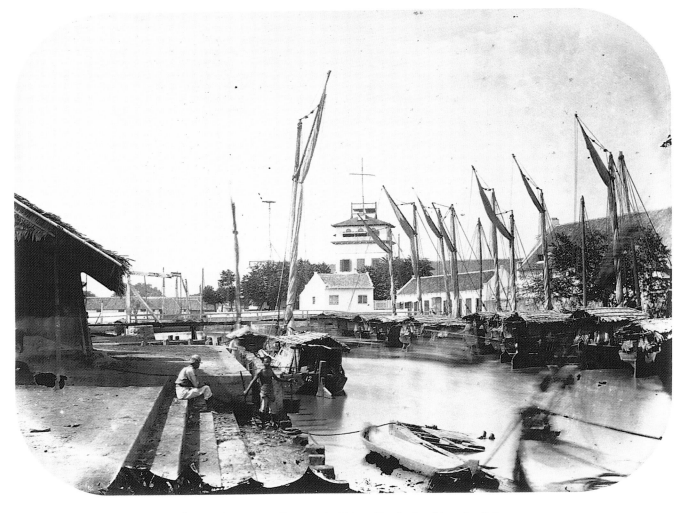

7. Photographer: **Woodbury & Page**, c. 1864–5 ■ albumen print ■ size: 18.4 x 24.0 cm ■ collection of the author, Melbourne.

The view from the Landingplaats

For new arrivals to Batavia by sea between 1839 (when the Culemborg lookout was built) and the completion of Tanjung Priok in 1885, this would have been the view which greeted them after they first set foot on dry land and gazed around from the Landingplaats ("Landing Place") or Kleine Boom ("Small Customs Post") on the eastern side of the canal.

In the centre we can see the Culemborg lookout and adjoining buildings together with the former VOC shipyard warehouses to the left of the lookout. On the far right-hand side, three *delman* or *sado* (horse-drawn carriages) and their drivers await passengers on the western bank of the canal, to the left of which the Pasar Ikan fish market stands (not visible).

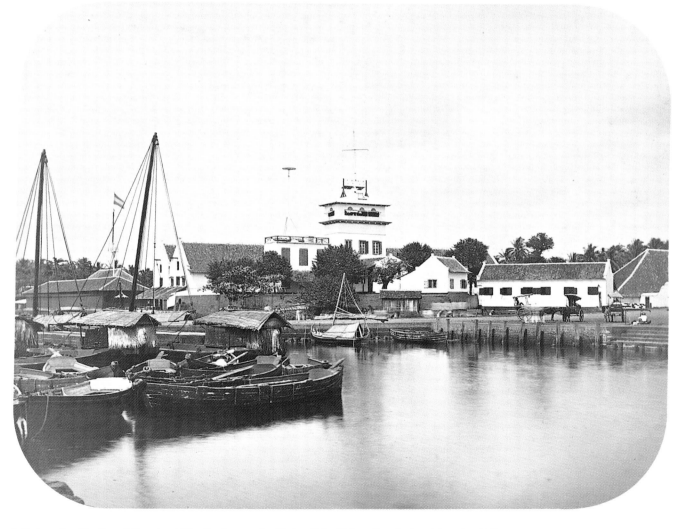

8. Photographer: **Woodbury & Page**, late 1860s ■ albumen print ■ size: 18.9 x 23.6 cm ■ collection of the author, Melbourne.

The Groote Boom

Just as there was the Kleine Boom ("Small Customs Post") on the eastern bank of the canal (*see pages 26-27*), which served as the arrival point for visiting passengers and the clearance of their luggage, there was also the Groote Boom ("Large Customs Post"), where ship cargoes were cleared and customs duties paid. The office of the Groote Boom was the double-storeyed white building visible in this photograph, and it was probably built in 1834. It was located on the western bank of the Ciliwung River just north of where the new toll road now crosses over the northernmost end of Kali Besar. However, this building only served the customs authorities between 1834 and 1852 because from 1 June 1852 a new customs office for large cargoes was opened on the eastern side of the canal. The new office and its warehouses can be seen on page 27. Nevertheless, the area in this photograph continued to be known as the Groote Boom for several decades after the customs office no longer functioned there.

This early office of the Groote Boom was located just 300 metres south of the Culemborg lookout and the top of the lookout can just be seen to the right of the buildings in the background.

Dealing with Batavia's customs officers could be a frustrating experience, as Weitzel noted in 1858:

> As soon as the voyager has reached the "Kleine Boom" then he thinks all difficulties have been overcome but he is wrong. He still has to have a word with the customs officers, and before that altercation has finished, he will feel his purse considerably lightened and he will have lost at least an hour of his time. The customs officer will also refer him to the "Groote Boom" and then back to the "Kleine Boom" and from the "Kleine Boom" he must then go again to the "Groote Boom" and maybe again back to the "Kleine Boom", because he is a foreigner and totally unacquainted with the regulations, so that he repeatedly forgets something or omits something, and therefore repeatedly has to come and go between the two places.[6]

This photograph was taken from the Hoenderpasarbrug ("Chicken Market Bridge") (*see page 67*). It is likely to have been one of the 16 "newly taken" photographs of Batavia which Woodbury & Page advertised for sale in May and June 1863 (*see Appendix Three*).

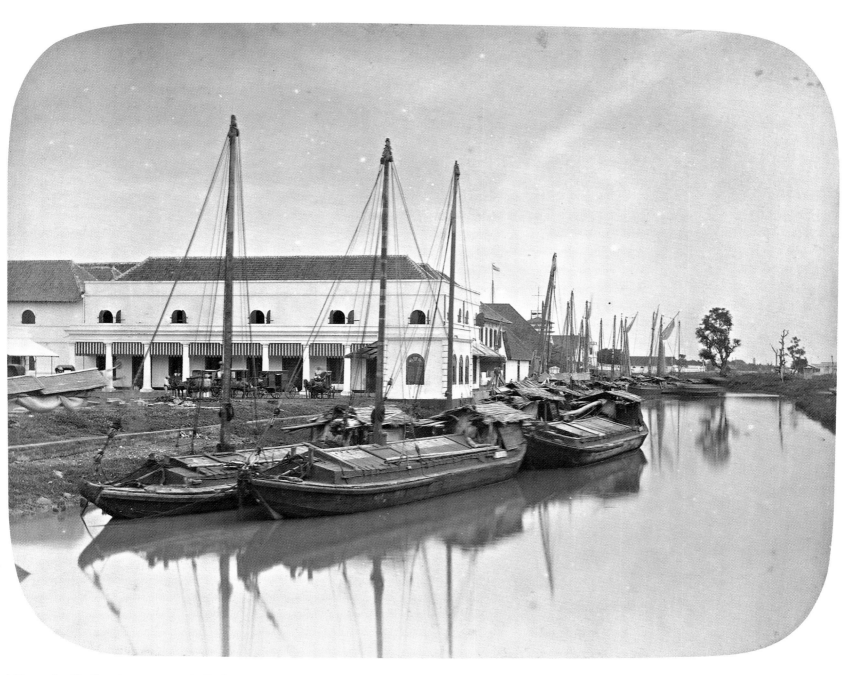

9. Photographer: **Woodbury & Page**, c. May 1863 ■ albumen print ■ size: 18.4 x 23.4 cm ■ collection of the author, Melbourne.

The bridge over the old moat

Another photograph taken from the Culemborg lookout, this time looking east at the bridge which connected the old port with the road into Batavia. This bridge was situated approximately 100 metres south of the Kleine Boom (*see pages 26-27*) and the Stads Herberg (*see pages 28-29*). New arrivals at the port would find a horse-drawn carriage, and head south over the bridge and along Kanaal Weg (Jalan Tongkol) into the city of Batavia.

The bridge was officially known as "Rusman's Bridge" during at least part of the colonial era although who Mr Rusman was and why the bridge was named after him is not clear. Apparently it was better known to many as "Schijtbrug" or "Djembatan Berak", no doubt reflecting the area's reputation from the 18th century for being filthy and unsanitary.

It has also been suggested that "Schijtbrug" may originally have been "Scheidbrug" from the Dutch word "afscheid" meaning "leave-taking" or "parting", given the proximity of the bridge to the Kleine Boom where many tearful farewells would have taken place as people departed from Batavia's old port.

The area to the right of the bridge in this photograph was the northern end of the site of the old castle built by Jan Pieterszoon Coen and which existed from 1627 to 1808/9, before being demolished by Daendels. It replaced a much smaller castle that Coen had built on the same site in 1619, when Batavia was founded.

At the time the castles were built, the river in this photograph was open ocean and the land on the right was the northern tip of Batavia. When the Dutch reclaimed the land on the left to extend the port's main canal, the river was created as a new branch of the Ciliwung. It enabled access by boat from the canal to the northern gate of the castle called the Waterpoort ("Water Gate"). This new branch of the river was later extended to become a moat surrounding all four walls of the castle. The river still exists today, but the part of the moat that faced the southern side of the castle was filled in many years ago.

The old drawbridge visible here still existed in the mid-1930s, but was later demolished. A newer and wider bridge stands today crossing the river at the same point as before. The building to the left of the bridge (partially obscured) still stands, although in a very dilapidated state, and is no longer used.

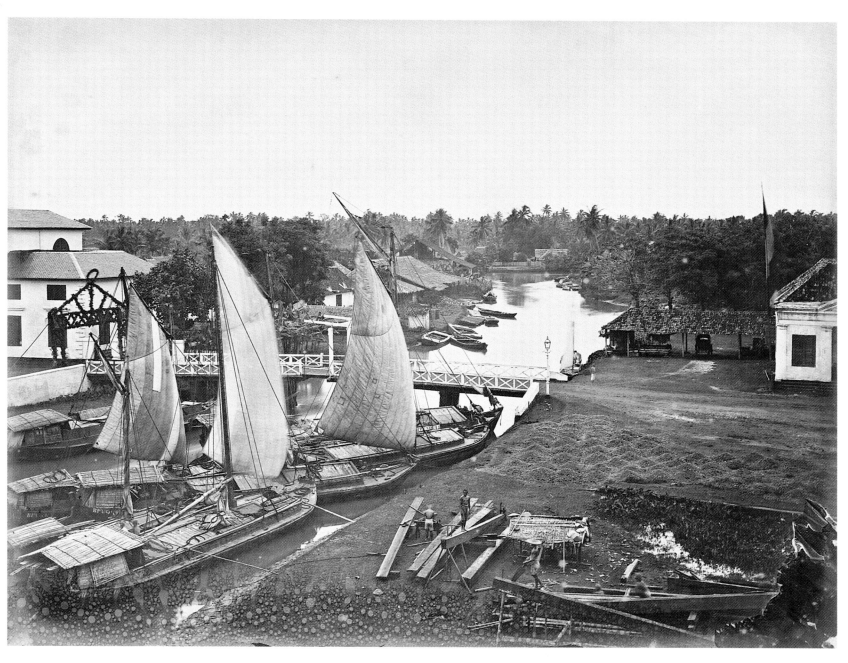

10. Photographer: **Woodbury & Page**, 1872 or earlier ▪ albumen print ▪ size: 18.8 x 24.1 cm ▪ collection of the author, Melbourne.

Kg Baroe

Kleine Boom

Kg Djapat

Spoorweg

Jaagpad

Pasar Ikan Waterfabr.

Tijdbal
Uitkijk

Voormalig

Trainway station Kg Embrat

Werf

van

Kg Haven kantoor

Batavia

Kasteel

Kg Pen

Klapa

Groote Boom

Kg Bandan

Kg

dja

Kg
Tiang
bendera

ringan

Amst. poort

Heemraden
plein

12

Kruit magazijn

Gedp Maleische gracht

11

Zoutpakhuis

West zijde Besa

Leeuwinne

K. Bla
Kan

straat

Gedempte

13 Raad v.
Justitie

Boea

14

Kg Bandan

Berkstraat

16

Moeka

Stadhuis Station Batavia

Post en telegr.
kantoor

Kadastraal
kantoor

Kg Krekot

Melakka
Gang Beursplein Javasche
bank kleeding
magazijn

Gelderlandsche weg

15

Stadskerk

Chineesche
hospitaal

Pasar Pintoe Ketjil Voorrij Zuid BATAV

Kg Petjah

INSIDE THE WALLS

I t is perhaps something of a misnomer to call this section of the book "Inside the Walls", given that most of the walls of the old city of Batavia and its castle were demolished in 1808/9, more than half a century before most of the photographs here were taken.

Nevertheless, thinking in terms of "inside" and "outside" the walls is very relevant to an understanding of the way Batavia developed during the 17th and 18th centuries. The walled city of Batavia was the heart of the Dutch trading empire in the Netherlands Indies until the demise of the VOC in 1799. The area inside the walls was the original "kota", the word that is still used today to refer to the older parts of north Jakarta.

The walls of the old city were built by the VOC between the late 1620s and the 1640s. The first castle had been built in 1619, but was replaced by a larger one on the same site in 1627. These fortifications were a means of defence for the Dutch, who were attacked by soldiers from the Central Javanese kingdom of Mataram in 1628 and again in 1629. Tensions also existed during most of the 17th century between the Dutch in Batavia and the Sultanate of Bantam (now Banten) to the west. By the mid-1680s, these threats had subsided but until then, to venture far outside the walls involved considerable personal risk. Bandits (often escaped slaves) and even wild animals were a danger in addition to marauding soldiers.

The walled city of Batavia was never large. When founded in 1619, Batavia was only meant to be a port where VOC ships passing between Europe and the spice islands of the Moluccas could be repaired and obtain supplies of fresh food and water. It was not expected to become a major settlement in its own right. In today's terms, the boundaries of the walls (including the castle) broadly speaking extended west to Jalan Gedung Panjang (as far north as Jalan Luar Batang 2) and Jalan Pejagalan (as far south as Jalan Telepon Kota); to the south along Jalan Telepon Kota, Jalan Asemka and Jalan Jembatan Batu (as far as the bridge over the Ciliwung River before Jalan Pangeran Jayakarta); east to the stretch of the Ciliwung River which runs past Kampung Muka Timur (as far as where the river joins Jalan Krapu in the north) and north to where the northern end of Museum Bahari at Pasar Ikan leads to the corner of Jalan Luar Batang 2 and Jalan Gedung Panjang.

For almost two centuries from 1619 until 1808/9, most of the administrative, commercial and judicial activities of Batavia were concentrated inside the walls of the city and its castle. From the 1750s, successive governors-general chose to live and work in Batavia's healthier southern districts, particularly the grand estate Weltevreden, but lowly VOC clerks and officials continued to toil away in the desperately unhealthy conditions within the city's walls.

The demolition of the walls under Daendels' orders in 1808/9, only a decade after the end of the VOC, was an important symbolic act. It marked both the end for the "old city" of the north as the heart of Batavia as well as the beginning of the transfer of political and administrative power to the "new city" of the south, where it continues to be to this day.

The Amsterdam Poort (1)

By the middle of the 19th century, the only surviving part of Batavia's old castle was the Amsterdam Poort ("Amsterdam Gate") seen here in this photograph. The Amsterdam Poort was the southern entrance to the castle and was located due north from the front steps of the Stadhuis ("Town Hall") (*see pages 44-45*). In this photograph we are looking in a northerly direction and the Stadhuis would be directly behind us some 400 metres to the south.

First built in the 17th century, the Amsterdam Poort was remodelled several times over the years. Its original design would have been quite different from the view we see here. The southern end of the castle, including the Amsterdam Poort, was renovated in the Rococo style during the governor-generalship of Gustaaf Willem Baron van Imhoff (1743-50). By the end of the 18th century, the two curved wings flanking the sides of the gate (visible in the photograph) were connected to rather grand three-storeyed buildings which formed part of the castle.[7]

When the castle was demolished by Daendels in 1808/9, all the buildings were destroyed except for the Amsterdam Poort and its two side wings, which somehow survived. Nevertheless, they were neglected and fell into disrepair. In the 1830s or 1840s, the gate was substantially rebuilt into what appears in this photograph, with the fierce statues of Mars (the Roman god of war) and Minerva (the Greek god of the arts) acting as guards. The Amsterdam Poort was located on the northern end of what is now Jalan Cengkeh, on the southern side of the railway bridge which crosses over at the point where Jalan Cengkeh connects with Jalan Tongkol.

New arrivals by sea at Batavia in the middle of the 19th century would depart from the old port and cross the bridge over the old moat on page 35, before travelling along Kanaal Weg ("Canal Street") and then on to Kasteelplein Weg ("Castle Plain Street"), which are both now Jalan Tongkol, and pass through the Amsterdam Poort before heading along the road visible here called Prinsenstraat ("Prince Street"), now Jalan Cengkeh, into Stadhuisplein ("Town Hall Square"), now Taman Fatahillah, and the centre of the old city of Batavia.

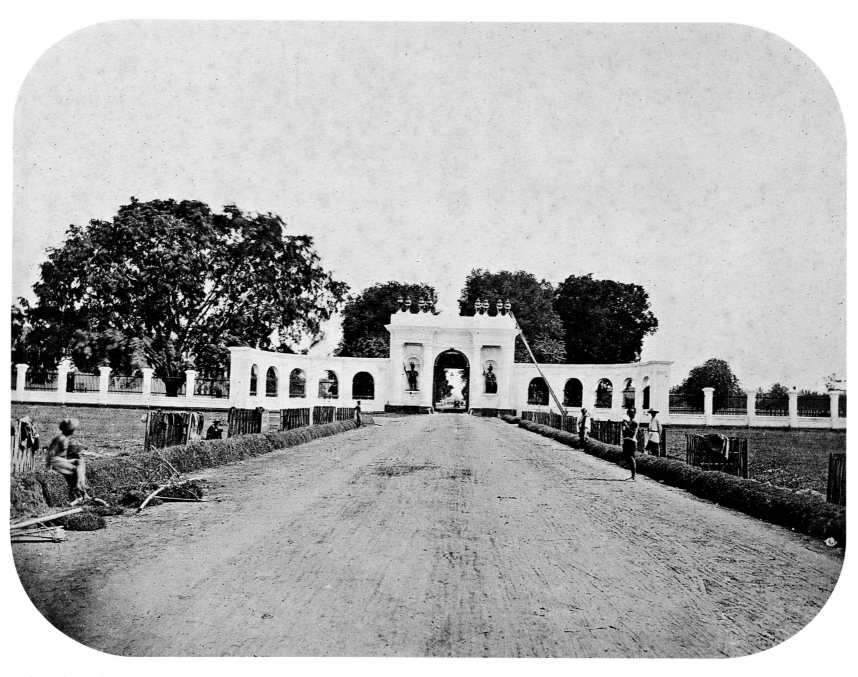

11. Photographer: **Woodbury & Page**, mid-1860s ▪ albumen print ▪ size: 18.0 x 22.9 cm ▪ collection of the author, Melbourne.

The Amsterdam Poort (2)

In April 1869, horse-drawn trams commenced operations in Batavia. The route started at Kanaal Weg (now Jalan Tongkol) near the old port and ran along Prinsenstraat (Jalan Cengkeh), through the Stadhuisplein (Taman Fatahillah), Nieuwpoort Straat (Jalan Pintu Besar Utara and Jalan Pintu Besar Selatan) and along the western side of Molenvliet (Jalan Gajah Mada).

Accordingly, the Amsterdam Poort ("Amsterdam Gate"), which had been no hindrance for horse-drawn carriages, became something of a nuisance for the larger trams. However, rather than demolish the entire gate, only the side wings and fences that can be seen on page 39 were torn down, in around 1868. This meant that the trams had to take a circular route around the gate, as can be seen from the tram lines in this photograph.

The gate in the form seen here survived until the Japanese Occupation (1942-5), during which time the statues of Mars and Minerva disappeared. By the end of the 1940s, the gate had become not only a lonely and neglected reminder of the past but also a traffic obstacle. It was demolished in December 1950 and nothing remains of it today.

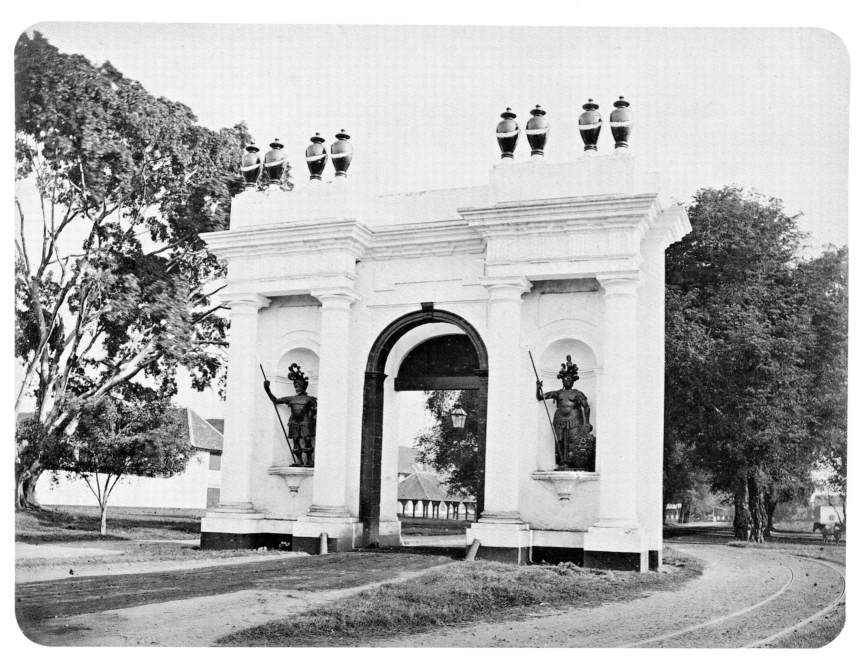

12. Photographer: **Woodbury & Page**, 1880s ■ albumen print ■ size: 18.4 x 23.6 cm ■ collection of the author, Melbourne.

Prinsenstraat

In this rare photograph from around September 1867, we are looking north along the full length of Prinsenstraat ("Prince Street") towards the Amsterdam Poort ("Amsterdam Gate") which can be seen in the distance. The photographer, Jacobus Anthonie Meessen, would have been standing just south of the intersection of Prinsenstraat with Pasar Pisang on the left (now Jalan Kali Besar Timur 3) and Leeuwinnen Straat on the right (now Jalan Kunir). The Stadhuis ("Town Hall") would have been directly behind Meessen 100 metres away.

European visitors arriving in Batavia by sea in the 19th century would have (until Tanjung Priok was completed in 1885) travelled from the old port south along Prinsenstraat through the old city of Batavia and then usually on to the hotel and residential districts of Weltevreden in the south.

Until well into the 20th century, Prinsenstraat was the location of many offices, warehouses and commercial premises of European firms. In the 1860s, when this photograph was taken, Prinsenstraat would have been busy with trade and business activity during the day but much quieter by night, given that the European employees would have mainly lived in the southern districts "uptown".

A visitor to Batavia in 1862 noted the silence of the area as he was driven through Prinsenstraat early one evening:

The evening had started to fall when we stepped into our carriage and entered old Batavia, and I was impressed by the unbelievably deathly quiet which reigned here all over. One drives past the well known City Inn, over a lonely square, where formerly a castle stood then passes through a large gate and finally sees the city hall in front, with both buildings reminding us of the construction style of the 17th century.[8]

13. Photographer: **Jacobus Anthonie Meessen**, c. September 1867 ■ albumen print ■ size: 15.8 x 20.1 cm ■ collection of Amsterdam University Library, Special Collections.

The Stadhuis

One of the most important buildings in Batavia was the Stadhuis ("Town Hall"), built between 1707 and 1710 and located on the site of two earlier town halls that existed from 1620 to 1626 and 1627 to 1707 respectively. This building still exists today, and has been used since 1974 as the Jakarta History Museum. The Stadhuis stands on the southern side of the square now known as Taman Fatahillah but which used to be called Stadhuisplein ("Town Hall Square").

The Stadhuis was not only Batavia's centre of administration, but also for many years contained the offices of the Council of Justice and the Bench of Magistrates. Law and order were dealt with from the Stadhuis including the legalizing of contracts and mortgages, the registering of marriages, the freeing of slaves, the issuing of licences, the buying and selling of ships and the punishment of capital crimes. Many injustices were apparently perpetrated against unfortunate souls who found themselves on the wrong side of the law, particularly during the VOC days. The Stadhuis contained prisons, and torture was a common means of extracting confessions.

Public executions were carried out in front of the Stadhuis with judges watching from the second floor. The last execution carried out there was the hanging of a Chinese murderer and thief in 1896. By the latter part of the 19th century, punishment of criminals in public was not as frequent nor as harsh as during the days of the VOC two centuries earlier. Note the following description from the journal of a German soldier, Christopher Schweitzer, who was in Batavia in 1676 (the spelling is Schweitzer's):

> The 29th, Four Seamen were publickly Beheaded at Batavia, (which is here the common Death of Criminals) for having killed a Chinese. At the same time, six Slaves that had Murthered their Master in the night, were broke upon the Wheel. A Mulatto (as they call those that are begotten betwixt a Black-a-Moor and a White) was Hang'd for Theft. Eight other Seamen were Whipt for Stealing, and running away, and were besides this, Burnt on the Shoulder with the Arms of the East India Company. Two Dutch Soldiers that had absented themselves from the Guard two days, ran the Gauntlet. A Dutch School-master's Wife that was caught in Bed with another Man, (it being her frequent Practice) was put in the Pillory, and Comdemn'd to 12 years Imprisonment in the Spinhuys [women's prison].[9]

Administration of Batavia from this building continued until 1913 when the Batavia City Council moved to premises in Tanah Abang West and then in 1919 to Koningsplein Zuid (now Jalan Medan Merdeka Selatan). For several years after 1925, this building served as the office of the Governor of West Java.

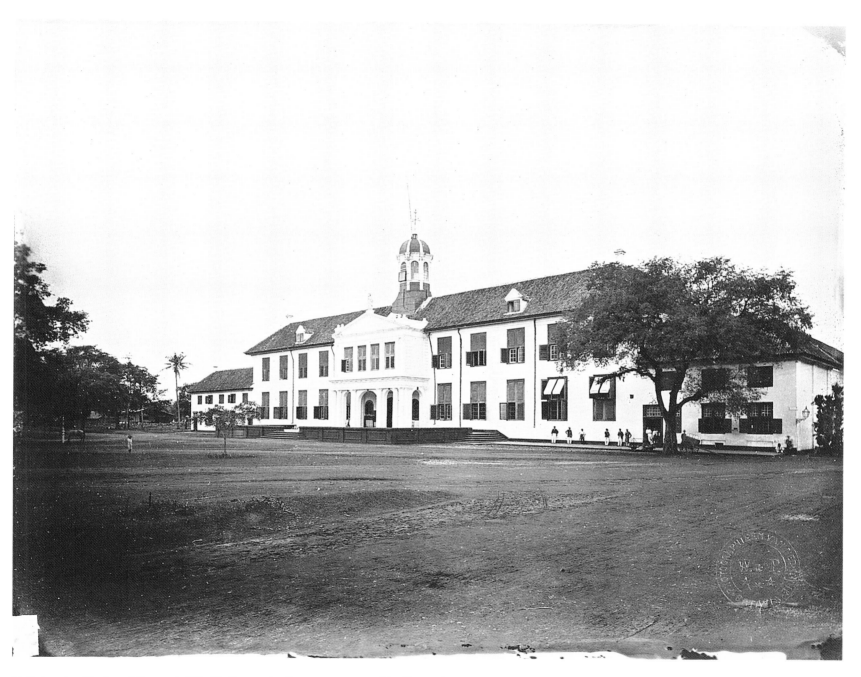

14. Photographer: **Woodbury & Page**, early 1870s ■ albumen print ■ size: 20.0 x 25.3 cm ■ collection of the author, Melbourne.

Looking north along Binnen Nieuwpoort Straat

Nieuwpoort Straat ("New Gate Street") was the main southern entrance to the walled city of Batavia and took its name from the "new" gate which was added to the wall in 1631. It was known as the Groote Poort ("Large Gate"), from which the current Indonesian name for this street, "Pintu Besar", is derived. Nieuwpoort Straat had two sections: Binnen Nieuwpoort Straat ("Inner New Gate Street") which, as the name suggests, was within the walled city and which is now known as Jalan Pintu Besar Utara and Buiten Nieuwpoort Straat ("Outer New Gate Street") which was outside the wall on the southern side of the new gate, and which is now called Jalan Pintu Besar Selatan.

This rare photograph is looking north along Binnen Nieuwpoort Straat and we can see the buildings on the eastern side of the road. The third building from the right (the one with the carving above the main entrance) was occupied by the Algemeen Kleedingmagazijn ("General Clothing Storehouse"). It was built around 1770 and demolished in 1921. All of the buildings at the southern end of this block were demolished in the 1920s and a branch of Bank Mandiri now stands on the site. The building seen partially obscured at the northern end of the street in the distance is the western wing of the Stadhuis ("Town Hall").

The absence of tram lines running down the western side of the street means that this photograph was taken before 1869, when horse-drawn trams were introduced into Batavia.

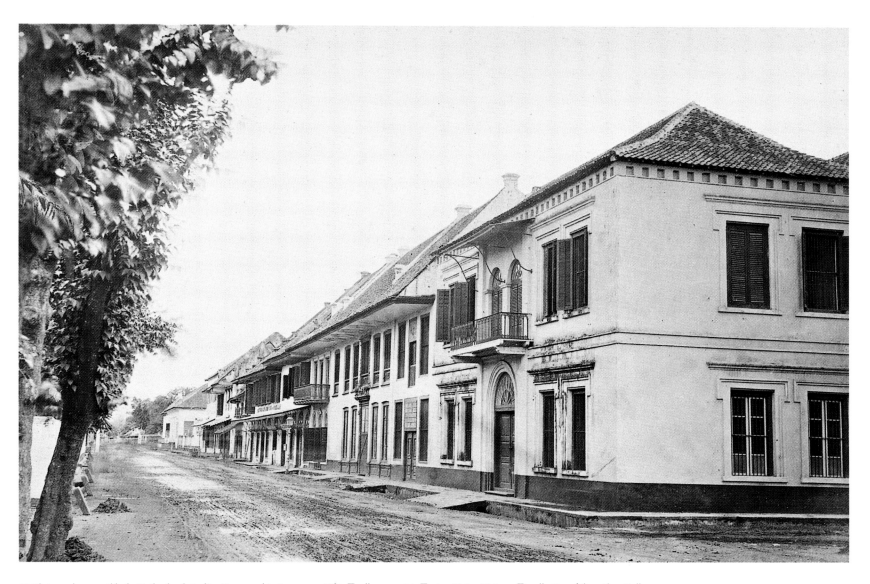

15. Photographer: possibly the **Netherlands Indies Topographic Bureau**, c. 1867 ■ albumen print ■ size: 20.1 x 30.0 cm ■ collection of the author, Melbourne.

Looking south along Binnen Nieuwpoort Straat

This photograph of Binnen Nieuwpoort Straat (Jalan Pintu Besar Utara) was taken from the western side of the Stadhuis ("Town Hall") and is looking towards the south. A corner of the Stadhuis wall can be seen on the far left-hand side. The horse-drawn carriage and driver in the foreground are in front of the tram stop that was for many years located behind the Stadhuis. The buildings on the right date back to the 18th century and were built during the VOC era. The building on the far right was the premises of the Nederlandsch-Indische Escompto Maatschappij, which was founded in 1857 and became the second largest bank in Java after the Java Bank.

Note the steam tram in the centre of the photograph. A plan to use trams in Batavia, drawn by horses, had been mentioned in the *Java Bode* newspaper as early as 15 December 1860 as the idea of a certain Mr. J. Babut du Mares. However, it was not until 1867 that the concession to build tram lines in Batavia was awarded to the firm Dummler & Co. The commencement of construction was noted in the *Java Bode* of 10 August 1867 and the first horse-drawn trams came into operation on 20 April 1869 with the line running from just north of the Amsterdam Poort (*see pages 38-41*) along Nieuwpoort Straat and Molenvliet and finishing at the Harmonie building (*see pages 122-125*).

Two months later in June 1869, additional lines were opened from the Harmonie building to Tanah Abang and from the Harmonie building along Rijswijk through Kramat and ending at Meester Cornelis (now Jatinegara). The concession was subsequently taken over by the Batavia Tramways Company. However, a wide range of problems was encountered with the horse-drawn tramways, including a horrible toll on the horses. In 1872 alone, 545 horses were reported to have died. The horses could only pull one carriage at a time and if there was a slope in the road, a team of buffaloes was placed in front of the tram to either assist or replace the wretched horses, as was noted in the *Java Bode* of 20 November 1869. The financial performance of the tramways was also poor, and complaints from the public were frequent. Furthermore, many European citizens regarded using the trams as being beneath their dignity. In March 1870, the line from the Harmonie building to Tanah Abang was closed only nine months after it had been opened.

On 12 June 1882, steam trams began operating in Batavia under the management of the Netherlands Indies Tramways Company and proved to be far more satisfactory and popular. Electric trams were first used in Batavia in July 1900, but it took many years before they completely replaced steam trams. Electric trams were still in operation in Jakarta in the 1960s, but are now no longer to be found.

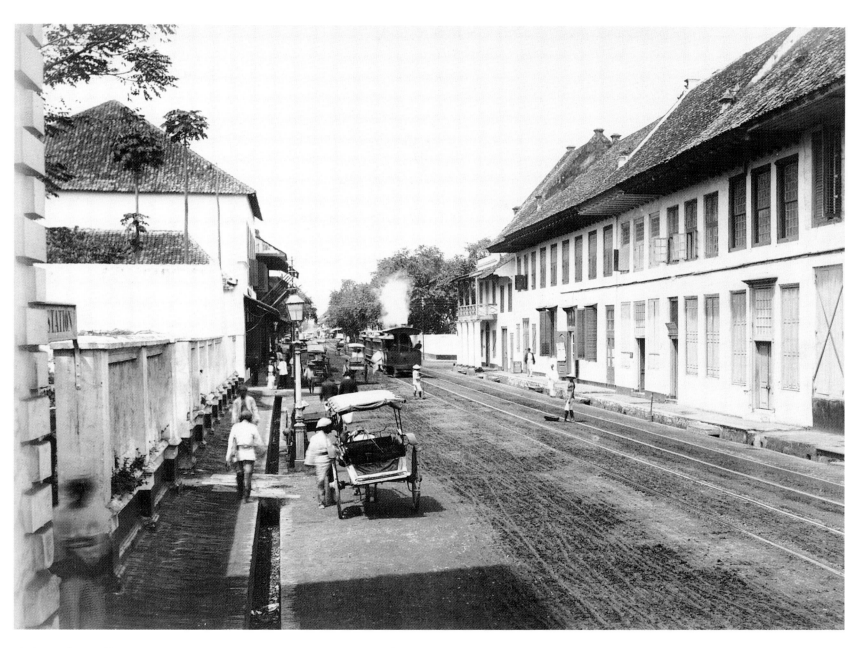

16. Photographer: possibly **Woodbury & Page**, mid to late 1880s ■ albumen print ■ size: 20.6 x 27.1 cm ■ collection of the Tropen Museum, Amsterdam.

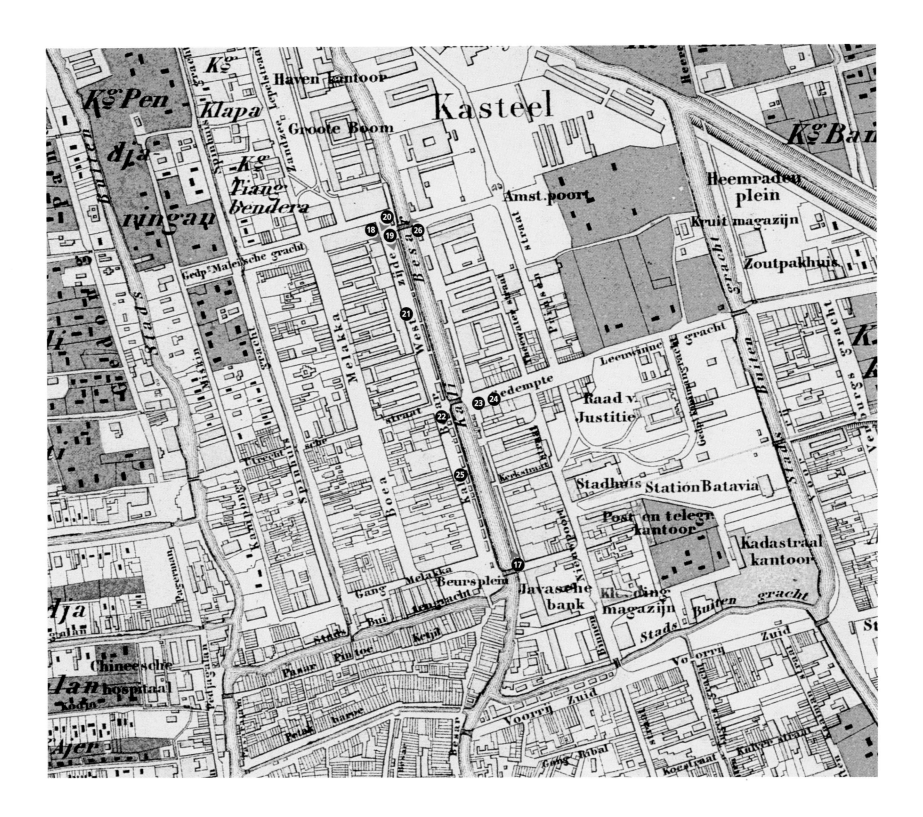

KALI BESAR

Kali Besar literally means "large river" or "great river" and refers to the straight stretch of the Ciliwung River south of what is now Jalan Tiang Bendera and north of Jalan Malaka, which became almost the heart of the old walled city of Batavia. It was the location of the Ciliwung River which contributed to the Dutch choice of this area as the site for the city. Kali Besar played a central role in the history of Batavia for three centuries, spanning almost the entire Dutch colonial era.

The twisting bends of Kali Besar were straightened in 1631 and 1632 under orders from Governor-General Jacques Specx (governor-general 1629–32) to facilitate shipping activity along the river. Indeed, in the first decades of Batavia's history, ships of modest size could sail from the sea along the Ciliwung River into the Kali Besar area to load and unload supplies and merchandise. However, the silting of the river and the formation of sand banks at its mouth meant that eventually only smaller vessels were able to navigate along the shallow depths.

In the VOC era of the 17th and 18th centuries, there was a variety of buildings along Kali Besar including warehouses, fine private residences, churches and markets. At first, both Europeans and Chinese could be found living in the Kali Besar area but after the Chinese massacre in 1740, the Chinese were forbidden to live within the walled city and many settled in neighbouring Glodok. By the second half of the 19th century, the churches and markets were gone and Kali Besar had become primarily a business and trading centre and was predominantly European in character.

One of the catalysts for the changing face of Kali Besar was the passing of the Agrarian Law in Holland in 1870 (the so-called "De Wall Act") which marked the end of the controversial government "cultivation" (or "culture") system and permitted a major expansion of private enterprise. This led to a rapid growth in the number of banks, trading firms, shipping agents, insurance brokers and general merchants, many of which were located in the Kali Besar area. The sugar and coffee industries dominated Batavia's commerce in the 1870s and 1880s and a large proportion of sugar and coffee exports were handled by Kali Besar firms.

The European owners of many of these firms lived in fine houses in the southern districts of Batavia such as the areas around the Koningsplein, Prapatan, Tanah Abang and along Molenvliet, where living conditions were much healthier than in the old city. A daily commute was therefore required along Molenvliet.

Many businesses in Kali Besar feared the decline of the area's commercial importance following the completion of the new port of Tanjung Priok (10 kilometres away) in 1885. However, such fears turned out to be groundless as Tanjung Priok was soon regarded as being too unhealthy and too malaria-infested to enable a new commercial and trading centre to develop there. It was only from the early 1900s that many businesses gradually began to move their headquarters south to Molenvliet and along Noordwijk and Rijswijk.

Kali Besar: a panoramic view looking north

This rare two-part panorama of Kali Besar was taken from the southern end of Kali Besar Oost (Jalan Kali Besar Timur) near the corner of Java Bank Straat (Jalan Bank) and looks north in the direction of the old port. The Middelpunt Brug ("Middle Point Bridge") is visible in the centre with the sails behind it. Not being a drawbridge, the Middelpunt Brug was the fur-

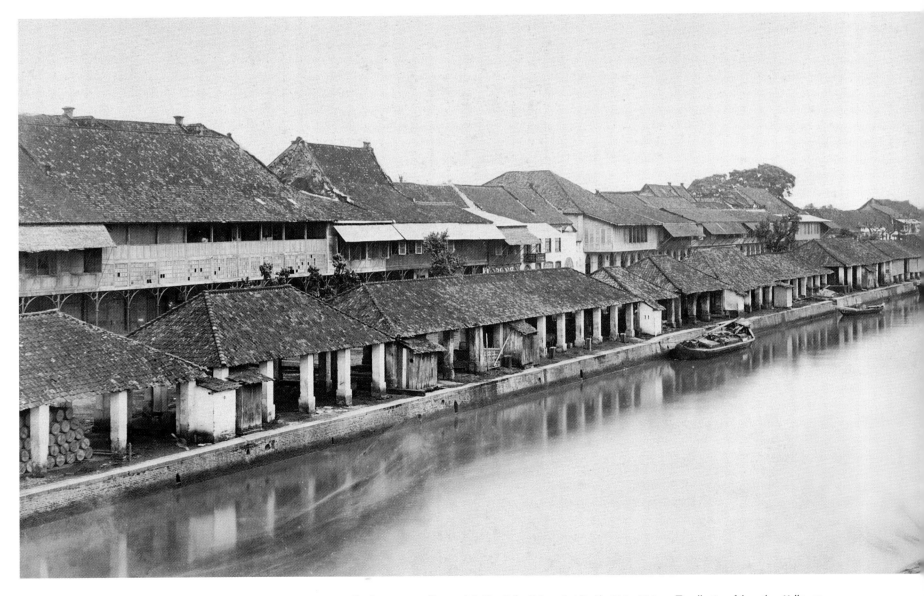

17. Photographer: possibly the **Netherlands Indies Topographic Bureau**, c. 1870s ■ albumen prints ■ sizes: left side, 19.6 x 30.2 cm & right side, 20.1 x 30.0 cm ■ collection of the author, Melbourne.

thest point south along the Kali Besar that sailing vessels could travel. The Hoenderpasarbrug further north was the only drawbridge. The open godowns visible on both sides of the river were for temporary storage of merchandise and were used by the trading firms whose offices and warehouses were located along Kali Besar or the streets nearby.

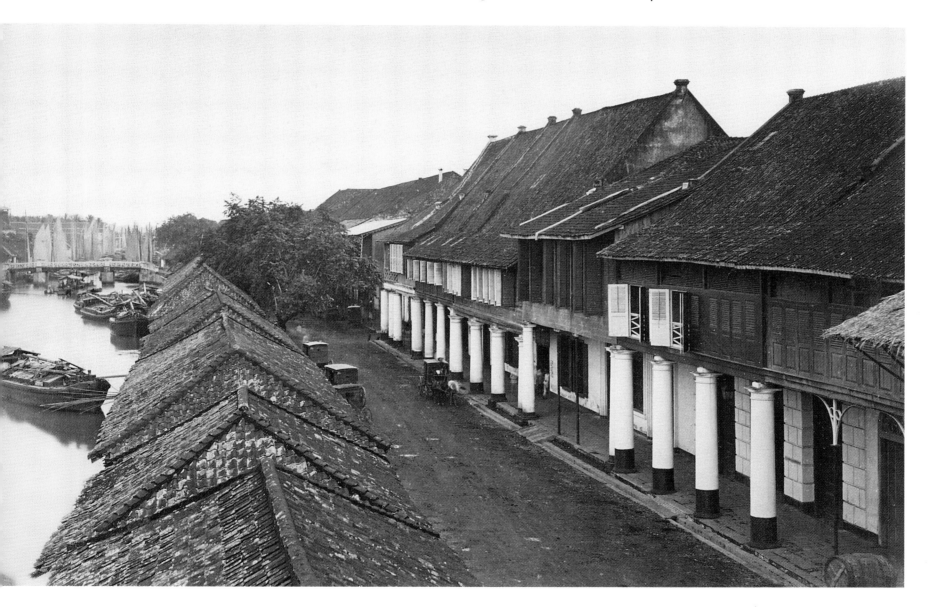

Looking south along Kali Besar West (1)

This photograph was taken at the beginning of what was to be a very prosperous decade for the trading, shipping and insurance firms along Kali Besar after the passing of the Agrarian Law in Holland in 1870 that allowed for the expansion of private enterprise in the Indies.

This view was taken from the northern end of Kali Besar West (Jalan Kali Besar Barat), just to the north of where the Omni Batavia Hotel is today, and looks across Kali Besar West in a south-easterly direction. The dome with the spire visible in the background on the left is the Stadhuis ("Town Hall").

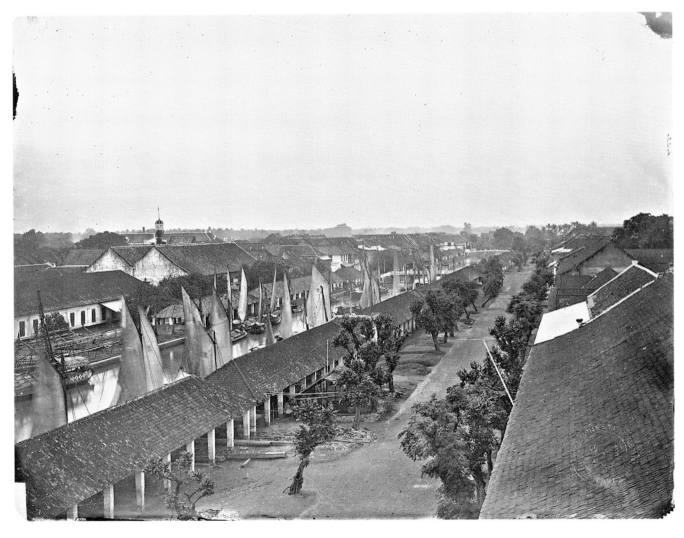

18. Photographer: **Woodbury & Page**, c. 1870 ■ albumen print ■ size: 19.7 x 24.8 cm ■ collection of the author, Melbourne.

Looking south along Kali Besar West (2)

A view along Kali Besar West (Jalan Kali Besar Barat) taken from the northern end of the street and looking south. Part of the premises of Maclaine, Watson & Co. (*see pages 56-57*) is visible on the far right. Other offices with their stately white columns stretch out along the street. The building to the left of Maclaine, Watson & Co. still stands, although the façade of the northern half of the building has been altered and the columns are gone. The columns of the southern half still exist. Beside this building, in the centre of the photograph, is where the Omni Batavia Hotel now stands.

19. Photographer: **Woodbury & Page**, c. 1870 ■ albumen print ■ size: 19.3 x 24.5 cm ■ collection of the author, Melbourne.

The premises of Maclaine, Watson & Co.

The premises of Maclaine, Watson & Co. were situated at the very northern end of Kali Besar West (Jalan Kali Besar Barat) on the corner of what is now Jalan Tiang Bendera. The firm was founded in Batavia in 1825 as G. Maclaine & Co. by Gillean Maclaine, who sailed for Java in 1820 at the age of 22. In 1827, the firm's name became Maclaine, Watson & Co. and over the years it grew to become one of the major British firms in the Netherlands Indies. They were importers and exporters as well as shipping, insurance and commission agents.

In the late 19th and early 20th centuries, Maclaine, Watson & Co. was particularly active in the sugar industry and was apparently one of the most important sugar traders in the Netherlands Indies. They also owned sugar estates and factories near Semarang and Surabaya. Sugar was by far the largest export commodity for the Netherlands Indies during the last three decades of the 19th century.

Maclaine, Watson & Co. was an agent for various steam shipping companies, including P & O, in addition to being an agent for a number of British insurance companies. The firm also held the position of British Consul in Batavia until 1913. Unlike some of its competitors, Maclaine, Watson & Co. survived the economic crisis in the Netherlands Indies in the 1880s (caused by the collapse of international sugar prices) and the firm went on to celebrate its centenary on 1 May 1927. In 1937, the firm was an agent for several airlines, including Qantas of Australia. They were still in existence in 1953. Perhaps part of Maclaine, Watson & Co.'s success was its ability to adapt to changing market conditions, as was evident from the firm's diversification into rubber trading, probably early in the 20th century. One comment from 1937 on Maclaine, Watson & Co.'s activities in the rubber industry suggested that the firm possessed an energetic and all-embracing sense of purpose:

> The object has been to market rubber in all forms in which it is produced to every country that can consume it.[10]

Maclaine, Watson & Co. enjoyed considerable prosperity in the 19th century as is evident from its investment in the rather grand commercial premises featured in this photograph. A description of this building in 1925 noted that:

> At the extreme end of Kali Besar West is a large, noteworthy building which has the appearance of having been constructed many decades ago, when the cost of materials was not so prohibitive as in these greatly changed and keenly competitive times. Contrary to modern trade methods, there is no name nor sign on the building to indicate its connection or the purpose to which it is devoted.[11]

The building has since been demolished.

20. Photographer: **Woodbury & Page**, 1870s ▨ albumen print ▨ size: 19.0 x 23.0 cm ▨ collection of the KITLV, Leiden.

The premises of Busing, Schroder & Co.

The premises of the German trading firm and shipping and insurance agents Busing, Schroder & Co. were located near the northern end of Kali Besar West (Jalan Kali Besar Barat).

Busing, Schroder & Co. was established around 1847. The firm's founders were probably Eduard Busing, who is listed as a resident of Batavia between 1843 and 1848, and either Adolph Christian Schroder or Johan Caspar Schroder.

Busing, Schroder & Co. acted as the agents in Batavia for a wide variety of European (mainly German) insurance, finance and transportation companies from Bremen, Dresden, Berlin, Vienna, Hamburg and Frankfurt.

The coat of arms of the German Grand Duchy of Mecklenburg-Schwerin can be seen above the firm's name-plate. Mr Herman Heinrich Vaupel, one of the principals of Busing, Schroder & Co., was the honorary consul in Batavia for Mecklenburg-Schwerin from 1855 until perhaps 1868.

The man in the centre leaning against the column and wearing a sun helmet and white suit was Carl Friedrich Ernst Schwabe, who was also a principal of Busing, Schroder & Co. for several years. Schwabe was born in 1823 in the German town of Malgendorf near Mecklenburg and arrived in Batavia in 1850. He was head of the Singapore branch office of Busing, Schroder & Co. from 1859 until 1866. Schwabe returned to Germany in 1866 and initially settled in Wandsbeck near Hamburg before moving to Coburg in 1873. He died in Coburg in 1884. It was apparently Schwabe who commissioned Woodbury & Page to take this photograph, the provenance of which is believed to include Schwabe's descendants.

Busing, Schroder & Co. last appeared in the government almanac in 1882 and therefore probably went out of business in that year or in early 1883. The reason for the demise of the firm is not known.

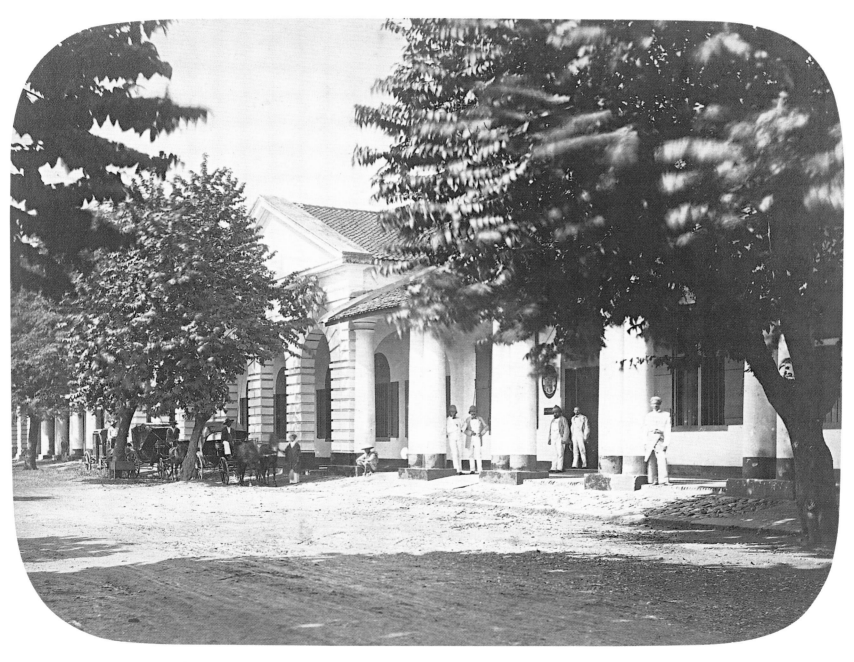

21. Photographer: **Woodbury & Page**, c. 1865 ▪ albumen print ▪ size: 18.0 x 23.2 cm ▪ collection of the author, Melbourne.

The premises of C. Bahre & G. Kinder

The premises of the German trading firm, shipping and insurance agents C. Bahre & G. Kinder were located near the southern corner of Kali Besar West (Jalan Kali Besar Barat) and Utrechtsche Straat (Jalan Kopi). These buildings still exist today but in a rather dilapidated state. The firm was established around 1848 or 1849. One of the founders was Gustav Kinder, who first appeared on the official name list of Europeans living in Batavia in 1846 and disappeared after 1860. The only "Bahre" listed around that time was Eduard Bahre whose sole appearance on the name list was in 1848.

Gustav Kinder was honorary consul in Batavia for the German Kingdom of Saxony in 1858 and for Denmark, Saxony and the German Grand Duchy of Oldenburg in 1860.

The sign hanging over the main entrance of these premises shows the coat of arms of the German city-state of Bremen and the wording "Consulat der Freien Hansestadt Bremen". One of the principal officers of C. Bahre & G. Kinder, Mr F. W. Heineken, was the honorary consul in Batavia for Bremen from 1857 to 1866. There was no consul listed for Bremen in Batavia in 1867 or 1868. However, another senior officer of C. Bahre & G. Kinder, Mr Christiaan Adolf Diederik Bauer, was consul for the Noord-Duitsche Bond ("North German League"), which included Bremen, in 1868 or 1869.

C. Bahre & G. Kinder went into liquidation in November 1884. The firm was active in sugar and coffee trading and was therefore probably ruined by the economic crisis in the Netherlands Indies which followed the collapse of sugar prices in that year.

The crisis was mainly due to the excess supply of sugar from the large amount of new private-sector investment in the sugar industry which had taken place since the early 1870s. The price of "Grade 14" sugar was 15 guilders per pecul in April 1883, but fell to 8.5 guilders in October 1884 and for most of the next decade was 8-9 guilders per pecul. By July 1895, the price had fallen further to only 6 guilders.[12] Sugar prices remained low for more than 20 years and didn't really recover strongly until 1905.[13] Sugar alone accounted for 46.5 per cent of the total value of Netherlands Indies exports in 1884, and so the plunge in prices was particularly devastating for the economy. Even by 1893, sugar still accounted for 41.5 per cent of Batavia's total exports.[14]

This photograph shows a busy scene, no doubt arranged for the camera. Note the "B&K" emblem on the barrel on the left-hand side.

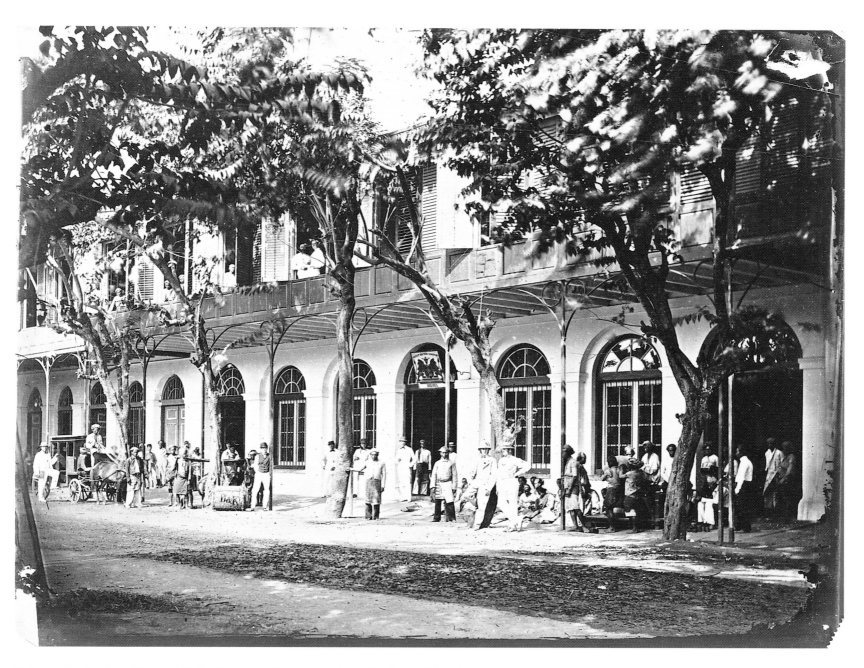

22. Photographer: **Woodbury & Page**, c. 1865 ▦ albumen print ▦ size: 19.3 x 24.5 cm ▦ collection of the author, Melbourne.

The premises of G. Kolff & Co.

One of the most famous commercial firms ever to operate in Batavia was G. Kolff & Co., booksellers and printers. Established in 1848 by Willem van Haren Noman and initially operating under his name, the firm was one of the first booksellers to open in Batavia. Possibly only Lange & Co. on Rijswijkstraat preceded them.

On 3 July 1850, Gualtherus Johannes Cornelis Kolff joined the firm from Holland. He was made a partner in 1853 and the name of the firm was changed to Van Haren Noman & Kolff. In 1858, van Haren Noman returned to Holland and the firm became G. Kolff & Co.

The firm's first bookshop in 1848 was located in a small rented room on Buiten Nieuwpoort Straat (Jalan Pintu Besar Selatan) but not long after, more spacious premises were acquired on Binnen Nieuwpoort Straat (Jalan Pintu Besar Utara). Eventually these also proved to be inadequate for a growing business and in 1860, the firm bought the building seen in this photograph for 28,000 guilders. These premises were located on the southern corner of Pasar Pisang (Jalan Kali Besar Timur 3) and Kali Besar Oost (Jalan Kali Besar Timur). They served as the head office of G. Kolff & Co. until May 1921, when new and larger premises were opened in Jalan Pecenongan near Pasar Baru. Kolff also opened a bookshop in Noordwijk (now Jalan Juanda) in 1894 to be closer to the expanding residential districts in the south. Over the years, branches were opened throughout Java.

Kolff was not only a bookseller and printer, but was also active in newspaper publishing. The firm was one of the early promoters of the leading newspaper, *Java Bode,* in the early 1850s and had affiliations with leading newspapers in Semarang (*De Locomotief*) and Surabaya (*Het Soerabaiasche Handelsblad*). In 1885, Kolff launched the successful daily, *Bataviaasch Nieuwsblad*, which was published in Batavia for more than half a century.

A further highlight came in 1930 when the Dutch Queen granted Kolff the right to use the word "Koninklijke" (Royal) in their name and the firm became N.V. Koninklijke Boekhandel en Drukkerij G. Kolff & Co. ("Royal Bookshop and Printing Office G. Kolff & Co."). In 1932, Kolff entered the security printing field when the government awarded the firm contracts to print banderoles for the collection of tobacco excise. Kolff was a major supplier of educational books in the Netherlands Indies and also one of the largest producers of picture postcards of Batavia in the early 20th century. These postcards are now collectors' items and also provide an important pictorial record of Batavia's topography in the first two decades of the 20th century. G. Kolff & Co. celebrated its centenary in 1948, but no longer exists today.

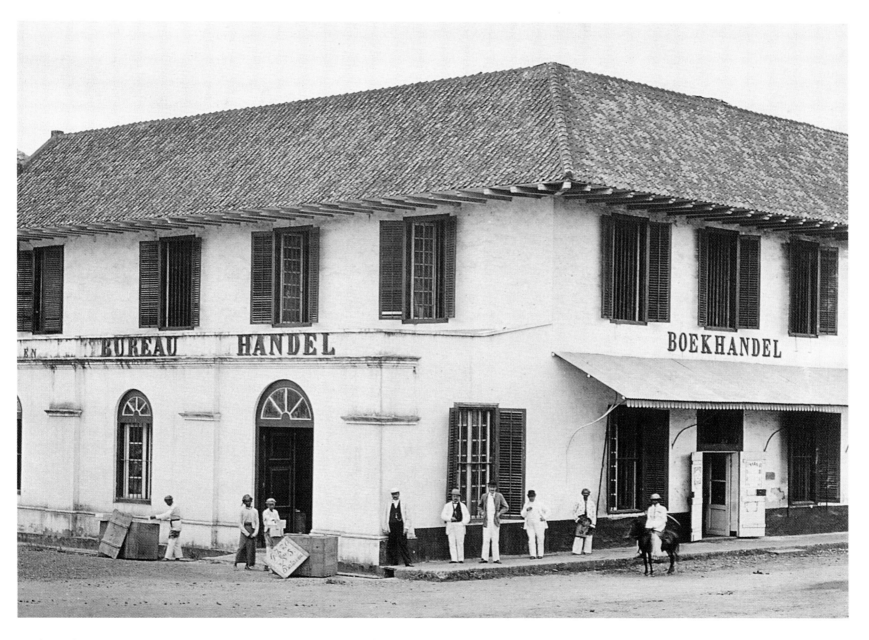

23. Photographer: **Woodbury & Page**, 1872 or earlier ▨ albumen print ▨ size: 19.0 x 24.5 cm ▨ collection of the KITLV, Leiden.

The premises of Van Vleuten & Cox

The firm of Van Vleuten & Cox was located on the southern side of Pasar Pisang ("Banana Market", and now Jalan Kali Besar Timur 3). Just as with Kali Besar, Pasar Pisang was home to many commercial firms, particularly after opportunities for private enterprise were expanded after 1870.

Van Vleuten & Cox was established in Batavia on 15 August 1865 by Diedericus Bernardus van Vleuten (probably born 1835) and Willem Hendrik Cox (1834-84). Van Vleuten was first listed as a resident of Batavia in 1854, while Cox was first listed in 1857, which probably meant he had arrived a year earlier. Van Vleuten & Cox were shopkeepers, auctioneers and commission agents. The firm sold a wide range of merchandise from its Pasar Pisang premises, including food, beer, furniture, lamps, glass, earthenware, porcelain, cigars, jewellery, toys, fireworks, carriages, cement and wire netting. It also acted as an auctioneer of deceased estates and of household items for Europeans who were leaving Batavia.

Willem Hendrik Cox was born on 3 November 1834 in Beek in the province of Limburg in Holland and was the son of a clergyman. In 1848, at the age of 13, he was admitted into the school of navigation in Amsterdam, where part of his training included making two round trips on sailing vessels from Europe to Batavia. Around 1856, Cox returned to Batavia, where his elder sister, Petronella Wilhelmina Cox (1824-70), had married Felix Peter Joseph Cassalette (1819-67). Not long after his arrival, Cox began working at his brother-in-law's firm of auctioneers, Cassalette & Co., where he remained until the establishment of Van Vleuten & Cox in 1865.

This photograph was probably commissioned by Van Vleuten & Cox for advertising purposes and it was quite possibly taken prior to Cox's departure with his family for leave in Holland on 4 February 1869. According to Cox family legend, the man with long sideburns who appears in this photograph wearing a white outfit and hat and standing with his foot on the foot board of the middle carriage is Cox himself.[15] Cox stayed in Holland for over two years, during which time he sought new suppliers and agencies for his firm in Batavia.

Cox arrived back in Batavia on 26 September 1871 and rejoined his partner Van Vleuten. The 1870s were a decade of prosperity in the Netherlands Indies, and Van Vleuten & Cox took advantage of the growing wealth. In 1876 the firm's merchandise included gold jewellery.

On 1 January 1876, Cornelis Knegtmans and Theodorus Roselje were admitted as partners to the firm and on the same date, Van Vleuten resigned. On 1 January 1881, Cox also resigned from the partnership even though he had already returned in 1878 to Holland, where he settled in Utrecht and died there on 13 October 1884. Cox enjoyed a comfortable retirement in Holland, which suggested he had done well financially during his two decades in Batavia.

Van Vleuten & Cox was liquidated on 31 December 1901. The demise of the firm was possibly due to the economic malaise which hit the Netherlands Indies from 1884 because of the sugar crisis and severe competition from the modern cooperative department stores Onderlinge Hulp (opened in 1885) and Eigen Hulp (established in 1890, *see pages 114-115*). These new cooperative stores undermined the profitability of the old-style shopkeepers like Van Vleuten & Cox.

This photograph was taken from the northern side of Pasar Pisang looking in a south-westerly direction. At the far right-hand side we can see the corner of Pasar Pisang and Kali Besar Oost (Jalan Kali Besar Timur). The building on the far right, partly obscured from view, was the premises of the leading bookseller and publisher G. Kolff & Co.

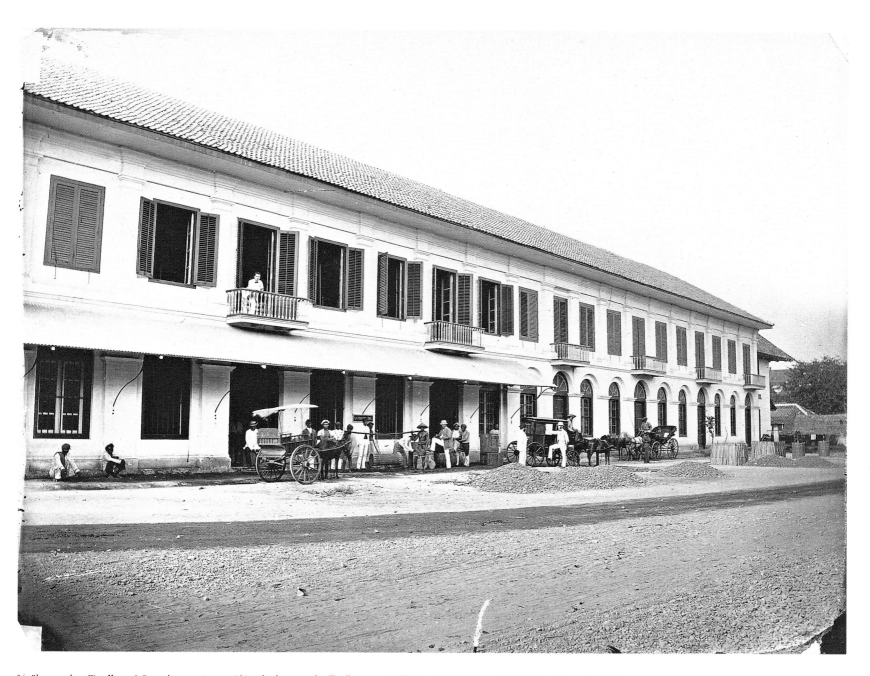

24. Photographer: **Woodbury & Page**, between August 1865 and February 1869 ▪ albumen print ▪ size: 19.5 x 24.8 cm ▪ collection of the author, Melbourne.

The premises of the Borneo Company, Limited

The Borneo Company, Limited was established around 1859 and its Batavia offices were located near the southern end of Kali Besar West (Jalan Kali Besar Barat). They were a general trading company and insurance and shipping agents, but also owned teak mills in Surabaya and were active in timber trading.

An account of the firm in 1909 noted:

The Borneo Company, Ltd., were the first to adopt in Netherlands India the system now followed by most other timber companies of treating the rough logs by machinery instead of having them squared by axe in the jungle.[16]

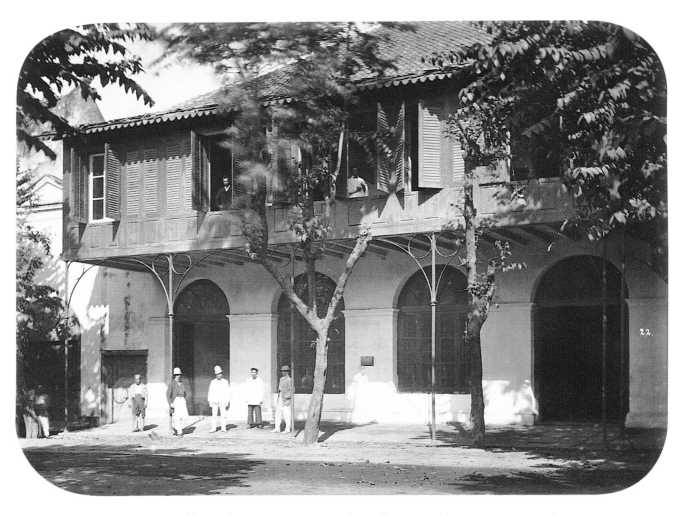

25. Photographer: **Woodbury & Page**, c. 1864–5 ■ albumen print ■ size: 18.0 x 24.2 cm ■ collection of the Tropen Museum, Amsterdam.

The Hoenderpasarbrug

The Hoenderpasarbrug ("Chicken Market Bridge") was the northernmost of the three bridges which crossed Kali Besar and the only one which was a drawbridge. Its name was taken from a large poultry market that stood nearby on the northern end of Kali Besar West (Jalan Kali Besar Barat) during at least part of the second half of the 18th century.

This photograph is looking north and the old Groote Boom ("Large Customs Post") is visible in the centre behind the bridge (*see pages 32-33*).

The Hoenderpasarbrug still exists today, but has been repaired or completely rebuilt on numerous occasions. Many of the old wooden beams have been replaced with steel.

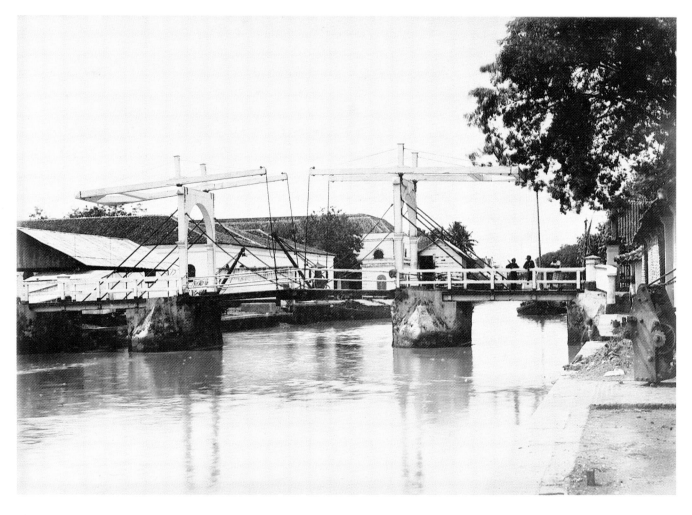

26. Photographer: unknown, c. 1890 ■ albumen print ■ size: 18.4 x 24.9 cm ■ collection of the author, Melbourne.

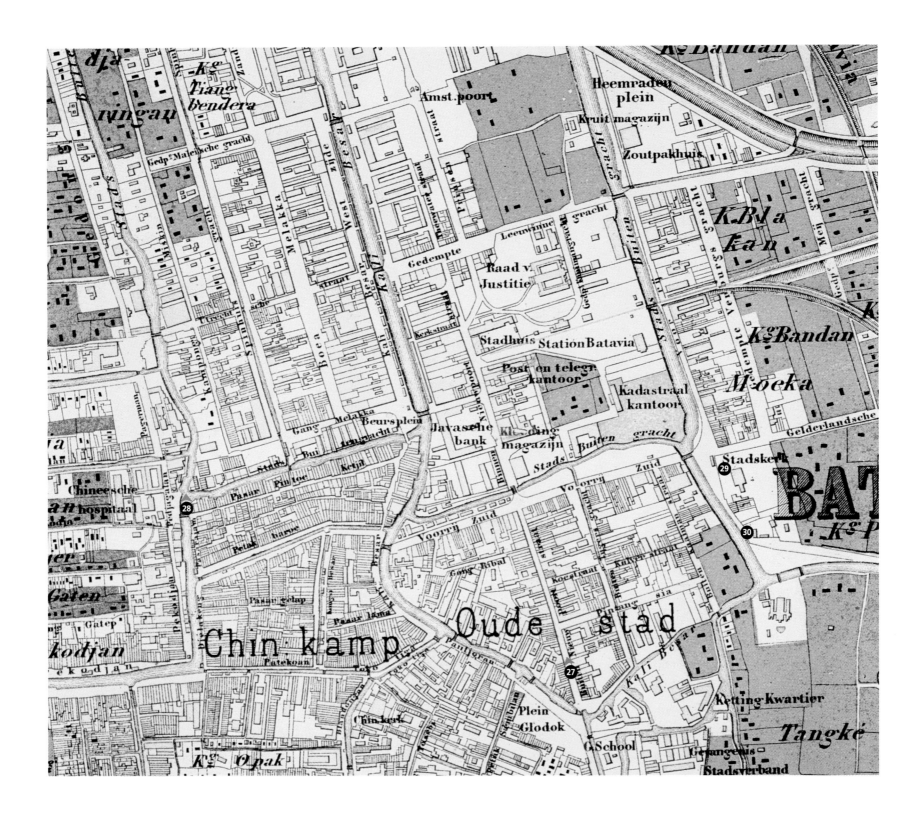

OUTSIDE THE WALLS

The heading "Outside the Walls" can be interpreted very generally to include many parts of Batavia that were developed outside the old walled city. However, for the purposes of this section, we have only included those areas that belong to the first century of Batavia's history during the golden days of the VOC in the 17th and early 18th centuries. These include Buiten Nieuwpoort Straat (Jalan Pintu Besar Selatan), Jacatra Weg (Jalan Pangeran Jayakarta and Jalan Dr Suratmo), and the outer city canal. Of course, Molenvliet (Jalan Gajah Mada and Jalan Hayam Wuruk) also falls into this category, but is covered separately in Part Two of this book.

Jacatra Weg is one of the oldest streets in Jakarta, and during most of the VOC era a small fort existed at what is today the eastern end of Jalan Dr Suratmo. The fort was demolished by Daendels in 1808/9. At the northern end of Jacatra Weg (Jalan Pangeran Jayakarta), the "Portuguese Outer Church" was completed in 1695 and still stands today as what is almost certainly the oldest building in Jakarta that is still used for its original purpose.

From the last decades of the 17th century, Jacatra Weg was an elite residential area for those who wanted to escape the unhealthy conditions of Batavia's walled city and who could afford to do so (although attacks by bandits, wild animals and anti-Dutch forces loyal to Mataram or Bantam still remained a threat for those who lived outside the city walls). Early in the 18th century, many grand country houses with lavish gardens could be found along Jacatra Weg, which provided a sight that greatly impressed visitors. De Haan noted a comment of 1722 made by a Captain Shelvocke who enjoyed riding in the Jacatra Weg area and who saw "a great variety of very beautiful prospects of fine country seats and gardens".[17] A certain Mr Speenhoff was even moved to song:

> At long last I enjoyed myself
> Outside Batavia
> Along the green heather
> On the Jaketra road.[18]

However, conditions on Jacatra Weg eventually also proved to be unhealthy and by the second half of the 18th century, Molenvliet had become the preferred residential area for the wealthy outside the walled city. The homes on Jacatra Weg were left to decay and when the German doctor Franz Wilhelm Junghuhn visited the area in 1835, he noticed ruin after ruin.[19]

Looking north along Buiten Nieuwpoort Straat

This photograph looks north along Buiten Nieuwpoort Straat (Jalan Pintu Besar Selatan). It was taken from the southern end of the street near the point at which it joins with Molenvliet (Jalan Gajah Mada and Jalan Hayam Wuruk) at the junction with Pancoran. During most of the 17th century, the VOC deliberately kept this area south of the walled city thinly populated and preferred not to have trees planted there for defence reasons. The few houses in existence were made of timber or bamboo. Stone houses were not permitted. The VOC still feared attacks from remnants of forces loyal to the Kingdom of Mataram in Central Java or from the Sultanate of Bantam (now Banten) in the west.

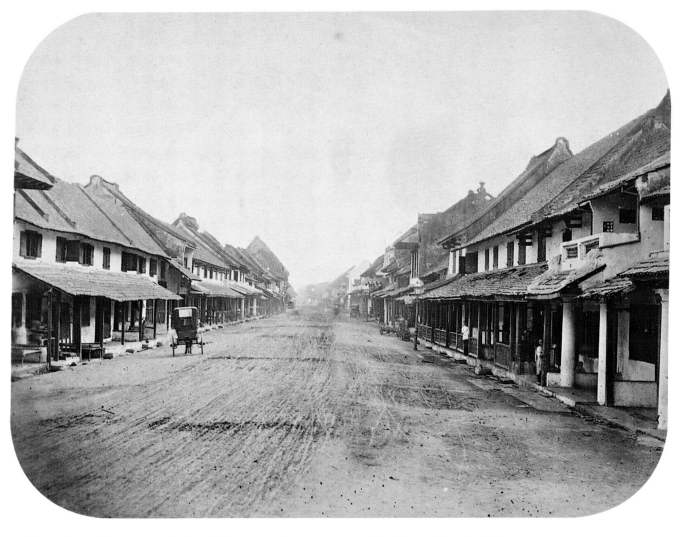

27. Photographer: **Woodbury & Page**, mid-1860s ■ albumen print ■ size: 18.9 x 23.8 cm ■ collection of the author, Melbourne.

The Stads Buiten Gracht

This photograph provides a view of the south-western corner of the Stads Buiten Gracht ("Outer City Canal"), which was the canal that encircled the old walled city of Batavia in the 17th and 18th centuries. This view is looking north along the western arm of the canal (now Kali Jelakeng) and was taken from the point where the western arm of the canal met with the southern arm. This view today would be a few metres north of the corner of Jalan Pejagalan and Jalan Pasar Pagi. The southern arm of the Stads Buiten Gracht was reclaimed as a road in 1936 and is now Jalan Telepon Kota.

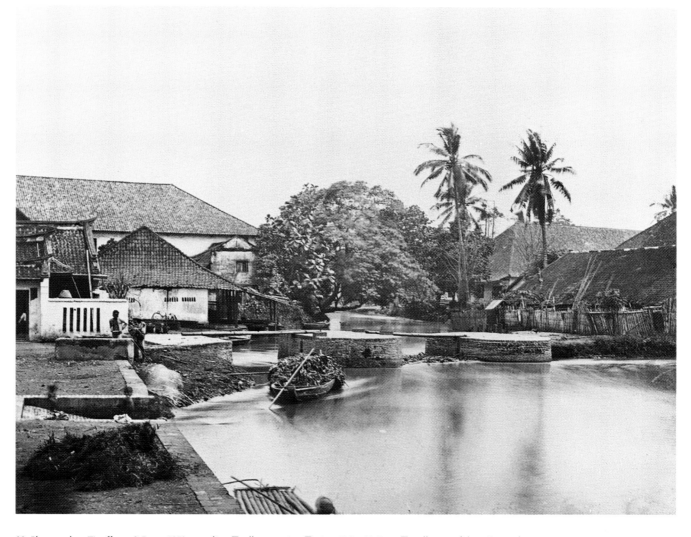

28. Photographer: **Woodbury & Page**, 1872 or earlier ■ albumen print ■ size: 19.0 x 22.5 cm ■ collection of the KITLV, Leiden.

The Portuguese Buiten Kerk

The Portuguese Buiten Kerk ("Portuguese Outer Church") was built between 1693 and 1695, at the northern end of Jacatra Weg (Jalan Pangeran Jayakarta). It still exists today as the oldest surviving Dutch building in Jakarta. It is probably also the oldest building in Jakarta which is still used for its original purpose. It is now known as Gereja Sion. The term "Portuguese" was derived from the fact that the church was used mainly by Mardijkers or freed Portuguese-speaking slaves who had originally been brought to Batavia from the Coromandel coast of India or from Malacca. Portuguese was, therefore, the main language used in this church for many years. It was known as the "Outer" church because it was located just outside the south-eastern corner of the old walled city of Batavia. By comparison, there was also a "Portuguese Inner Church" which existed until 1808 within the walls of the city on the northern corner of Kali Besar West (Jalan Kali Besar Barat) and Utrechtsche Straat (Jalan Kopi).

The heyday of the Portuguese Outer Church was the late 17th and 18th centuries when there was still a relatively large Portuguese-speaking population in Batavia and when Jacatra Weg was a fashionable residential area for the wealthy. However, during the final decade of the 18th century, the number of Portuguese speakers gradually declined and by 1815, Portuguese had ceased to be a language of religious instruction in this church altogether.

In the 19th century, the church building seems to have been largely forgotten, which perhaps explains why there are so few early photographs of it, despite its age and historical significance. The church's grounds were more extensive in the past than they are today, and also included a large cemetery. However, they have gradually been taken over for modern development. The building on the far left of this photograph has been demolished and is where Jalan Mangga Dua now runs in the direction of Jalan Gunung Sahari.

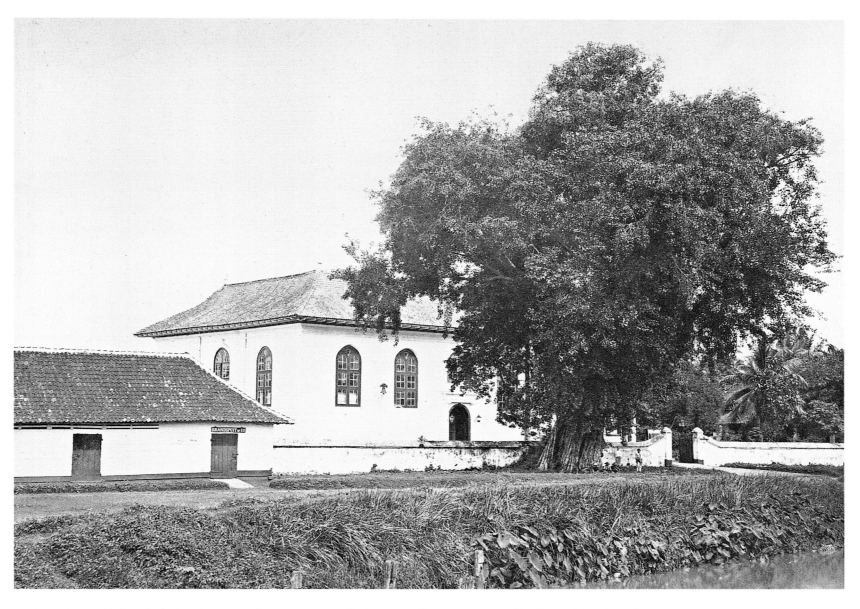

29. Photographer: possibly the **Netherlands Indies Topographic Bureau**, c. 1870s ■ albumen print ■ size: 20.3 x 28.5 cm ■ collection of the author, Melbourne.

The Pieter Erbervelt monument

The monument to the "traitor" Pieter Erbervelt with the skull mounted on top, visible on the right-hand side of this photograph, was located for over two centuries just a few metres south from the Portuguese Church on Jacatra Weg (Jalan Pangeran Jayakarta). Erbervelt was accused of plotting to overthrow VOC rule in Batavia, found guilty and sentenced to death. He and 18 of his alleged co-conspirators were quartered on 22 April 1722 on the plain on the southern side of the old castle (now the southern end of Jalan Tongkol). This was a very cruel punishment indeed. Horses were tied to each arm and leg and then were driven in different directions until the limbs of the condemned were literally ripped off their body. The monument was erected as a warning to others who might decide to challenge the VOC's authority.

Some doubts exist as to whether Erbervelt was truly guilty or whether he was falsely accused by the then Governor-General Hendrik Zwaardecroon (governor-general 1718-25) who apparently wanted to gain possession of Erbervelt's land on Jacatra Weg. The inscription written on the monument in both Dutch and Javanese script reads:

> As a detestable memory of the punished traitor Pieter Erbervelt nobody shall now or ever be allowed to build, to carpenter, to lay bricks, or to plant in this place. Batavia, 14 April 1722.[20]

The monument was torn down during the Japanese occupation (1942-5) and the original stone inscription in the centre of it can still be seen today in the Jakarta History Museum on Taman Fatahillah. In 1970, the Jakarta city government erected a replica of the monument at its original location on Jalan Pangeran Jayakarta. However, around 1985, it was moved to Taman Prasasti in Tanah Abang (*see pages 244-245*) where it still stands today.

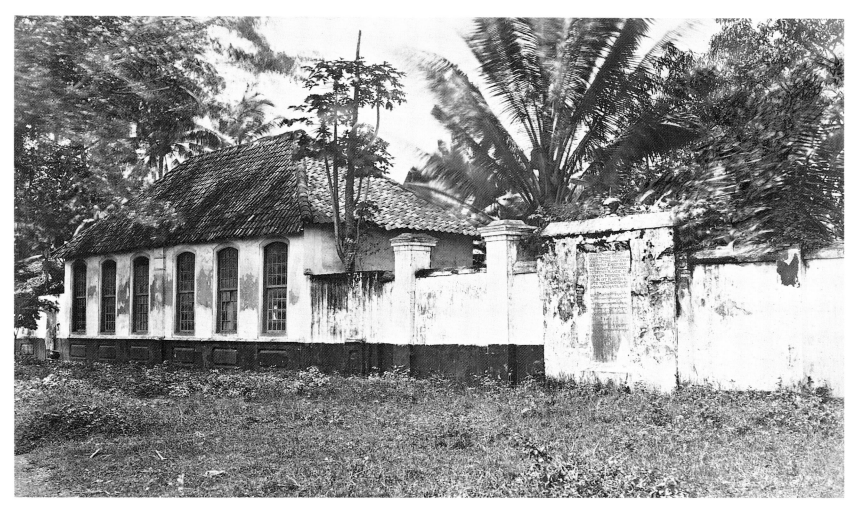

30. Photographer: possibly the **Netherlands Indies Topographic Bureau**, c. 1870s ■ albumen print ■ size: 18.9 x 31.1 cm ■ collection of the author, Melbourne.

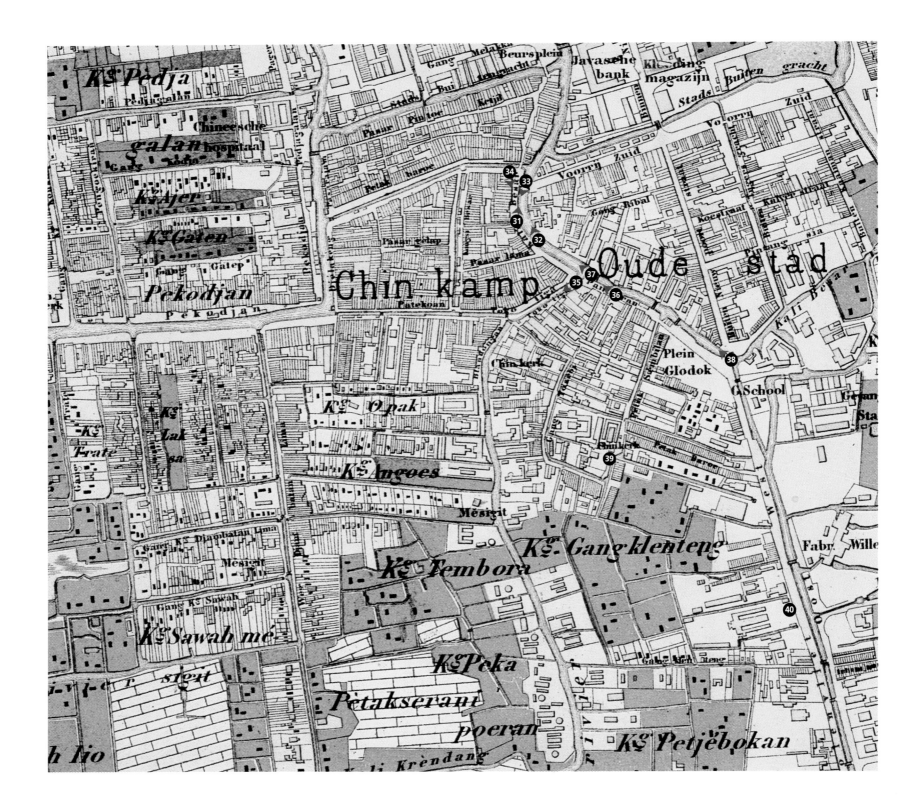

CHINATOWN AT GLODOK

The first Chinese contact with what is now Indonesia can be traced back to the 5th century AD, and there was already a Chinese camp in what is now Jakarta when the first Dutch fleet arrived there in November 1596.

The governor-general of the Netherlands Indies in 1619 at the time of the founding of Batavia, Jan Pieterszoon Coen, enjoyed good relations with Batavia's Chinese community and saw how he could use their energy and entrepreneurial skills to the benefit of the new Dutch settlement. The Dutch population was very small in number, and yet had a great need for fresh food for Batavia's townsfolk and to supply VOC ships passing on their way to the fabled spice islands of the Moluccas. Batavia also needed carpenters, bricklayers, iron workers and other tradesmen to repair ships, build houses and dig canals. For all these and many other tasks, Coen turned to the Chinese.

Coen really had little choice but to encourage Chinese cooperation. As the Dutch had conquered the Bantenese Prince Jayawikarta (or Wijayakarta) by a mixture of force and deception to establish Batavia in the first place, he could certainly not trust the Bantenese to serve the VOC. Nor could he trust the Javanese further east, particularly the Kingdom of Mataram in Central Java which was hostile to Batavia and which launched unsuccessful attacks on the city in 1628 and 1629.

Until 1740, the Chinese were free to live anywhere in or near Batavia, including within the walled city that had been built by the Dutch. However, in October 1740, more than 5,000 Chinese were massacred in what was one of the blackest incidents in Batavia's history. The massacre grew out of a combination of events, including a sharp increase in the number of Chinese in Batavia between 1719 and 1739 and the collapse of sugar prices in Europe in the 1730s, which caused unemployment in Batavia to soar when many sugar mills had to close. The VOC decided to ship many of the unemployed Chinese to Ceylon (Sri Lanka), but rumours spread that the Dutch were actually throwing the Chinese overboard into the sea *en route* to Ceylon rather than resettling them.

In response to the rumours, many desperate Chinese outside the walled city formed armed gangs and attacked Dutch outposts, including the city's western wall. The governor-general then ordered that all Chinese houses within the city be searched for arms even though there was no evidence that these Chinese were sympathetic to the gangs on the outside. During the search on 9 October 1740, fire broke out and the city panicked. Mobs entered Chinese homes and robbed and murdered thousands of Chinese men, women and children.

In addition to the human tragedy, the economy of Batavia suffered a major blow from which it would take many years to recover as most of the Chinese who survived the massacre fled in terror, taking with them their skills which were the lifeblood of Batavia's trade and industry.

Eventually, the Chinese did return to Batavia but they were no longer allowed to live within the walled city. Instead, they settled outside the Diestpoort ("Diest Gate") on the south side of the city in the area which became known as Glodok and which is still the heart of Jakarta's Chinatown to this day.

This pair of stereotypes of the Pintu Kecil area of Glodok are two of seven known glass stereotype views of Batavia made by Woodbury & Page, probably between early June and 15 July 1859. They are among the earliest topographical photographs ever taken of Batavia and may be only slightly predated by the three salt prints that appear on pages 152, 155 and 239. When Walter Woodbury visited England in the second half of 1859, he sold the seven Batavia stereotypes (among many other photographs of the Netherlands Indies) to the famous London firm of Negretti & Zambra, which published them in late 1860 or early 1861.[21]

These photographs were taken with a stereoscopic camera which had two lenses and thus captured two slightly different images of the same scene (i.e. note that in the first stereotype there is more of the river visible on the left-hand panel than in the right-hand panel). When seen through a stereographic viewer (or stereoscope), the scene appeared to be in three dimensions. Stereotypes rose to prominence after the Great Exhibition at Crystal Palace in London in 1851 and retained their popularity throughout the second half of the 19th century. They have been aptly described as "Victorian television".[22]

A stereotype on glass is similar to a collodion negative because it shows a mirror-reversed view of the actual scene. However, here the images have been "re-reversed" to show them in their correct perspective for the sake of topographical accuracy.

These photographs are not dated, which is typical of almost all of the topographical work of Woodbury & Page.[23] However, they are likely to have been taken between early June and 15 July 1859 when Walter Woodbury, James Page and Henry James Woodbury operated a temporary studio in Glodok, after they closed their Rijswijkstraat premises at the end of May. This was just before Walter Woodbury departed for England in the second half of July 1859, to establish contact with suppliers of photographic equipment and also to sell some of their photographs, including those sold to Negretti & Zambra.

It is striking that six of the seven Negretti & Zambra Batavia stereotypes show Chinese related scenes including views of Glodok and Chinese cemeteries.[24] This may have been because Woodbury & Page increased their output of topographical views in June and July 1859 specifically with Walter's imminent departure for England in mind so as to give him more photographs to sell. However, it may also have been because Woodbury & Page probably sensed that photographs of Chinese themes would be commercially successful in Europe as they would provide glimpses of the "mysterious" and "exotic" Far East.

It should be remembered that when Walter Woodbury brought these views back to England in late 1859, the vast majority of Europeans knew nothing about China and would certainly have never seen a photograph of a Chinese residential and commercial district such as is revealed in these stereotypes. Felice Beato's first photographs of China are from 1860 and John Thomson did not commence photography in Asia until 1862. The topographical views of earlier European photographers in Asia such as Alphonse Itier (the 1840s) and M. Rossier (the late 1850s) were never widely known, either then or now.

It is clear that Batavia's Chinatown made a strong impression on Walter Woodbury from his earliest visit there. In a letter to his mother on 26 May 1857 (only eight days after arriving in Batavia), Woodbury noted:

> There are 5,000 Chinese in Batavia, only 2,000 Europeans and about 1 million of natives. After passing through the Chinese town we come to the Chinese market, a scene well worth seeing. There is a kind of theatre (open to all) in the centre. There were several Chinese women dancing in it and going through extraordinary motions with their hands and singing in a peculiar kind of drawl. One of them was very good-looking. In the market are also Chinese gambling tables and opium smoking houses which were all very interesting.

The stereotype at the top of the opposite page was taken from the corner of Pintu Kecil and Gang Rotan (now Jalan Pintu Kecil 2). We are looking in a northerly direction along Pintu Kecil towards the junction of Pintu Kecil with Jalan Petongkangan and Jalan Petak Baru. The river is visible on the right, while the large double-storey house on the far left can be seen more clearly with its distinctly Chinese-style tipped roof in the centre of the photograph on page 81. The Negretti & Zambra catalogue reference for this stereotype is "3983, Chinese camp".

In the stereotype at the bottom of the page we are also looking in a northerly direction. The houses on the left run along the western side of Pintu Kecil and can be seen more clearly in the stereotype above. The partially obscured buildings on the far right-hand side of the photograph are where the multi-storey Pasar Pagi market and car park are now located. The Negretti & Zambra catalogue reference for this stereotype is "3979, River in Chinese camp".

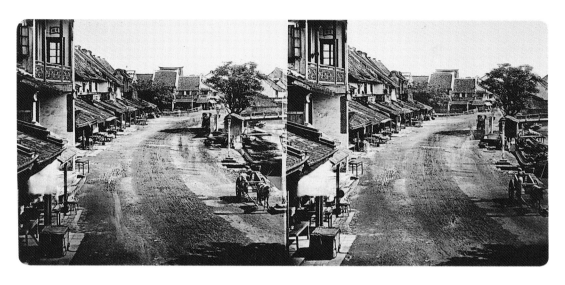

31. Photographer: **Woodbury & Page**, between early June and 15 July 1859 ■ stereotype on glass ■ size: 6.6 x 14.1 cm (shown here actual size) ■ collection of Wim van Keulen, Amsterdam.

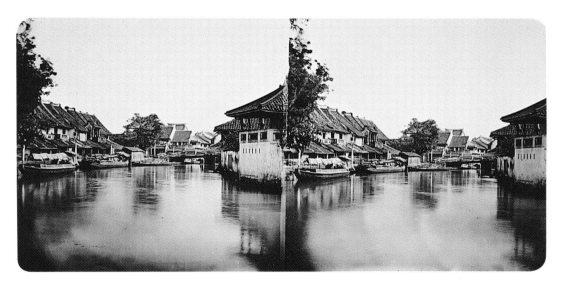

32. Photographer: **Woodbury & Page**, between early June and 15 July 1859 ■ stereotype on glass ■ size: 6.6 x 14.1 cm (shown here actual size) ■ collection of Wim van Keulen, Amsterdam.

PINTU KECIL

In the richly toned photograph on the opposite page we are looking south towards the southern end of the Pintu Kecil district. This photograph would have been taken from near the corner of Jalan Pintu Kecil and Jalan Petongkangan and we can see Jalan Pintu Kecil bending around to the left towards Jalan Toko Tiga. Behind the white-shirted man on the left-hand side is the entrance to the bridge from which the photograph below was taken. The name "Pintu Kecil" means "small door" or "small gate" in Indonesian, and was derived from a gate that was built into the southern side of the walled city in 1638 (and fortified with stone in 1657) beside the Diest bastion. It was known as the Diestpoort ("Diest Gate") or Pintu Kecil. This was distinct from the Pintu Besar ("Large Gate") that was added to the city wall seven years earlier in 1631 and which separated Binnen Nieuwpoort Straat (Jalan Pintu Besar Utara) from Buiten Nieuwpoort Straat (Jalan Pintu Besar Selatan).

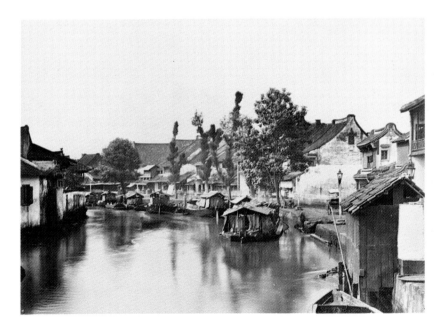

33. Photographer: **Woodbury & Page**, 1870s ■ albumen print ■ size: 19.0 x 24.0 cm ■ collection of the KITLV, Leiden.

This photograph was taken from the bridge which connects what is now Jalan Asemka to Jalan Pintu Kecil and is looking in a southerly direction. Around the bend in the river on the left are the Toko Tiga and Pancoran areas. On the left-hand side, where the houses stand on the edge of the river, the multi-storey Pasar Pagi market and car park are now situated.

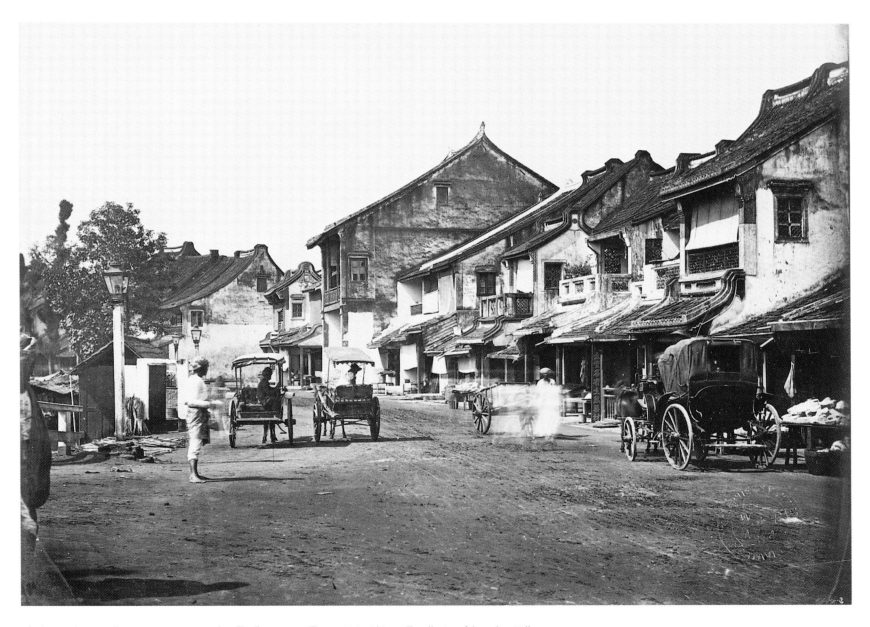

34. Photographer: **Woodbury & Page**, 1872 or earlier ■ albumen print ■ size: 20.2 x 24.9 cm ■ collection of the author, Melbourne.

The Krukut River at Toko Tiga

This photograph was taken from the bridge at the eastern end of Jalan Toko Tiga between Jalan Pintu Kecil and Jalan Pancoran. It looks along the Kali Krukut ("Krukut River") towards the bridge which marks the opposite end of Jalan Toko Tiga. The distinctive architecture of the Chinese houses and shops is very evident here and is one of the main features of the Glodok district.

The Chinese played an important role in almost every aspect of trade, commerce, distribution, industry and agriculture in Batavia, and they continue to do so to this day. In the 1720s, the Dutch minister François Valentijn made the following observation about the Chinese of Batavia:

> They are an extraordinarily clever, polite, diligent and attentive people who supply great services to this town. They not only carry out important trade in the city in tea, porcelain, silk and lacquerware, but they also engage themselves diligently in many crafts. They are very good smiths and carpenters; they make very beautiful chairs for homes as well as for extraordinarily beautiful palanquins. All umbrellas that are used are made by them. They varnish and gild very beautifully. They are also the most important Arak distillers, contractors of large buildings, brick makers and managers of the sugar mills outside Batavia, and tradesmen in the same field. Many organize eating houses for sailors and soldiers, or also teahouses for the same people, and many among them keep themselves busy with fetching water, fishing, or carrying people everywhere with Chinese *prahus* (which are a great comfort), which they always row standing with two oars. Many also sail with sampans and large vessels to take goods from the ships. The whole agriculture of Java depends upon them, because they are most ingenious and diligent, and ensure that everything is available all the year round, but they are also peddling anything they can think about all day long, and bring all kinds of vegetables, materials, porcelain, lacquer, tea and other items to the houses, and sell them for a small profit.[25]

Toko Tiga remains an important commercial area in Glodok to this day and some of the old-style Chinese houses visible on the right still exist, although usually in a heavily altered form.

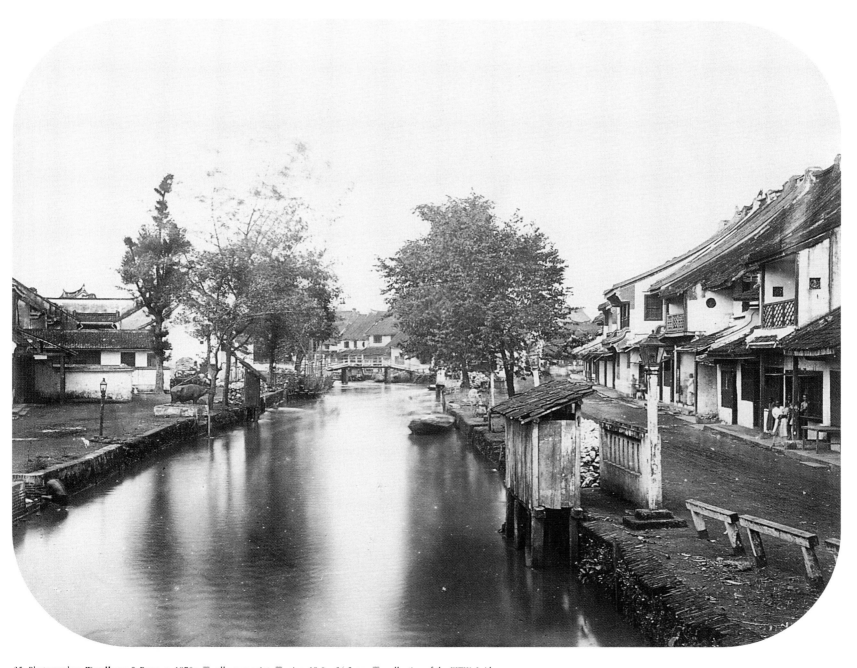

35. Photographer: **Woodbury & Page**, c. 1870s ▦ albumen print ▦ size: 19.0 x 24.5 cm ▦ collection of the KITLV, Leiden.

Chinese house at Pancoran

Here we can see the northern end of Jalan Pancoran running over the Toko Tiga bridge, beyond which is visible a row of houses at the southern end of Jalan Pintu Kecil. The large double-storey Chinese house with the decorative four-pointed roof in the centre seems to have had many uses over the years. Around the turn of the 20th century, it was the home of a member of Batavia's Chinese Council. In a later photograph from 29 June 1939 it had become Hotel Ho Hoa and also accommodated a watchmaker, a gold dealer and a hairdressing salon for both men and women. This building still exists today although it now has an ugly concrete façade and is devoid of its previous charm.

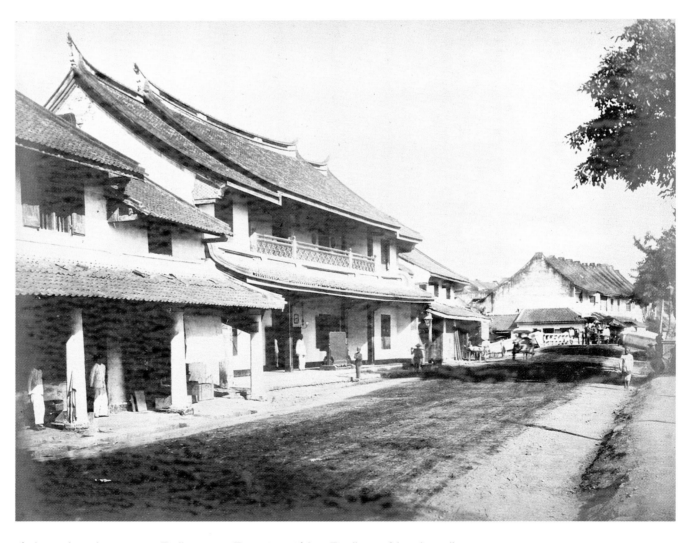

36. Photographer: unknown, c. 1880 ■ albumen print ■ size: 20.7 x 26.4 cm ■ collection of the author, Melbourne.

Junction of Toko Tiga and Pancoran

This photograph was taken from a bridge that used to span the river at the northern end of Jalan Pancoran. We are looking in a north-westerly direction towards the Pintu Kecil district. The river along Jalan Pancoran was filled in around the turn of the 20th century, and the bridge on which the photographer would have been standing was demolished.

On the left-hand side of this view, we can see the bridge at the eastern end of Jalan Toko Tiga from where the photograph on page 83 was taken. Behind it, the houses at the southern end of Jalan Pintu Kecil are visible. On the right, where the houses stand on the edge of the river, the multi-storey Pasar Pagi market and car park are now situated.

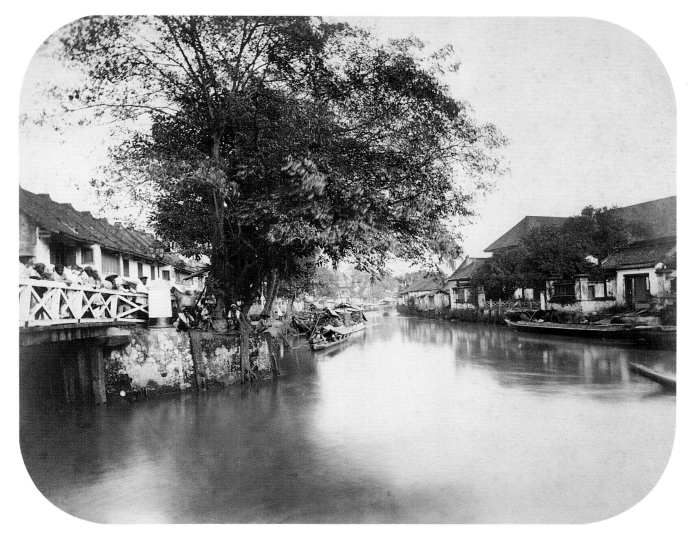

37. Photographer: **Woodbury & Page**, late 1860s ■ albumen print ■ size: 18.9 x 23.6 cm ■ collection of the author, Melbourne.

The Glodok market and Pancoran

This photograph was taken from the old Glodok bridge which was situated for almost two and a half centuries at the junction of Pancoran and Buiten Nieuwpoort Straat (Jalan Pintu Besar Selatan). We are looking in a north-westerly direction from the bridge along Jalan Pancoran, with the Glodok market on the left. In a modern context, the site of the gutted shell of the City Hotel, which was destroyed by fire during the violence of May 1998, would be on the far left of this view.

The name "Pancoran" means fountain or water spout in Indonesian, and was derived from two wooden pipes, that were constructed around 1670 at the northern end of Molenvliet (just south of the opposite side of the Glodok bridge), which spurted drinking water. Batavia's citizens and visiting sailors in the latter part of the 17th century would queue to hold barrels under the pipes to collect water. It was possible in those days to bring small boats as far as the Pancoran area by navigating along the Kali Besar and through Pintu Kecil. According to de Haan, people wishing to collect water often had to queue for several hours for the privilege, which frequently gave sailors the opportunity to smuggle in barrels of contraband goods or to procure the services of local prostitutes. It was, therefore, not surprising that this neighbourhood developed a "special reputation".[26]

Around the turn of the 20th century, the river along Jalan Pancoran (seen here) was filled in and the Glodok bridge was demolished. Where this river once flowed, many small shops and stalls now stand in its place in what is one of the busiest parts of Chinatown today.

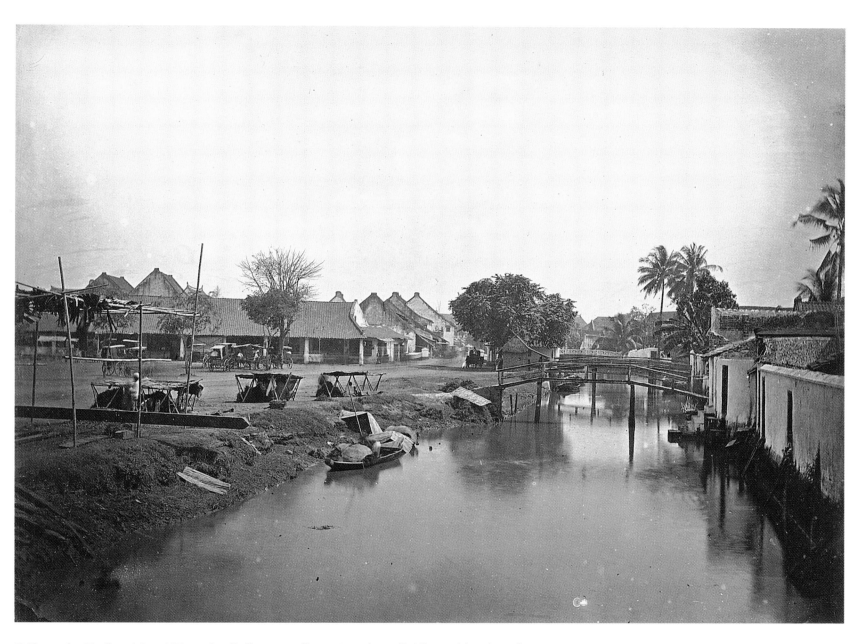

38. Photographer: **Woodbury & Page**, 1872 or earlier ▪ albumen print ▪ size: 18.1 x 24.3 cm ▪ collection of the author, Melbourne.

The Jin De Yuan temple

The Jin De Yuan temple (also known as the "Wihara Dharma Bhakti" or as "Kim Tek I") is located on the corner of Jalan Kemenangan and Jalan Kemenangan 3 and is one of the two oldest surviving Chinese temples in Jakarta, the other being the Da Bo Gong temple in Ancol.

The Jin De Yuan temple can trace its origins back to approximately 1650 when it was first built as the Guan Yin temple by Guo Xun-Guan in honour of Guan Yin, the Buddhist female deity of mercy. Its name was changed in 1755 by a Chinese "Captain" to Jin De Yuan, which means "Temple of Golden Virtue".

It is not clear whether the main temple as it stands today is the original building from approximately 1650, or whether the temple was damaged or destroyed and then rebuilt after the Chinese massacre in Batavia in October 1740. However, with the exception of an altar table from 1724, there is noth-ing in the temple which can be reliably dated to before 1740.

This photograph was taken before restoration work was carried out on the temple in 1890. During the restoration, the shape and the ornamentation of the roof were significantly changed to the form that still exists today.

Despite the restoration work, many important aspects of the original temple design were not altered. These include the two large circular windows, visible in the front of the temple, containing carved wooden interpretations of mythical creatures called *qi-lin* which portend very good fortune; the carved panels on both sides of the main entrance (faintly visi-ble in this photograph); and the two *bao-gu* (lions) which guard the front of the temple. Another distinctive feature of this temple is the tall ornamental money burner, seen here between the two lions, which was apparently made in Guangdong in 1821.[27]

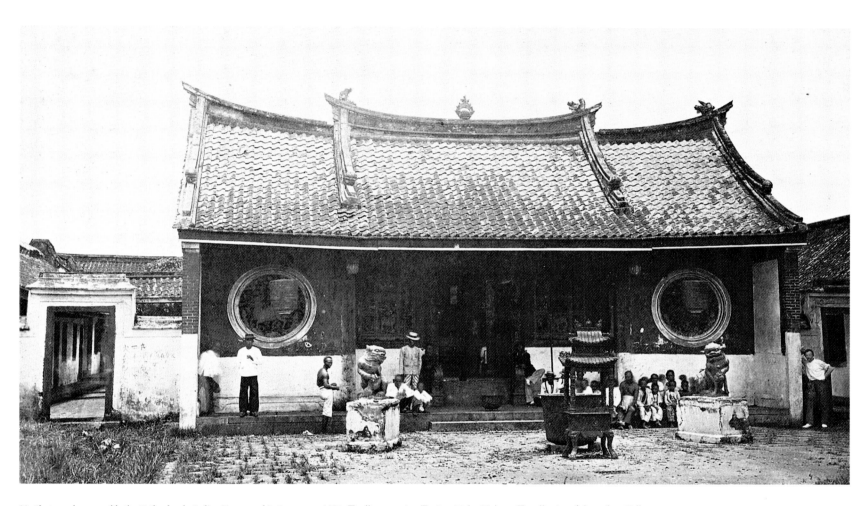

39. Photographer: possibly the **Netherlands Indies Topographic Bureau**, c. 1880 ■ albumen print ■ size: 17.4 x 30.4 cm ■ collection of the author, Melbourne.

Chinese house on Molenvliet West

One of the grandest Chinese houses ever seen in Batavia, this private residence was located near the northern end of Molenvliet West (Jalan Gajah Mada) and was probably built in the latter part of the 18th century. The precise history of this house and its owners is difficult to piece together, but it appears to have belonged to the Khouw family for many years, possibly until 1946.

The Khouw family traced its origins in the Netherlands Indies back to Khouw Tjoen who migrated from China, firstly to Tegal in Central Java and then to Batavia. His son Khouw Tian Seck (often called Teng Seck) became very wealthy through owning large tracts of rice fields and several rice mills in the Batavia and Tangerang areas. He was also a substantial landowner of prime property in downtown Batavia, including several sites along Molenvliet (Jalan Gajah Mada and Jalan Hayam Wuruk).

With wealth came prestigious appointments under the Dutch-sponsored "Chinese Officer" system. One of Teng Seck's grandsons, Khouw Yaouw Kee, was a "Captain" on Batavia's Chinese Council for many years in the late 19th century. His family home was on Molenvliet West and is almost certainly the house in this photograph. Another man, probably from the same family, Khouw Kim An was Chairman of Batavia's Chinese Council, holding the highest position of "Major" from 1910 to 1918 and from 1927 until the beginning of the Japanese occupation in 1942. As late as 1936, Khouw Kim An was living at No. 185 Molenvliet West, which is likely to have been the Khouw family home that appears here.

Khouw Kim An was clearly a highly regarded member of Batavia's Chinese community. His appointment to the chairmanship of the Chinese Council as Major in 1910 was the consequence of the Dutch colonial government's belief that he satisfied the criteria of being "a person belonging to the progressive element of the Chinese community, who could give a clear idea for the development of his people, and one who understood their expectations and accordingly could give appropriate guidance to their goals".[28] At the time of his nomination to the rank of Major, he was still only a relatively young Lieutenant on the Council, which meant he had first to be quickly promoted to Captain so he could then assume the rank of Major. Khouw Kim An was also a member of the Volksraad ("People's Council") from 1921 to 1931.

Khouw Kim An apparently died in 1946 and the house came into the possession of a son who either sold or donated it to a Chinese social and educational organization called Sin Ming Hui, which was also known as Chandra Naya. For almost the next half-century, Chandra Naya operated a school and a medical clinic from this site.

Around 1992, the Chandra Naya building was sold to a private developer who planned to demolish it and erect an office and apartment complex on the site. However, widespread protests led to a compromise being reached whereby the main buildings of the old house seen here in this photograph would be retained and form part of the lobby of the new structure. Construction proceeded on this basis until the developer suffered severe financial losses during the economic crisis which began in Indonesia in mid-1997. As at the time of writing, the main buildings of this fine old Chinese house can still be seen in the dark and unfinished concrete shell of the ill-fated new development.

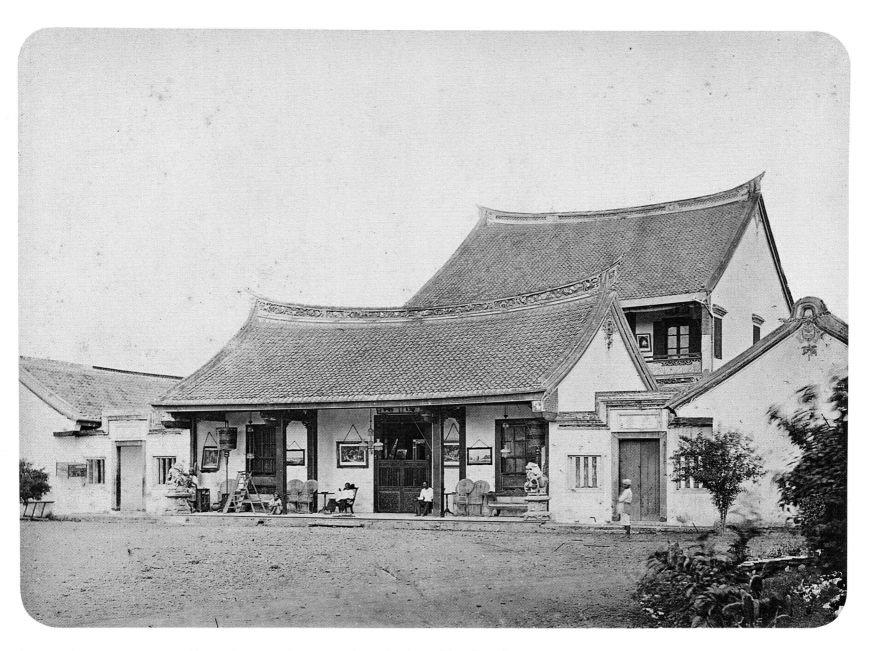

40. Photographer: **Woodbury & Page**, c. 1864–5 ◼ albumen print ◼ size: 17.9 x 24.1 cm ◼ collection of the author, Melbourne.

MOLENVLIET

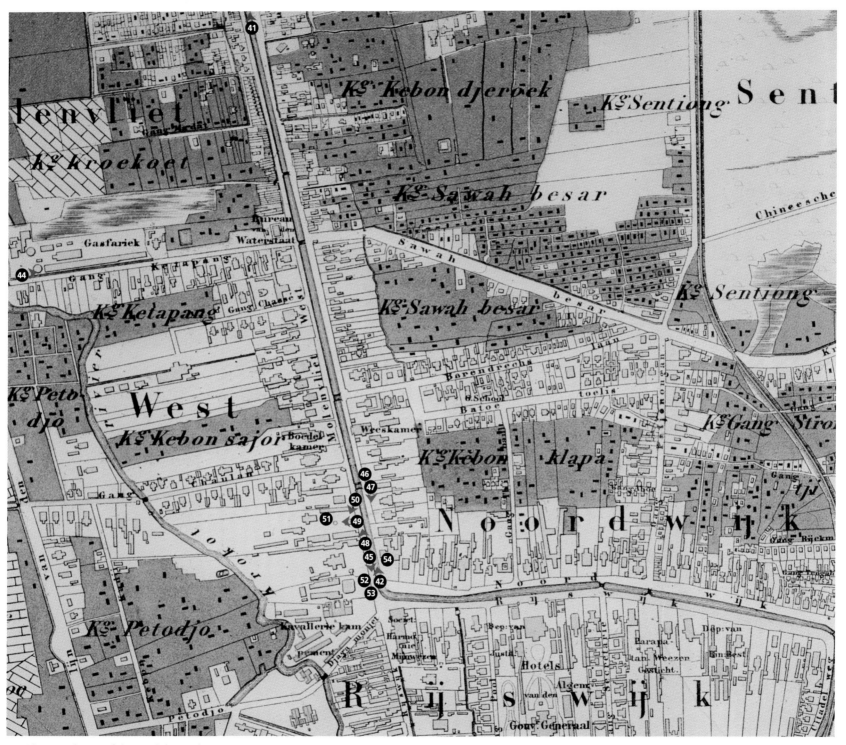

Note: The precise location of photograph 43 is not known.

MOLENVLIET

Dr Susan Blackburn very succinctly described the shape of 19th-century Batavia when she wrote: "The Dutch saw Batavia in the shape of a barbell, the connecting bar between lower and upper towns being the Molenvliet".[1] There could hardly be a more accurate description than this of the Molenvliet ("Mill Way"), the link between Batavia's old city in the north and the new city in the south and which was, therefore, one of the key topographical features of Batavia in the 19th century.

The Molenvliet was a straight three-kilometre-long man-made canal with a road on either side that was built in 1648 by the Captain of the Chinese community, Phoa Bing Ham. The western side of the Molenvliet is now Jalan Gajah Mada and the eastern side is now Jalan Hayam Wuruk.

When the Molenvliet was first built, it connected with the Ciliwung River at what soon afterwards became Pancoran in the north and ran south to what is now the junction of Jalan Majapahit and Jalan Juanda/Jalan Veteran. Early in the 20th century, it was shortened slightly when the Ciliwung River was reclaimed between the Toko Tiga bridge and the eastern end of Pancoran where Pasar Glodok is now located. At around the same time, Molenvliet was reclaimed from the southern end of Buiten Nieuwpoort Straat (Jalan Pintu Besar Selatan) to a point near where Jalan Labu is today.

The original purpose of the Molenvliet canal was to facilitate the supply of wood for ship and house building to Batavia's walled city in the north from what were then forests in the south around Tanah Abang and surrounding areas. Wood was floated down the Molenvliet canal to the area just in front of the southern wall of the city where Jalan Pintu Besar Selatan is located today. Later in the 17th century and the early part of the 18th century, the Molenvliet was also used to send supplies to the growing number of sugar and gunpowder mills located in the southern areas of Batavia.

In 1657, the VOC tried to increase the water flow along the Molenvliet canal to drive the mills, and four years later in 1661, it took over the operation of the canal. In the same year, the canal was first given the name "Molenvliet". From the early 1730s, when the walled city of Batavia was gradually becoming a dangerously unhealthy place to live, it became fashionable for the wealthy to build large houses with spacious gardens along both sides of the Molenvliet. Today, only one of those grand homes survive, namely the Gedung Arsip ("National Archives") building which was built in 1760 for Reinier de Klerk, who later was governor-general of the Netherlands Indies from 1777 to 1780. De Klerk's house is located towards the northern end of Jalan Gajah Mada and has recently been thoroughly renovated.

It was common for many Europeans in the second half of the 19th century and the early decades of the 20th century to commute along Molenvliet from their homes in the south to their offices in the old city of the north. Horse-drawn carriages were the first mode of transport for this purpose but from 1869, there was also the option of using horse-drawn trams. Thirteen years later in 1882, steam trams were introduced, followed by electric trams from 1900.

The northern end of Molenvliet

This photograph of the northern end of Molenvliet was probably taken not far from the southern end of Buiten Nieuwpoort Straat (Jalan Pintu Besar Selatan). Nieuwenhuys suggests that in this photograph we are looking north along Molenvliet West (Jalan Gajah Mada) towards the old city, although it is not clear on what basis he drew this conclusion.[2] It is also possible that we could be looking south along Molenvliet Oost (Jalan Hayam Wuruk). More research is required.

Either way, this is certainly one of the earliest photographs of Batavia which can be reliably dated. It is from the period between 18 March 1861 and 31 December 1862 when Walter Woodbury had ceased his partnership with James Page and was operating independently as "Atelier Woodbury".

Evidence of this is the "Photographed by Walter Woodbury, Java" blind-stamp embossed on the mount to which this photograph is affixed.

In the *Java Bode* of 28 August and 31 August 1861, Walter Woodbury for the first time offered for sale views of Batavia as distinct from portraits and views of Java and "Indisch Typen" ("Native Types"). These advertisements were the only known occasions that he specifically advertised views of Batavia during 1861 or 1862 before Atelier Woodbury once again became Woodbury & Page on 1 January 1863. They were also the first known instances of any photographer advertising views of Batavia for sale, and it is quite possible that this photograph was one of the views which Woodbury was offering at that time.

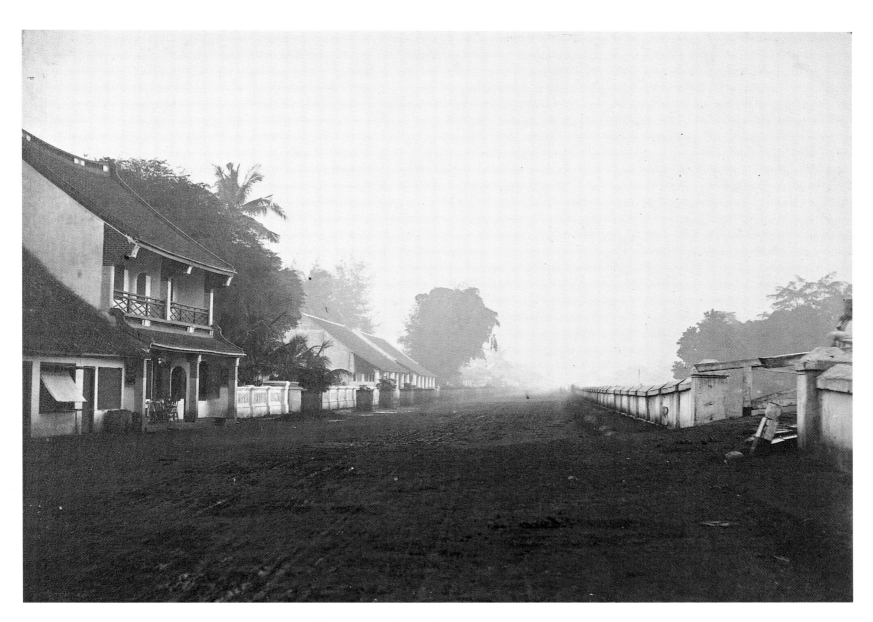

41. Photographer: **Walter Woodbury**, 1861-2 ■ albumen print ■ size: 14.6 x 20.3 cm ■ collection of the author, Melbourne.

Looking north from the southern end of the Molenvliet canal

This photograph shows the Molenvliet canal from the southern end of the canal looking north. Molenvliet West (Jalan Gajah Mada) is on the left and Molenvliet Oost (Jalan Hayam Wuruk) is on the right. At that time, there was no access from Molenvliet Oost to Noordwijk (Jalan Juanda) because the corner site (visible on the far right-hand side of this photograph) was occupied by a large private residence which around the 1860s became Hotel Ernst (*see pages 116-117*). The buildings on the left belong to the Hotel des Indes (*see pages 106-111*), while the lantern-topped gate posts marking the entrance to the grand private estate "Moenswijk" are visible on the far left.

A visitor riding along Molenvliet on an evening in 1862 noted:

> The very dusty road went along the perfectly straight canal. Public lighting was not seen anywhere, then the gas factory [*see page 102*] was under construction, but I could still distinguish that we passed Chinese and European residences and small country seats.[3]

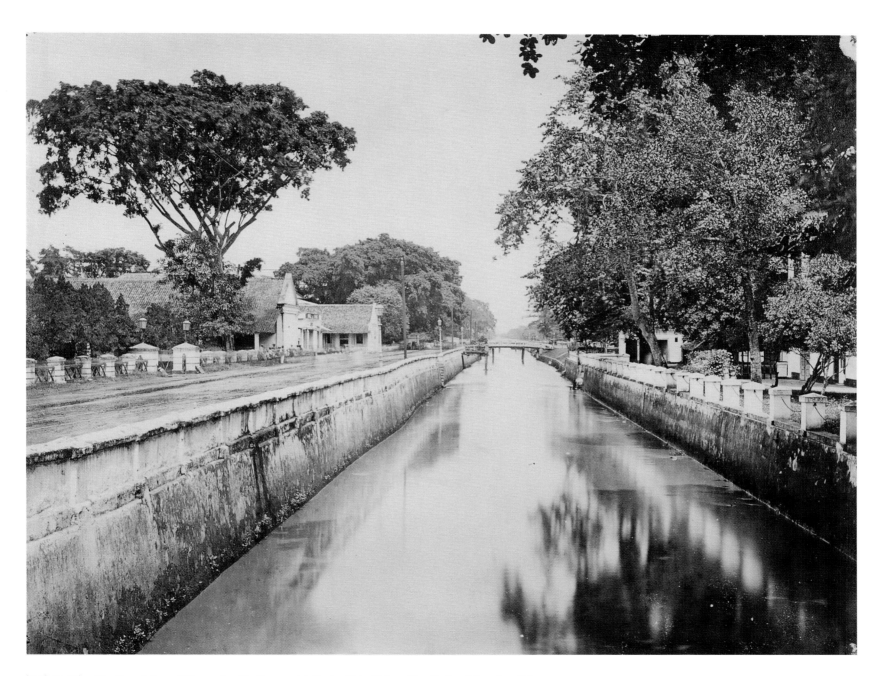

42. Photographer: **Woodbury & Page**, 1872 or earlier ▦ albumen print ▦ size: 19.1 x 23.9 cm ▦ collection of the author, Melbourne.

Bazar: a grand private residence possibly on Molenvliet West

Many grand private homes were built along Molenvliet in the 18th century by senior VOC officials, and in the 19th century by wealthy merchants. Sadly only one, namely what is now the Gedung Arsip ("National Archives") building on Molenvliet West (Jalan Gajah Mada), has survived.

One such grand estate that was demolished long ago and which by the 1860s had taken the name "Bazar" can be seen here in this photograph. The precise location of this house is not known, but it was possibly on Molenvliet West.

The name "Bazar" is unusual for a home and Nieuwenhuys suggests that by the time this photograph was taken, the residence had already been converted into a shop.[4] This view can possibly be supported by official records which show that between 1863 and 1868, a Mr A. Thomann operated a business in Batavia under the name "Bazar", although the location of his premises and the nature of his business were not given. However, based on an advertisement in the *Java Bode* of 1 October 1864 it would seem that Mr Thomann's Bazar was a drapery and clothing store for men. The advertisement announced that Bazar had "just unpacked" a shipment of "coloured flannels for men's jackets", "white flannel", "gold cuff links" and "fine clothing".

Mr Thomann was still listed as being a resident of Batavia in 1869 but little else is known about him.

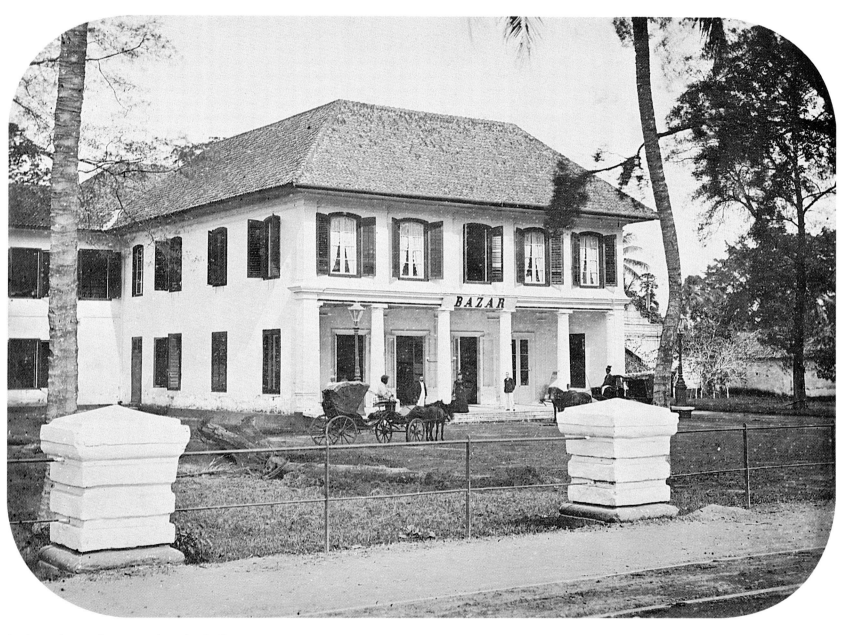

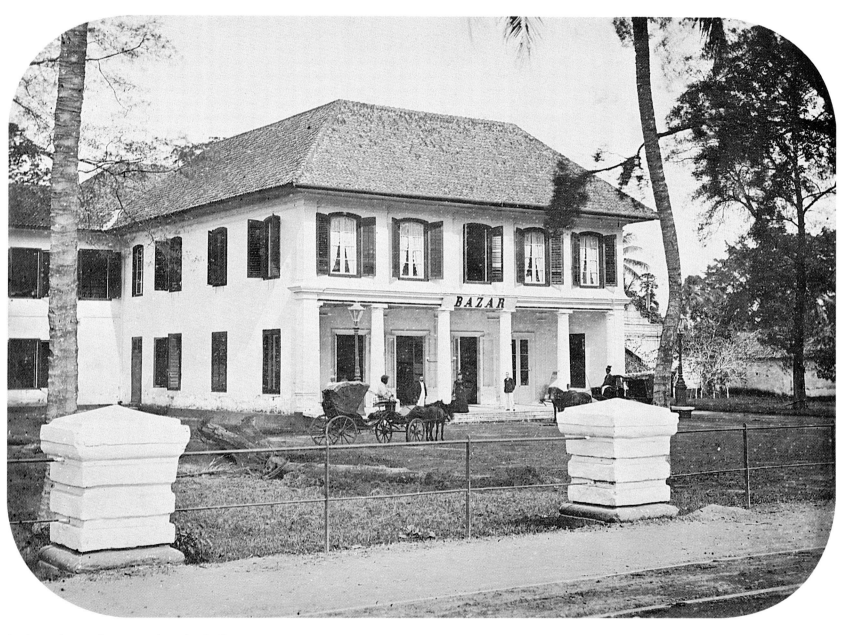

43. Photographer: **Woodbury & Page**, late 1860s ▪ albumen print ▪ size: 17.8 x 23.7 cm ▪ collection of the author, Melbourne.

Batavia's Gas Works, Gang Ketapang

In November 1859, a 20-year concession was granted by the Dutch government to the firm L. J. Enthoven & Co. of The Hague for the purpose of providing gas lighting in Batavia and the neighbouring district of Meester Cornelis (Jatinegara). The gas works were completed by 1861 and taken over in 1864 by the Netherlands Indies Gas Company. They were located on the northern side of Gang Ketapang (Jalan K. H. Zainul Arifin) which runs off Molenvliet West (Jalan Gajah Mada). Gas lights were lit for the first time in Batavia at the official residence of the governor-general (now Istana Negara, *see pages 128-129*) on 4 September 1862 and the installation of street lamps on public roads followed from 1 October 1862.

The Gang Ketapang site is still used today as a gas works by the now state-owned gas company, Perum Gas Negara.

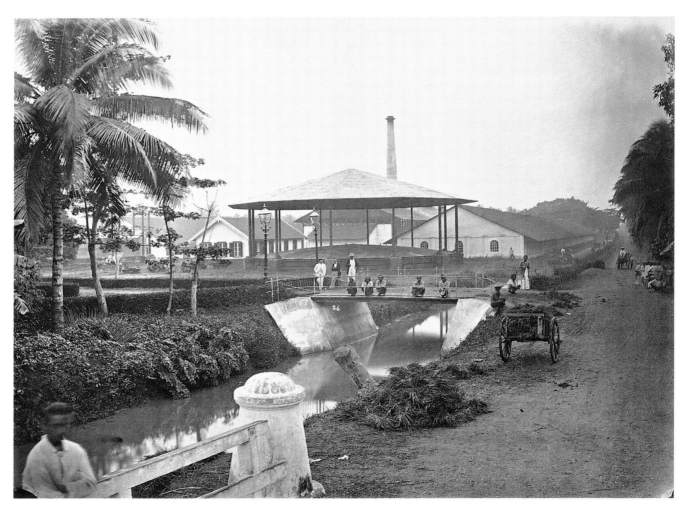

44. Photographer: **Woodbury & Page**, 1872 or earlier ■ albumen print ■ size: 18.1 x 24.1 cm ■ collection of the Tropen Museum, Amsterdam.

Looking south along Molenvliet West

In this view looking south towards the southern end of Molenvliet West, the canal is on the left while the lantern-topped entrance to the grand private estate Moenswijk is visible on the right. In the distance we can see the Harmonie building on the left (*see pages 122-125*) and the premises of the famous tailors, Oger Freres, on the right (*see page 153*).

In the 19th century, Batavia's roads were all dirt-surfaced.

In the wet season, mud and occasional flooding were problems while in the dry season dust was a persistent nuisance.

This photograph is likely to have been one of the 16 "newly taken" views of Batavia that were advertised by Woodbury & Page in May and June 1863. It is, therefore, among the earliest topographical photographs of Batavia that can be reliably dated (*see Appendix Three for further discussion*).

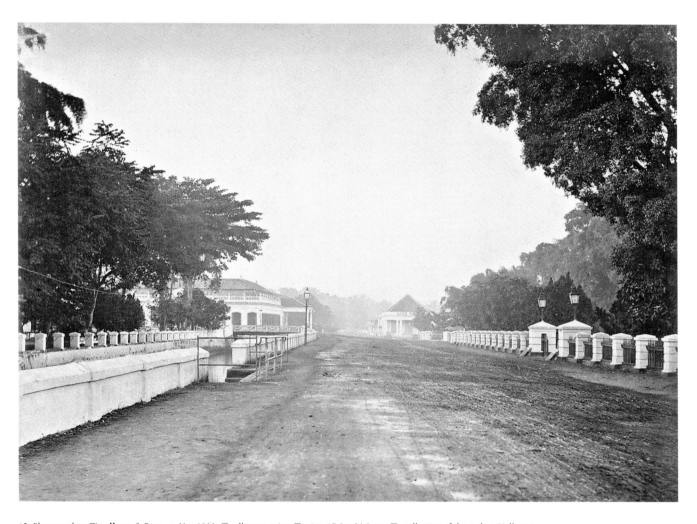

45. Photographer: **Woodbury & Page**, c. May 1863 ■ albumen print ■ size: 17.9 x 24.0 cm ■ collection of the author, Melbourne.

A family home on Molenvliet Oost

A comfortable family home on Molenvliet Oost (Jalan Hayam Wuruk) located just to the south of where Jalan Batu Ceper is today. Nieuwenhuys suggests that the Beynon brothers lived in this house in the 1870s, which is probably when this photograph was taken.[5]

One of the brothers, Jan Daniel Beynon, was a noted painter best known for landscapes, still lifes and portraits. He was born in Batavia in 1830 and moved to Holland in 1848 to study at the Royal Academy in Amsterdam. He returned to Batavia in 1855 and died there in July 1877.[6]

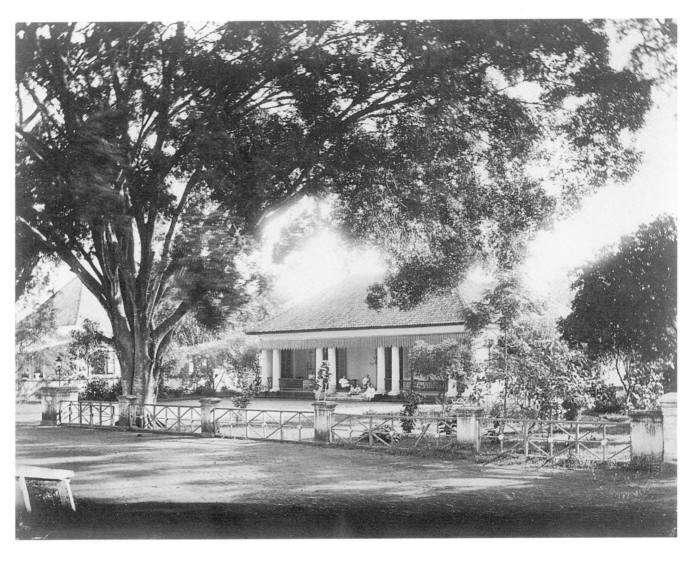

46. Photographer: **Woodbury & Page**, 1870s ■ albumen print ■ size: 19.0 x 23.0 cm ■ collection of the KITLV, Leiden.

Looking south along Molenvliet Oost

This view looking south towards the southern end of Molenvliet Oost (Jalan Hayam Wuruk) was probably taken within minutes of the photograph on page 104 and from only a few metres further north.

In the centre of this scene, the front buildings of the Hotel des Indes (*see pages 106-111*) are visible on the opposite side of the Molenvliet canal along Molenvliet West. On the far right, we can see a large private residence nestled amongst the trees. Such mansions were not an uncommon sight along both sides of Molenvliet in the 19th century.

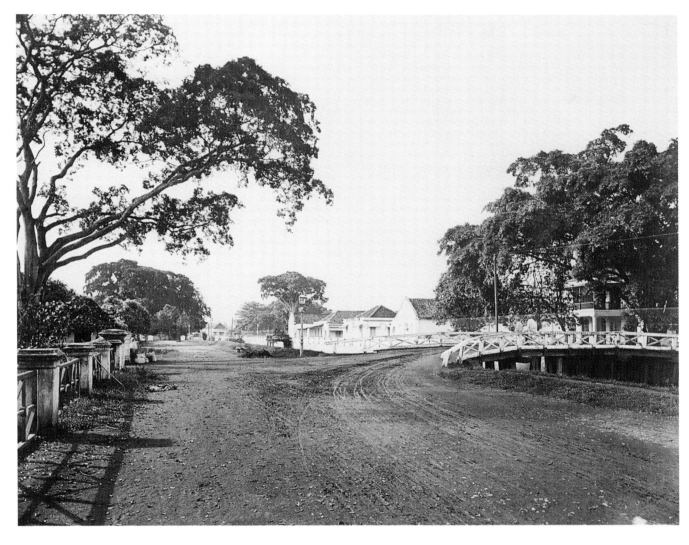

47. Photographer: **Woodbury & Page**, 1870s ▓ albumen print ▓ size: 19.0 x 23.5 cm ▓ collection of the KITLV, Leiden.

THE HOTEL DES INDES

Anyone with memories of Batavia in the first half of the 20th century will tell you that without a doubt the grandest hotel in the city and indeed in the entire Netherlands Indies was the famous Hotel des Indes. The hotel of choice for visiting dignitaries and for social functions for the elite of Batavian society was located near the southern end of Molenvliet West (Jalan Gajah Mada). The hotel's spacious grounds were centred on the site of what is now the Duta Merlin shopping centre beside the BTN (Bank Tabungan Negara) headquarters.

However, in the second half of the 19th century, the Hotel des Indes often had a less than grand history and probably competed with the Hotel der Nederlanden (*see pages 130–131*) for the title of the leading hotel in Batavia.

The Hotel des Indes was located on a 3.1-hectare site which had initially been developed as a private residence as early as 1747 by an engineer employed by the VOC. A famous owner of part of the site in the 1760s was Reinier de Klerk, who was governor-general of the Netherlands Indies from 1777 to 1780.

In 1824, the government purchased the site and transformed it into a boarding school for girls. However, only four years later in 1828, the school was moved to a different location and in 1832, it was closed altogether (according to de Haan, because the lady teachers kept leaving to get married).[7]

By a deed of 3 March 1829, the site was transferred to a Frenchman, Surleon Antoine Chaulan, who apparently was first responsible for converting the premises into a hotel under the name of "Hotel de Provence". This name was taken from the region in southern France where Chaulan was born. In 1835, Hotel de Provence was managed by one of Chaulan's sons, Antoine (born 1793), while another son, Etienne (born 1807), functioned as the cook.

For reasons not entirely clear, the hotel was put up for auction on 12 November 1845 "in accordance with the verdict of the Council of Justice"[8] and it was Etienne Chaulan who was the successful bidder, paying 25,000 guilders. Chaulan appeared not to be lacking in creativity with regard to promoting his hotel and he offered ice (which was still a rarity in those days) to attract guests. The first ice factory in Batavia was still several years away, but Chaulan was able to purchase natural ice from a ship which arrived in Batavia on 16 November 1846. Chaulan offered "ice evenings" at the Salon des Glaces at his hotel.[9] On 22 December 1846,

the Hotel de Provence placed the following advertisement in the *Javasche Courant* newspaper:

> Next Thursday some musicians will play music pieces in the "Salon des Glaces" at the Hotel de Provence. Various kinds of ice will be available that evening.[10]

The rarity of ice can be gauged from the fact that it was not until nearly a year later, in October 1847 (and after that not until September 1848), that the Salon des Glaces would be able to advertise that a new shipment of ice had arrived.

By the early 1850s, Etienne Chaulan appears to have shifted his focus to other endeavours and left the management of the hotel to Cornelis Denninghoff, who may have been responsible for the change of the hotel's name in 1851 to Het Rotterdamsch Hotel ("The Rotterdam Hotel"). The Rotterdam Hotel did not appear to inspire praise. One traveller wrote in 1852 that:

> It is difficult to say which is the best hotel at a place [Batavia] where all are bad. We were advised to reside at the Rotterdamsch; but we should have done better, as we subsequently discovered, had we selected the Hotel der Nederlanden.[11]

On 20 April 1852, Chaulan sold the hotel for 40,000 guilders to François Auguste Emile Wijss, who was born in Switzerland in 1821. Wijss was an employee of the hotel prior to becoming its owner and in 1851, he married 16-year-old Victorine Antoinette Chaulan, who was most likely a niece of Etienne Chaulan. It was during Wijss' ownership that the hotel's name became the Hotel des Indes (officially from 1 May 1856) at the suggestion of (so the story goes) Douwes Dekker (Multatuli), the famous Dutch author of the classic story *Max Havelaar*.[12]

On 9 July 1860, Wijss sold the hotel for the same price he had paid eight years earlier (40,000 guilders) to a Frenchman, Louis George Cressonnier, who was born in Beauvais, France in 1806. From 1849 until his purchase of the Hotel des Indes, he had been an innkeeper in Semarang. Cressonnier owned and managed the Hotel des Indes until his death in 1871 and the photograph on the opposite page would have been taken while he was proprietor of the hotel. His family were to remain owners until 1880.

Cressonnier was quick to recognize photography as a medium to promote his hotel. In the *Java Bode* in December 1866, he advertised that:

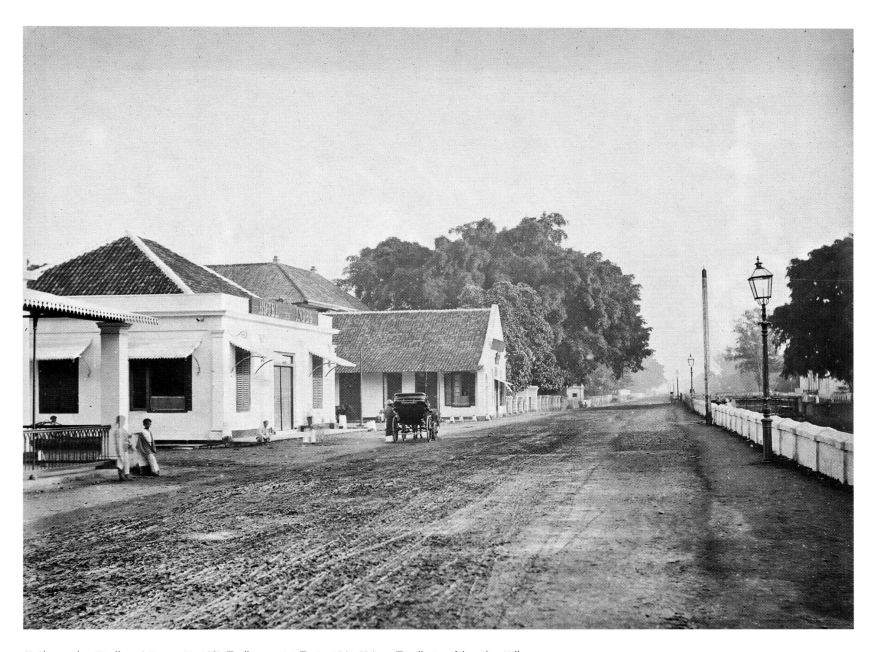

48. Photographer: **Woodbury & Page**, c. May 1863 ▪ albumen print ▪ size: 17.9 x 23.8 cm ▪ collection of the author, Melbourne.

The front buildings of the Hotel des Indes are visible on the left in this view, which looks north along Molenvliet West (Jalan Gajah Mada). The Molenvliet canal is on the right behind the white fence. A horse-drawn carriage waits outside the front of the hotel. The gas lamps on the right would have been installed only a few months earlier.

. . . as the owner of the Hotel des Indes, he has the honour to inform the public that his Hotel will undergo general improvement, which has already been started and will be continued intensively, and will soon be finished. Looking at the rooms which are ready, one will get a picture of the considerable beautification. As soon as the reconstruction is completed, a PHOTOGRAPH will be distributed.[13]

Louis Cressonnier was apparently a colourful character in Batavia, as indicated in an account of him which was published in the *Nieuws van de Dag* ("News of the Day") in the early 1870s after his death:

Cressonnier, who was also known as "Pere Cressonnier" was a very amiable man. His Dutch wife... all too often imposed upon his good nature and gave him more trouble than roses on this life on earth. He [Cressonnier] liked to join the so called "gossip table" on the front verandah of his hotel, where the newly arrived guests were initiated by the older "regular guests" on all possible and impossible situations in the Indies and on the "chronique scandaleuse" [chronicle of scandals] of Batavia.

Cressonnier joined in drinking heartedly. With a beer or wine glass in his upheld hand, he welcomed the high authorities or fortune seekers who had just travelled by Peninsula and Oriental steamers and was extraordinarily polite towards them. ... For the ones who reciprocated his courtesy, he led them around his hotel in person and he showed to them the rooms to be occupied; but if he was treated with haughtiness or distrust, then he instructed a servant to take care of the new guest. In general, however, the visitors felt friendly and amicable towards the generous host, whose support and help they soon learned to appreciate in an environment which was still strange to them.

To be sure, with the evening sun going down, Cressonnier's soberness also declined and his stories became more and more marvellous, but he always remained the jolly and fatherly friend of the hotel occupants.

... But Cressonnier could not fall asleep in the hours when his guests rested so quietly on their beds and dreamed about the future and their careers. His annoying wife made his life difficult, and the restless husband tried to calm himself by taking all kinds of drugs. So on a beautiful sunny morning in 1871, when the cannons of old and new Batavia roared, spitting fire and flames to greet the Siamese ships which brought the king [of Siam] across as a visitor to Java, they found the life-weary owner of the Hotel des Indes dead on his bed with opium and bottles of painkiller beside him.[14]

The atmosphere of the Hotel des Indes in the 1870s suggests a greater cosiness and mingling among the guests than one is likely to find at a grand hotel today:

In the hotel people soon became acquainted with each other and all kinds of matters were discussed and debated which occupied the minds of the guests, who after visiting the Harmonie Society or other places of diversion, sat closely together in the spacious hall of their temporary home.[15]

On 21 June 1880, the Cressonnier family sold the Hotel des Indes to Theodoor Louis Gallas, on whose death in 1886, the property passed to his wife and children. It can perhaps be said, that the next owner of the Hotel des Indes, a former soldier named Jacob Lugt, who bought the hotel for 177,000 guilders on 1 March 1888, was the man responsible for the vision of creating a truly grand hotel. Lugt set out to buy the adjoining plots of land to greatly increase the size of the hotel's grounds.

On 11 May 1891, he bought for 37,500 guilders the 6,923 square metre plot and its residence on the northern side of the hotel which had been a boarding school for boys and had possibly operated under the name "Institute Kok & Van Diggelen" named after Corstiaan Justus Kok and Lugas Jan Van Diggelen, who had bought the lot on 2 January 1871.

Subsequently, on 29 June 1892 Lugt purchased for 55,000 guilders the 21,880 square metre plot and residence on the southern side of the Hotel des Indes. This site had for over a century been a grand private estate, known as "Moenswijk". Finally, on 2 July 1894 Lugt was able to purchase an additional 3,920 square metres located at the rear of the Moenswijk estate. With these three purchases, the size of the Hotel des Indes reached 6.5 hectares.

However, sadly for Lugt, the 1890s were a period of economic difficulty for the Netherlands Indies and rather than profit from his ownership of the hotel and the expansion of its grounds, he met only with financial ruin. He lost control and ownership of the Hotel des Indes just under a decade after he first purchased it. On 9 November 1897, a limited liability company named N.V. Hotel des Indes was established to own and run the hotel and take over its liabilities. On 26 April 1898, Lugt transferred to the company the four plots of land that made up the grounds of the Hotel des Indes as well as:

all furniture, household wares, dinnerware and linen, horses, vehicles, harnesses, provisions, drinks, outstanding accounts. In one word: all movables and rights, within and belonging to and used for the Hotel des Indes.[16]

In return for transferring these assets to the company for which Lugt had invested over 300,000 guilders, he received shares in the company to the value of 1,000 guilders; namely ten so-called "C Class" shares of 100 guilders each. Lugt later asked that his shares be converted into cash and then he disappeared from the scene, a saddened and, no doubt, greatly humbled man.

A turning-point in the hotel's history appears to have been the appointment in 1903 of Mr J. M. Gantvoort as hotel manager, a position he held until 1911. It was under Mr Gantvoort's leadership that the Hotel des Indes entered a golden age which was to last until the end of the colonial era. The financial performance of the hotel also finally improved after so many difficult years. The first dividend was paid by the company in 1908 at a rate of 5 per cent. Dividends rose steadily, peaking at 25 per cent in

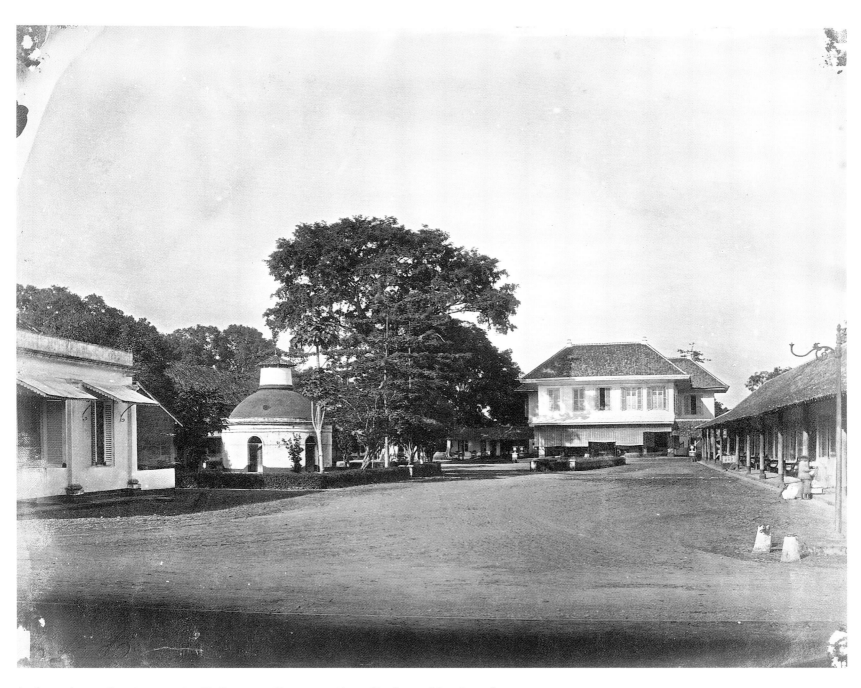

49. Photographer: **Woodbury & Page**, c. 1870 ▪ albumen print ▪ size: 19.9 x 24.7 cm ▪ collection of the author, Melbourne.

The front courtyard of the hotel was used creatively in 1848 by the then owner, Etienne Chaulan, when he allowed a miniature circus to pitch its tent there. The circus reportedly operated successfully for several months. The side buildings seen here on the right were originally built between 1791 and 1801 as "writing rooms". They may have also been used as classrooms when the buildings were owned by a school in the 1820s prior to becoming a hotel. The purpose of the dome-shaped structure on the left is a mystery.

both 1918 and 1919 before gradually declining to 7 per cent in 1930, which was the last year in which a dividend was paid. Also in 1930, a grand new main building was completed on the grounds of the hotel, which quickly became one of the most famous landmarks in late colonial Batavia. However, the 1930s were scarred by the great depression and the 1940s were marked by the Japanese occupation (1942–5) and the struggle for recognition of Indonesia's independence which lasted until 1949.

After independence, the hotel's name was changed to "Hotel Duta Indonesia". The new name was apparently carefully chosen so that the initials "HDI" were the same as before, thereby allowing the same crockery and cutlery to be used. However, the hotel never regained the glory of earlier years. In 1962, Hotel Indonesia, the inspiration of President Soekarno, was completed at the southern end of Jalan Thamrin and became the new grand hotel of Jakarta. The Hotel Duta Indonesia went into decline as the social centre of the city moved to Jalan Thamrin, and eventually it was demolished in 1971 or 1972.

50. Photographer: unknown, 1890s ■ albumen print ■ size: 18.0 x 25.5 cm
■ collection of the author, Melbourne.

The "coiffeur's" salon at the Hotel des Indes, seen here on the right, was operated by Louis Dimier who was not given to modesty in his advertisements where he described himself as the "ex-premier employee of the principal Houses of Holland, Paris, Brussels and London".[17]

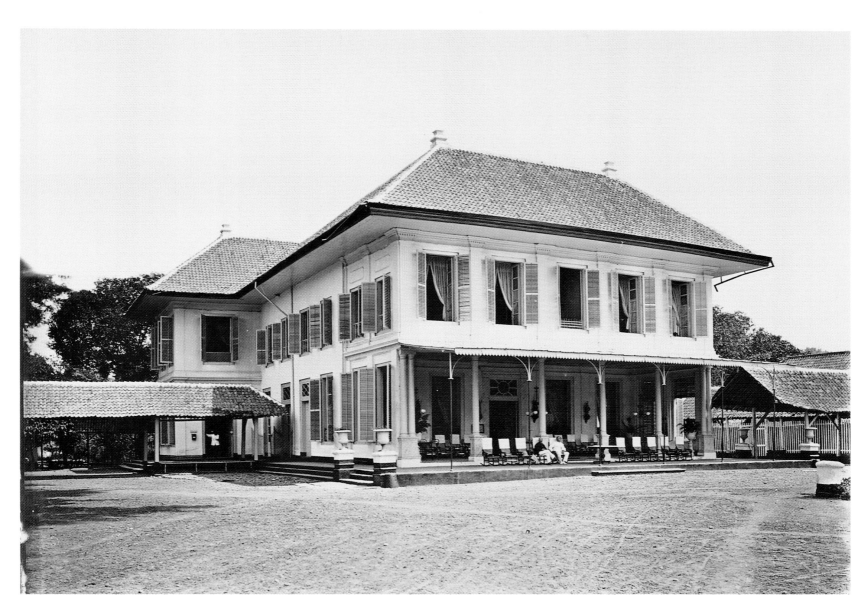

51. Photographer: **Woodbury & Page**, c. 1870 ▪ albumen print ▪ size: 19.0 x 25.2 cm ▪ collection of the author, Melbourne.

This photograph shows the main building of the Hotel des Indes as it appeared around 1870. It was on the front verandah of this building that Cressonnier's "gossip table"[18] congregated. In the 1870s, the best rooms of the hotel were on the top floor of this building while the dining room was on the ground floor. One occupant of the top floor during that period was an American named Henderson who:

> After he had enjoyed himself enormously in the evening with his friends and had drunk much champagne, he used to throw all the furniture, including mirrors and paintings through the window, and then he wrote out a cheque for new furniture.[19]

The Marine Hotel

The Marine Hotel was located at the very southern end of Molenvliet West (Jalan Gajah Mada) beside the grand private estate "Moenswijk" approximately where the old white BTN (Bank Tabungan Negara) headquarters now stand.

On this site in 1656, a small fort was constructed by the VOC, presumably to guard the southern end of the Molenvliet. The fort was vacated in 1697 because security concerns had largely diminished by the mid-1680s with the subjugation of the Sultanate of Bantam (now Banten). The fort was demolished in 1729. However, after the massacre of the Chinese in 1740, the need for a new security post was felt and one was built on approximately the same site. This new post was subsequently demolished on Daendels' orders in 1808/9, although remnants of it still existed in 1815.

It was in approximately 1815 that Jan Tiedeman bought the site for 4,150 Spanish piastres and built a large house on it, although it is not clear whether his house was the same building shown in this photograph, which later became the Marine Hotel. The plot and house were then sold before 1819 to Pieter Willem Helvetius van Riemsdijk for 32,000 Spanish silver piastres.

A hotel seemed to have existed on this site from at least the early 1830s. Pieter Christiaan Stelling (born 1794 or 1795) was listed as an innkeeper at Molenvliet in 1832 and he bought this plot, which was already being used as a hotel, in 1833. Stelling died in 1836 and his widow sold the hotel to Hendrik Loust in 1853.

It was also in early 1853 that a travelling commercial photographer, L. Saurman, visited Batavia and advertised in a local newspaper that he was opening a Daguerrian Gallery for a month at the Marine Hotel.[20] These were the earliest known advertisements by a commercial photographer in Batavia (see Appendix One).

In 1861, the Marine Hotel was sold to Cornelis Kramers, whose widow sold it to Eugene Achille Bonnet in 1867. Bonnet may have briefly been the resident chef, but he died in 1868. His widow sold the hotel in 1870 to Europe Honore Girardeau, who was the managing partner of the famous firm of bakers, Leroux & Co. (see pages 154-155). Girardeau died in 1875. His widow and four children managed the hotel until 1888, in which year the property was sold at auction and thereafter ceased to be a hotel. It briefly became the home of a Burgersocieteit ("civic club") named "De Club", but by 1890 the old building had been demolished and the new cooperative department store Eigen Hulp (see pages 114-115) had been built in its place.

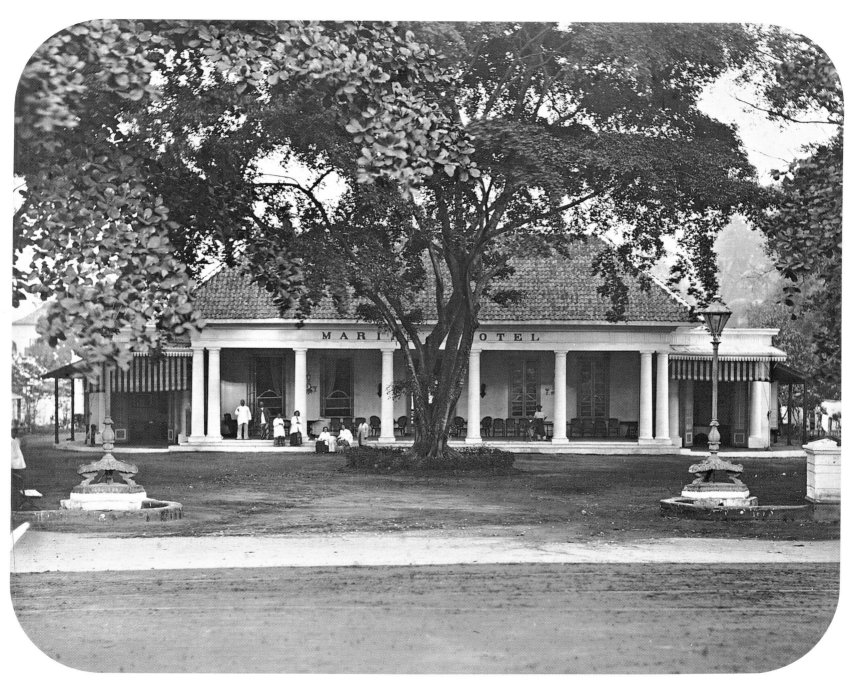

52. Photographer: **Woodbury & Page**, c. 1870 ■ albumen print ■ size: 19.5 x 24.5 cm ■ collection of the Tropen Museum, Amsterdam.

The Eigen Hulp Cooperative Department Store

The famous cooperative department store Eigen Hulp ("Mutual Help") or Winkel-Maatschappij Eigen Hulp Ltd., to give its full legal name, was established in 1890. It was the second of two large cooperative department stores to open in Batavia. The first was Onderlinge Hulp, which opened on Noordwijk (Jalan Juanda), in 1885. Eigen Hulp's customers tended to be mainly government employees and other civilians, while Onderlinge Hulp had a large customer base among Batavia's military personnel.

Eigen Hulp operated two branches in Batavia, the main one located at the southern end of Molenvliet West (Jalan Gajah Mada) where the Marine Hotel had previously stood (*see pages 112-113*). This store can be seen on the far left-hand side of the photograph on the opposite page, partially obscured by trees.

The concept of a "cooperative" store was that customers who spent more than a certain amount each year would receive a rebate equivalent to a percentage of their expenditure. With Eigen Hulp in particular, customers who spent more than 500 guilders per annum would receive a rebate that was determined according to the profits of the firm. This scheme proved to be very popular among Batavia's consumers, no doubt partly because people would have been far more price-conscious during the severe economic malaise which afflicted the Netherlands Indies during the 1880s and 1890s, following the collapse of international sugar prices in 1884. The cooperative stores would have made the local retailing environment in Batavia much more competitive, to the detriment of older-style shops such as Van Vleuten & Cox (*see pages 64-65*).

Eigen Hulp offered a wide range of fashion and household merchandise. It had a large department for ladies including a dressmaker's establishment and a hosiery and millinery department. Eigen Hulp was the sole importer in Batavia for Liberty & Co. and for Royal Worcester American corsets; it apparently carried a wide variety of the latter. Eigen Hulp sold gentlemen's wear, it had a toy department and also offered music boxes, albums, vases, terracotta and bronze statues, cigars, saddles, riding whips and fine foods.

The second, smaller branch of Eigen Hulp was located on Noordwijk (Jalan Juanda), and specialized in furniture. It was particularly well known for its wide selection of teak furniture and won the gold medal at the 1907 Pasar Gambir exhibition for furniture made in the "modern style".[21]

A visitor to Eigen Hulp in the mid-1890s observed that:

> The shops of Eigen Hulp and the warehouses and offices belonging to it are extraordinarily spacious If one wants to buy himself a new hat, gloves, necktie or collars, umbrella or shirt, one should, after entering, go to the right. The Chinese cashier, who always sits in a dignified manner near his counting board and books, greets you a little with his head, smiles, and continues counting to accept your money later on after you have finished the necessary purchases.[22]

> . . . and if you want to treat yourself to fresh cheese, delicious butter, ham, tinned sausages, sardines or crawfish, and to find the best and the richest that the stomach may desire, then in the back part of the great building there is a marble counter with a supply which makes the gourmet's mouth water.[23]

Eigen Hulp's sales rose from approximately 520,000 guilders in 1906, to 540,000 guilders in 1907 and 610,000 guilders in 1908. Dividends were paid to shareholders in each of these three years. Eigen Hulp was still in business in 1925, but had ceased to exist by 1929.

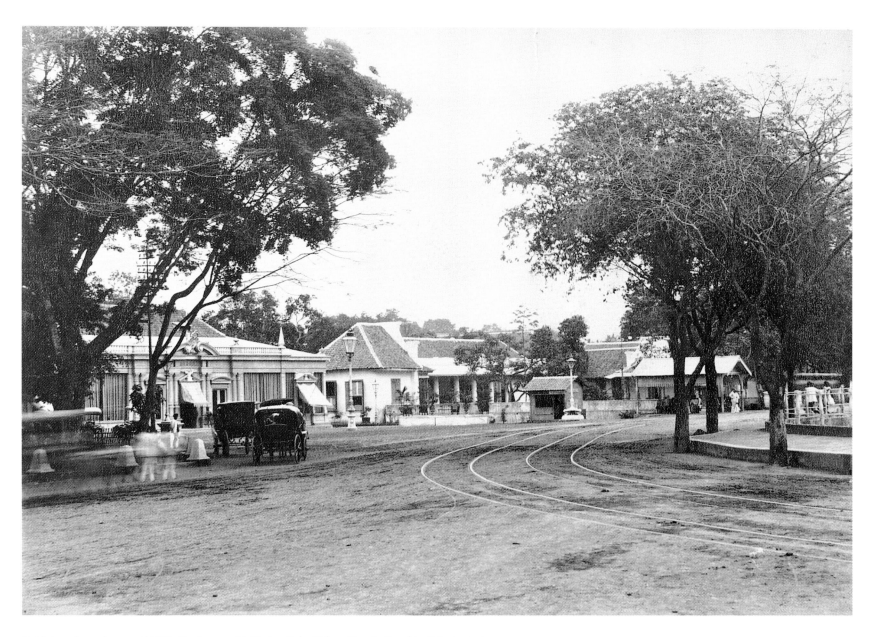

53. Photographer: unknown, mid-1890s ▓ albumen print ▓ size: 17.4 x 23.4 cm ▓ collection of Leo Haks, Amsterdam.

Hotel Ernst

The grand residence which was to become Hotel Ernst was originally a large private estate or "country seat" built by Governor-General Petrus Albertus van der Parra (governor-general 1761-75) between 1745 and 1767. It was situated at the very southern end of Molenvliet Oost (now Jalan Hayam Wuruk) on the corner of Noordwijk (Jalan Juanda). The term "country seat" would not have been an exaggerated description of the property when it was built, because at that time Noordwijk was still very rural. It would be almost another half-century before Daendels ordered the destruction of the old walled city and castle of Batavia in the north and moved the administrative capital of the city south, not far from the area chosen by van der Parra for his country residence.

The transition from private home to Hotel Ernst had already occurred by the 1860s and the hotel's name may have been taken from its first proprietor, "Mother Ernst".

A visitor to Batavia in 1896 wrote of Mother Ernst:

If the hotel is organized by a lady, which often occurs, then such a lady, usually she is one of older age, is soon called with the honourable name of "mother so and so"; thus in Batavia for example, there are still many stories circulating about Mother Ernst, the former proprietress of Hotel Wisse, an energetic and vigorous lady, who truly mother-like cared about the well-being of her guests, who was strongly outspoken with a razor like tongue, with which she stood up to everyone. On the other hand, however, if it was convenient she could also see the sun shining in the water and enjoy some fun.[24]

The name "Hotel Ernst" was used until 1890, after which it became Hotel Wisse. The building seen here was demolished in 1920. A new hotel, Hotel des Galeries, was then built on the same location and it still exists today but now operates under the name Hotel Melati.

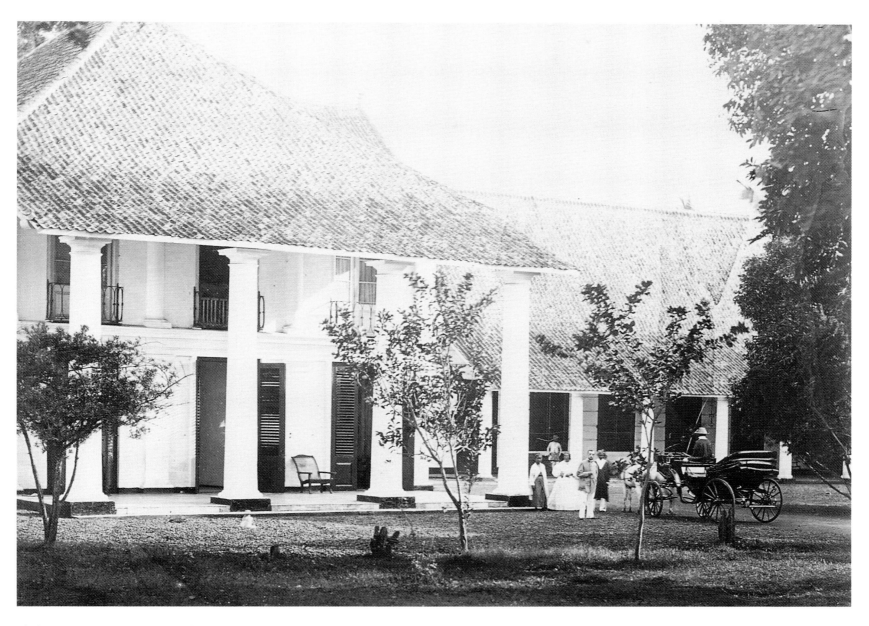

54. Photographer: **Woodbury & Page**, c. 1864–5 ■ albumen print ■ size: 19.0 x 25.5 cm ■ collection of the KITLV, Leiden.

UPTOWN BATAVIA

The New City of the South

RIJSWIJK AND NOORDWIJK ■ RIJSWIJKSTRAAT ■ KONINGSPLEIN ■ WELTEVREDEN AND THE SOUTHERN ENVIRONS ■ TANAH ABANG

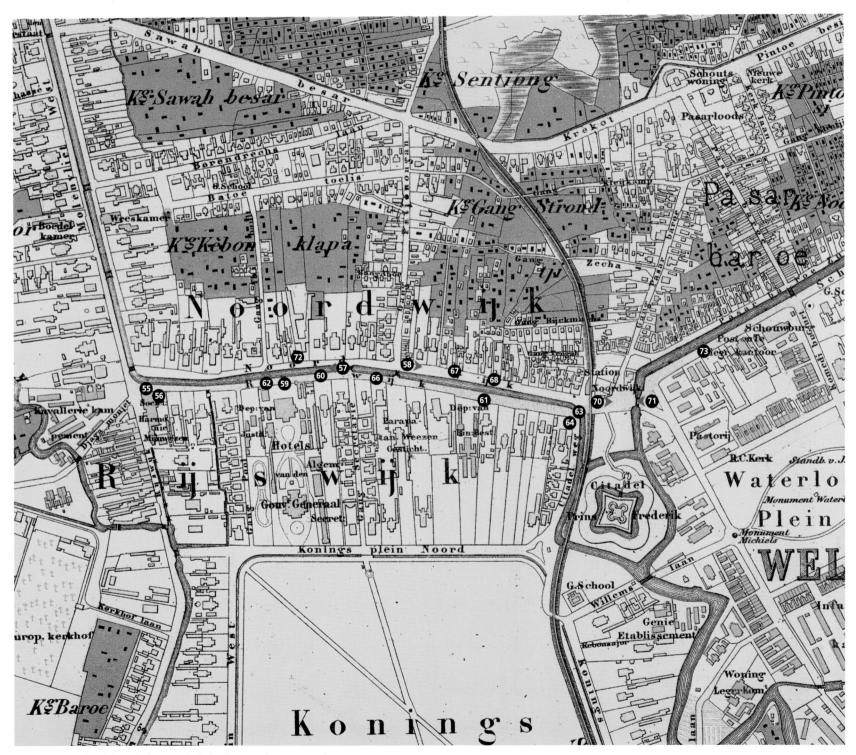

120

Note: Photographs 65 and 69 are both on Noordwijk, but the precise locations are unknown.

RIJSWIJK AND NOORDWIJK

In the second half of the 19th century, the social heart of Batavia and the elite shopping areas for Europeans were Rijswijk, Noordwijk and Rijswijkstraat (now Jalan Veteran, Jalan Juanda and Jalan Majapahit respectively). Rijswijk and Noordwijk were also among the most fashionable residential areas in Batavia during the same period.

Small forts had existed at Rijswijk (approximately where the old white BTN building now stands) to guard the southern end of Molenvliet and at Noordwijk (probably where the overhead rail line now crosses over Jalan Juanda and Jalan Veteran) from the 17th century. The Noordwijk road appears to have been built as part of the Buitenwacht ("Outer Guard") in the VOC days to connect the Rijswijk fort with the fort at Noordwijk. The early name for the road was "the road from Rijswijk to Noordwijk". During the English period, the Noordwijk fort was demolished and the name of the road was shortened to "Noordwijk".

The Rijswijk/Noordwijk area was sparsely populated until the early years of the 19th century. A number of indigenous villages and Chinese shops coexisted with several grand country estates owned by senior VOC officials such as Petrus Albertus van der Parra (governor-general 1761-75) on the corner of Molenvliet Oost (now Jalan Hayam Wuruk) and Noordwijk.

The Rijswijk area blossomed into an elite neighbourhood during the English period (1811-16). Lieutenant-Governor Thomas Stamford Raffles lived in Rijswijk at the house that later became the Hotel der Nederlanden (*see pages 130-131*). The adjoining house on the western side became the official residence of the governor-general of the Netherlands Indies from 1820 (*see pages 128-129*) until the current Presidential Palace was completed in 1879. The stature of the area was also enhanced by the opening of the Harmonie Society clubhouse on the corner of Rijswijk and Rijswijkstraat in 1815 (*see pages 122-125*). In 1812, Raffles had all the indigenous houses and Chinese shops demolished on Rijswijk (and probably also on Noordwijk) so that they would not detract from the increasingly European character of the area.

Two of Batavia's three major hotels, the Hotel der Nederlanden (opened around 1840) and the Grand Hotel Java (opened in 1834) were located on Rijswijk. Rijswijk and Noordwijk were also home to some of Batavia's leading boutiques, tailors, jewellers and shoe stores.

Writing of his experiences in 1858, Weitzel was full of praise for Rijswijk and Noordwijk:

Rijswijk forms a row of elegant villas, and together with Noordwijk which lies on the opposite side of the Ciliwung, it constitutes a most beautiful unity.[1]

In 1885, the first "modern" department store, Onderlinge Hulp, opened in Noordwijk. A second (Eigen Hulp) followed nearby in 1890 (*see pages 114-115*), at the southern end of Molenvliet West. Indeed, it was not really until the early 1960s that the area lost its status as one of the main shopping and hotel districts of the city when the new heart of Jakarta on Jalan Thamrin was developed under President Soekarno.

The Harmonie Society (1)

By far the most famous building in the Rijswijk area was the home of the prominent social club, the Harmonie Society, which can be seen in the photograph on the opposite page. There were actually two leading social clubs in 19th century Batavia, the second being the Concordia Military Society at Waterlooplein (*see pages 196-201*). However, the Harmonie was perhaps the better known of the two because of its longer history and also its excellent location on the corner of Rijswijk and Rijswijkstraat (now Jalan Veteran and Jalan Majapahit respectively).

The Harmonie Society was already in existence in 1803 and may have even dated from the 1780s. In the early 19th century, its clubhouse was located on the eastern side of Buiten Nieuwpoort Straat (Jalan Pintu Besar Selatan) just outside the old walled city of Batavia in the north.

It was Herman Willem Daendels (governor-general 1808-11) who gave the order in 1809 to build a new clubhouse for the Harmonie Society in Rijswijk as part of his grand plan to relocate the administrative centre of Batavia to the southern districts of Weltevreden from the old and decaying walled city in the north, which he ordered to be demolished. It was Daendels' belief that building a new clubhouse in the south would encourage more of Batavia's citizens to move south with him. He was also suspicious of the activities of the two Masonic lodges in Batavia (*see pages 206-207*) and he possibly believed that a grander clubhouse for the Harmonie would provide European men with a more attractive alternative for social gatherings than the Freemasons.

A tender was organized to choose a contractor to build the new club premises, and on 31 March 1810 a contract was awarded which stipulated a project cost of 105,000 rijksdaalders and that construction was to be completed within 15 months. However, the political and economic turmoil of the time, which included the French being driven out of Java after the British attack on Batavia in August 1811, combined with a severe devaluation of the currency and the subsequent difficulties in obtaining building materials and labour, meant that construction couldn't be finished either on schedule or in line with the budget. Work on the project was suspended for several months.

In 1812, the new British lieutenant-governor of Java, Thomas Stamford Raffles, instructed that work on the clubhouse continue. A new tender was held which fixed a revised construction cost of 360,000 rijksdaalders (more than three times the original tender price from only two years before). By late 1814, construction had been completed.

On 18 January 1815, the new Harmonie Society clubhouse was officially opened, apparently by Raffles himself, and legend has it that he threw the front door keys into the nearby Rijswijk/Noordwijk canal, declaring that the doors of the club would never close.

Attendance was modest in the early years of the new clubhouse because it was regarded as being too far away from the old city in the north where many members still lived. From around 1820, a monthly ball and supper were organized for members. However, it was later changed to once every three months and then abandoned altogether. Poor attendance also created financial difficulties, and building maintenance was neglected. A press report from 1861 suggested that the condition of parts of the building was so bad as to be dangerous.

Nevertheless, as the European population in the south rose in the second half of the 19th century, the Harmonie Society clubhouse grew to become one of the main centres of Batavia's social life and was famous as a venue for grand balls and state functions as well as just for casual recreation.

The Harmonie building was sadly demolished in April 1985 to facilitate the widening of Jalan Majapahit.

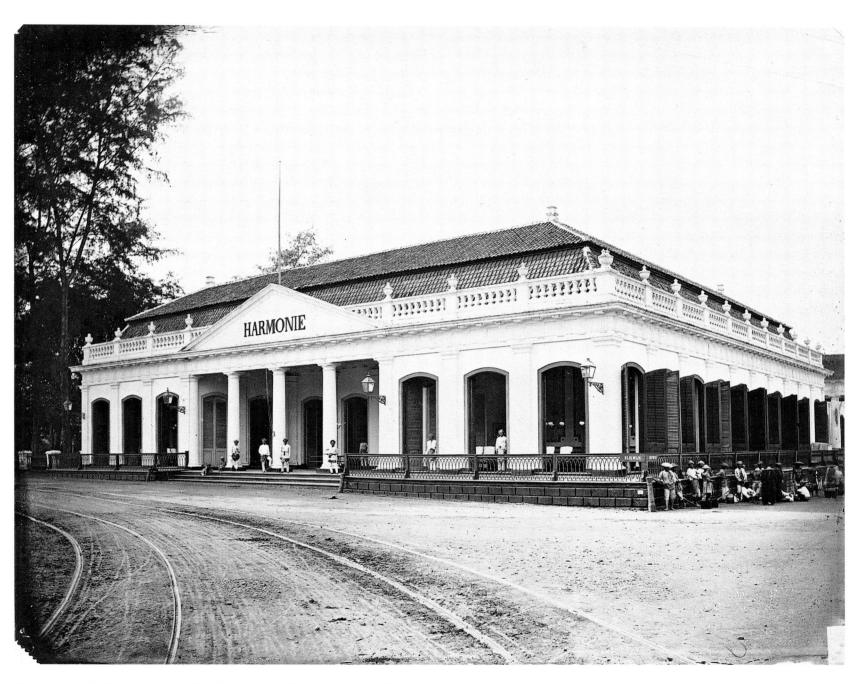

55. Photographer: **Woodbury & Page**, early 1870s ■ albumen print ■ size: 20.0 x 25.2 cm ■ collection of the author, Melbourne.

The Harmonie Society (2)

The date of the official opening of the new Harmonie Society clubhouse (18 January 1815) was chosen to coincide with the official birthday of Queen Charlotte, wife of the then British King George III. A grand ball and supper were held the same evening to mark the occasion. Great festivities were no doubt enjoyed in the main rooms of the clubhouse, one of which can be seen ornately decorated in classical style in the photograph on the opposite page.

An enthusiastic account of that gala evening was recorded for posterity:

A large portion of the members of the Batavian Harmonie Society have recently removed to Rijswijk, and taken possession of the superb building which has excited so much general admiration. These rooms were thrown open on the 18th instant to celebrate the anniversary of Her Majesty's Birthday, and we never recollect to have seen apartments in the Indies better calculated for purposes of public festivity. The house in question is admirably constructed for the entertainment of a considerable number. The extensive ballroom being arched, is well suited for the conveyance of musical sounds, and the spaciousness of the supper rooms, together with the suites of apartments that have been prepared for the amusement of those visitors who are not disposed to sport "the light fantastic toe", does great credit to the gentlemen and artists who have been concerned with the erection and completion of the building.[2]

The dancing commenced about nine o'clock, and was kept up with great spirit until twelve, when the supper rooms were thrown open, and the party sat down to a sumptuous board, on which delicacies in abundance were conspicuous. The loyal and patriotic toasts that were given by the Commander of the Forces, were drunk with the greatest enthusiasm, and in short the harmony that prevailed during the whole of the entertainment was in every way worthy of the occasion. The dancing was resumed with renovated spirits immediately after supper, and was continued until a very late hour, whilst a few votaries of Bacchus did not fail to usher in "the rosy morn" with bumpers of claret to the health of our beloved Queen.[3]

Almost a century after it was established, the Harmonie Society was still highly regarded, as can be seen from the following account published in 1909:

No one in Batavia can complain reasonably of the lack of good clubs. The "Harmonie", which on account of its excellent situation in Rijswijk is perhaps best known to visitors, will compare quite favourably with most of the social institutions found in tropical countries. It has excellent accommodation for its members—a ball room, a fine billiard room containing six tables, a library, and a spacious reading room, where many of the leading papers from Europe, Australia, and America may be found, while every Sunday evening an admirable military band gives a concert in the gardens. The residents of Batavia have a keen appreciation of good music, and these musical treats, for so they may be called, are always well attended by the members of the club and their friends.[4]

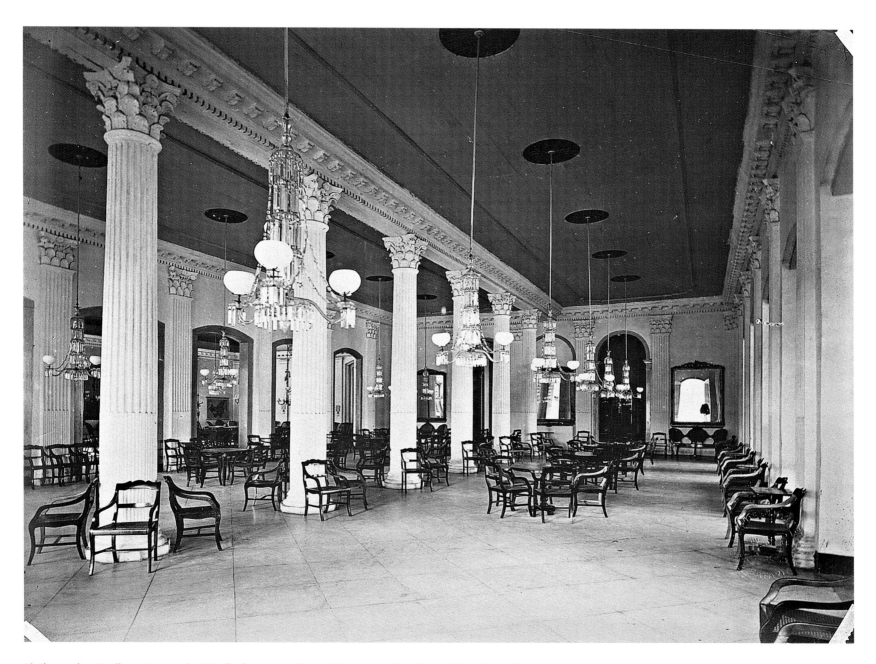

56. Photographer: **Woodbury & Page**, early 1870s ▪ albumen print ▪ size: 20.9 x 27.1 cm ▪ collection of the author, Melbourne.

Looking west along Rijswijk

This photograph was taken from a point directly in front of the Woodbury & Page photographic studios on the corner of Rijswijk and Gang Secretarie and is looking west along Rijswijk. On the left-hand side, we see the partly obscured entrance to the Hotel der Nederlanden (*see pages 130-131*) and further along, the front buildings of the official residence of the governor-general (*see pages 128-129*) are visible among the trees. On the opposite side of the canal, we can see the western end of Noordwijk and the white painted fences of some of the private residences located there.

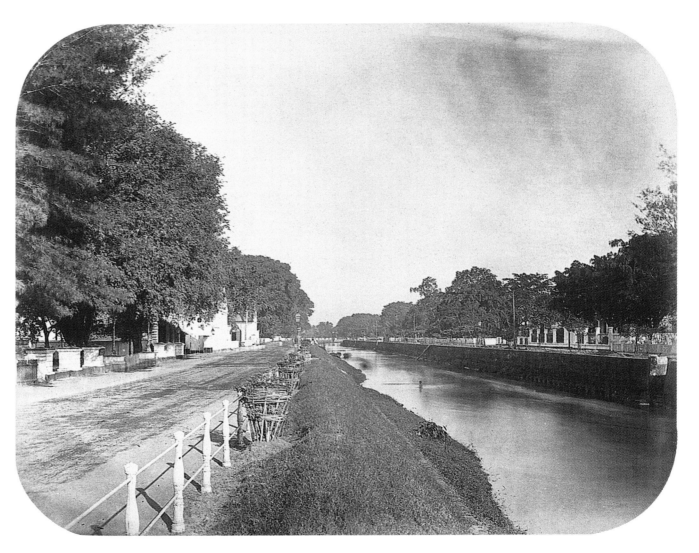

57. Photographer: **Woodbury & Page**, mid-1860s ■ albumen print ■ size: 18.8 x 23.5 cm ■ collection of the author, Melbourne.

Looking east along Noordwijk

In this view we are looking in an easterly direction along Noordwijk (Jalan Juanda). The corner of Noordwijk and Gang Pecenongan (Jalan Pecenongan) would be just behind the photographer on his left. From the 1850s, Noordwijk and Rijswijk developed as fashionable shopping areas with retail stores interspersed among many fine houses and hotels. The two white buildings in the centre of this photograph are shops which can be more clearly seen on page 140.

An early portrait photographer, Antoine François Lecouteux, operated what was perhaps the first permanent photographic studio in Batavia from a location on Noordwijk from approximately 1854 until 1857 *(see Appendix One)*. It is not known whether Lecouteux also took topographic views of Batavia but if he did, none appear to have survived.

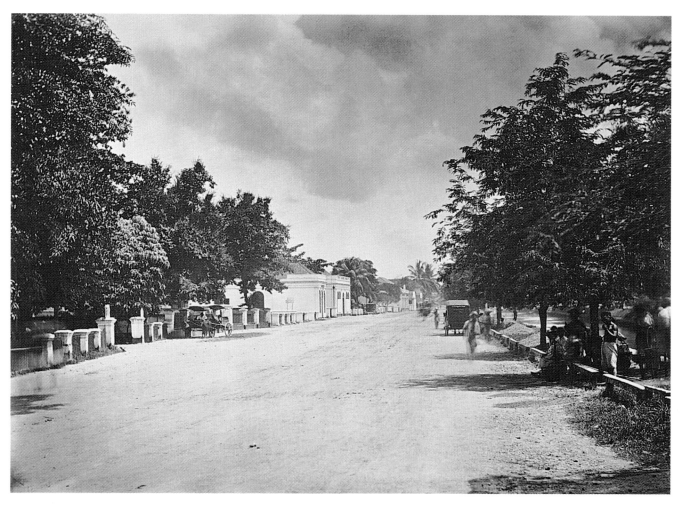

58. Photographer: **Woodbury & Page**, mid-1860s ▨ albumen print ▨ size: 18.3 x 24.1 cm ▨ collection of the Tropen Museum, Amsterdam.

The official residence of the governor-general (1820-1879)

The fine white building near the western end of Rijswijk (Jalan Veteran) which is now the Istana Negara ("State Palace") was built as a private residence by J. A. van Braam in the late 1790s or the very early 1800s. Its grounds originally stretched all the way back to Koningsplein Noord (Jalan Medan Merdeka Utara) and included the land on which the Istana Merdeka ("Independence Palace") now stands.

This house was occupied for a while during the English period (1811-16) by Hugh Hope, the civil commissioner or governor of Java's north-east coast. Upon the return of the Dutch in 1816, the house became the residence of Governor-General Godert Alexander Gerard Philip Baron van der Capellen (governor-general 1816-26), who preferred it to the one next door which had been used by Raffles (*see page 131*).

The government bought the house after van Braam died in 1820 and converted it into the official residence of the governor-general in Batavia. This had not been the plan of Governor-General Herman Willem Daendels (governor-general 1808-11), who had intended that the much grander building on Waterlooplein which he had begun in 1809 (*see page 193*) become the palace of the governor-general. However, Daendels' palace was not completed until 1828, and it was used as government offices rather than as an official residence.

Although van Braam's house was deemed to be the home of the governor-general, it was never considered to be large enough nor sufficiently regal to be a proper "palace". In 1848, the second storey was demolished and the verandah extended to make the building appear more dignified.

In 1858, Weitzel observed:

> It is a beautiful house that gave honour to the rich private person who had it built, but it is not at all a suitable residence for the man, who in the name of the King, has authority over millions of citizens, who has the right to declare war and peace, and who has life and death at his disposal.[5]

Nevertheless, the residence was tolerated, perhaps because the governors-general rarely lived in it, preferring instead to spend most of their time in the cooler climate of Buitenzorg (Bogor). For this reason it was frequently described on 19th century maps of Batavia as the "hotel of the governor-general". Many governors-general only visited Batavia when necessary for official business such as meetings of the Raad van Indie ("Council of the Indies") which were held in this building. Some of the work of the state secretariat was also conducted there. The first gas lights in Batavia were lit in this building on 4 September 1862.

There was no official "palace" of the governor-general in Batavia until 1879, when what is now the Istana Merdeka was opened on Koningsplein Noord (*see pages 172-173*). A Dutch visitor to Batavia in 1862 was not impressed with the governor-general's residence and noted:

> As for public buildings, Batavia has little that are noteworthy. The residence of the governor-general, a large square white house with a few side buildings, and behind it a small garden, according to me barely earns the title "palace". On the façade there is the royal coat of arms of the Netherlands, but the building gave to me the impression of being a colossal horse station. For the housing of an even not large family, it is too small, while for large parties, it offers far too little space, with the increase of the European population in Batavia. But otherwise the white plastered building with its marble floors and covered galleries internally was built with much taste.[6]

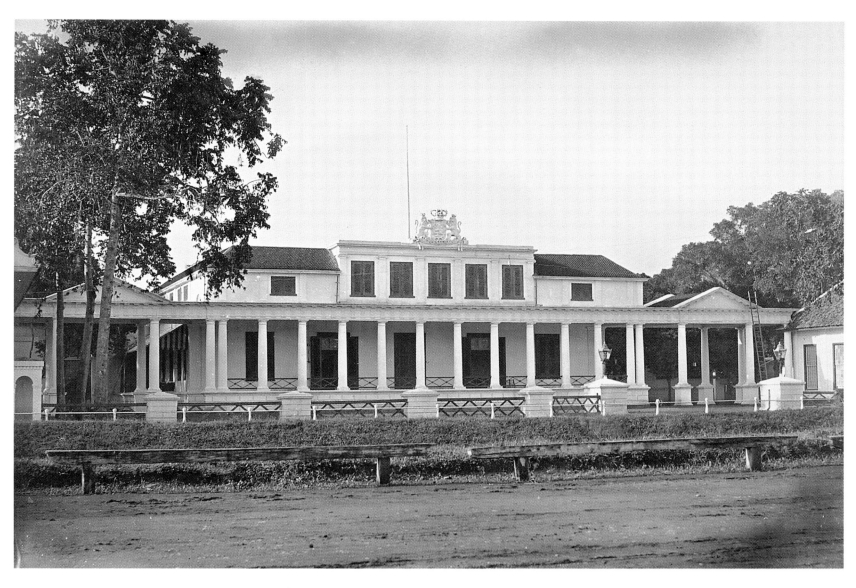

59. Photographer: probably **Isidore van Kinsbergen**, c. 1870 ■ albumen print ■ size: 20.4 x 29.4 cm ■ collection of the author, Melbourne.

Hotel der Nederlanden

The Hotel der Nederlanden was probably the leading hotel in Batavia in the second half of the 19th century before being surpassed by the Hotel des Indes (*see pages 106-111*) in the first decade of the 20th century. It was located on Rijswijk (Jalan Veteran) on a large plot of land which stretched all the way back to Koningsplein Noord (Jalan Medan Merdeka Utara). The official residence of the governor-general (*see pages 128-129*) was located on the western side of the hotel and the studio of photographers Woodbury & Page (*see pages 258-263*) was on the eastern side.

The hotel was originally built in 1794 as a private residence by Pieter Tency who later sold it to a member of the Council of the Indies, Mr W.H. van Ijsseldijk. Its most famous owner was Thomas Stamford Raffles, best known as the founder of Singapore, but who also served as lieutenant-governor of Java from 1811 to 1816. He bought the property for 27,000 rupees and later sold it to the Dutch government when he left Batavia in 1816. Around 1840, the building became a hotel with the name "Hotel Place Royale" under the ownership of Johannes Petrus Faes. It became the Hotel der Nederlanden in 1846.

An American lady visiting Batavia in the 1890s was not impressed by the decorum and dress code of the other guests at the Hotel der Nederlanden and noted:

The hotel is a series of one-storeyed buildings surrounding the four sides of a garden court, the projecting eaves giving a continuous covered gallery that is the general corridor. The bedrooms open directly upon this broad gallery, and the space in front of each room, furnished with lounging-chairs, table and reading lamp, is the sitting-room of each occupant by day. There is never any jealous hiding behind curtains or screens. The whole hotel register is in evidence, sitting or spread in reclining chairs. Men in pyjamas thrust their bare feet out bravely, puffing clouds of rank Sumatra tobacco smoke as they stared at the new arrivals; women rocked and stared as if we were the unusual spectacle, and not they; and the children sprawled on the cement flooring, in only the most intimate undergarments of civilized childrenWe were sure we had gone to the wrong hotel; but the Nederlanden was vouched for as the best, ...[7]

The Hotel der Nederlanden was significantly rebuilt in the early 20th century, and a writer in 1919 looked back on the hotel in the 1890s with considerable disdain, describing it as:

The pinnacle of unsociableness. One immense long table in the dining room; dark uncomfortable guest rooms, poorly furnished, gloomy bathrooms, no recreational hall. Still a large private residence organized as a hotel ...[8]

However, the reviews were not all bad and a Dutch visitor in the mid-1890s noted:

What drew my attention further on there was that the beautiful Hotel der Nederlanden situated in Rijswijk has a Tiffen-Room downtown, where the hotel visitors who in the afternoon have to be in town, can have their lunch, a comfort which is highly appreciated by the guests, because it spares so much time. I happen to know that the Hotel der Nederlanden is the only hotel in the Netherlands-Indies which can point to such a branch.[9]

The Hotel der Nederlanden survived at least until the late 1940s, but was later demolished. On the site now is Bina Graha, the office of the President of the Republic of Indonesia.

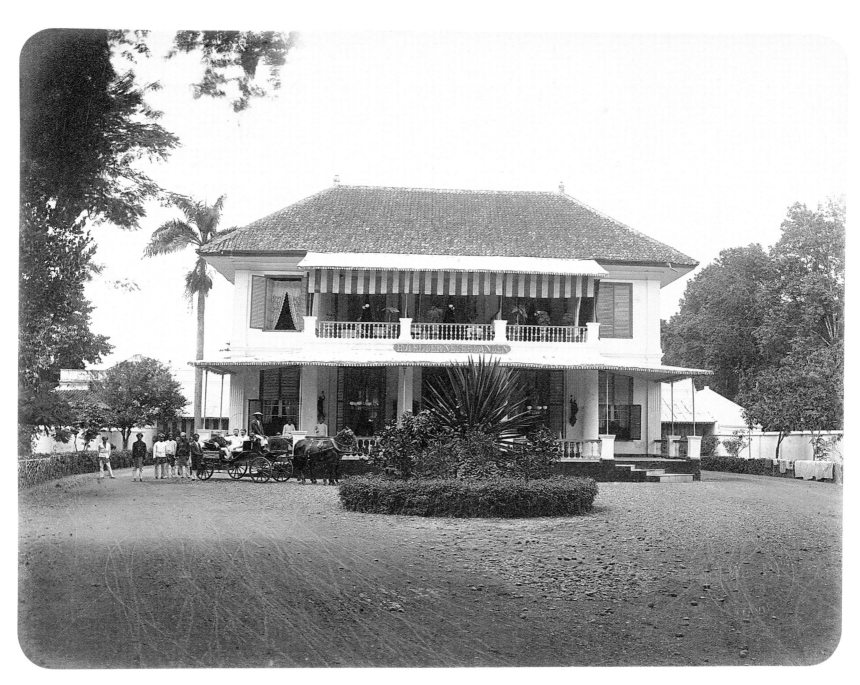

60. Photographer: **Woodbury & Page**, early 1870s ■ albumen print ■ size: 19.1 x 23.9 cm ■ collection of the author, Melbourne.

Grand Hotel Java

Established in 1834, the Grand Hotel Java was a spacious hotel with its main building located near the eastern end of Rijswijk (Jalan Veteran) approximately 100 metres from Citadelweg (Jalan Veteran 1). Its grounds ran all the way through to the eastern end of Koningsplein Noord (Jalan Medan Merdeka Utara). A feature of the hotel was that many of the rooms were built on platforms four feet (1.2 metres) above the ground to help keep them cooler. The Grand Hotel Java was located beside the headquarters of the colonial civil service, which made it popular with government officials.

Having frontages on both Rijswijk and Koningsplein Noord meant that guests of the hotel could enjoy the breezes blowing north through the hotel grounds from across the Koningsplein. To take advantage of these breezes the hotel was redesigned by the early 20th century into long lines of relatively spacious pavilions, which in turn made the hotel popular with long-staying guests and families. The hotel had an atmosphere of a large residence.

The Grand Hotel Java appears to have been less frequented by guests who were staying in Batavia for only a short time, which is probably why it was rarely mentioned in the published journals of 19th century visitors to Batavia.

Despite the spacious grounds, in 1909 the Grand Hotel Java had only 70 rooms. An account of the hotel in the same year noted that:

> In the reading room there is always a good supply of Dutch, English, French and German papers and magazines, all of which languages are spoken fluently by the hotel officialsIn every way the convenience of the visitor is studied. Telephones are installed in all parts of the building; there is a well-equipped dark room for the use of amateur photographers, and large and well-appointed livery stables where horses and plain or rubber-tyred carriages may always be obtained.[10]

Some time after independence, the Grand Hotel Java was closed. The buildings on the Rijswijk side were taken over by the Indonesian military and those on Koningsplein Noord are now used by the Ministry of the Interior.

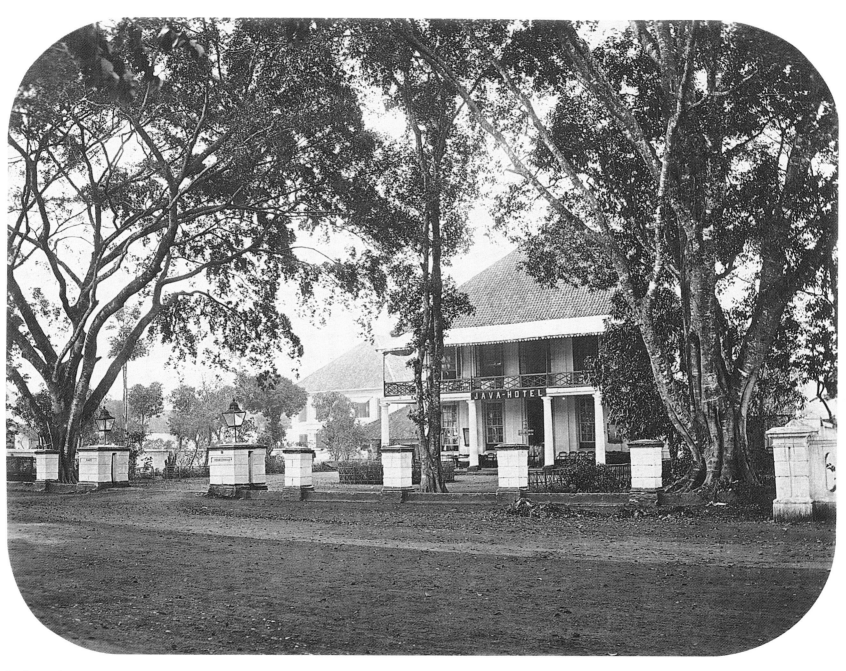

61. Photographer: **Woodbury & Page**, 1872 or earlier ▪ albumen print ▪ size: 18.6 x 23.5 cm ▪ collection of the author, Melbourne (gift from Mr Leo Haks).

Gang Thiebault

It was a common practice in 19th century Batavia for streets to be named after local middle-class residents such as shop-keepers and innkeepers, rather than historic figures or military heroes. De Haan sarcastically ascribes the practice to "colonial indifference".[11]

Gang Thiebault (now Jalan Juanda 3) was such a street. Alfred Thiebault, who was already in Batavia by 1852, started his career as a teacher, but became the innkeeper of the Concordia Military Society (*see pages 196-201*) and later, innkeeper of the Harmonie Society (*see pages 122-125*). He was a prosperous man who wrote poetry and also studied genealogy and heraldry. He seems to have owned a number of properties in Batavia and later in his life earned his living as a landlord.

This photograph looks north into the entrance of Gang Thiebault and was taken from Rijswijk, looking over the canal to the corner of Noordwijk and Gang Thiebault. On the right, we can see the sign of the Hotel de L'Europe. Little is known about this probably modest hotel, which was first listed in the government almanac in 1880 and last appeared in 1887. However, the almanacs were often incomplete and the hotel was certainly established several years before 1880 because this photograph could not have been taken after 1872, given that it appears in an album dated that year.

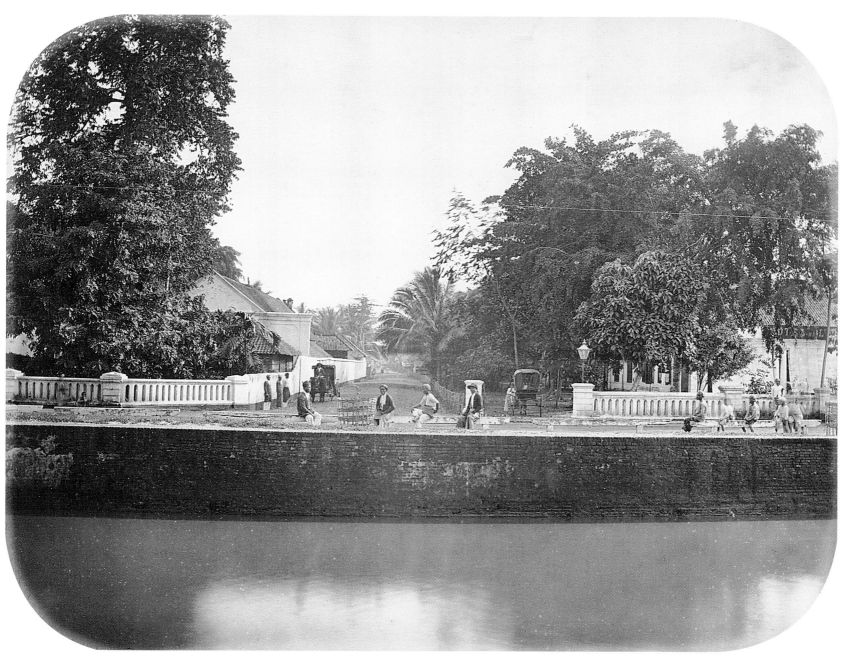

62. Photographer: **Woodbury & Page**, 1872 or earlier ■ albumen print ■ size: 18.9 x 24.1 cm ■ collection of the author, Melbourne.

C. A. W. CAVADINO, RESTAURANTEUR, HOTELIER AND SHOPKEEPER

The restaurant and firm of confectioners and pastry-cooks C. A. W. Cavadino was established around 1863 by Conrad Alexander Willem Cavadino. Previously, Mr Cavadino had been the innkeeper at the Concordia Military Society on Waterlooplein (*see pages 196–201*). Probably an active Catholic, Mr Cavadino was the treasurer of the official body in charge of Catholic Church property in Batavia in 1863 and was still a member of that body in 1870.

Cavadino's premises were located on the corner of Rijswijk (Jalan Veteran) and Citadelweg (Jalan Veteran 1). The bridge in front of his premises was known for many years in the late 19th century as "Cavadino Bridge". By the late 1860s or very early 1870s (certainly by 1872), the restaurant in the fine building on the opposite page had become the Hotel Cavadino while the retail operations were conducted from the store Toko Cavadino just in front of the hotel, as can be seen in the photograph below.

1870 was the last year in which C. A. W. Cavadino was listed as being a resident of Batavia although the firm traded under the name C. A. W. Cavadino until 1871. From 1872, the firm was listed as "Cavadino & Co.". Possibly Mr Cavadino retired and moved elsewhere or passed away. From 1871, the only Cavadino listed as living in Batavia was Mr J. A.

Cavadino, but it is not known whether he was a relative nor whether he was involved in the business.

Both the hotel and the retail activities continued through to the end of the 19th century. An advertisement from 1894 indicated that Toko Cavadino offered: "bonbons and chocolate, Dutch, Havana and Manila Cigars, fine comestibles, wine—beer, liquors etc. etc. etc."[12]

The hotel was still called Hotel Cavadino in 1898 but from 1899, it became the Hotel du Lion d'Or. A photograph from July 1941 shows that the name had changed yet again to the Park Hotel. By approximately the mid-1950s, it had become Hotel Sriwijaya. For a brief time after independence, the hotel may have been used by the Indonesian Air Force as a mess hall.

The two-star-rated Hotel Sriwijaya still exists in the same building. With an almost unbroken record of over one and a quarter centuries as a hotel, it is probably the oldest surviving hotel in Jakarta today notwithstanding the several changes of name and the significant remodelling of the facade and the interior. The "toko" has now become the Sriwijaya Hotel's restaurant, and the entrance to it is now from the side rather than from the front.

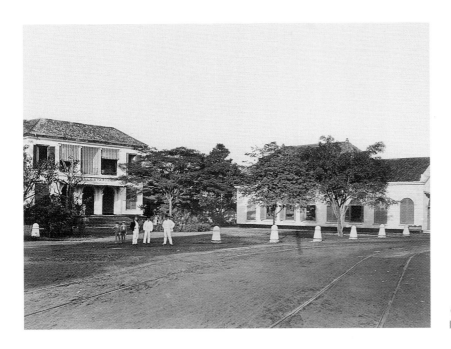

63. Photographer: probably **Woodbury & Page**, mid–1870s
▨ albumen print ▨ size: 19.0 x 24.5 cm ▨ collection of the KITLV, Leiden.

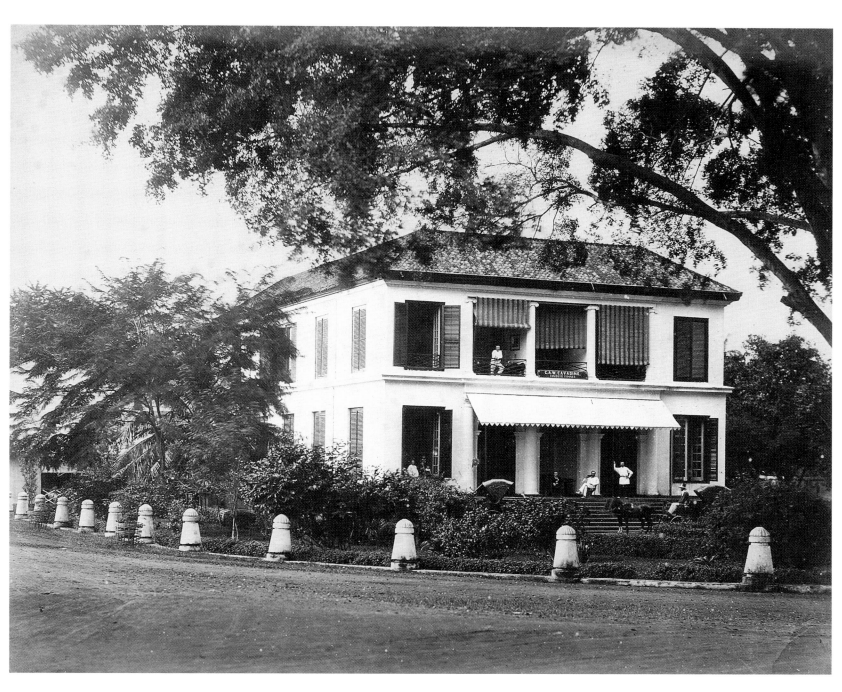

64. Photographer: **Woodbury & Page**, c. 1864–5 ■ albumen print ■ size: 23.5 x 28.9 cm ■ collection of the author, Melbourne.

VAN ARCKEN & CO.

Clemens Gerardus Franciscus van Arcken was born in Deventer, Holland, in 1822 and started his career as a watchmaker in his home town while still in his teens. In 1851, he moved to Amsterdam to continue his profession. He was well known in the court of King Willem III as a watch- and instrument-maker and as a musician, and he was appointed a Royal Warrant holder in 1854.

Van Arcken and his family moved to Batavia in 1861, where Van Arcken & Co.'s first store was opened near the Harmonie Society clubhouse *(see pages 122-125)*. Late in 1864, for reasons that are unclear, Van Arcken & Co. was liquidated and a new firm, Van Arcken, was established. An advertisement in the *Java Bode* newspaper on 11 November 1864 announced that Van Arcken had opened a new store on Noordwijk (Jalan Juanda) offering a great assortment of merchandise but also mentioned that a wide variety of goods was still available at "the liquidated firm of Van Arcken & Co."

Later, the name of the firm again became Van Arcken & Co. and the firm moved to larger premises in Rijswijk (Jalan Veteran) just past the eastern side of the corner of Gang Secretarie (Jl. Veteran 3).

Whatever the problems of the 1860s, Van Arcken & Co. seemed to prosper for many years. They became famous as gold- and silversmiths, watchmakers, jewellers and engravers in Batavia and could count among their clientele governors-general, and the royal courts of Yogyakarta and Surakarta, as well as the royal family of Siam (Thailand). Van Arcken & Co. were even described as the "Tiffany of the East" by one source.[13]

The founder, Clemens van Arcken, died in 1885. The business was continued by his eldest son, C. J. W. van Arcken who was assisted by his younger brothers, G. A. van Arcken and E. C. van Arcken.

An account of Van Arcken & Co. from 1925 noted that:

> The interesting establishment, which also forms the residence of the proprietor of the business, Mr. Edward C. van Arcken, is by its means and methods reminiscent of the times when apprentices lived with their employers, and the ancient guilds embraced none more honoured nor powerful than that of the goldsmiths, silversmiths and jewellersThe work in Messrs. van Arcken & Co.'s premises, bounded at the back by a romantic, old-fashioned garden, is performed in an environment that harmonizes admirably with the ideals and traditions of jewellery production.[14]

Van Arcken & Co. went bankrupt during the great depression that began in 1929. However, from around 1932 or 1933, the firm was continued on a much smaller scale by grandsons of the founder from a side pavilion of the Rijswijk building. The family fled Indonesia in 1958 along with most of the rest of the Dutch population, only three years short of what would have been the centenary of the firm in Indonesia.

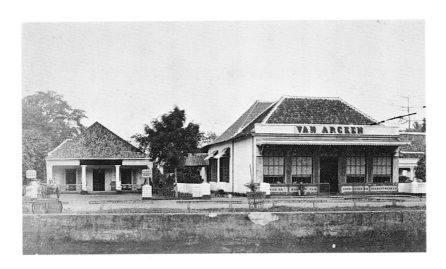

65. Photographer: **Woodbury & Page**, between November 1864 and 1874
■ albumen print ■ size: 6.0 x 9.5 cm ■ collection of the Tropen Museum, Amsterdam.

This photograph shows what was probably the "new" store of Van Arcken on Noordwijk that was established late in 1864, after the earlier firm of Van Arcken & Co. had been liquidated.

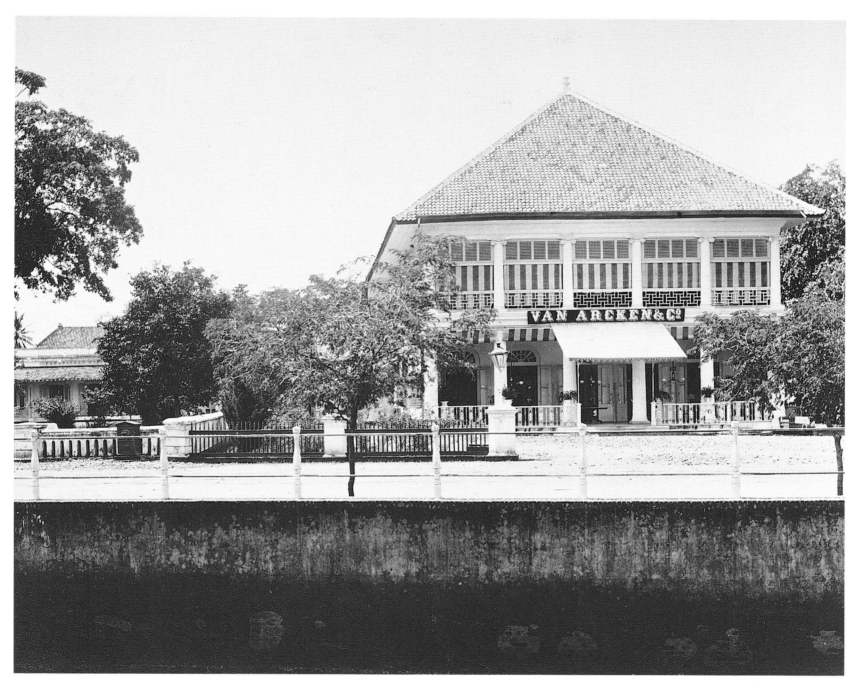

66. Photographer: **Woodbury & Page**, c. 1880 ▪ albumen print ▪ size: 20.0 x 24.5 cm ▪ collection of the Tropen Museum, Amsterdam.

At some point between late 1864 and the time when this photograph was taken around 1880, the firm Van Arcken again became Van Arcken & Co. and had relocated from Noordwijk to these grander and much larger premises on Rijswijk (Jalan Veteran) just past the eastern side of the corner with Gang Secretarie (Jalan Veteran 3). The building no longer exists.

The premises of Combet (Maison Seuffert)

The shoe store founded by Jean Nicolas Justin Seuffert, seen here on the right on Noordwijk (Jalan Juanda), first appeared in the government almanac in 1857, but may have been established earlier. Seuffert himself was first listed in 1846. He must have built up a good reputation for himself because when his store was sold to Jean Baptiste Marie Combet around 1858, the new owner kept Seuffert's name and traded as "Combet (Maison Seuffert)". Mr Combet was last listed as being a resident of Batavia in 1865 and by 1868, the name of the firm had become "Combet (Maison Seuffert) and Co.". By 1876, "Maison Seuffert" had been dropped altogether and the firm traded as "Combet & Co." It was last listed in the government almanac in 1896. Nothing is yet known about the smaller store on the left.

Both of these buildings can also be seen in the centre of the photograph on page 127. They have both long since been demolished and other commercial premises line Jalan Juanda today. However, the area now has a somewhat neglected feel to it and its days of prominence as a major business and insurance centre and shopping promenade came to an end with the development of Jalan Thamrin and Jalan Jendral Sudirman from the 1960s and 1970s.

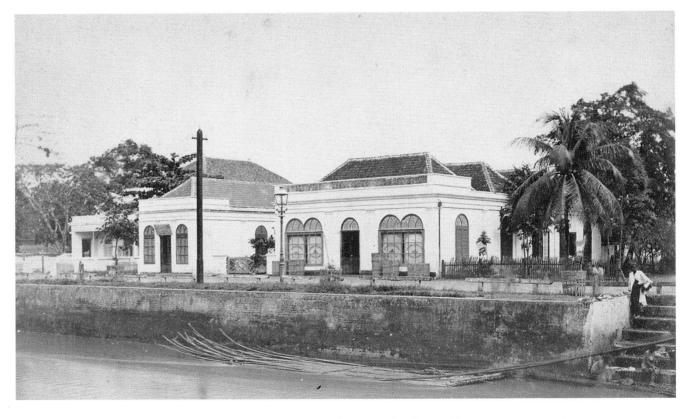

67. Photographer: **Woodbury & Page**, 1874 or earlier ▨ albumen print ▨ size: 6.0 x 9.5 cm ▨ collection of the Tropen Museum, Amsterdam.

The premises of Mayr & Co. and H. Van Riet & Co.

The firm of watchmakers and jewellers, Mayr & Co., was located near the eastern end of Noordwijk (Jalan Juanda) just opposite the Grand Hotel Java on Rijswijk *(see pages 132-133)*. They described themselves on their shop-front sign as "opvolgers van Van Arcken" (successors to Van Arcken) *(see pages 138-139)*. The business may have been the original operations of Van Arcken & Co. which were liquidated late in 1864, although this cannot yet be ascertained with any certainty. Mayr & Co. appeared in the government almanac for the first time only in 1867, but the almanacs were not always complete or up to date. However, Mayr & Co. proved to be an enduring firm and was still operating from the same premises early in the 20th century.

The tailors H. van Riet & Co., seen here on the right, were established around 1863, probably by Hendrik van Riet who was first listed as being a resident of Batavia in 1848. His firm was last listed in 1874.

None of the buildings seen here are still standing. Today on this site the spacious premises of an office supplies store can be found.

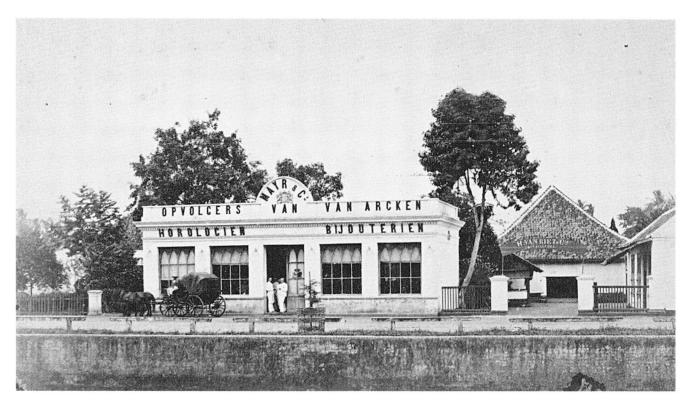

68. Photographer: **Woodbury & Page**, 1874 or earlier ■ albumen print ■ size: 6.0 x 9.5 cm ■ collection of the Tropen Museum, Amsterdam.

The premises of A. Herment & Bastiere

A. Herment & Bastiere was a firm of gentlemen's tailors on Noordwijk (Jalan Juanda). August Herment and Christolphe François Bastiere were both listed for the first time as residents of Batavia in 1847, while the firm of A. Herment & Bastiere first appeared in the government almanac in 1857. The firm was awarded a bronze medal at the Batavia Exposition in 1865. "Bastiere" last appeared in the firm's name in 1872, after which it became "A. Herment".

An account of A. Herment in 1909 noted that the firm:

…may also be thoroughly recommended both to residents and tourists who are in need of well-cut clothes made from the best material and at moderate prices They are civil and military tailors, and make clothes not only upon the European plan but in accordance with the American fashions also. Their stock includes many varieties of English and Scottish tweeds and suitings manufactured especially for use in the tropics, and a fine selection of linens and drills from the best makers in Europe.[15]

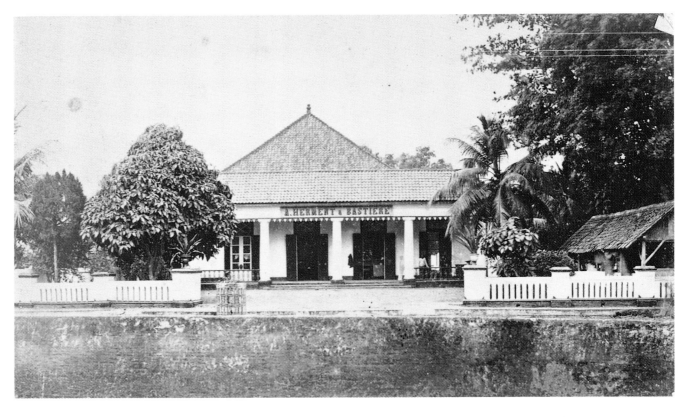

69. Photographer: **Woodbury & Page**, 1872 or earlier ■ albumen print ■ size: 6.0 x 9.5 cm ■ collection of the Tropen Museum, Amsterdam.

The premises of Nicolas Pascal

Nicolas Pascal's shoe store at Sluisbrug (Pintu Air), Fabricant de Chaussures de Paris ("Manufacturer of Shoes from Paris"), seen here on the left of this photograph, dates back to at least the late 1850s. Mr Pascal used French not only on his shop-front, but also in his newspaper advertising. In the *Java Bode* of 10 January 1863, he announced *Un Grand Deluge* *De Chaussures* ("a grand flood of shoes"). The firm last appeared in the government almanac in 1886. In this photograph, we are looking in an easterly direction and the *sluisbrug* (lock bridge) which was used to control water flow to the Molenvliet and Gunung Sahari canals can be seen in the distance on the right (*see also pages 144-145*).

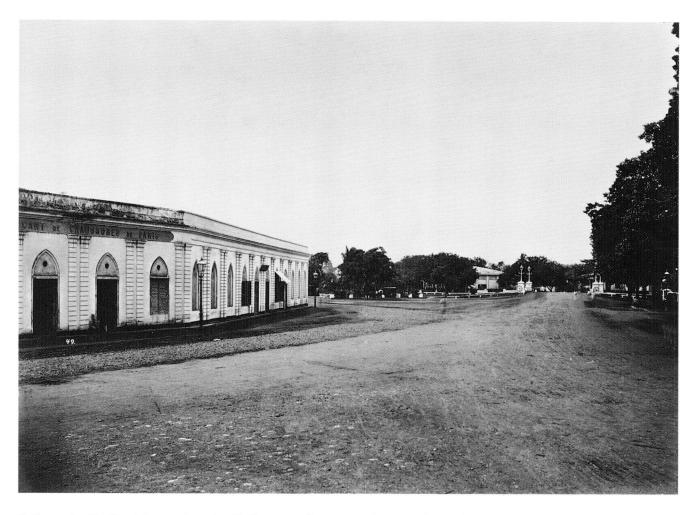

70. Photographer: **Woodbury & Page**, 1872 or earlier ■ albumen print ■ size: 18.0 x 24.1 cm ■ collection of the Tropen Museum, Amsterdam.

The Sluisbrug at Pintu Air

As early as the 17th century, an important series of canals had been built in Batavia. The most important section of these was the western leg, known as the Molenvliet canal, which still exists today between Jalan Gajah Mada and Jalan Hayam Wuruk. The Molenvliet canal was originally built in 1648 to supply wood for ship and house building to the walled city of Batavia in the north. By the late 1650s, the VOC was attempting to increase the flow of water along the Molenvliet canal to provide water power for a variety of industries, most notably sugar, timber and gunpowder mills.

The source of the water was the Ciliwung River. Water flowed along two legs of the Ciliwung on either side of where the Istiqlal Mosque is now located. The western leg of the river flowed into the canal between Noordwijk (Jalan Juanda) and Rijswijk (Jalan Veteran) and then turned south into the Molenvliet canal. The eastern leg originally followed the natural contours of the Ciliwung itself, but after the digging of the Gunung Sahari canal, the water was re-channelled to flow along Post Weg (Jalan Pos) and School Weg (Jalan Dr Sutomo) and then south into Gunung Sahari and along Jacatra Weg (Jalan Pangeran Jayakarta). From both the Molenvliet canal and Jacatra Weg, the water also flowed into the Kali Besar as well as into the Stads Buiten Gracht ("Outer City Canal") which surrounded the walled city (*see page 71*).

A constant problem from Batavia's early days was the widely fluctuating water levels in these canals due to seasonal factors. During the wet season, the canals would often flood and water pressure could sometimes be so great as to be dangerous. By contrast, during the dry season there was frequently insufficient water to be commercially useful for the mills.

To help overcome this problem, a number of *sluisbrug* (lock bridges) were built along the canals to help control water levels and so ensure regular and adequate water supplies to key users, particularly those needing water from the Molenvliet. The most prominent sluisbrug was the one at the eastern end of Noordwijk and Rijswijk, near Pasar Baru, seen here in this photograph. The original sluisbrug in this area apparently dated back to 1699 and was made of wooden beams. In the dry season, this lock bridge was closed so that the Gunung Sahari canal did not receive any water and all water could flow into the Molenvliet to drive the mills. In the wet season, it was opened so that excess water flowing into the Molenvliet could be re-channelled into the Gunung Sahari canal.

The lock bridge seen here was used until around the second decade of the 20th century when it was replaced by the current one. It is, of course, no coincidence that the Indonesian name for the road running south of this area is Jalan Pintu Air, which means "Water Door Street".

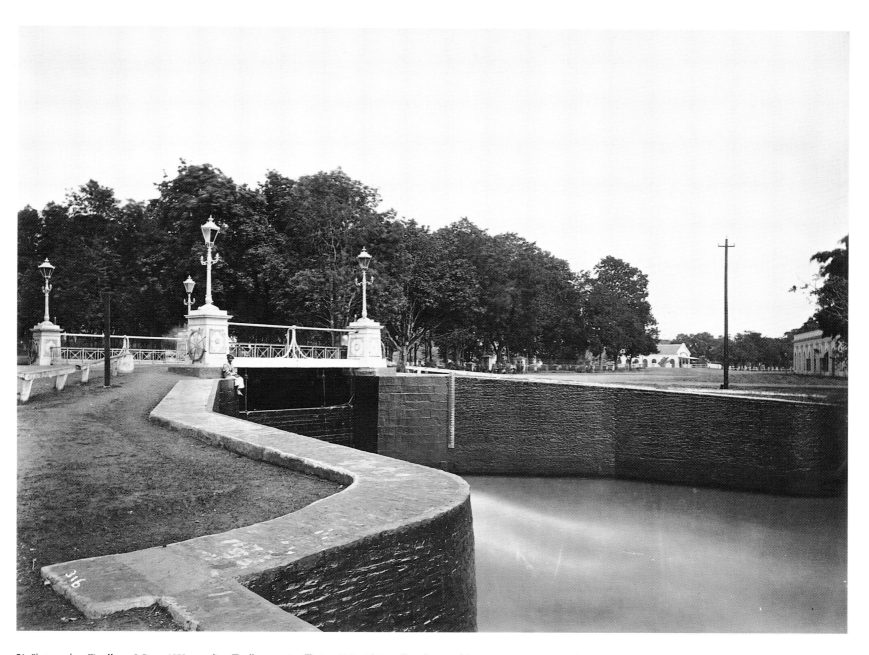

71. Photographer: **Woodbury & Page**, 1872 or earlier ▨ albumen print ▨ size: 18.3 x 24.1 cm ▨ collection of the Tropen Museum, Amsterdam.

The Convents of the Ursulin Sisters (1)

Catholic education for girls in Batavia was the initiative of Monsignor P. M. Vrancken who was appointed by Pope Pius IX to be Apostolic Vicar of Batavia in 1848. Monsignor Vrancken invited the Ursulin Sisters to establish a presence in Batavia, because of his concern for the low priority the Dutch authorities had long given to education in the Netherlands Indies, especially for girls. Seven sisters from the Ursulin order in Holland were chosen for the mission. They departed from Rotterdam on 20 September 1855 and arrived off the coast of Batavia on 5 February 1856 before disembarking two days later. Tragically, one of the seven, who had contracted a fever during the voyage, died only four days after arriving in Batavia at the age of 27.

A large two-storeyed house in Noordwijk (Jalan Juanda) opposite the official residence of the governor-general (*see pages 128-129*) was purchased for the Ursulin sisters for 30,000 guilders to be their convent and school and it can be seen here in the photograph on the opposite page. Dormitory facilities were also available for boarders.

The educational work of the sisters developed quickly. The dormitory received its first three girls on 13 May 1856 and the school was formally opened on 1 August 1856. By October in the same year, there were already 40 girls in the dormitory. By the end of 1856, there were 62 students in the kindergarten and 295 in the primary school. This was quite a burden for the six remaining sisters. Their heavy responsibilities, combined with the unfamiliar tropical surroundings and frequent epidemics of disease, placed great pressures on their health. Five of the original seven sisters died between 1856 and 1863; one of them was only 23 years old. Cholera and typhus were the main killers.

A second group of eight sisters arrived in Batavia from Holland in April 1858 after a voyage lasting almost six months during which time it was feared they had been lost at sea.

This photograph was taken from the interior courtyard of the convent facing south towards the convent's front buildings. The young girls in this view are wearing the dress of boarders at the convent's dormitory.

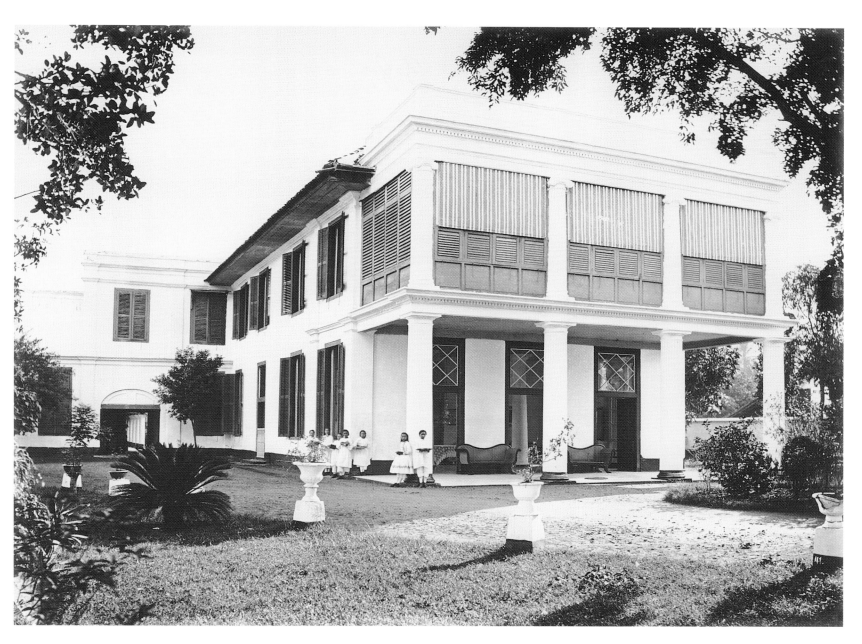

72. Photographer: **Woodbury & Page**, 1872 or earlier ■ albumen print ■ size: 18.1 x 24.1 cm ■ collection of the Tropen Museum, Amsterdam.

The Convents of the Ursulin Sisters (2)

Late in 1858 or early in 1859, several of the Ursulin sisters in Batavia began to work outside the convent in Noordwijk, especially among children of poor families and orphans. Initially, a house in the Pasar Baru area was used as a dormitory and classrooms, but this soon became too small and a move was made to a permanent residence at a house on Post Weg (Jalan Pos) beside the central post office on 18 January 1859. Henceforth, the original convent on Noordwijk became known as the Groote Klooster ("Large Convent"), while the new residence on Post Weg became known as the Kleine Klooster ("Small Convent"). The terms "large" and "small" referred to the number of sisters in each convent and not to the size of their respective grounds. For several decades there were tensions between the two convents with regard to the question of membership of the Unio Roma ("Union of Rome"). The Groote Klooster joined the Union of Rome in 1907, only seven years after it was initiated, whereas the Kleine Klooster did not join until 1939. Both of these Ursulin convents are still in operation today and the sisters are now predominantly Indonesians rather than Europeans.

This photograph of what may have been the entire staff and student body of the second convent was taken from Post Weg (Jalan Pos) facing the front of the house that became the Kleine Klooster. Extensions were added to the left and right of this house with a double-storey wing extending to the rear on the left-hand side and a chapel on the right-hand side which was completed in 1888. However, the basic form of this house with the columns and the roof line is still visible today.

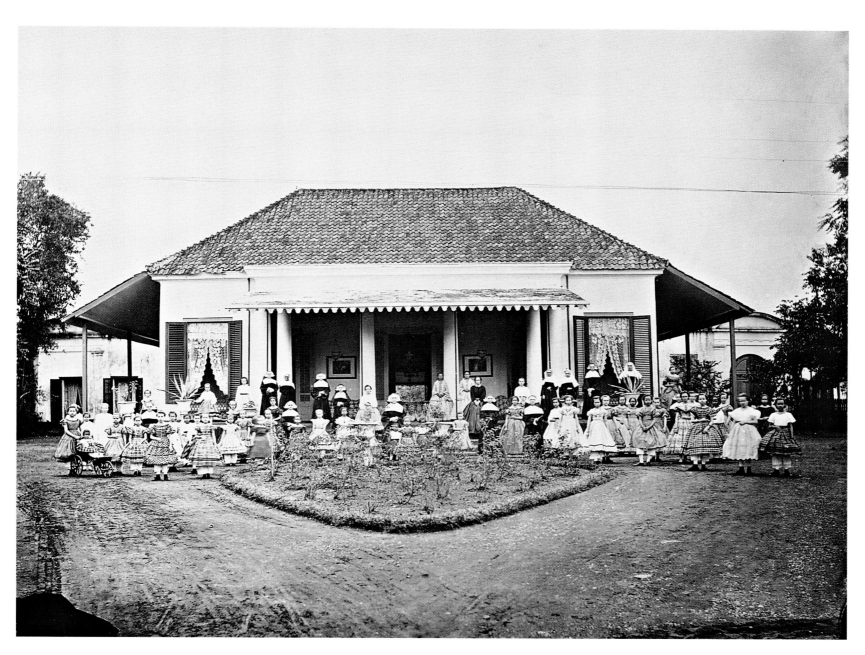

73. Photographer: **Woodbury & Page**, c. 1870 ■ albumen print ■ size: 18.1 x 24.3 cm ■ collection of the Tropen Museum, Amsterdam.

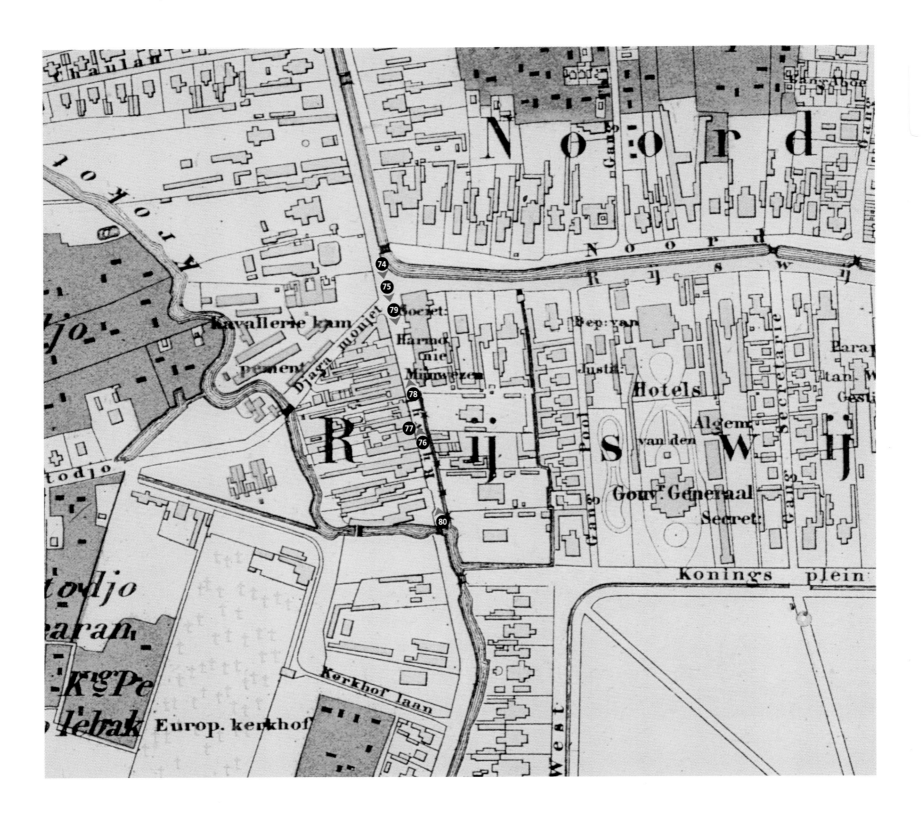

RIJSWIJKSTRAAT

Rijswijkstraat (sometimes also called "Rijswijk", but actually running south at right angles from the main Rijswijk thoroughfare) was known as the Frans Buurt ("French Neighbourhood") of Batavia, particularly during the second half of the 19th century, because of the large number of French shopkeepers situated there. As with nearby Rijswijk and Noordwijk, Rijswijkstraat was an elite European shopping area, and its status was no doubt also enhanced by the location of the Harmonie Society building on its north-eastern corner. Rijswijkstraat is now Jalan Majapahit.

The origins of Rijswijkstraat were military in nature and during the English interregnum (1811-16), officers' quarters, barracks and stables occupied the western side of the street. The English later sold the military buildings and the area gradually developed into a shopping district.

From the second quarter of the 19th century there was a noticeable French influence in Batavian arts and social life. This is primarily attributed to the popularity of French opera at the Schouwburg ("Theatre") (*see pages 208-209*) which was opened in 1821 and the large number of French actors and actresses who played there from the 1830s. Some of the actors gave French lessons and taught dancing, while a number of the actresses opened fashion boutiques.

The relatively small population of French citizens in Batavia seemed to be particularly enterprising, and not only in Rijswijkstraat. The French were also active as shopkeepers in Noordwijk and Rijswijk, as hotel proprietors, tailors, bakers and photographers. Newspaper advertisements from the second half of the 19th century highlighted the large number of French merchants and hoteliers in Batavia. Names such as Leroux, Pascal, Seuffert, Cressonnier, Combet, Bastiere, Giradeau and Rinchon were all prominent.

A Dutch visitor to the Netherlands Indies in 1862 noticed the rather odd situation where Dutch citizens were a minority among the European shopkeepers in their own colony and that the non-Dutch European population appeared to be more enterprising:

> Remarkable is also how many foreign Europeans [i.e. non-Dutch] are found among the tailors, watchmakers and shopkeepers etc. in our Indies harbours, which is partly the result of the difficulties which young Dutch citizens have to surmount to be able to establish themselves in the Indies. For the greater part, however, this is to be ascribed to the too little spirit of enterprise among our middle-class.[16]

Junction of Rijswijkstraat, Rijswijk and Molenvliet West

The junction of Rijswijkstraat, Rijswijk and Molenvliet West seen here was one of the most famous and most frequently photographed parts of Batavia with the Harmonie Society clubhouse on the left and the premises of the tailors Oger Freres on the right. This photograph is the earliest known view of this area, and probably dates to the period between December 1858 and May 1859 when Woodbury & Page operated a photographic studio on Rijswijkstraat beside the premises of the bakers Leroux & Co. (*see pages 154-155*).

The somewhat grainy texture of this image is due to it being a salt print rather than an albumen print. This means the glass collodion negative would have been applied to salted paper rather than paper coated with a mixture of albumen (i.e. egg whites) and ammonium chloride. Only two other early salt print views of Batavia are known to exist; these appear on pages 155 and 239 and probably date from the same period.

Salt prints were already well past their prime by the late 1850s, and it is strange that Woodbury & Page would have produced them at all. Both men were already familiar with the superior tonal qualities of albumen prints before they arrived in Java in 1857. Perhaps they were experimenting with different papers in Java's high humidity, or perhaps they had temporarily run out of albumen paper.

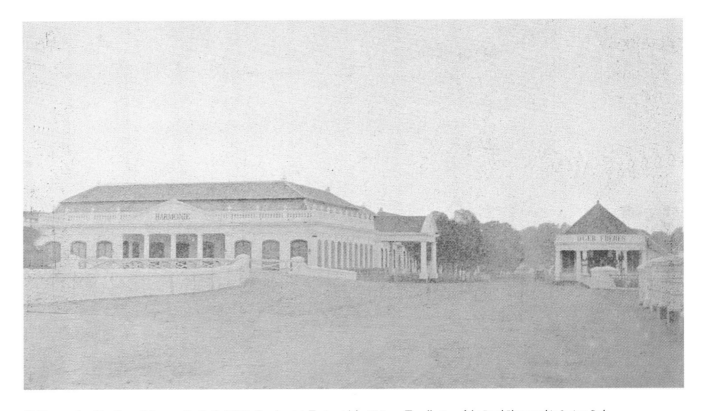

74. Photographer: **Woodbury & Page**, c. first half of 1859 ■ salt print ■ size: 14.6 x 22.2 cm ■ collection of the Royal Photographic Society, Bath.

Oger Freres on Rijswijkstraat

Situated on the north-west corner of Rijswijkstraat, the famous firm of tailors Oger Freres, seen here on the right, occupied one of the best and most visible sites in the entire of Batavia opposite the Harmonie Society and at the southern end of Molenvliet West. Oger Freres was founded in 1823 by two French brothers and made gentlemen's formal and casual attire of both a civilian and a military nature. They existed for over a century in the same location. An account of the firm in 1925 noted that Oger Freres:

> has been an unfailing barometer of the prevailing fashions in European male apparel. Decade after decade, these fashions have altered, and the clothes made there now are very different from those which the elite of the island wore when the business was founded by the two French brothers of its designation.[17]

The Nitour travel agency now occupies the Oger Freres site.

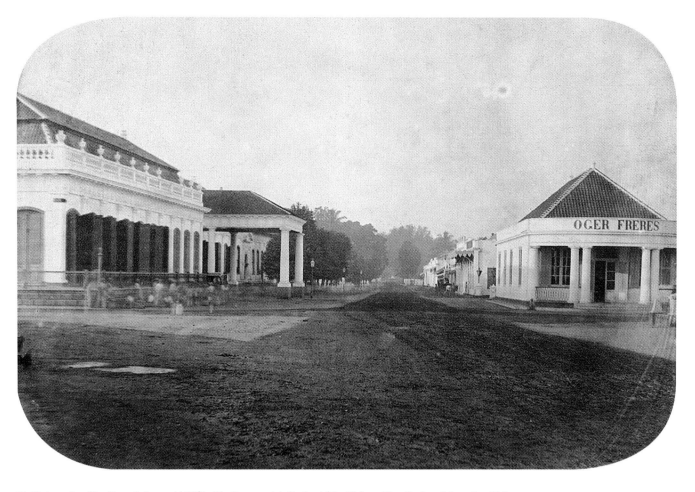

75. Photographer: **Woodbury & Page**, mid-1860s ■ albumen print ■ size: 14.2 x 19.9 cm ■ collection of the author, Melbourne.

The premises of Leroux & Co., bakers, Rijswijkstraat

One of the most famous firms of pastry-cooks and bakers in Batavia for many years was Leroux & Co. Jacques Leroux was first listed as a resident of Batavia in 1850 and from 1852 he operated with a partner under the name "Leroux & Berne" offering a wide variety of cakes, pastries and biscuits. From around 1856, the firm became Leroux & Co. It was an enduring business and still existed at the end of the 19th century.

Leroux & Co.'s retail premises were located on the western side of Rijswijkstraat and can be seen on the opposite page with what might have been be the full complement of the store's staff, both European and indigenous, posing together for this rare early photograph.

Woodbury & Page operated a photographic studio beside Leroux & Co.'s store from early December 1858 until the end of May 1859. It was probably during that short period that this salt print was taken, making it one of the earliest known topographical views of Batavia. The only other two known salt prints of Batavia, which most likely date from the same period, can be seen on pages 152 and 239.

This photograph was ambitious for its day because of the large number of people in front of the store who would have needed to stand very still for what would have been an exposure time of several seconds. Some of the blurred figures on the right suggest that not everybody was able to remain still for the required time.

Woodbury & Page's studio may have been the premises on the far right-hand side of this photograph where the two covered windows and door are visible. The studio could not have been on the left of Leroux & Co. because the firm of Brandon & Co. was located there, although it is not visible in this photograph (but can be seen in the view below).

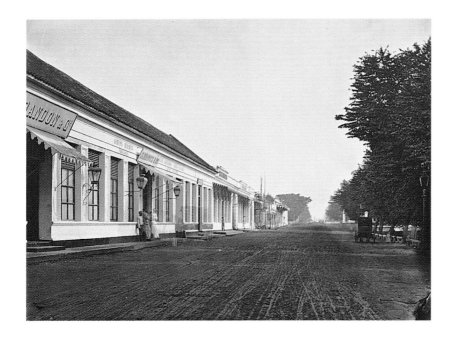

76. Photographer: **Woodbury & Page**, c. 1864-5 ■ albumen print ■ size: 18.1 x 23.7 cm ■ collection of the Tropen Museum, Amsterdam.

A slightly later view of Leroux & Co.'s premises than the one on the opposite page. Here we are looking north along Rijswijkstraat towards Molenvliet. Next to Leroux & Co. on the far left is the firm of Brandon & Co. which carried a wide range of merchandise including men's and children's shirts, shoes and slippers and Havana cigars and probably ceased operations around 1865.

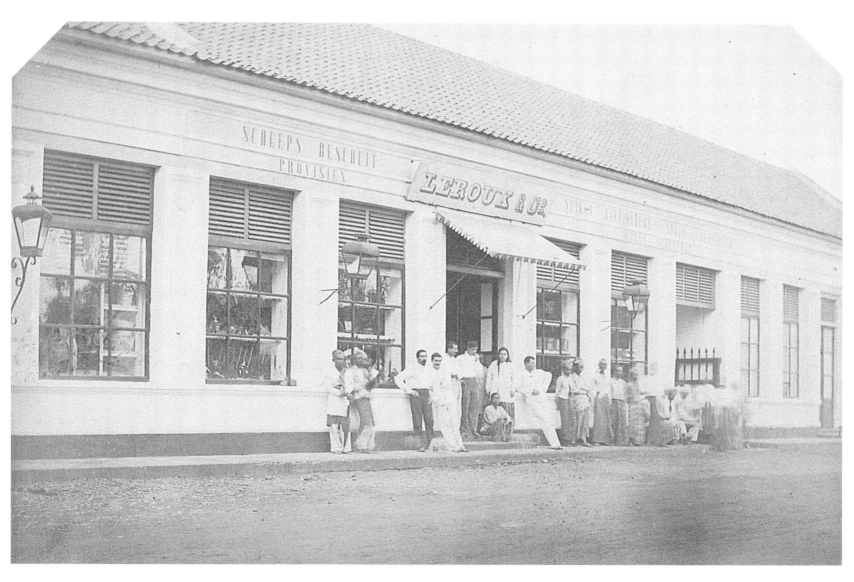

77. Photographer: **Woodbury & Page**, c. first half of 1859 ■ salt print ■ size: 14.0 x 20.9 cm ■ collection of the Royal Photographic Society, Bath.

Looking north along Rijswijkstraat

In this scene we are looking north along Rijswijkstraat towards Molenvliet. The Harmonie Society clubhouse is on the right-hand side. Notice also on the far right the man up the ladder extinguishing the gas lamps. This photograph, like the majority of photographs of the era, was taken in the early hours of the morning when the daylight was felt to be the most conducive to successful photography.

On the left is the firm of jewellers and watchmakers V. Olislaeger & Co., which was founded in 1850 by Victor Johan Olislaeger, probably a German.

An account of the firm published in 1909 observed:

Upon two occasions, in 1865 and again in 1895, Messrs. Olislaeger & Co. have been awarded the highest prize for a general exhibit of jewellery at the Batavia Exposition. The firm have been established for considerably over half a century; during this period they have built up a large and valuable trade, and their name is well and favourably known throughout the whole of Netherlands India. They are importers and retailers of jewellery of every variety, but their specialty is precious stones, of which they always retain a large stock, both mounted and unmounted. In addition, they are watch and clock makers, and deal extensively in silver plate and cut glass. For repairs, for making various settings and for fashioning different designs in gold and silver, they have their own workshops and a large staff of highly skilled native workmen under the supervision of a European manager and assistants.[18]

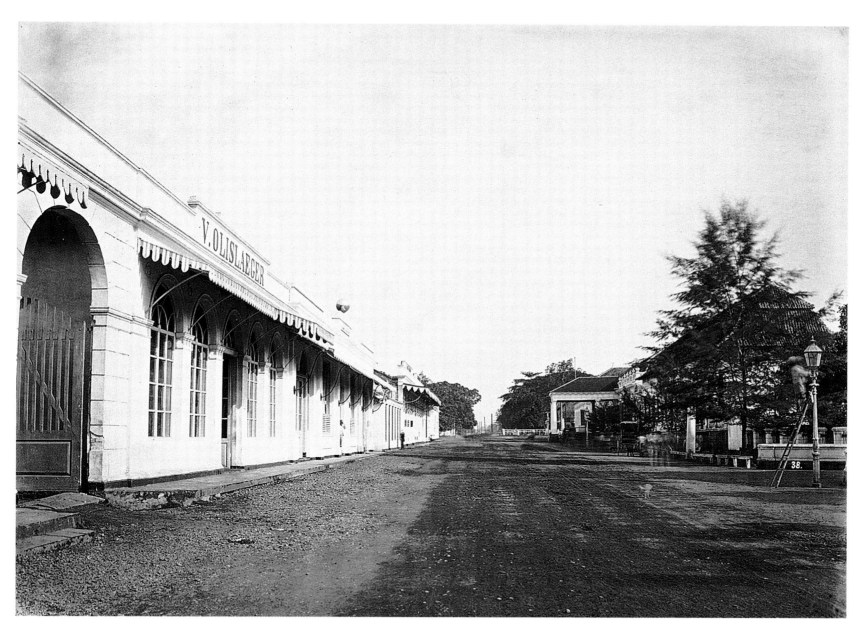

78. Photographer: **Woodbury & Page**, c. 1865 ■ albumen print ■ size: 18.2 x 24.1 cm ■ collection of the Tropen Museum, Amsterdam.

Looking south along Rijswijkstraat

In this view we are looking south along Rijswijkstraat towards Tanah Abang. The Harmonie Society can be seen on the left. On the right is the Apotheek ("Pharmacy") of Carel Gustav Werner Wilcke, who was first listed as a resident of Batavia in 1857 and who received his licence to operate as a pharmacist in the private sector on 4 April 1862. Both Mr. Wilcke and his pharmacy were last listed in 1872.

Next to the pharmacy we can see the store of G. Pouligner, which offered a diverse range of imported merchandise including perfumes, toiletries, clothing and cigarette paper although strangely no firm or man of this name appeared in the government almanacs in the 1860s or 1870s. Just along from G. Pouligner we can see the firm of opticians J. Duret, which was listed as operating between 1866 and 1888.

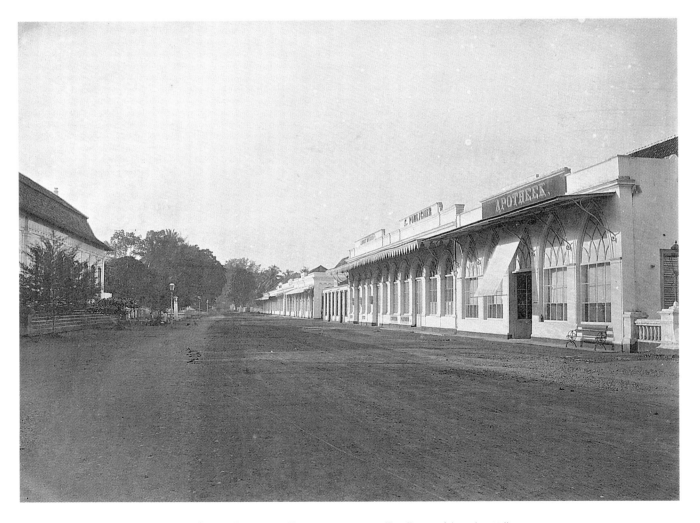

79. Photographer: **Woodbury & Page**, late 1860s ■ albumen print ■ size: 18.0 x 23.9 cm ■ collection of the author, Melbourne.

Looking north along Rijswijkstraat

This photograph looks north along Rijswijkstraat. It was probably taken just north of the junction of Rijswijkstraat (Jalan Majapahit), Koningsplein Noord (Jalan Medan Merdeka Utara) and Tanah Abang West (Jalan Abdul Muis). The shops of the "French neighbourhood" on the west side of Rijswijkstraat are visible in the centre between the trees. The southern end of Rijswijkstraat must have been residential in nature at this time as evidenced by the houses on both sides of the foreground in this picture. The entire western side of Rijswijkstraat (on the left) is now shops and commercial premises. All the buildings and homes on the eastern side (right in the picture) were demolished many years ago so that the road could be widened. The grounds now occupied by the state secretariat would be on the far right just out of view.

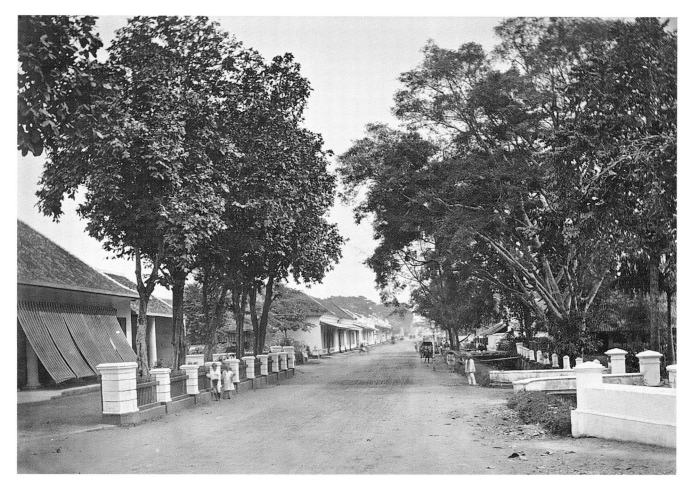

80. Photographer: **Woodbury & Page**, 1870s ■ albumen print ■ size: 18.4 x 23.3 cm ■ collection of the Museum of Ethnology, Rotterdam.

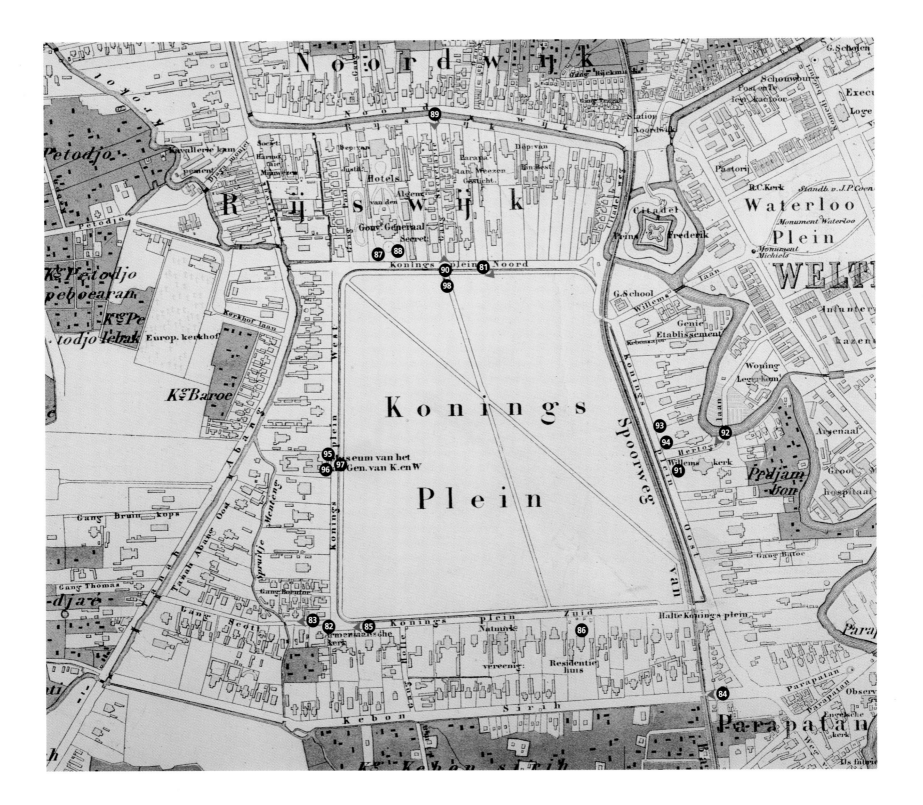

KONINGSPLEIN

What is now Medan Merdeka was in the VOC era referred to as Buffelsveld ("Buffalo Field"). In addition to the grazing of cows and buffaloes, a brickworks existed there until at least 1797. At the northern end, there may also have been the Buiten Ziekenhuis ("Outer Hospital"). In 1796 and 1804, military exercises were conducted on Buffelsveld.

In 1809, Governor-General Daendels named the plain "Champ de Mars" and decided it would be used as a military exercise field although at the time the area was still swampy and had an uneven terrain. In 1818, the Dutch Government renamed it Koningsplein ("King's Square"), a name which endured until the end of the colonial era. The building of homes around Koningsplein started in the same year, although at that time Rijswijk and, later, Noordwijk were still the residential areas of choice for the elite. It was not until after the middle of the 19th century that grand houses on spacious grounds began to dominate the four sides of Koningsplein and it became truly the most fashionable address in Batavia.

The photographers Walter Woodbury and James Page, founders of Woodbury & Page, spent five months boarding in a house on the southern side of Koningsplein from May to October 1857. Woodbury was very impressed by the area, as is clear from a letter to his mother on 26 May 1857 only eight days after arriving in Batavia. He noted:

> Koningsplein as it is called is the Hyde Park of Batavia and the residence of all the fashionables amongst them myself. This part of the town is a perfect paradise with banyan and coconut trees and other beautiful trees (planted some 40 years ago).

Other facilities found on Koningsplein over the years included a horse-racing track in the 1840s and 1850s, a velodrome around the turn of the 20th century and a hotel and amusement park in the 1920s. Visitors to Batavia frequently commented on the Koningsplein, but opinions were varied. In 1858, Weitzel clearly enjoyed himself there and commented:

> It [Koningsplein] bears its name correctly; because for its expansiveness, it is indeed a royal plain. The military sometimes undertake tests there with light artillery, without causing any anxiety to the occupants of the surrounding houses. A race course is fenced in there for the Batavia Racing Club and although it is quite large it is almost not noticeable. Koningsplein forms an irregular square and to walk around it, one must, when one does not want to tire oneself, take almost an hour. It is bordered by broad well kept roads planted with tamarind trees, along which one beautiful villa after another are linked together. The Koningsplein, that is to say the roads bordering it, is the beloved walking place of that part of the Batavia population living in its vicinity. On each beautiful afternoon, between half past five and half past six, here one meets many carriages, pedestrians and horse riders. With pleasure one moves in the middle of all that stir. The heat of the day has gone, the air has noticeably cooled off, and on the western horizon there is the beautiful glow of the already setting sun. New zest for living flows through you and you regret that the sudden invading darkness makes so soon an end to your joy.[19]

Looking across Koningsplein

This photograph was taken from Koningsplein Noord (Jalan Medan Merdeka Utara) looking across the north-eastern corner of Koningsplein to Koningsplein Oost (Jalan Medan Merdeka Timur). Visible across the plain in the background between the trees in the centre of the photograph is the dome of the Willemskerk (*see pages 176-177*) and just to the right of the church we can see what are probably the buildings of Weltevreden railway station which was opened on 4 October 1884 and is now known as "Gambir" station.

The small hut on the left-hand side of the photograph with the sign that reads: Petodjo Ijs ("Petodjo Ice") is selling ice made at the Petodjo ice-works, which were located on the southern side of Djaga Monjet (now Jalan Suryo Pranoto), on the western bank of the Kali Krukut. Batavia's first ice-works commenced operations in April 1870, on the eastern side of what is now Jalan Menteng Raya. However, as early as 1866, ice machines for household use were being advertised for sale by the firm of Van Vleuten & Cox at Pasar Pisang (*see pages 64-65*).[20] Although 19th century Batavia was not as hot as Jakarta is today, ice was no doubt a welcome source of cool relief for local residents and also a means of cooling the ice-chests in homes.

Not everyone was impressed by Koningsplein, and one visitor to Batavia in 1862 noted that:

New Batavia lies spread over such a large surface, and as such it is therefore somewhat uncosy. People cannot visit each other, except by carriage. The spacious construction may in that climate be beneficial for health, but according to me it lacks cohesion. Moreover, the spaciousness is here and there rather excessive. This among others is the matter with the Koningsplein. People assured me that this square is larger than the Champs de Mars in Paris and as large as the whole city of Utrecht and that one needs one and a half hours to walk around it. The plain is therefore almost interminable and may be most suitable for military exercises. But I believe that with the scarcity of arable land in the vicinity of Batavia, one should be able to make a much more profitable use of it; now only a small part has been used for a racetrack.[21]

However, a later guidebook from 1917 was somewhat kinder:

To a newcomer it is an unattractive open space of trapezium shape, with only a few trees and small patches of coarse grass. To the Batavians, however, its very barrenness seems to be its attraction, as thus the "refreshing wind blows unimpeded and the absence of vegetation ensures dryness of air." Here there gather in the evenings all the wealth and fashion of Weltevreden on horseback or in handsome equipages.[22]

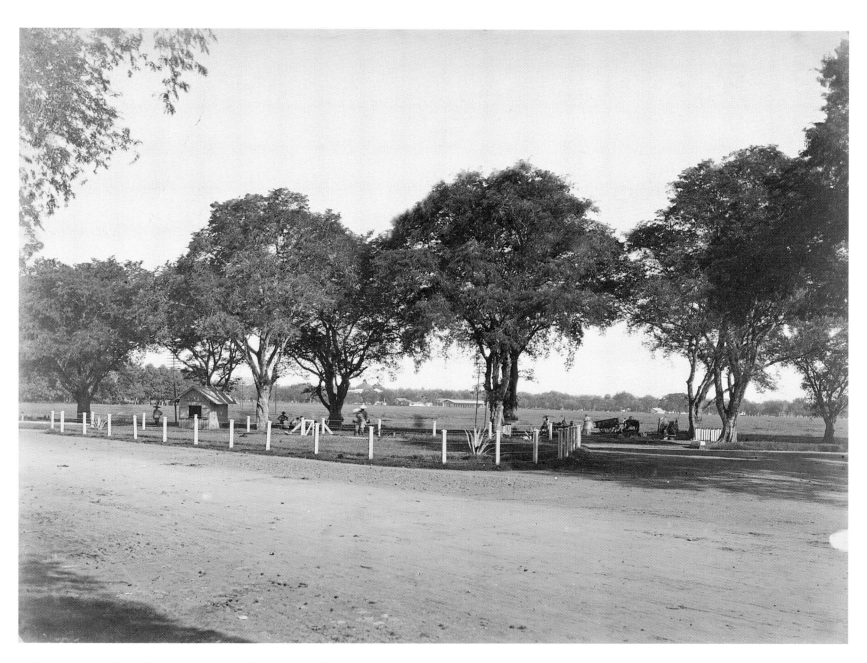

81. Photographer: probably **Woodbury & Page**, late 1880s ■ albumen print ■ size: 21.6 x 27.9 cm ■ collection of the author, Melbourne.

The Armenian church

A small number of Armenians were living in the Netherlands Indies from as early as the middle of the 17th century, mainly active in trade and commerce in the Moluccas. On 31 March 1747 the Dutch Government granted the Armenian community in the Netherlands Indies full rights as European citizens. The number of Armenians in the Indies appeared to rise towards the end of the 18th century. In 1831, a prominent Armenian merchant living in Batavia named Jacob Arathoon (or "Hakob Haroutyounian" to give him his Armenian name) built at his own expense a wooden chapel named St Hripsime (or "St Ripsima") in Batavia as a place of worship for Armenians. It was later renamed the Church of Holy Resurrection, but was badly damaged by fire in 1842 or 1844. Arathoon also financed the restoration of that chapel after the fire, before he passed away on 19 June 1844.

In 1852, the Armenian community in Batavia decided to build a more substantial church and sought donations from amongst its members. A large portion of the funds were donated by two wealthy Armenian sisters, Mrs Mariam (Mary) Arathoon (the widow of Jacob Arathoon) and Miss Tagouhie Manouk (or "Manuck"). The two sisters appear to have inherited wealth from a bachelor brother, Gevorg Manouk (or "Manuck"), who died in Batavia on 2 October 1827 "aged about 60" and whose tombstone in the European cemetery in Batavia (*see pages 244-245*) describes him as an "Opulent and Pious Armenian Merchant". Mrs Arathoon was also presumably left an inheritance by her late husband.

Also in 1852, the Haikian Miabanoethioen social foundation was established in Batavia "for the support of needy Armenian widows and orphans as well as crippled and stranded Armenians, and for the education of poor Armenian children". (Another source gives 1855 as the year of the establishment of the Haykian Congregation of Java

fund supported by the same two sisters "to help the poor Armenians living in Java".)

Construction work on the Armenian church in this photograph commenced on 1 May 1854 and the church was consecrated in 1857. It was called St Hovhanness Church in honour of Hovhanness Mkrtich. It was also known as the Church of St John. A marble monument to the two sisters was erected outside the church.

The church was located at the junction of Koningsplein Zuid (Jalan Medan Merdeka Selatan), Koningsplein West (Jalan Medan Merdeka Barat) and Gang Scott (Jalan Budi Kemuliaan). In modern terms, it could be described as having been located on the north-west corner of Jalan Thamrin and Jalan Budi Kemuliaan, just to the north of where Bank Indonesia now stands. Jalan Thamrin did not exist in the 19th century.

The two sisters also founded the Manuck and Arathoon School in 1855, presumably in Batavia, in addition to making bequests to help cover the running costs of the Armenian church and the needs of the priest. Mrs Mariam Arathoon died on 4 May 1864 aged 87.

In 1917, the Armenian Archbishop Torgom Manoukian wrote of the Armenian church in Batavia in his book *Hndkahayk* (Indian Armenia) that:

> the church was built of stone, on a gradual height, had a small cupola made of wood, ornamented porticoes on both sides and a building in the yard belonging to the church, where there were several rooms for the priest and the guests, and a large hall for the library.[23]

After the Second World War, many Armenians in Indonesia moved to the United States. In 1976, there were apparently only 300 Armenians living in the country.

The Armenian church was demolished in 1963 or 1964 after the Bank Indonesia building was completed.

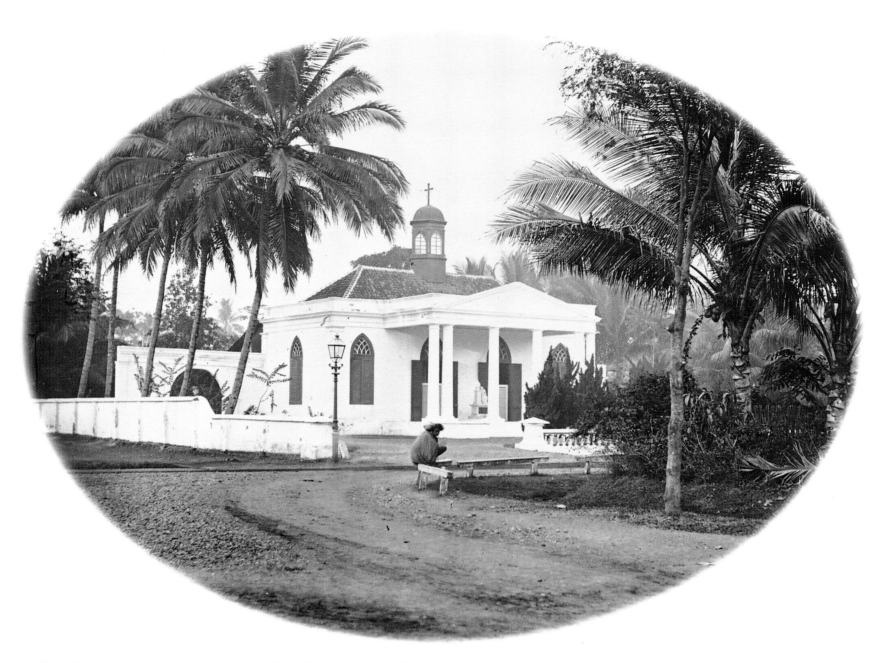

82. Photographer: **Jacobus Anthonie Meessen**, c. September 1867 ■ albumen print ■ size: 16.0 x 21.3 cm ■ collection of the Royal Library, The Hague.

Looking west along Gang Scott

Gang Scott (Jalan Budi Kemuliaan) was a popular residential area in Batavia for the well-to-do in the 1860s and 1870s and the shade-giving foliage of the many beautiful trees was, no doubt, part of the attraction of the area.

Gang Scott was named after an Englishman, Robert Scott, who was acting harbourmaster in Semarang before arriving in Batavia in 1820. He built the so-called Kampong Scott ("Scott Village") in this area on both sides of the street. His own house was located on the north-eastern corner of Gang Scott, possibly the area just out of view on the right-hand side of this photograph (although his house may have been demolished by the time this photograph was taken).

83. Photographer: **Woodbury & Page**, c. May 1863 ■ albumen print ■ size: 18.6 x 24.2 cm ■ collection of the author, Melbourne.

166

Kebon Sirih

The origins of Kebon Sirih (still Jalan Kebon Sirih today) can be traced back to the early 1830s when Governor-General Johannes van den Bosch (governor-general 1830–3) had this road built as part of what came to be known as the "van den Bosch defence line". Van den Bosch's plan was to encircle the southern districts of Batavia with a military fortification centred on the Prince Frederik Citadel (where the Istiqlal Mosque is today). Whatever military threat van den Bosch envisaged never materialized and around 1853, Kebon Sirih began to be settled as a residential district. Kebon Sirih was known at the time as "the new road behind Koningsplein"[24] and "the dilapidated defence line behind Koningsplein".[25]

84. Photographer: unknown, late 1890s ■ albumen print ■ size: 18.0 x 23.7 cm ■ collection of the author, Melbourne.

A private residence on Koningsplein Zuid

This photograph is looking in a westerly direction and shows the western end of Koningsplein Zuid (now Jalan Medan Merdeka Selatan). A private residence is visible on the left of the splendid tree in the centre of the photograph. On the right-hand side behind the tree, we can see the front of the Armenian church (*pages 164-165*). When this view was taken in the 1870s, this area was near the very southernmost end of Batavia's residential districts.

This photograph is interesting for comparing old Batavia with modern Jakarta because where both the house and the tree were located is now the northern end of Jalan Thamrin, which did not exist in the 19th century. If a photograph was taken from the same position today, the photographer would be standing on the eastern side of the northern end of Jalan Thamrin and looking across at the Bank Indonesia building. It was not until after Indonesian independence was proclaimed in 1945 that the narrow Gang Timboel ("Timboel Lane") was substantially upgraded to become the important thoroughfare that Jalan Thamrin is today. However, the beautiful tree in this photograph was probably cut down several decades before independence so that Koningsplein Zuid could be widened for the motor car.

The owner of the house on the left is not known. However, Woodbury & Page operated their first photographic studio in Batavia from 5 June 1857 to 15 October 1857 in a private residence owned by a Mrs Bain, a Scottish lady, who lived on the south side of Koningsplein near the Armenian church. Their studio must, therefore, have been very close to where this photograph was taken. It may even have been this house but, if so, it would only have been a coincidence, because neither Walter Woodbury nor James Page could have taken this view as they had both left Batavia several years beforehand. It is clearly the magnificent tree which captivated the photographer, not the neighbouring buildings.

85. Photographer: **Woodbury & Page**, 1870s ■ albumen print ■ size: 18.2 x 23.8 cm ■ collection of the author, Melbourne.

The house of the resident of Batavia

In the second half of the 19th century and the early 20th century, the senior European government official at provincial level throughout the Netherlands Indies usually held the title "resident" and was appointed by the governor-general. Smaller provinces were sometimes headed by an "assistant resident". A resident had full civil and financial authority in his respective province and was also in charge of the administration of the local police and the local courts. Residents were frequently chosen from among the officers of the Dutch military and the title resident equated with the army rank of colonel.

The number of European staff reporting directly to a resident at provincial level was always very small. It was Dutch policy that the indigenous population should be ruled as much as possible by their own leaders, but that these leaders would be responsible to the resident in his capacity as the senior provincial representative of Dutch authority.

In 1909, there were 17 residencies in Java, including Batavia, which was itself a separate residency. This photograph shows the official residence of the resident of Batavia which still stands today at No. 8 Jalan Medan Merdeka Selatan (previously Koningsplein Zuid).

After a restructuring of administrative zones during the latter years of colonial rule prior to the Second World War, this house became the official residence of the Governor of West Java. From 1945 until 1954, it was used by the Dutch High Commission and from 1954 until the present time, it has been owned by the municipal government of greater Jakarta. This building is now officially known as the Gedung Balai Kota Jakarta ("Jakarta Town Hall Building").

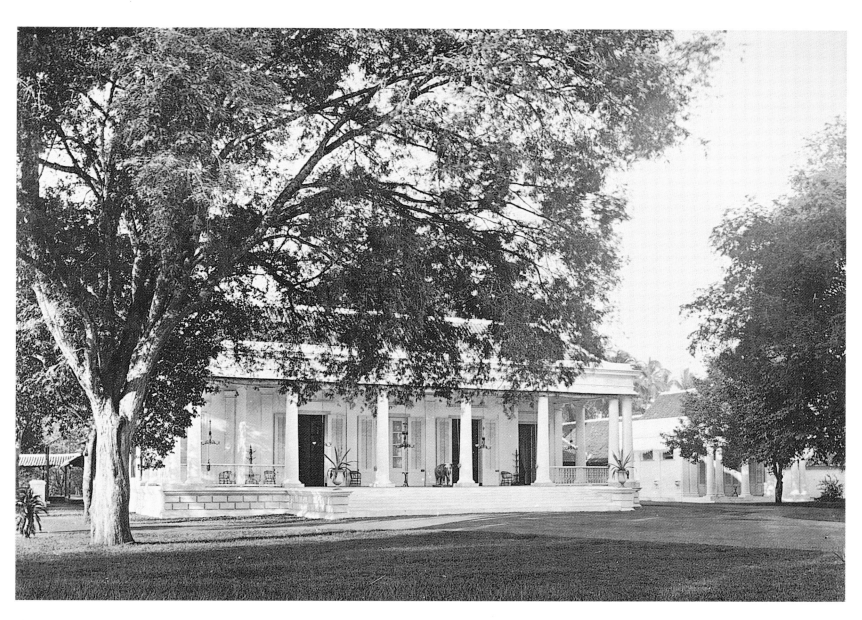

86. Photographer: **Woodbury & Page**, 1870s ▪ albumen print ▪ size: 19.1 x 23.4 cm ▪ collection of the Museum of Ethnology, Rotterdam.

THE GOVERNOR-GENERAL'S PALACE

In 1869, Governor-General Pieter Mijer (governor-general 1866-72) requested permission from the Dutch Minister of Colonial Affairs to build a new official residence for the governor-general because the existing residence on Rijswijk (*pages 128–129*) was no longer considered to be adequate. Approval was granted and the new palace was built in the backyard of the old official residence facing on to Koningsplein Noord (now Jalan Medan Merdeka Utara). It was completed in 1879. On 27 December 1949 Holland recognized the sovereignty of the Republic of Indonesia and the Indonesian flag flew here for the first time. This was highly symbolic given that the palace had been considered the centre of Dutch colonial power. It is now called Istana Merdeka ("Independence Palace") and is the official residence of the President of the Republic of Indonesia. The fine view of the front of the palace on the opposite page would have been taken not long after its completion in 1879.

87. Photographer: possibly the **Netherlands Indies Topographic Bureau**, 1880s ■ albumen print ■ size: 21.4 x 29.1 cm ■ collection of the author, Melbourne.

A view of the guard post located at the western entrance to the palace; it is still in use today. This is an unusual image because the guard post was rarely photographed.

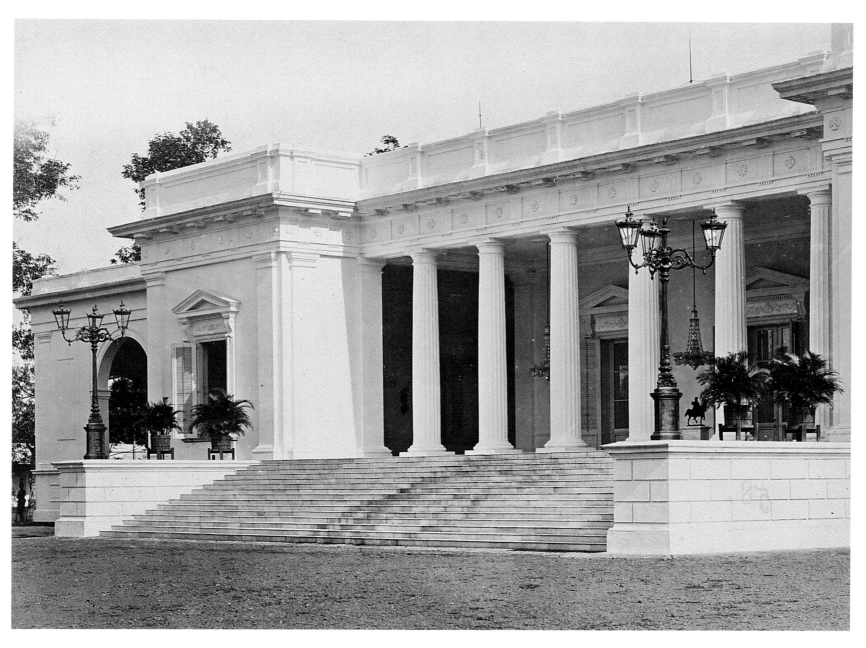

88. Photographer: **Woodbury & Page**, early 1880s ■ albumen print ■ size: 19.1 x 23.7 cm ■ collection of the author, Melbourne.

GANG SECRETARIE

Gang Secretarie ("Secretariat Lane" and now Jalan Veteran 3) was originally a square containing the offices of the state secretariat that served the governor-general. The state secretariat in this location may have dated back to the English interregnum (1811–16) given that it was situated beside the house that was used by Lieutenant-Governor Thomas Stamford Raffles as his official residence (*see pages 130–131*).

De Haan suggests that the original secretariat buildings were sold for demolition in 1825.[26] This street may then have been built in 1827 on the former site of those buildings. After Commissioner-General Leonard Pierre Joseph Burggraaf du Bus de Gisignies completed Daendels' "palace" at Waterlooplein in 1828 (*see pages 192–193*), the state secretariat was relocated to that building.

In the second half of the 19th century, Gang Secretarie was an elite residential area. The shopping districts of Rijswijk and Noordwijk were at the northern end of the street, while the Harmonie Society clubhouse was only a few hundred metres away and the governor-general's palace, completed in 1879, was not far behind the houses seen here on the western side of the street (on the left).

In the photograph on the opposite page we are looking north towards Rijswijk and Noordwijk. All of the houses on the left have been demolished and the land now forms part of the Presidential palace complex and related offices. The houses at the southern end of the eastern side of the street (on the far right of this photograph) also no longer exist and the supreme court building now stands on that site.

89. Photographer: **Woodbury & Page**, 1870s ■ albumen print ■ size: 20.3 x 25.4 cm ■ collection of the author, Melbourne (acquired from the Woodbury family).

This photograph is looking south along Gang Secretarie towards Koningsplein and was taken from Rijswijk. On the right, the home and studio of the photographers Woodbury & Page can just be seen behind the trees. The Bina Graha office of the President of the Republic of Indonesia is now located on that site.

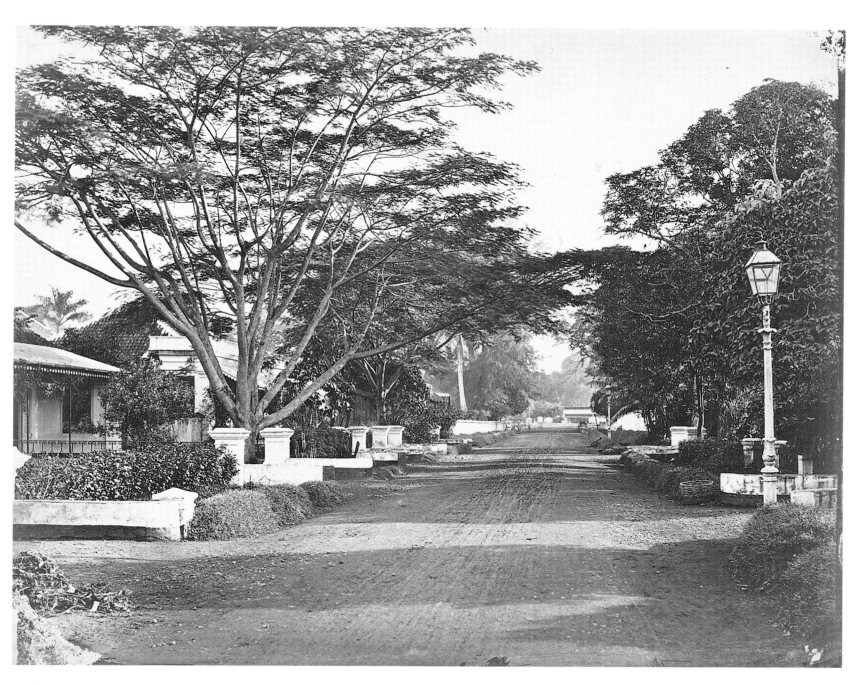

90. Photographer: **Woodbury & Page**, 1870s ■ albumen print ■ size: 19.1 x 25.4 cm ■ collection of the author, Melbourne (acquired from the Woodbury family).

THE WILLEMSKERK

On 20 December 1832, a committee was formed by the members of the Reformed and Lutheran congregations in Batavia to plan the building of a new church to serve both denominations in the newly developing southern environs of the city. The earlier Reformed church in the old city (which was located where the Wayang Museum now stands on Jalan Pintu Besar Utara) had been demolished in 1808 and the old Lutheran church that was located not far away, at the northern end of Jalan Kali Besar Timur, was demolished in 1835.

Indeed, the lack of a Protestant church in the south would have been quite striking during the 1820s and early 1830s. Other denominations with relatively small congregations had already established themselves there well before the Reformed and Lutheran communities came together in 1832 to plan their new church building. A Roman Catholic church could be found in the Senen area from 1810 before relocating to a new site at Waterlooplein in 1829 (*see pages 202–205*), while the English community in Batavia had a simple chapel in Prapatan from 1822, that was upgraded to a more permanent building by 1829 (*see pages 224–225*).

The Gambir area on Koningsplein Oost (Jalan Medan Merdeka Timur) was chosen as the site for the new church and the committee appointed an architect, J. H. Horst, to produce the design. The first stone was laid on 24 August 1835. The church was officially opened exactly four years later on 24 August 1839 and was named the "Willemskerk" after King Willem I of Holland. A fine organ which was installed in the early 1840s is still in use today.

The Reformed and Lutheran congregations held their services at this church on alternate Sundays until the two parishes were united in 1854.

The name of the church was changed to Gereja Imanuel ("Emmanuel Church") on 31 October 1948 and still bears that name today.

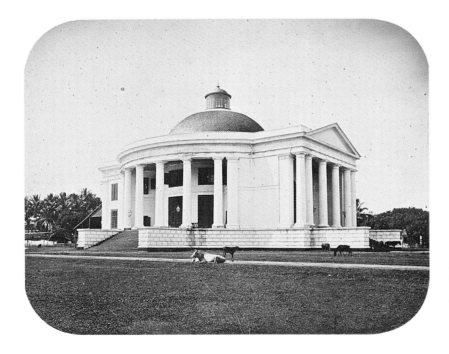

91. Photographer: **Woodbury & Page**, mid-1860s ■ albumen print ■ size: 19.0 x 23.6 cm ■ collection of the author, Melbourne.

The front of the Willemskerk can be seen on the right of this view and the northern entrance on the left. The photographer would have been standing on the corner of Koningsplein Oost and Pedjambon. The resting cow has been captured for posterity.

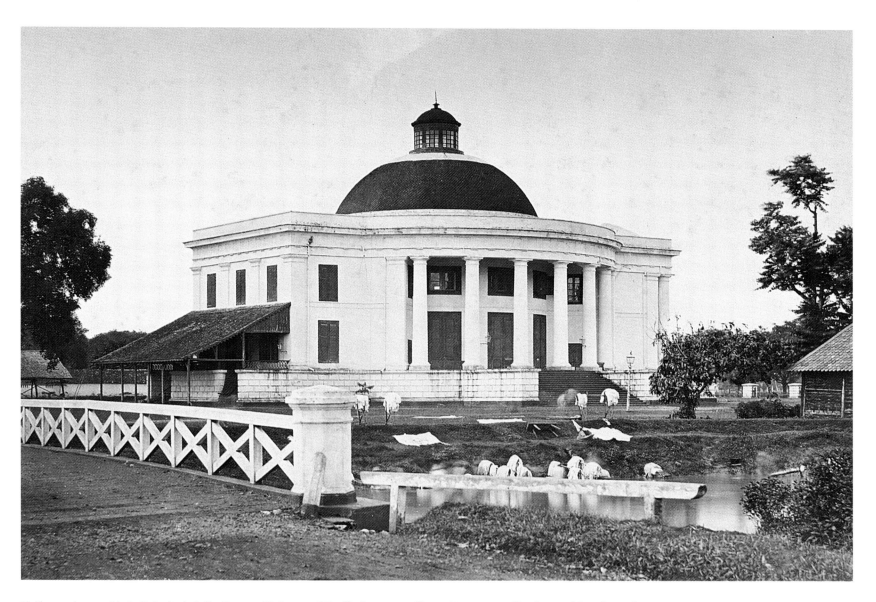

92. Photographer: possibly the **Netherlands Indies Topographic Bureau**, 1870s ■ albumen print ■ size: 20.0 x 28.9 cm ■ collection of the author, Melbourne.

The Willemskerk is seen here from near the bridge on Pedjambon which spans the Ciliwung River. The rear of the church is on the left and the northern entrance is on the right.

A private residence on Koningsplein Oost (1)

This photograph shows a grand private residence on Koningsplein Oost (now Jalan Medan Merdeka Timur). Wealthy European merchants and plantation managers built such imposing homes in the Koningsplein area from around the middle of the 19th century. Many of the owners would have had their trading, insurance and shipping offices in the vicinity of the Kali Besar district in the north of Batavia and would have commuted daily along Molenvliet.

This particular house belonged to a prominent merchant, John Montgomery Tannatt Pryce, who was born in Wales on 11 September 1819 and arrived in Batavia in March 1848, presumably choosing the Netherlands Indies because his older brother, David Tannatt Price (1815-1892) had already migrated to Batavia in September 1839.

John Pryce married Augusta Elisabeth Du Puy on 3 January 1850 and the couple had three sons between 1850 and 1854. However, Augusta died at the age of only 31 on 29 April 1855, possibly during the course of a voyage to Europe.

Pryce was married again on 30 January 1858, to Margaret Maxwell Maclaine; but just over three years later, on 5 February 1861, Margaret died at the age of 27 in Edinburgh, Scotland, the day after giving birth to a stillborn daughter.

Pryce married his third wife, Ellen Jane Rankin in 1867, but tragedy was again to strike and Ellen died at the age of 26 on 1 May 1872, probably in Wales, just after giving birth to their second daughter.

His fourth and longest marriage was to Eleanor Rogers, whom he married in 1873 and who would outlive him.

In 1853, Pryce founded the firm of "John Pryce & Co." of which he was senior partner. The firm was active as merchants, commission agents, ship suppliers and shopkeepers.[27] On 18 December 1855, Pryce took Dutch nationality. Other family members also joined the firm, including his older brother David; his youngest brother Thomas Pryce (1833-1904), who arrived in Batavia in 1854; and a brother-in-law Guillaume (Willem) Louis Jacques van der Hucht (1812-1874), who in 1848 married Mary Pryce (1830-1894) in Batavia. Thomas Pryce was a keen amateur photographer in the very earliest days of photography in Batavia and he may have taken lessons and bought photographic supplies from Woodbury & Page.

The firm of John Pryce & Co. evidently prospered, which helped finance a lavish colonial lifestyle for the family as members of Batavia's elite. It was also an enduring firm. All three of John Pryce's sons from his first marriage, John Edwin Pryce (1850-1927), David Tannatt Montgomery Pryce (1852-1920) and James Tannatt Pryce (1854-?) went on to work in the firm.

Eduard Julius Kerkhoven, a frequent guest at John Pryce's house during a visit to Batavia in 1860, observed:

> I am often at the home of Mr. Pryce. Last Tuesday, I was there at a reception where people danced. The homes are all splendidly lit here. You can understand how expensive that is. Thus I hear that the cost of maintaining Mr. Pryce's household is 2,000 Guilders per month. From Mr. Herman Holle, I hear that Mr. Pryce spends 3,000 Guilders per month.[28]

Nieuwenhuys suggests this house was located on Koningsplein West (now Jalan Medan Merdeka Barat).[29] However, captions at the KITLV in Leiden, to this photograph and the one on page 181 of the adjoining house, suggest the location was actually Koningsplein Oost.[30]

John Pryce died in England on 12 March 1893 at the age of 73.

His house has long since been demolished and a number of official buildings now stand in its place, including the headquarters of the Army pension fund "Yayasan Kartika Eka Paksi" and the national headquarters of the Scout movement.

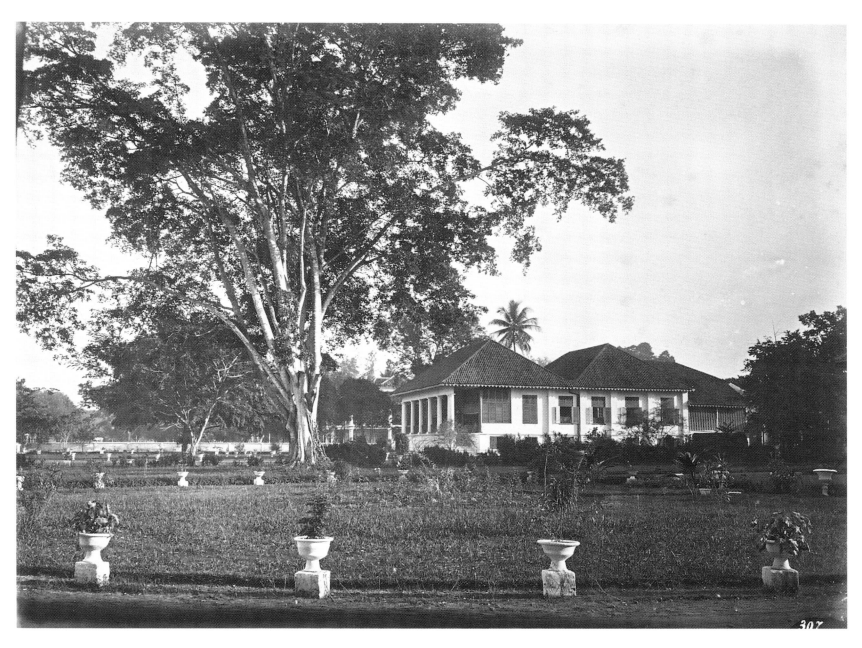

93. Photographer: **Woodbury & Page**, 1872 or earlier ■ albumen print ■ size: 18.3 x 24.1 cm ■ collection of the Tropen Museum, Amsterdam.

A private residence on Koningsplein Oost (2)

Another fine private residence located on the northern corner of Koningsplein Oost (now Jalan Medan Merdeka Timur) and Pedjambon (Jalan Pejambon). The Willemskerk was situated just across the road on the southern corner of the same two streets. The house in the photograph on page 179 was the northern neighbour of this residence.

Note the spacious grounds and the long sweeping driveway. It is presumably the owner of the house with his family and servants on the front verandah. A visitor to Batavia in 1862 was not impressed with the homes and gardens of the Europeans and noted:

> In the front of the houses there is usually a garden full with blooming shrubs and large flower pots, closed off by a flower-rich hedge from the public road. In the layout of these luxuriant gardens, and in the forms of the houses themselves, according to me, still much more beautification could be added, but in Java there is still a lack of capable architects and gardeners.[31]

This house has long since been demolished. Government buildings now occupy the site, including the Inspectorate General's Department of the Ministry of the Interior.

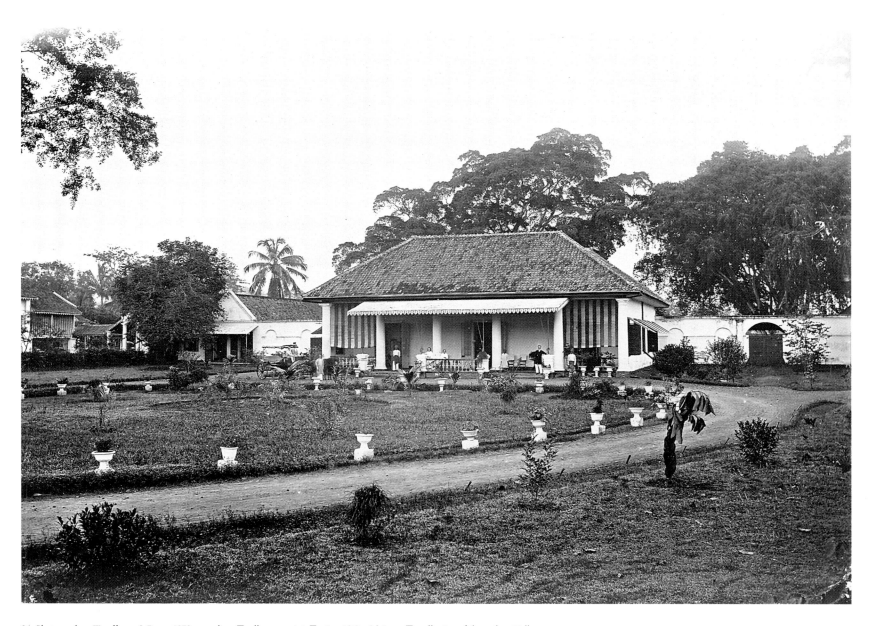

94. Photographer: **Woodbury & Page**, 1872 or earlier ▪ albumen print ▪ size: 19.9 x 24.7 cm ▪ collection of the author, Melbourne.

One of the earliest and most famous societies of higher learning anywhere in Asia was the Bataviaasch Genootschap van Kunsten en Wetenschappen ("Batavian Society of Arts and Sciences") which was founded in Batavia on 24 April 1778 and was dedicated to scientific and other intellectual pursuits relating to all aspects of the Netherlands Indies.

The Society's first driving force was Jacobus Cornelis Mattheus Radermacher (1741–83) who also founded the first Freemasons' lodge in Batavia (*see pages 206–207*). Radermacher was born in Holland and moved to the Netherlands Indies at the age of 16 to work for the VOC, initially as a junior merchant. He married well by taking as his wife Margaretha Verijssel, a step-daughter of Reinier de Klerk who was later governor-general from 1777 until 1780. Radermacher studied law in Holland between 1763 and 1767 before returning to the Netherlands Indies.

Reinier de Klerk had already become governor-general by 1778 when the Society was founded and he was very supportive of his son-in-law's efforts. De Klerk became the first director of the Society and encouraged all senior VOC officials to join. In its first year, there were 103 members resident in Batavia and another 77 in other parts of the colony in addition to several members in Holland. De Klerk also ordered government employees to collect animal, plant and mineral specimens for the Society.

In its earliest days, the Society also served an additional purpose of enabling well-educated Dutch men in the Netherlands Indies to meet together and to maintain intellectual links with the mother country, Holland, which like much of western Europe in the late 18th century was experiencing the "Age of Enlightenment". This was particularly important for younger men, such as Radermacher, who saw their time in the Netherlands Indies as only one part of their career and who intended eventually to return to Holland. The establishment of the Society was also a reaction against the persistent lack of intellectual activity among many of the older Dutch officials in Batavia at the time, who were presiding over the final years of decay and demise of the VOC and for whom science and higher learning appeared to hold little interest.

Radermacher was not only one of the founders of the Society but also one of its first major benefactors. He donated a large house on Kali Besar, six cupboards full of curiosities and two slaves. The house was located near where the old Bank Indonesia building stands today on Jalan Pintu Besar Utara and became the main meeting place for members.

The first five years of the Society under Radermacher were a period of great activity. The Society published its own journal; and articles included works on Javanese history, cultivation of agricultural products in Java, plant and animal life, tropical diseases, anthropology, geography, housing and the sewage system in Batavia. It was not without reason that this period was referred to as the "Indies Enlightenment".

Radermacher left Batavia in 1783, aged 42, to return to Holland but was murdered during a mutiny on the ship. With his departure and untimely death, the Society lapsed into a period of lethargy for almost 30 years until the arrival of Thomas Stamford Raffles as Lieutenant-Governor of Java in 1811. Raffles, an enthusiastic supporter of the Society, allowed it to use the government printing press, and also gave it access to the government library. He became Society President in 1813 and allocated space at the new Harmonie clubhouse (*see pages 122–125*) for the use of the Society and its library and collections. However, with Raffles' departure from Java in 1816, the Society again went into a period of decline.

The 1840s marked the Society's next "golden age", partly because of the leadership of clergyman and scholar Dr W. R. Baron van Hoevell, who had a strong interest in Javanese history and culture. On 5 October 1843, van Hoevell made a speech which would define the direction of the Society for much of the next century. He stated his belief that the work of the Society should be more focused to cover languages, ethnology, history and antiquities, with particular emphasis on Javanese and Malay linguistics and the preservation of antiquities. This approach implied that natural history would no longer be a field of study.

Van Hoevell's view was accepted and led to many years of active research and scholarship in the directions he proposed. The Society collected and researched early manuscripts from wherever they could be located in the Netherlands Indies, particularly Java. It also became the driving force behind the preservation and study of Javanese antiquities.

It was quite possibly the support and advice of the Society (probably van Hoevell in particular) which encouraged the Dutch government to fund Adolph Schaefer's expedition to photograph the bas-reliefs of Borobudur, Central Java, in 1845. Schaefer also photographed some of the Society's own collection of Javanese and Balinese statues in Batavia before he departed for Borobudur. One can almost imagine van Hoevell's excitement as he recognized how photography could be used to record and preserve his beloved Javanese antiquities. Schaefer's Daguerreotypes are the oldest-known surviving photographs ever taken in Indonesia.

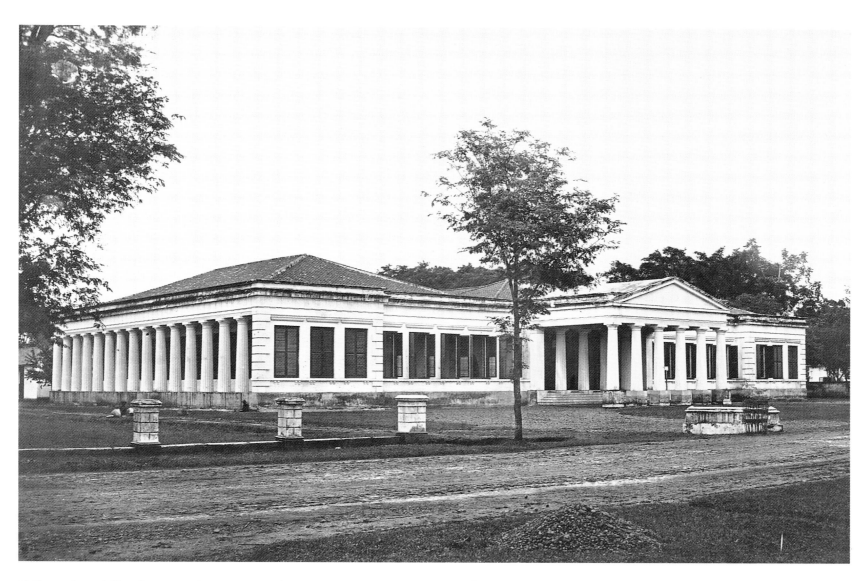

95. Photographer: probably **Isidore van Kinsbergen**, c. March 1868 ▪ albumen print ▪ size: 14.7 x 21.4 cm ▪ collection of the author, Melbourne.

This photograph was taken not long after the completion of the museum in 1868, probably around the time Van Kinsbergen was in Batavia in March of that year.

The second storey of the museum above the central portico was only added in 1913 to house some of the Society's rarest items and is still known as the "treasure room" today.

The Society, in conjunction with the Dutch government, also commissioned other photographs of antiquities in the early decades of photography, most notably in the 1860s and 1870s from the well-known artist, theatre producer and photographer, Isadore van Kinsbergen (1821–1905), whose involvement in photography dated back to at least 1855 when he was hand-colouring portraits taken by another photographer in Batavia, A. Lecouteux of Noordwijk.

In 1862, the Society commissioned van Kinsbergen to produce approximately 300 photographs as part of a plan to prepare an inventory of antiquities in Java. He was contracted to make six prints of each negative and had three years to complete the work for which he was to receive 37,500 guilders. He started in 1863 and finished the project well behind schedule. However, the Society was very satisfied with his high-quality photographs and gave him another commission in the 1870s.

Also in 1862, the Society decided to build a new headquarters which could serve as a museum to exhibit its collections and house its growing library. The museum, located on Koningsplein West (Jalan Medan Merdeka Barat), was completed in 1868.

In February 1950, the Society became the Lembaga Kebudayaan Indonesia ("Indonesian Cultural Institute") which was dissolved in 1962, when it came under the control of the Indonesian government on 17 September of that year. The Society's museum became known as the Museum Pusat ("Central Museum") until 28 May 1979, when it was renamed the Museum Nasional ("National Museum").

96. Photographer: possibly the **Netherlands Indies Topographic Bureau**, c. 1880 ■ albumen print ■ size: 15.6 x 29.0 cm ■ collection of the author, Melbourne.

This photograph provides an interesting view of the front of the museum with the shutters open and some of the collections visible. There were no iron bars on the windows in those days. The elephant statue can be seen in the centre.

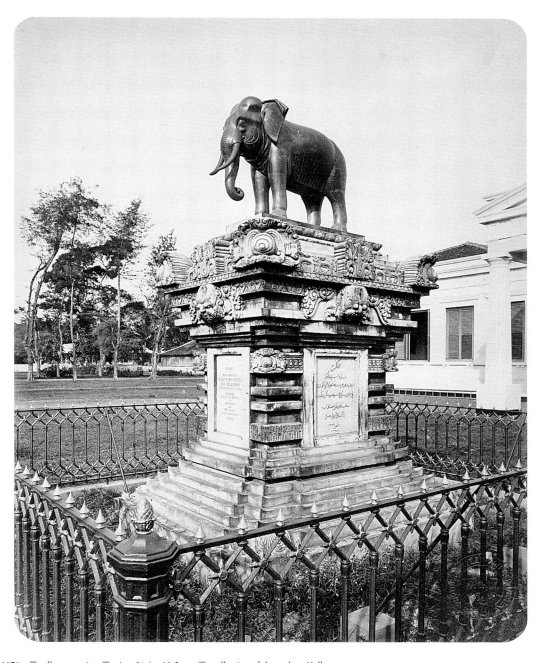

97. Photographer: **Woodbury & Page**, 1870s ■ albumen print ■ size: 24.6 x 19.5 cm ■ collection of the author, Melbourne.

This bronze statue of an elephant, situated in front of the museum, was presented by King Chulalongkorn of Siam (Thailand) in 1871 during his visit to the Netherlands Indies. With the prominence of the statue near the museum's entrance for so many years, the museum has long been unofficially known as the Museum Gajah ("Elephant Museum").

Artesian wells for drinking water

From the earliest days of Batavia in 1619, finding fresh clean drinking water had always been a problem. Ignorance about the benefits of boiling water combined with poor hygiene and the fact that the old walled city of Batavia was built on low-lying swampy terrain contributed to horrific death rates among citizens in Batavia in the 17th and 18th centuries. Even in the early 20th century, diseases caused by poor water quality, such as cholera, typhus and diphtheria, were still common. Cholera epidemics, in particular, caused great fear among Batavia's citizens.

One attempted remedy carried out by the government in the 19th century was the digging of artesian wells, and the first of these was completed in 1843 at the Prince Frederik Citadel which is now the location of the Istiqlal Mosque. Thirty years later, in the 1870s, another six artesian wells were dug, including the one on the northern edge of Koningsplein (Medan Merdeka) which we can see on the opposite page. As this photograph shows, the wells were built in an ornate and artistic manner which made them striking landmarks.

An 1891 guidebook to Batavia made the following observation regarding these wells:

> Mention should also be made of the artesian waterworks that supply Meester Cornelis [now Jatinegara] and the entire uptown and downtown areas [of Batavia] with good drinking water, free of charge. The water tanks and hydrants are distributed in such a way that the whole indigenous and European population profit from them. The pipe system for these waterworks is 90 kilometres long. Since these waterworks came into existence, the sanitary conditions of Batavia have improved dramatically.[32]

However, not everyone liked the taste of the water from the artesian wells. A resident of Batavia in the late 19th and early 20th centuries wrote:

> . . . well water, river water and rain water were used to make drinking water but this was far short of meeting the needs of the population. . . . Another source of drinking water was from artesian wells. But there weren't many people who liked to drink this because as drinking water, it didn't taste good and if you used it to make tea, the tea water went black. Because of this, river water was most commonly used by residents, even though to obtain artesian well water, pipes could be connected to the house The river water was cleaned in limestone filters by those who could afford them.[33]

By the end of the second decade of the 20th century, there were approximately 50 artesian wells in Batavia ranging in depth from 100 to 395 metres. Lack of water pressure in the pipes was a frequent problem and 14 pumping stations were built to try and improve the water flow. However, the wells continued to be inadequate as the population increased. Furthermore, there were many complaints (such as the one above) about the low quality of the water as well as the yellow colour, the unpleasant taste and the high temperature (around 39 degrees).

In October 1918, the city government of Batavia decided to construct new waterworks which piped spring water into Batavia from Ciomas, situated at the foot of Mount Salak near Buitenzorg (Bogor), some 270 metres above sea level. The new waterworks were completed by the end of 1922, after which date the ornate old artesian wells, including the one in this photograph, were sadly destroyed.

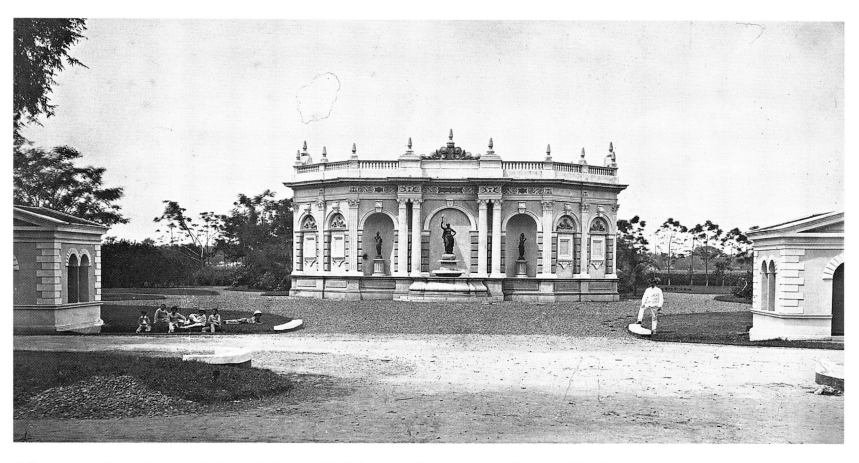

98. Photographer: possibly the **Netherlands Indies Topographic Bureau**, c. 1880 ■ albumen print ■ size: 17.2 x 31.6 cm ■ collection of the author, Melbourne.

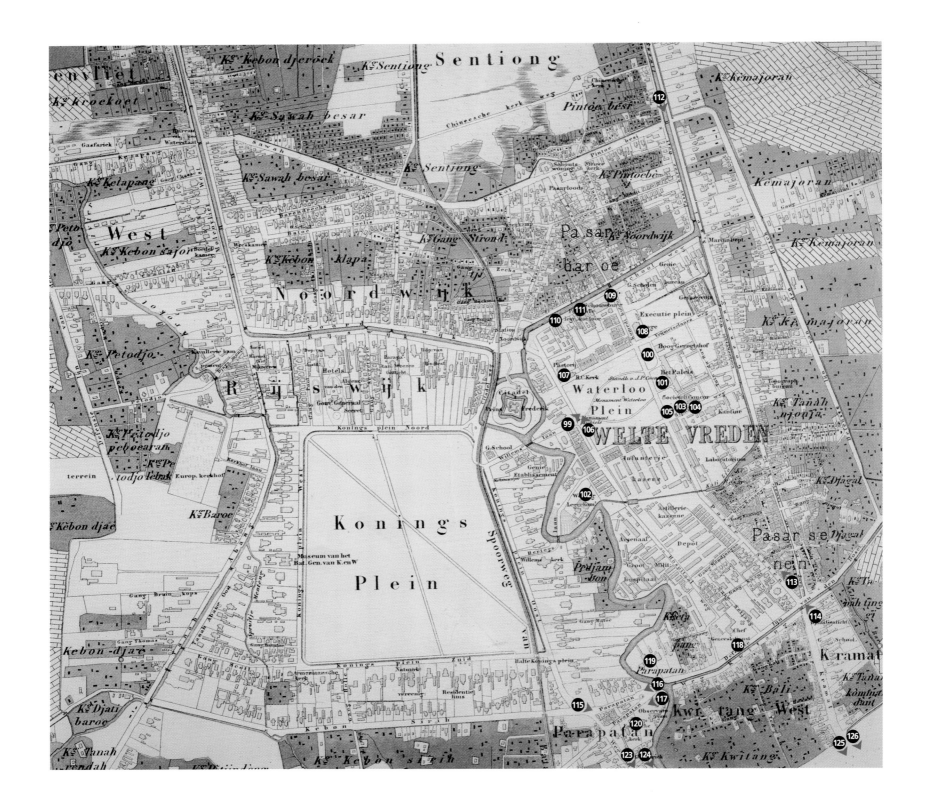

WELTEVREDEN AND THE SOUTHERN ENVIRONS

The most famous private estate to ever exist in Batavia was undoubtedly "Weltevreden", the centre of which was what are today Lapangan Banteng and the Hotel Borobudur complex. Not only did Weltevreden include one of the largest private homes ever built in Batavia, but its ownership by three different governors-general, who preferred to live and work at the estate rather than in the increasingly unhealthy walled city to the north, helped to move the administrative centre of Batavia gradually southwards to where it is today.

From around the 1750s or 1760s until perhaps the early 1930s, the name Weltevreden ("Well Contented") was widely used to refer to almost the entire of the southern districts of Batavia as distinct from the "old city" or "kota" in the north. This was despite the fact that the estate itself was sold to the government in 1808 and gradually broken up. A resident in Batavia in the second half of the 19th century, when the photographs in this book were taken, would commonly have thought of Batavia as being the old city "downtown" and Weltevreden as being the newer southern city "uptown". This distinction was actually formalized in 1905, when "Batavia" and "Weltevreden" were the names given to the northern and southern districts respectively of the newly formed municipality of Batavia.

The original Weltevreden estate was never as large as this usage implied, but it was still of grand proportions. By 1787, its borders were to the north what are now Jalan Pos and Jalan Dr Sutomo; to the east Jalan Gunung Sahari and Jalan Pasar Senen; to the south Jalan Prapatan, and to the west the Ciliwung River. It was an estate of considerable value even then and would be of immense value today, given that it comprised a significant part of what is now Central Jakarta, including Lapangan Banteng and the land now occupied by Hotel Borobodur, the old and new buildings of the Ministry of Finance, the Roman Catholic Cathedral, Gedung Kesenian, the Pasar Senen market, the Gatot Soebroto military hospital and the central post office.

Waterlooplein

The most prominent area of modern Jakarta that formerly belonged to the old Weltevreden estate is the square at Lapangan Banteng. From around the turn of the 19th century until the mid-1960s, this area had a strongly military character. For many years around the square, or nearby it, were located numerous barracks, the military commander's residence, a social club and houses for officers and a military hospital. The square was frequently used for military parades and in the early 19th century was known as Paradeplaats ("Parade Square").

In 1828, the Waterloo monument was erected on Paradeplaats to commemorate the defeat of Napoleon at the battle of Waterloo. This led to the new name "Waterlooplein" being given to the square which remained in use until after the proclamation of Indonesian independence in 1945. The Waterloo monument was a tall white column with a rather small statue of a lion perched on top that gave rise to Waterlooplein sometimes being called Leeuwinplaats ("Lioness Square"). The monument was subject to widespread derision and was the butt of frequent jokes, with many people claiming the lion looked more like a poodle. Nevertheless, it remained in place for more than a century until it was demolished during the Japanese occupation of 1942-5.

The military atmosphere of Waterlooplein was very evident to a visitor to Batavia in 1862:

> The environment of Waterloo square is almost entirely dedicated to the military population. The houses and residences for the officers, the barracks and military warehouses are found there, and on the square itself there is a very tidy officers club where on Sundays military music is played. Not far away I visited the military hospital which is excellent but still needs some extension.[34]

For several decades, from around the 1820s, Waterlooplein was the fashionable place "to see and be seen" in Batavia. Ladies and gentlemen from the upper echelons of society paraded around Waterlooplein in their fine horse-drawn carriages or on horseback (gentlemen only). Nobody walked because for Batavia's elite, it was not the "fashionable" thing to do.[35]

One observer in 1827 noted that on Waterlooplein:

> Once a week a beautiful military orchestra played in public, and this was a kind of Almeida in a nutshell, the beau monde appeared here not so much to hear the music, but to see and be seen. When the carriages stopped, the ladies had the most beautiful opportunity to exhibit their charms shining in the full glory of their beautiful gowns, for the greedy eyes of the gentlemen. These were mostly on horse and they tried to attract the eyes of the beauties by their elegant dressing as well as by showing their horsemanship, and the superior qualities of their Persian or bastard-Arab horses. The music is the word, but most of them went to the music not to divert their ears but their eyes.[36]

Waterlooplein maintained its military feel until well into the 20th century. Officers' houses existed on the southern flank of Lapangan Banteng, where the Borobudur Hotel now stands, and barracks were nearby, until the mid-1960s.

This photograph looks east across Waterlooplein. Daendels' "palace" (*see pages 192-193*), which is now occupied by the Ministry of Finance, dominates the picture. The tall white column of the Waterloo monument (erected in 1828) with the much ridiculed lion on the top is clearly visible in the centre. The supreme court building (completed in 1848) is partly obscured from view by the tree on the left. The strong glare of the rising sun on the right is an unusual feature of this photograph.

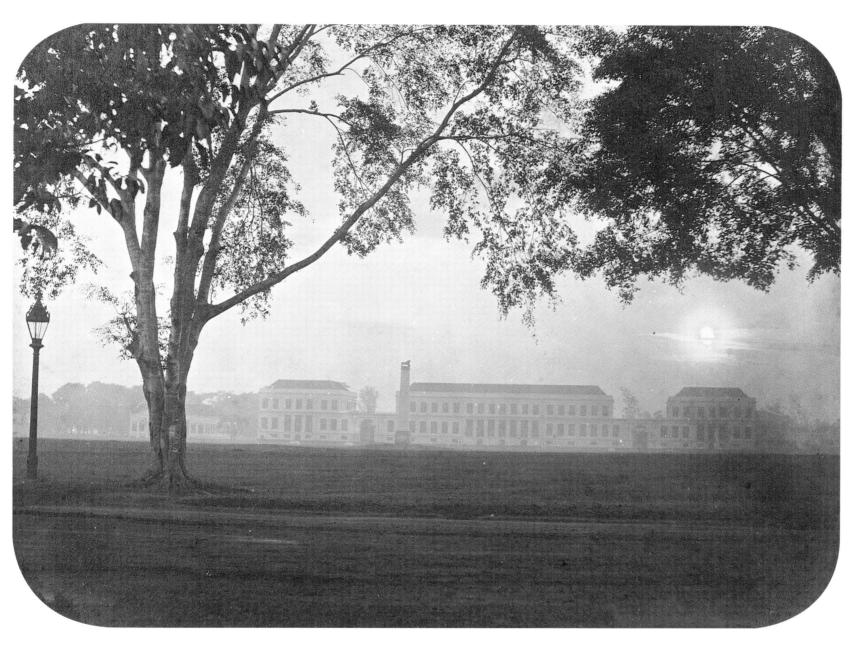

99. Photographer: **Woodbury & Page**, c. 1865 ▧ albumen print ▧ size: 15.4 x 20.4 cm ▧ collection of the author, Melbourne.

Daendels' "palace"

In 1808, when Daendels decided to destroy the old castle and walled city of Batavia in the north and formally move the administrative centre of the city southwards, he also needed to build a new governor-general's residence. In theory, governors-general had lived in the old castle of the VOC since the 1620s, but in practice from the middle of the 18th century they had started to live and work from private residences south of the walled city (such as at Weltevreden) because of the increasingly unsanitary conditions behind the walls.

On 7 March 1809, Daendels chose the eastern side of the Paradeplaats (now Jalan Lapangan Banteng Timur) as the site for his new "palace".

Never modest in his ambitions, Daendels undoubtedly envisaged building a grand palace that would be at the heart of the new Batavia he dreamed of creating. He instructed Lieutenant-Colonel J. C. Schultze (who had also designed the Harmonie Society clubhouse) to prepare the plans. The design called for a large central main building with wings on either side. The palace would be for the exclusive use of the governor-general. Government bureaus were to be in separate buildings and there would also be guest houses and a stable for 120 horses. Work proceeded quickly and foundations for the palace were built from the old materials of the demolished castle. By 1811, when Daendels was replaced as governor-general by Jan Willem Janssens (governor-general 1811), the main building and the wings were half finished.

However, for Janssens, completing the palace was not a priority given that an attack on Batavia from British forces was imminent. Instead, he had a simple thatch roof placed on top and then no further work was carried out for 15 years. Even during the English period (1811-16), the energetic Lieutenant-Governor Thomas Stamford Raffles saw no reason to continue with its construction, preferring to live in Rijswijk (*see pages 130-131*).

De Haan notes that a poet from the time described the decrepit and partly completed building in quite mournful tones:

Now it lies there forsaken and dirty
And in the front hall an owl is lost in reverie.[37]

In 1826, Commissioner-General Leonard Pierre Joseph Burggraaf du Bus de Gisignies ordered his chief engineer, Tromp, to finish the building to house government bureaus that were then badly accommodated in other parts of Batavia. Construction was finally completed in 1828, some 19 years after it began, but the building was never used as a governor-general's palace as Daendels had originally intended. In 1835, the lower floor housed the post office, the state printing office, the supreme court and the general clerk's department.

A visitor to the building in 1862 was not impressed with its spartan interior decor and noted:

Internally, in the offices not the least touch of luxury or splendour is found, and everything is arranged in the least expensive way. In the large meeting room of the Council of the Indies hangs a row of portraits of the successive administrators of the Netherlands-Indies, which are most important from an historical point of view, but in general have very little artistic value, while the hall itself should have had better furniture and decoration.[38]

This photograph looks in a southerly direction across the front of Daendels' "palace" which still stands today and is now used as the headquarters of the Indonesian Ministry of Finance. The white-columned building on the left housed the supreme court from 1 May 1848, but is no longer in use, while the statue of the founder of Batavia, Jan Pieterszoon Coen, standing on a pedestal (*see page 194*), is visible on the far right.

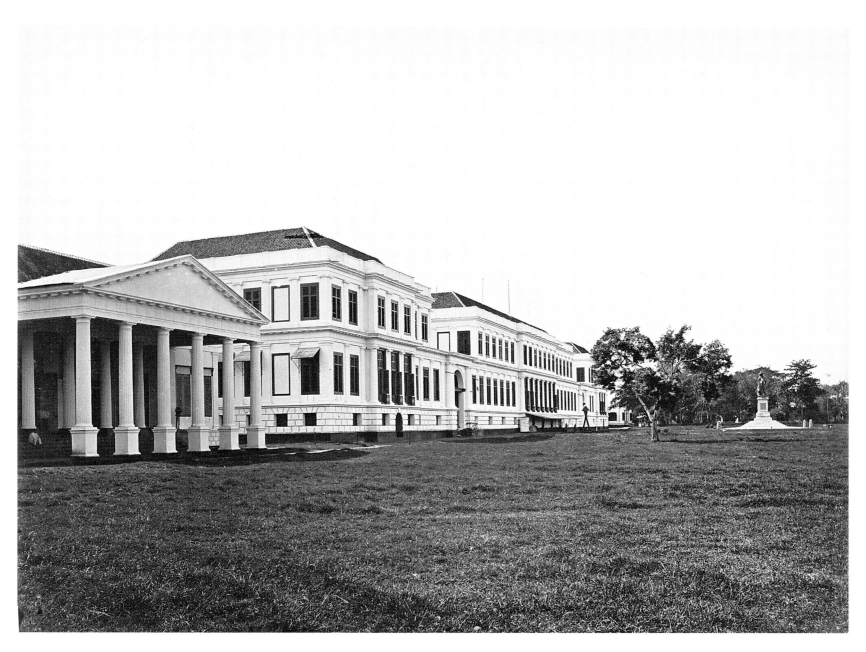

100. Photographer: **Woodbury & Page**, c. 1880 ■ albumen print ■ size: 18.9 x 24.1 cm ■ collection of the author, Melbourne.

The Coen monument

The Coen monument was located in front of Daendels' "palace" on Waterlooplein (Lapangan Banteng). It was erected in honour of Jan Pieterszoon Coen, founder of Batavia in 1619 and governor-general 1619-23 and 1627-9.

The first stone for the monument was laid in 1869 by Governor-General Pieter Mijer (governor-general 1866-72), probably to coincide with Batavia's 250th anniversary.

However, the statue was not officially unveiled until seven years later on 4 September 1876. The European community apparently feared that a statue of Batavia's first colonial ruler would invite a backlash from the local population. However, they need not have worried because no such backlash materialized, or at least not until the monument was torn down on 7 March 1943 during the Japanese occupation.

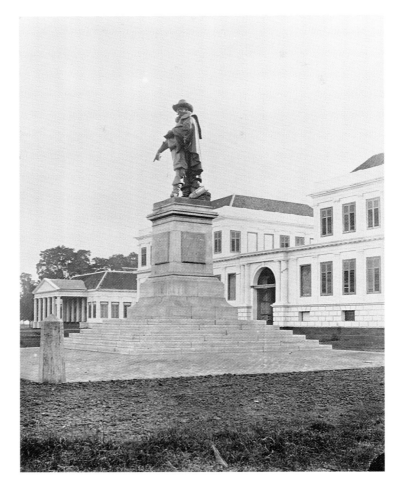

101. Photographer: **Woodbury & Page**, 1880s ■ albumen print ■ size: 24.0 x 18.5 cm ■ collection of the KITLV, Leiden.

The military commander's residence

In 1828, the official residence of the Dutch military commander was sold to the Catholic church. An elegant new official residence (*seen below*) was then built nearby on what is now Jalan Pejambon, probably in the early 1830s. This area later became known as Hertog's Park ("Duke's Park") after Duke Bernhard of Sachsen-Weimar-Eisenach (1792–1862) who served as army commander from 1849 to 1851.

During World War I, the Military Command was moved to Bandung and from 1918, this building was used as the headquarters of the newly formed Volksraad ("People's Council") which advised the governor-general. It still stands today as Gedung Pancasila ("Pancasila Building").

102. Photographer: **Woodbury & Page**, 1870s ■ albumen print ■ size: 20.4 x 27.1 cm ■ collection of the author, Melbourne.

The Concordia Military Society (1)

Batavia had two famous social clubs in the 19th century; namely, the Harmonie Society on the corner of Rijswijk and Rijswijkstraat (*see pages 122-125*) and the Concordia Military Society on Waterlooplein. The Harmonie Society was the older of the two having been established late in the 18th century, while the Concordia followed in 1833 although it did not have its own clubhouse until 1836.

Already from 1806 to 1809, there had been a coffee shop for military officers on the eastern flank of Paradeplaats (later renamed "Waterlooplein"), but it was demolished in 1809 to make way for Daendels' "palace" (*see pages 192-193*).

Nevertheless, officers still felt the need to have their own social club and in 1833 a small building was found for that purpose in the Waterlooplein area. The new Concordia quickly became popular, and non-military personnel were also permitted to join. The club started in a small way, but appeared to meet the needs of the time:

> Because of the little available space and the modest means of the club, there was no way of holding expensive festivities or gatherings on a large scale. Nevertheless, the purpose of the club was fully achieved, because it enabled a cosy get together, where a nice atmosphere reigned, so that the friendly interaction between military officers and civilian citizens was strongly stimulated.[39]

The need for a larger, more permanent clubhouse was quickly recognized and with government assistance a site on the southern end of Waterlooplein Oost (Jalan Lapangan Banteng Timur) was secured. Government approval for the new club building was granted in October 1835 and the official opening took place in 1836. The Concordia quickly became one of the main centres of social activity in Batavia. Its prime location at Waterlooplein almost guaranteed its success.

The early 1860s marked the beginning of a golden age for the Concordia that would last almost until the end of the 19th century. It was an era of grand balls, festivities and receptions that were known for "tastefully decorated rooms and the neat gowns of the ladies".[40]

In mid-1874, a renovation and extension programme was carried out on the Concordia club building, while in 1889 and 1890 a major remodelling took place. A ball was held on 24 June 1890 to mark the completion of the newly remodelled building seen here in this photograph. However, the tradition of lavish balls and splendid parties did not survive the end of the 1890s, and the 20th century marked a gradual decline in the status of the club.

After Indonesian independence, the Concordia building became the first headquarters of the Dewan Perwakilan Rakyat (Indonesian Parliament), until the current parliament building was completed in the 1960s. The Concordia building was subsequently demolished and Ministry of Finance offices now stand on the site.

103. Photographer: **Woodbury & Page**, early 1890s ■ albumen print ■ size: 18.5 x 23.6 cm ■ collection of the author, Melbourne.

The Concordia Military Society (2)

After 1861, mirrors and chandeliers decorated the walls of the Concordia and marble statues were placed in the corners of the ballroom seen here in this photograph. Gas lighting was installed in 1864.

In the 1860s, a tradition began of holding balls every two months, with the club beautifully decorated. Sometimes, fireworks were also organized. Dr Jan ten Brink gave the following description of a Concordia ball in 1868:

> . . . Around eight o'clock in the evening—it was again Saturday—an uninterrupted row of carriages and bendies drove to Waterlooplein. The Concordia Club offered its members and their ladies a dance. Always grand, there seemed to reign a great excitement among the beau monde of Batavia who were keen to enjoy the attractive, although not always new delight of a ball. The spacious front gallery of the club was already full with gentlemen who carefully put on their spotless white gloves and were ready to take in the arriving ladies. Soon the bloom of the beautiful world appeared and went inside on the arm of the attentive commissioners or helpful second lieutenants. The ball room was something larger than the most spacious pendopo of the most prominent mansions. It was a gigantic marble hall with glittering crystal chandeliers and side galleries which took the fresh cool evening wind inside. The band played its joyful sounds and at each moment beautifully attired dancers entered the hall.[41]

Grand costume balls became a feature of Concordia. The first was held in July 1883:

> The Batavia patricians regularly took part in these costume balls and ordered direct from Paris, London or Brussels the most beautiful costumes costing hundreds of guilders.[42]

The costume ball of July 1884 was particularly memorable:

> Days of preparations had made that festivity into the most successful, the most artistic of the whole year. The halls were decorated by the artistic hand of Van Kinsbergen in a fairy tale like way with rare plants, flowers and soft coloured gauze veils. Hidden lights were placed among the rock work and mirror glass gave a fantastic shine to the richly decorated halls, while in the middle of the large ball room a fountain of pure Eau-de-Cologne splashed down, throwing its sweet smelling spouts without pause. People also danced in the garden which was lit with hundreds of lanterns, and unforgettable was the sight of those whirling glittering costumes on the dance floor, bathed in the fairy tale like glow of Bengal fireworks in the colours of the rainbow.[43]

Early in the 20th century, this ballroom was apparently used for roller skating on the second Sunday of every month.

104. Photographer: **Woodbury & Page**, 1870s ■ albumen print ■ size: 20.8 x 26.4 cm ■ collection of the author, Melbourne.

The Concordia Military Society (3)

In 1857, the garden seen here in front of the club building was opened for members and Saturday evening garden concerts at the Concordia became one of the main social functions for the elite of Batavia's society. Concordia had long been popular for its music—not just military music, but also works by popular composers such as Strauss, Offenbach, Verdi and Donizetti.

> The concerts of the staff music always held a great interest, not only for the members of the club, but actually the whole of Batavia. The fame that the "Concordia" enjoyed was for the greater part because of the excellent music which was played there.[44]

A feature of the concerts was that not only that Concordia members could enjoy them, but that non-members could also listen to the music from beyond the boundaries of the club. Some were on horseback and others stood on Waterlooplein or on the roads surrounding the club. The term "nontonner" (spectator) was used to describe this practice.

After the bandmaster and his men had presented a most popular opera, for example: Verdi's "La Traviata" or Donizetti's "Lucia di Lammermoor", a thundering applause was heard—not only from the garden but also from far away. The bandmaster, who knew with whom he was dealing, bowed and out of politeness thanked the audience, not only the members in the lighted garden, but also his other admirers in the nightly dark of Waterlooplein.[45]

In a centenary publication in 1933, long after the Concordia had past its peak, the Board of the club wrote nostalgically about the height of the club's popularity in the latter decades of the 19th century. It noted:

> . . . the cosy Wednesday evenings for young and old; and who was absent on Saturday evenings at the garden concerts? There one's acquaintances were always found together; many members with their families had their fixed places, one knew exactly where to find them and those spots were respected for the good comradeship which ruled there. Those Saturday evenings were "taken into account" by Batavia, in the sense that performances, concerts etc. where much of the "Concordia-public" was expected, were preferably not given on Saturday evenings.[46]

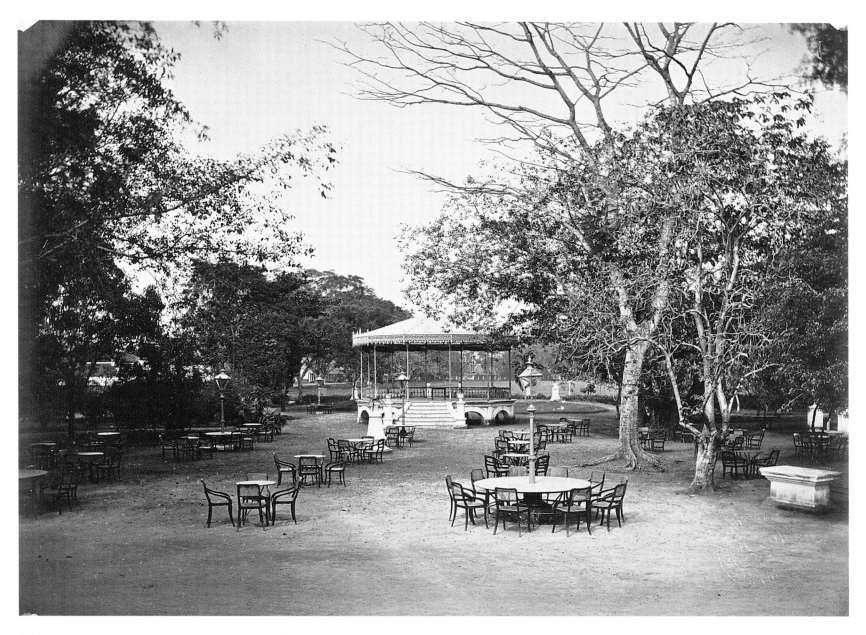

105. Photographer: **Woodbury & Page**, c. 1870 ■ albumen print ■ size: 20.2 x 26.8 cm ■ collection of the author, Melbourne.

The Roman Catholic church (1829-80) and the Michiels monument

Portuguese influence during the 16th century first brought Catholicism to several islands of what is now Indonesia, particularly to Ambon and Flores. However, Catholicism was banned in all VOC territories by the staunchly Protestant Dutch during the entire VOC period, which lasted from 1602 to 1799. The turning point came in 1806, when Louis Bonaparte was made king of Holland by his brother, the Emperor Napoleon, and he decreed that he would give equal protection to all religions. This paved the way for the formal entry of the Catholic church into the Dutch colonies.

On 8 May 1807, the Vatican and King Louis reached agreement for the Netherlands Indies to become an Apostolic Prefecture, which is a territory of the Roman Catholic Church that comes under direct control of the Vatican. It is headed not by a Bishop, but by an Apostolic Prefect. The first Apostolic Prefect appointed to the Netherlands Indies was Pastor Jacobus Nelissen, who arrived in Batavia accompanied by Pastor Lambertus Prinsen on 4 April 1808, after an eight-and-a-half-month journey from Holland via New York.

In February 1810, Daendels made available to the Apostolic Prefect a small church located on the south side of Jalan Kenanga, in the Senen area. Measuring only 8 x 23 metres, it had been built 40 years earlier and used by the Protestants. The government also helped pay for a small tower to be added to the church and for two houses to be built for the pastor and his sexton.

The first Roman Catholic to head the Netherlands Indies government was Leonard Pierre Joseph Burggraaf du Bus de Gisignies, who served as commissioner-general from 1825 to 1830. Du Bus worshipped at the Gang Kenanga church, but believed a worthier building was required. He identified the site on which the current Roman Catholic cathedral now stands on the corner of Jalan Kathedral and the northern side of Lapangan Banteng, where at the time the military commander's residence stood. Du Bus was not on good terms with the military commander of the day, General de Kock, who was also grand master of the Freemasons' lodge. Du Bus arranged for the military commander's residence to be sold to the Catholic church in 1828. Whether his sour relationship with de Kock influenced his decision is not clear.

It appears that du Bus instructed his chief engineer, Tromp, to design a completely new church building, given that architectural plans signed by Tromp and dated 1828 still exist today. However, Tromp's design was never built, possibly because of a lack of funds. Instead, the former military commander's residence was converted into a church and it was consecrated on 6 November 1829. In 1842, the Netherlands Indies was upgraded from "Apostolic Prefecture" to "Apostolic Vicariate", which meant the "church" became a "cathedral". It can be seen here on the right-hand side of this photograph with the Michiels monument on the left.

The Michiels monument was erected to honour the memory of Major General Andreas Victor Michiels, a military commander of West Sumatra who led the third Dutch military expedition against the Balinese and died of his wounds on 23 May 1849. The monument was located at the junction of the eastern end of Willems Laan (Jalan Perwira) and the western side of Waterlooplein (Jalan Lapangan Banteng Barat). It was probably erected between 1853 and 1855.

Michiels was buried in the European cemetery in Batavia at Tanah Abang (*see pages 244-245*) where a small tombstone still exists in his memory. The monument was destroyed either during the Japanese occupation (1942-5) or shortly after independence.

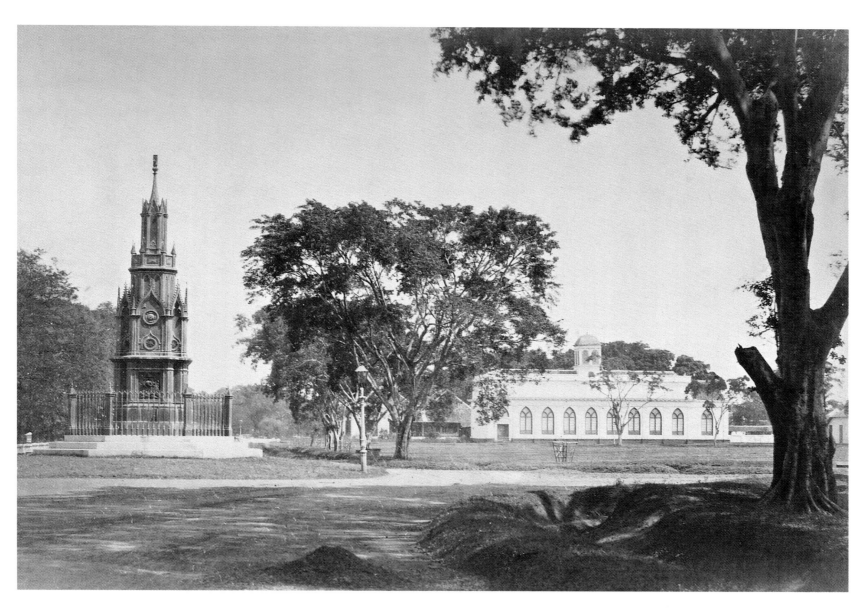

106. Photographer: possibly the **Netherlands Indies Topographic Bureau**, 1870s ■ albumen print ■ size: 21.7 x 30.8 cm ■ collection of the author, Melbourne.

The renovated Roman Catholic cathedral (1880–90)

From the very beginning in 1829, when the Roman Catholic church in the photograph on page 203 had been created out of the former military commander's residence, the building was frequently in need of repairs to overcome a wide range of problems. The foundations were not strong enough, the floor was not level, the plastering was of poor quality, the doors and windows did not shut properly and parts of the walls were considered unsafe. Leaks were also a constant problem, partly because the bell tower in the centre of the roof was too heavy to be supported by the building's structure.

Full-scale renovation was not possible because of a lack of funds but in 1859, major repairs were undertaken. By 1879, it was concluded that further repairs on a piecemeal basis would not be effective and that either a major renovation (including removal of the bell tower) or a completely new cathedral was required. Once again, inadequate financial resources prevented construction of a new building, but the first extensive renovation in half a century was undertaken. This included a new façade and the relocation of the bell tower from the centre of the roof to the top of the new façade. The newly renovated cathedral seen in this photograph was first used on 31 May 1880.

The renovations were good enough to last a decade, but on 9 April 1890 part of the roof collapsed and the decision was finally made to completely demolish the old cathedral and replace it with a new one. Plans for the new Gothic-style cathedral (the current cathedral) were prepared and a building permit was granted in 1891. Some of the foundations were laid soon after, but then a lack of funds caused construction to be halted. It was not until 16 January 1899 that work recommenced with the ceremonial laying of the first stone. The cathedral was consecrated on 21 April 1901, and remains in very active use to this day.

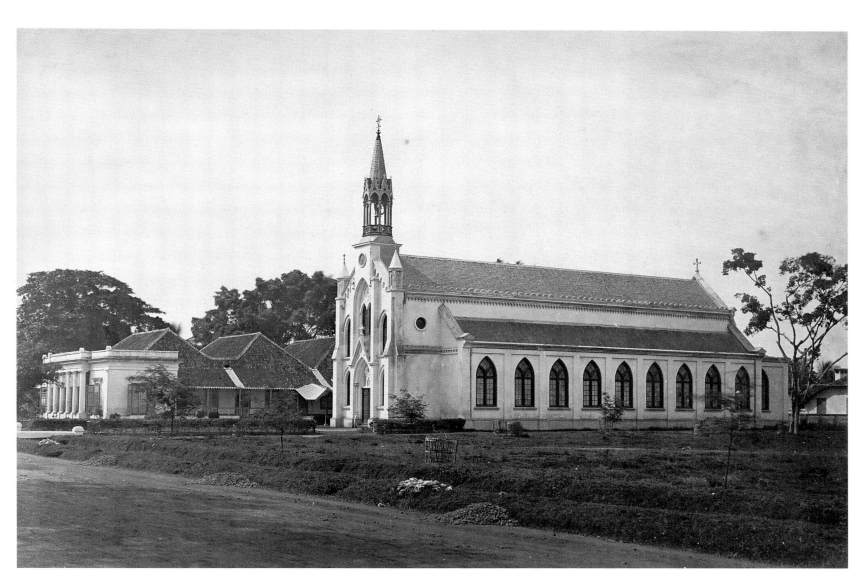

107. Photographer: possibly the **Netherlands Indies Topographic Bureau**, between 1880 and 1890 ■ albumen print ■ size: 20.6 x 30.6 cm ■ collection of the author, Melbourne.

The Freemasons' lodge

The first order of freemasons in Batavia was established under the name "La Choisie" in 1763 by Jacobus Cornelis Mattheus Radermacher (1741-83) and six other men. Radermacher later also founded the Batavian Society of Arts and Sciences in 1778 (*see pages 182-185*).

By the late 1760s, La Choisie had either ceased to exist or dissolved itself into two other lodges, "La Fidèle Sincérité" and "La Vertueuse". La Fidèle Sincérité had a strong military flavour and many of its leaders and members were officers from branches of the military. By contrast, La Vertueuse's members were often drawn from the higher levels of the VOC bureaucracy and their elite status may have led them to feel slightly superior to the members of the competing lodge. Certainly, relations between the two lodges in the 18th century were often strained.

Nevertheless, both lodges were eventually united under a constitution granted on 19 June 1837 and a new lodge, with 87 members, was born with the name "De Ster in het Oosten" ("The Star in the East"). It occupied the Masonic temple to which La Vertueuse had moved in 1830, on the corner of Komedie Buurt (Jalan Gedung Kesenian) and what became Vrijmetselaars Weg ("Freemasons' Street") that is now Jalan Budi Utomo. The land had formerly been part of the old Weltevreden estate and was donated to the freemasons by the government, while other donations from rich masons had helped make construction possible.

In 1856, the decision was made to demolish the temple and replace it with a new one at an estimated cost of 40,000 guilders. In the *Javasche Courant* of 9 May 1856, an appeal was made to freemasons throughout the Netherlands Indies to subscribe to shares of 100 guilders each, with four per cent annual interest, to help finance construction. The commission for the design and building of the new temple was given to a freemason, Mr D. Maarschalk. Demolition work on the old temple commenced on 12 May 1856 and almost two years later, on 26 June 1858, the new building that can be seen in this photograph was inaugurated. The five-pointed star that was the symbol of "The Star in the East" is clearly visible in the centre of the portico above the columns.

The completion of the new temple broadly coincided with a change in the objectives of freemasonry in the Netherlands Indies. The freemasons had originally been an insular organization where men of European descent could enjoy comradeship together. However, from around 1860, the freemasons became more outward looking and sought to contribute to the greater society. In 1864, they opened a public library in part of the temple and in 1865, they established a technical high school for boys.

A Dutch visitor and fellow freemason visiting Batavia in the mid-1890s was full of praise for members of "The Star in the East":

> . . . I have felt the delight to be welcomed in the Freemasons' lodge "The Star in the East". I have there attended the Saint John's festival in the beautiful, airy and tasteful halls decorated with Eastern green and I have taken the conviction with me to the Netherlands, that among the Indies brothers of freemasonry, a sincere and progressive mind and a continuous search for the good and the true is prevalent. I have at a reception there heard speakers who bear witness to their education which could serve as an example to many people. The unrestrained tone, the hearty sociability with which the highly placed and the humble are there together as true brothers, is proof that the freemasons in the Netherlands Indies fully understand their vocation.[47]

This building still stands today and is used by the state-owned pharmaceutical company Kimia Farma.

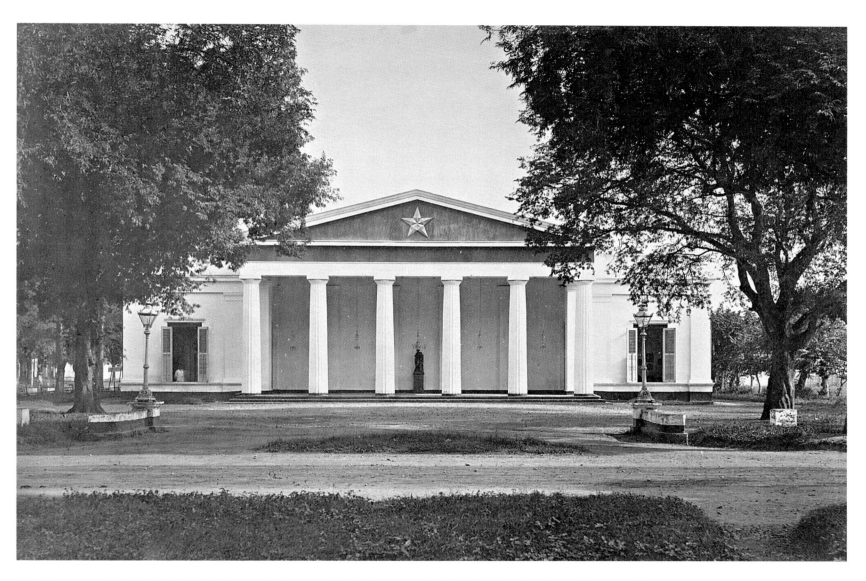

108. Photographer: possibly the **Netherlands Indies Topographic Bureau**, c. 1880 ▨ albumen print ▨ size: 20.0 x 30.3 cm ▨ collection of the author, Melbourne.

The Schouwburg

During the VOC era, hostility to the theatre among the staunchly Protestant clergy ensured that theatrical pursuits in Batavia were not encouraged by the government. It was not until the British interregnum (1811–16) that the situation began to improve. In 1814, an association of military officers and government employees built a simple theatre out of bamboo near what was to become Waterlooplein. With the return of the Dutch in 1816, a new theatrical association was formed and gave its first performance on 21 April 1817 in the bamboo theatre that had been used by the British.

It was clear that a more permanent theatre building was needed. To this purpose, the government donated a plot of land on the corner of what became Post Weg (Jalan Pos) and Komedie Buurt (Jalan Gedung Kesenian) and also provided a loan of 9,000 guilders to help fund construction. Another 43,600 guilders was received from public donations. A Chinese contractor was appointed to build the theatre at a cost of 22,000 guilders, while a further 36,000 guilders was used for the interior and for theatre requisites. The shortfall of 6,000 guilders was covered by a loan.

The new theatre (the "Schouwburg") was ready for use by the middle of October 1821. However, Batavia was still suffering from an outbreak of cholera that had begun six months earlier and the first performance, Shakespeare's *Othello*, was not held until 7 December 1821.

A ship's physician named Dr Strehler who visited Batavia around 1828 wrote of the theatre:

> The theatre decorations are excellent for a hobby-theatre and the costumes, suited to the heat of this climate, are a pleasure for the eye. The orchestra seems complete. As for the players, some acquit themselves masterfully of their roles, but others show enough that they are only theatre lovers. However, a shortcoming, not even to be

helped with the best will of the assembly, is that the men also have to play the roles of women.[48]

Since the earliest days of colonial rule, there had always been far more European men than women in the Netherlands Indies and given that the plays were presented in European languages, it was very difficult to recruit local women as actresses for the theatre.

Accordingly, the arrival in Batavia in 1835 of a French theatre troupe under the direction of Minard, with their light comedies that included *real* actresses, was a great success.

Minard returned to Batavia in 1836 with the first French opera to be offered in Batavia, and was again triumphant. Minard's successes marked the beginning of the strong French influence in Batavia's social and commercial life that would last for the rest of the 19th century.

Despite the popularity of the French operas, it was difficult for the theatre to operate as a viable financial concern. In 1848 and again in 1892, control of the theatre was taken over by the government after unsuccessful attempts were made by the private sector to run it profitably. In 1911, management was handed over to Batavia's municipal council.

The theatre building had a chequered history in the 20th century, including a time when it was a cinema for Chinese films and a period of neglect when it fell into disrepair. However, after renovations in the mid-1980s, it was returned to its original use as a theatre in 1986 and has been known since then as Gedung Kesenian ("Arts Building").

In this photograph, we are looking in a south-westerly direction from the corner of what are now Jalan Pos and Jalan Gedung Kesenian. The ornate white statues in the front archways near the steps no longer exist.

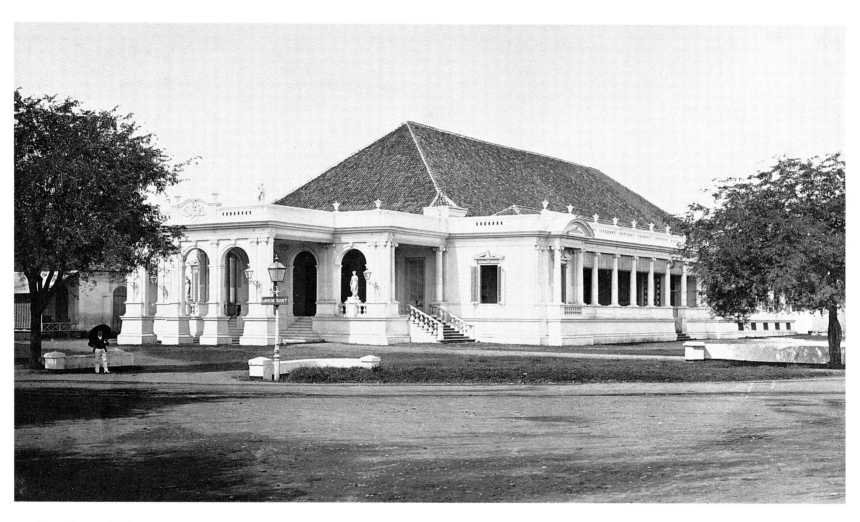

109. Photographer: possibly the **Netherlands Indies Topographic Bureau**, 1870s ■ albumen print ■ size: 18.3 x 30.0 cm ■ collection of the author, Melbourne.

THE POST AND TELEGRAPH BUILDINGS

The first post office in Batavia was opened on 26 August 1746 by Governor-General Gustaaf Willem Baron van Imhoff (governor-general 1743–50) and was situated in the Pasar Ikan area of the old port of Batavia in the north. In 1835, the central post office was located at Waterlooplein on the ground floor of Daendels' "palace" (*see pages 192–193*). By 1853, it had been relocated to the building in the centre of the photograph on the opposite page, on the street which was subsequently named Post Weg ("Post Street" and now Jalan Pos). The first postage stamps were introduced in the Netherlands Indies in 1864.

The first telegraph wire was erected between Batavia and Buitenzorg (now Bogor) in 1856. The first message on this line was sent using Morse code to the governor-general in Buitenzorg on 23 October 1856. The line from Batavia to Surabaya via Cirebon and Semarang was completed on 25 July 1858. The first international telegraph line was established from Batavia to Singapore in 1859, but was dismantled shortly thereafter due to the high cost of repairs. It was not until 1870 that a permanent line existed from Batavia to Singapore, installed by the British Australian Telegraph Company, Limited.

The merging of the post and telegraph services under one administration commenced in 1875 and was completed by 1878, from which time the headquarters of the telegraph service in Batavia were relocated to the central post office building.

Telephones were introduced into the Netherlands Indies in 1882, and were originally in the hands of the private sector. However, by 1907 the local telephone systems in Batavia, Weltevreden and Tangerang had been taken over by the government.

110. Photographer: unknown (possibly **Woodbury & Page**), mid-1870s ■ albumen print ■ size: 19.0 x 24.5 cm ■ collection of the KITLV, Leiden.

The first public telegraph office in Batavia was opened at Post Weg on 10 May 1858 and was probably the two buildings in this photograph, which for many years in the 19th century were used by the telegraph service. They were located near the corner of Post Weg and R. K. Kerk Weg (Jalan Kathedral). They still exist today (in a heavily altered form) and are used as residences for sisters of the Ursulin order of Catholic nuns.

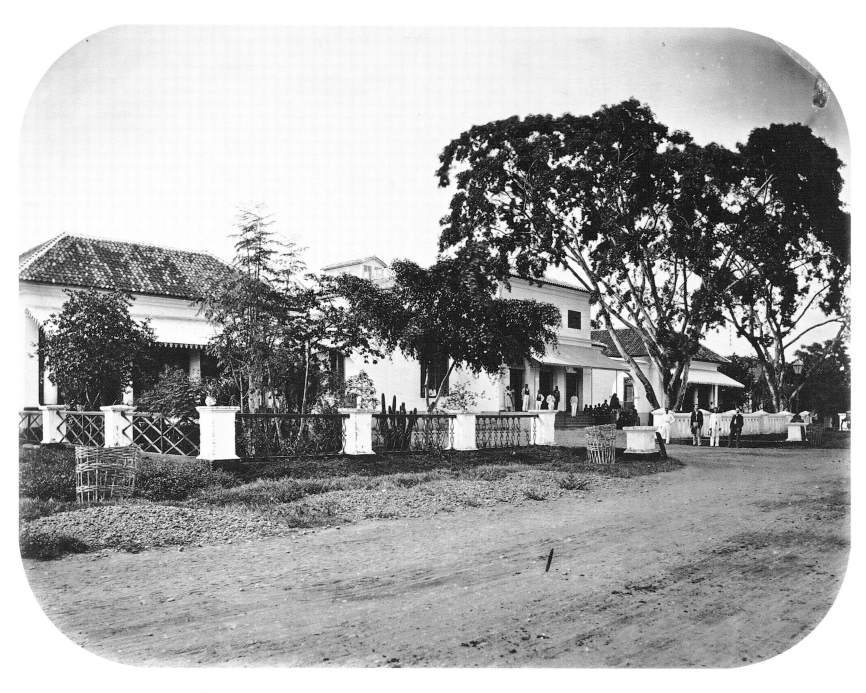

111. Photographer: **Woodbury & Page**, mid-1860s ■ albumen print ■ size: 18.1 x 22.7 cm ■ collection of the author, Melbourne.

The central post office buildings in the centre of this photograph were located on Post Weg between the Schouwburg (now Gedung Kesenian) on the eastern side and the so-called Kleine Klooster (the second of the Ursulin convents to open in Batavia) on the western side.

The precise year when the central post office first operated from this site is not clear, but it would have been between 1835 and 1853. These buildings were demolished around 1913 and replaced by larger premises that still exist today.

The Gunung Sahari road and canal

The origins of the Gunung Sahari road and canal are somewhat shrouded in mystery. De Haan writes that in 1678, an order was given by the government to build a road from the sea in the north at Ancol through to Meester Cornelis (now Jatinegara) in the south.[49] However, this view is not supported by early maps, which tend to suggest that the Gunung Sahari road only went as far north as the junction with Jacatra Weg (Jalan Pangeran Jayakarta and Jalan Dr Suratmo), where the VOC had built a small fort in the 17th century.

Nevertheless, Gunung Sahari is undoubtedly one of the oldest major roads built in Batavia outside the walled city, even if its form and length have not always been as they are now. From its earliest years, the Gunung Sahari road was an important thoroughfare to the south which was also known as the Groote Zuider Weg ("Great Southern Road"). It passed through Senen, Kramat, Salemba and Meester Cornelis before continuing on to Buitenzorg (Bogor) where, during the 19th century, governors-general of the Netherlands Indies would spend more time than they did in Batavia because of the cooler mountain climate.

What is now the Gunung Sahari canal probably dates from the late 17th century (possibly 1681), but its earliest location and form were different from the straight canal we know today. It may have originally flowed along the natural contours of parts of the Ciliwung River (located roughly between what are today the southern ends of Jalan Jakarta and Jalan Pintu Air Raya) which were long ago filled in and no longer exist. The original diggings of what became the Gunung Sahari canal were known as the Nieuwersloot ("Newer Ditch"), probably because they were started several decades after the digging of the Molenvliet canal, which dates from 1648.

By the 19th century, the Gunung Sahari canal was connected to the more important Molenvliet canal via the canal running between Noordwijk (Jalan Juanda) and Rijswijk (Jalan Veteran) and along Post Weg (Jalan Pos) and School Weg (Jalan Dr Sutomo). The main purpose of the Gunung Sahari canal was to help maintain the required water level in the Molenvliet. In the dry season, the *sluisbrug* ("lock bridge") (*see pages 144-145*) near what is now Pasar Baru would be closed so that the available water from the Ciliwung River could flow into the Molenvliet, at the expense of the water levels along Gunung Sahari. In the wet season, the lock bridge would be opened so that any excess water from the Ciliwung could be channelled into the Gunung Sahari canal.

This photograph looks south towards the southern end of Gunung Sahari which was popular as a residential district in the second half of the 19th century, particularly in the areas just north of Pintoe Besi (now where Jalan Samanhudi joins Gunung Sahari) and between Pintoe Besi and School Weg (now where Jalan Dr Sutomo joins Gunung Sahari). The white-painted front gates of many homes along both sides of Gunung Sahari are clearly visible in this photograph.

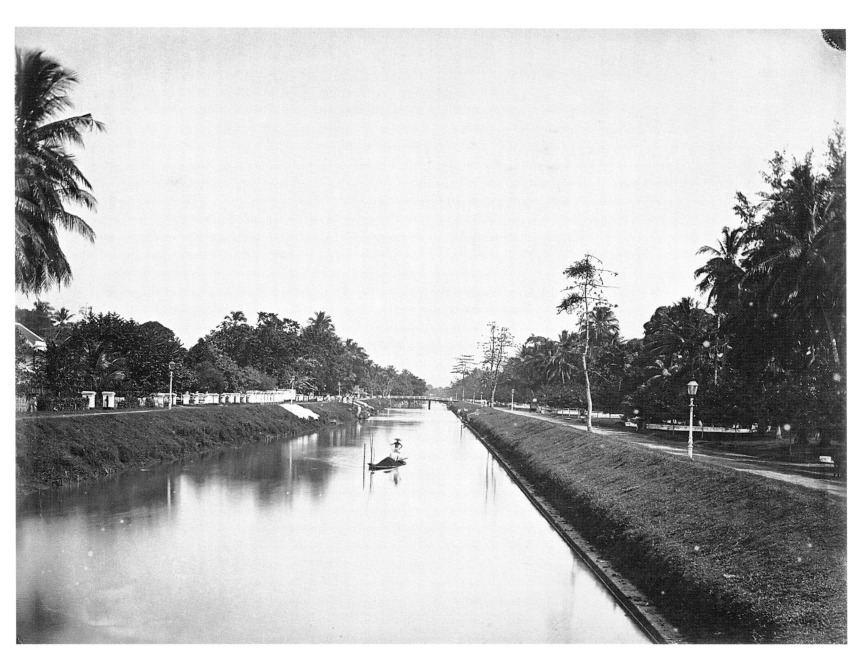

112. Photographer: **Woodbury & Page**, 1870s ▦ albumen print ▦ size: 18.9 x 24.3 cm ▦ collection of the author, Melbourne.

Pasar Senen market

The market at Pasar Senen dates back to 1735, when it was established by Justinus Vinck, who owned the Weltevreden estate between 1733 and 1749. Vinck opened his market on the south-eastern corner of the estate, which was on the western side of the section of the Groote Zuider Weg ("Great Southern Road") that is now Jalan Pasar Senen. Within a few years, the market had also spread to the eastern side of Jalan Pasar Senen which, strictly speaking, was not part of the Weltevreden estate.

Also in 1735, Vinck opened another market on land he owned at Tanah Abang, giving him the distinction of being the founder of two of the most important markets in Jakarta's history. Both the Pasar Senen and Tanah Abang markets have been vibrant centres of trade for more than 250 years. To connect his two markets, Vinck built a road which became the first east-west road link to be completed across the area which is currently Central Jakarta. This was also undertaken in 1735 and the roads were Prapatan (now Jalan Prapatan) and Kampong Lima (now Jalan Wahid Hasyim).

Permission to open Pasar Senen was granted to Vinck on 30 August 1735, with the stipulation that the market was to open only on Mondays, hence the name Pasar Senen ("Monday Market") but it was sometimes also known as Vinkepasser ("Vinck Market").[50] In 1751, Pasar Senen was also allowed to open on Fridays and from 1766, it could open every day. However, in 1813 market days were limited to just two days, Sundays and Tuesdays.

In the 18th century, the Pasar Senen market was a relatively simple affair and almost all of the shops were made of bamboo with thatched roofs. The shopkeepers were predominantly Chinese. Rents from the shopkeepers were a lucrative source of income for successive owners of the Weltevreden estate. In 1766, the rents totalled 4,000 rijksdaalders, and by the year 1800 they had risen to 10,000 rijksdaalders.[51]

Even by 1815, there were no stone buildings at Pasar Senen. Instead, there were 229 stalls made of timber with tiled roofs and 139 stalls made of timber or bamboo with thatched roofs.[52] A large part of Pasar Senen was destroyed by fire on 9 July 1826. Given the nature of the building materials used to construct the stalls, the fire would have spread very quickly.

Competition for the Pasar Senen market emerged in 1821, when the nearby Pasar Baru ("New Market") was established.

In this rare early photograph of part of the Pasar Senen market, we are perhaps looking in a north-westerly direction along what is now Jalan Senen Raya. The distinctly Chinese atmosphere of the area is evident from the roof lines of the Chinese houses. Many traders with their merchandise are visible at the side of the street.

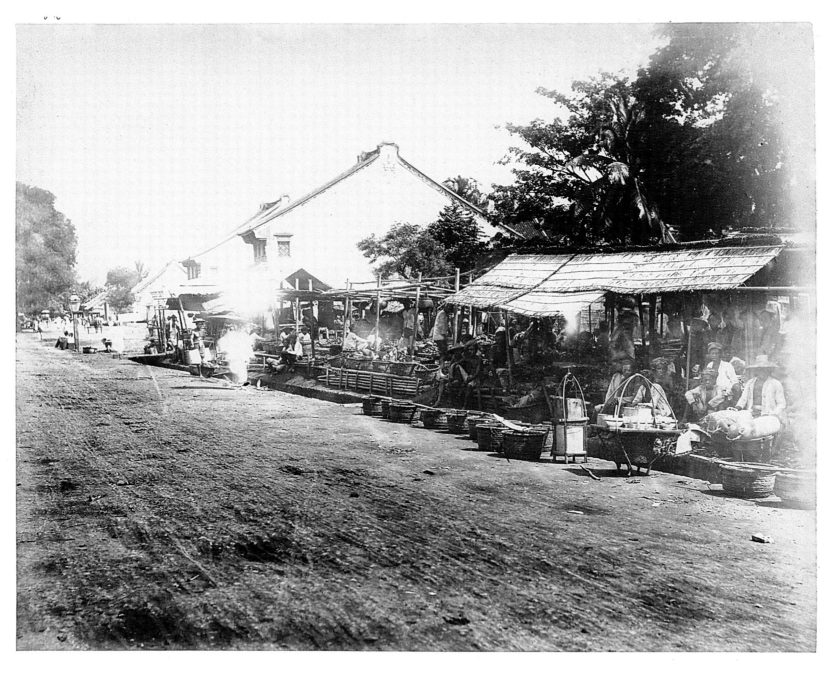

113. Photographer: unknown, 1870s ■ albumen print ■ size: 21.1 x 26.3 cm ■ collection of the author, Melbourne.

The Kramat bridge

In this photograph, we are looking north from the southern side of the Kramat bridge towards the shops at the southern end of the Pasar Senen market. The tram lines on the left head up along what is now Jalan Senen Raya towards the eastern flank of Waterlooplein (Lapangan Banteng).

The Kramat bridge no longer exists, and this area is now the busy junction of Jalan Prapatan, Jalan Kwitang, Jalan Kramat Bunder, Jalan Senen Raya, Jalan Pasar Senen and Jalan Kramat Raya. In the 1920s or 1930s, Jalan Pasar Senen was widened to allow for more efficient flow of traffic between Ancol and Gunung Sahari in the north to Salemba and Meester Cornelis (Jatinegara) in the south. As part of the road widening project, the Kramat bridge was demolished and the river on the right of this photograph was filled in so that Jalan Pasar Senen could continue in a straight line through to Jalan Kramat Raya.

114. Photographer: **Woodbury & Page**, 1870s ■ albumen print ■ size: 20.3 x 25.4 cm ■ collection of the author, Melbourne (acquired from the Woodbury family).

216

Corner of Menteng, Prapatan and Kebon Sirih

This photograph was taken from what is now the corner of Jalan Kebon Sirih and the southern end of Jalan Ridwan Rais, and is looking towards the corner of Jalan Prapatan and Jalan Menteng Raya. The road heading off to the east on the left is Jalan Prapatan and the road heading south on the right of the large tree and past the row of houses is Jalan Menteng Raya.

The two buildings on the left behind the tree still existed in the 1950s, but have since been demolished (along with the tree) for road-widening purposes. They were located on what is now the traffic island near the front of Hotel Aryaduta.

115. Photographer: **Woodbury & Page**, 1870s ■ albumen print ■ size: 18.0 x 21.5 cm ■ collection of the KITLV, Leiden.

PRAPATAN

These two photographs show views of the Prapatan area in the 1860s taken from the western side of the Prapatan Bridge, looking in a south-westerly direction towards Menteng.

In the second half of the 19th century, the road on the left-hand side of both images was known as Engelsche Kerk Weg ("English Church Road") because the English church (*see pages 224–225*) was (and still is) located on the southern side of the street (the left-hand side of the photographs), although it is not visible here because of the trees. This street is now Jalan Arif Rahman Hakim.

The road heading off to the right and clearly visible in the photograph below, but partially obscured on the opposite page, is Prapatan (now Jalan Prapatan) which leads to the junction of what are now Jalan Kebon Sirih, Jalan Ridwan Rais, Jalan Menteng Raya and Jalan Prapatan that can be seen on page 217. On the right-hand side of Prapatan, where the white-painted entrances to the private residences are visible in the photograph below, Hotel Aryaduta is now located.

The house behind the bamboo fence in both photographs occupied the site of what is now the traffic island between Jalan Prapatan and Jalan Arif Rahman Hakim in front of Hotel Aryaduta.

The Prapatan road dates back to 1735 when it was built by Justinus Vinck to connect the two markets he established in the same year, namely Pasar Senen in the east and Tanah Abang in the west.

116. Photographer: **Woodbury & Page**, mid-1860s ■ albumen print ■ size: 18.2 x 23.4 cm ■ collection of the author, Melbourne.

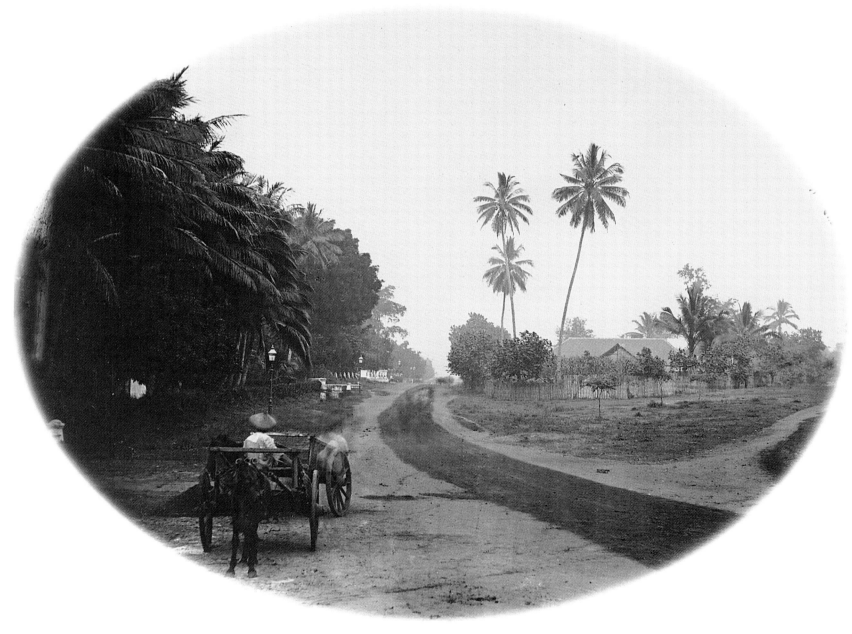

117. Photographer: **Jacobus Anthonie Meessen**, c. September 1867 ■ albumen print ■ size: 16.0 x 21.0 cm ■ collection of the Royal Library, The Hague.

The residence of the Head of the Medical Service

This beautiful mansion was the home of the Head of the Medical Service and was located on Prapatan (Jalan Prapatan) approximately halfway between Prapatan Bridge and Jalan Senen Raya. It was a truly splendid residence with a spacious white-columned front verandah and ornate cast-iron railings on the two curved and elegant front staircases. The main rooms were built more than two metres above ground level to make the house cooler. Such grand homes on extensive grounds were typical of the elite European areas of Batavia, including Prapatan, during the second half of the 19th century.

A visitor to Batavia in 1862 noted some of the characteristics of this type of home:

. . . the newer European houses in Batavia, yes, throughout Java, are usually built in the same trend. They mostly consist of one storey, some feet above the ground level. The most important houses have one open front and one back verandah, connected by a square space or hall, sometimes laid with marble tiles, from which side rooms extend which serve as bedrooms and the like. The kitchens, the servants' rooms and the stables are placed in the annexes, usually behind the main building. Almost everything, both inside and outside is chalked white, which is most conducive for cleanliness, and it presents under the always green trees a cheerful view. With the furniture, usually much luxury is shown, but also accompanied by good taste.[53]

This building still stands today although the façade has been changed and lacks its former elegance. It is now the headquarters of the Korps Brimob ("Police Mobile Brigade").

118. Photographer: **Jacobus Anthonie Meessen**, c. September 1867 ■ albumen print ■ size: 16.0 x 21.0 cm ■ collection of the Royal Library, The Hague.

A house in the Prapatan area by the Ciliwung River

This photograph shows a fine private residence in the Prapatan area that still stands today. It is located on the eastern side of the bend of the Ciliwung River behind Hotel Aryaduta on Jalan Prapatan.

This single-storey white-painted home with large white columns and a spacious front verandah was very characteristic of houses built by the European elite in Batavia in the 1860s and 1870s. It may well be the owner of the house standing under the tree on the right.

The photographer would have captured this view from the Prapatan bridge looking towards the north. In modern terms, Hotel Aryaduta would be just to his left.

In 1858 Weitzel was impressed by the beauty and tranquillity of Prapatan and he noted:

We come from Koningsplein and have reached the bridge of Prapatan, so let us stand still here for a while. The river Ciliwung runs here under your feet and flows through many bends to Weltevreden and Noordwijk; to your left and in front you see a row of very beautiful villas, whose residents enjoy the fresh morning air in their light morning attire. Among the many kampungs [villages] spread out in this vicinity, on your right is the large "Kampung Kwitang". The tops of the coconut trees are softly swayed to-and-fro by the breath of the blowing winds and among the dark green of the many fruit trees, blue smoke clouds rise twirling upwards.[54]

This house was used as an office by the late national hero Sultan Hamengkubuwana IX of Yogyakarta for many years after Indonesian independence in 1945. Since 24 February 1992 it has belonged to the Dewan Kerajinan Nasional Indonesia ("National Handicrafts Council of Indonesia").

119. Photographer: **Woodbury & Page**, c. 1870 ■ albumen print ■ size: 18.4 x 23.9 cm ■ collection of the author, Melbourne.

The English church

The oldest surviving English-language institution in Jakarta is the English church now called "All Saints' Anglican Church" which is located on Jalan Arif Rahman Hakim, previously Engelsche Kerk Weg ("English Church Road") in Prapatan. This church has occupied the same site since 1822, although the building has undergone numerous changes over the years.

The origins of the English church can be traced back to the desire of the London Missionary Society (LMS) in the early 19th century to spread the word of Christianity in China. However, with China being closed to foreigners, the decision was made to minister to Chinese living outside China in the hope that if they ever returned "home", they would take Christianity with them. Java was identified as a suitable place to conduct such work and the LMS chose the Reverend Walter Henry Medhurst to be their first missionary to Java's Chinese population.

Medhurst arrived in Batavia on 7 January 1822. In the same year, he purchased on behalf of the LMS a plot of land in Prapatan upon which he built a bamboo church. This sufficed for six years until the end of 1828, when a decision was made to build a proper brick structure. The new church building was completed in 1829 and can be seen in this photograph.

Medhurst spent 21 years in Batavia both as missionary to the Chinese and as chaplain to Batavia's English community. He eventually left Java for China in 1843, following the opening of several Chinese ports to foreigners the previous year.

After Medhurst's departure, the LMS saw no need to continue its work in Java and Batavia's English population found themselves without a chaplain. A committee was formed to arrange the purchase of the church building and land from the LMS for the sum of 8,000 guilders, which was borrowed at an interest rate of four per cent. However, it was nearly eight years before another chaplain could be found who was willing to work in Batavia.

The second half of the 19th century was generally a very difficult period for the English church. Three of the seven resident chaplains who served in Batavia between 1851 and 1879 could not complete their terms because of illness, while between March 1879 and August 1910 there was no resident chaplain at all. The years between 1888 and 1905 were particularly bad, and church life appears to have ground to a halt largely because of apathy among Batavia's English community. Church finances also deteriorated alarmingly and the mortgage of 8,000 guilders taken out in 1843 had grown to 18,000 guilders by 1899.

There were occasional bright spots in the history of the church. In April 1859, the Foreign Office in London announced that it would contribute to the church committee each year a sum equal to the amount raised locally in Batavia. However, this arrangement was terminated in 1875.[55]

It was only in 1910 that the church's affairs were finally put on a firm footing. At the suggestion of the Bishop of Singapore, the church was formally brought under the Anglican Diocese of Singapore, a position it still enjoys today.

This photograph shows the English church as it had developed by the 1870s from Medhurst's original building of 1829. Many alterations were made over the years to both the interior and exterior. The venetian sun blinds seen here between the columns were added in 1853. The following year a vestry was built by walling in the southern end of the west verandah. This would have been the room visible beside the fifth column on the right-hand side of this photograph. In 1863, the installation of a larger organ necessitated further alterations to the church building.

120. Photographer: **Woodbury & Page**, c. 1864–5 ■ albumen print ■ size: 19.2 x 24.8 cm ■ collection of the Tropen Museum, Amsterdam.

Raden Saleh

Raden Saleh Sarif Bustaman (1814?–80) was the most famous Indonesian artist in the 19th century and his works are greatly prized to this day. He was born near Semarang into an aristocratic Javanese family, and his artistic talents were noticed very early in his life. From about 1822, when Raden Saleh was only eight, he received instruction from the Belgian painter A. A. J. Payen until Payen returned to Europe in 1826. Three years later in 1829, Raden Saleh travelled to Holland, where Payen helped him obtain government assistance to study art for two years. He studied drawing, portraiture, landscapes and even copying old masters. He is best known today for his portraits and for his oil paintings of wild animals and hunting scenes that are characterized by a strong dramatic intensity.

Raden Saleh remained in Europe for more than 20 years, during which time he travelled extensively and achieved considerable fame. He was feted by nobility and was received at several royal courts in Europe where he was honoured with numerous decorations, including the "Order of the Oaken Crown" from the Dutch King Willem II in 1845. He became the model for the character Prince Jalma in a popular 19th century French novel, *Mystères de Paris*, by Eugene Sue.

He returned to Batavia late in 1851, together with his first wife, a wealthy Eurasian, and built the ornate mansion that can be seen on page 229. The extensive grounds of this estate included the land he later donated in 1864 for the establishment of Batavia's Botanical and Zoological Gardens (*see pages 230–231*).

Raden Saleh lived in Yogyakarta between 1867 and 1869, during which time he married a cousin of Sultan Hamengkubuwana VI who can be seen with her attendant in the photograph on the opposite page. He later settled in Buitenzorg (Bogor) and died there on 23 April 1880.

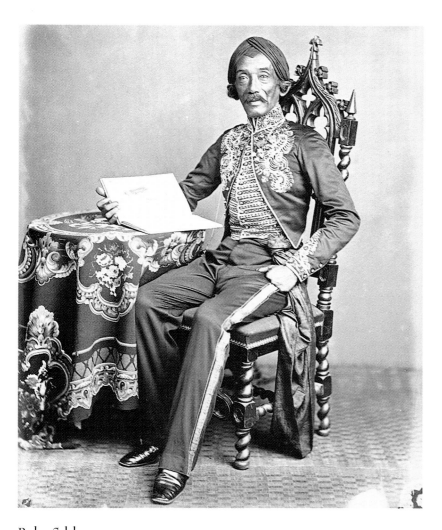

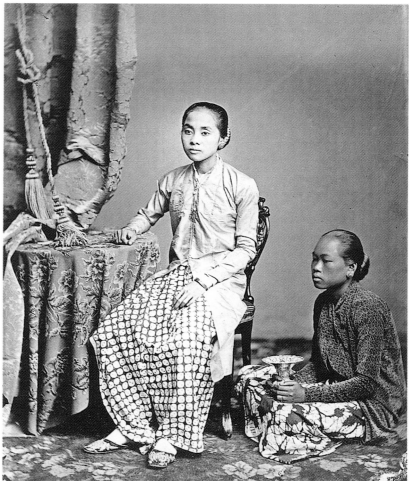

Raden Saleh

121. Photographer: **Woodbury & Page**, 1872 or earlier ■ albumen print ■ size: 24.2 x 18.3 cm
■ collection of the Tropen Museum, Amsterdam.

Raden Saleh's Second Wife (name unknown)

122. Photographer: **Woodbury & Page**, between 1867 and 1872 ■ albumen print
■ size: 23.5 x 19.3 cm ■ collection of the author, Melbourne.

Raden Saleh's mansion

Built in 1852, Raden Saleh's uniquely styled home still exists today as one of the more extraordinary reminders of 19th century Batavia and of the greatly talented man who inspired it. Even in the colonial days, the street on which this mansion stands was named Raden Saleh Laan ("Raden Saleh Lane"). It is now Jalan Raden Saleh, in Menteng.

A visitor to Raden Saleh's home in the 1860s gives us a glimpse of the mansion and its interior and also of Raden Saleh himself:

> One excursion is worthy of special mention. It was to the palace of Rahden Saleh, a native prince. This palace consisted of a central part and two wings, with broad verandahs on all sides. On entering the main building we found ourselves in a spacious hall, with a gallery above. In the centre of the floor rose a sort of table, and around the sides of the room were chairs of an antique pattern. Side-doors opened out of this hall into smaller rooms, each of which was furnished with a straw carpet, on which was a table ornamented with carved-work, and surrounded with a row of richly-cushioned chairs. Along the sides were similar chairs and small, gilded tables. On the walls hung large steel engravings, among which I noticed two frequently seen in our own land: "The Mohammedan's Paradise", and one of two female figures personifying the past and the future. In the front of the palace the grounds were tastefully laid out as small lawns and flower-plats, bordered with a shrub filled with red leaves It is the richest residence owned by any native prince in the whole East Indian Archipelago.[56]

> The Rahden at the time was in the adjoining grounds, which he is now forming into large zoological gardens for the government at Batavia When I was introduced to him, he at once, with all a courtier's art, inquired whether I was from the North or the South [of the United States]; and on hearing that I was not only from the North, but had served for a time in the Union army, he insisted on shaking hands again, remarking that he trusted that it would not be long before all the slaves in our land would be free.[57]

In 1897, the mansion and its grounds were acquired for the purpose of conversion into a hospital by an association devoted to providing church-funded medical services in the Netherlands Indies. The association was the initiative of Adriana Josina de Graff-Kooman, the wife of the Dutch missionary, the Reverend Cornelis de Graff. The acquisition of the estate was assisted by a donation of 100,000 guilders from Queen Emma of Holland, and on 12 January 1898 it was inaugurated as "Queen Emma Hospital". A training centre for nurses was also established on the grounds.

Numerous new buildings were added to the hospital over the years and it also underwent a number of name changes. In January 1998, as the "PGI Cikini Hospital", it celebrated its centenary. Raden Saleh's former mansion is now used as a dormitory for nurses. The grounds of the hospital in front of the mansion enjoy the shade of many fine old trees.

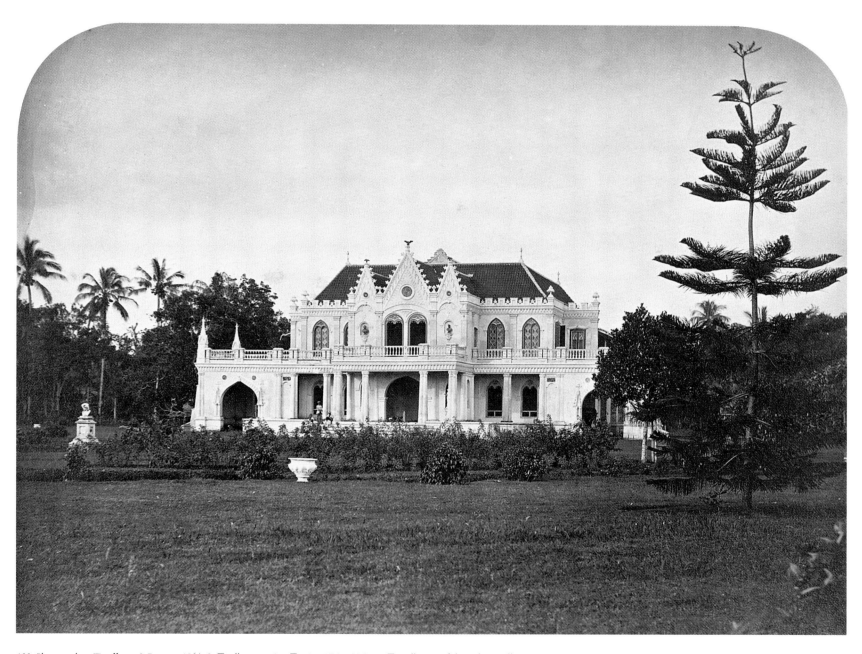

123. Photographer: **Woodbury & Page**, c. 1864–5 ■ albumen print ■ size: 17.2 x 22.8 cm ■ collection of the author, Melbourne.

The Botanical and Zoological Gardens

Batavia's Planten en Dierentuin ("Botanical and Zoological Gardens") were established in 1864 on Jalan Cikini. The land for the gardens was donated by the famous painter Raden Saleh, whose own beautiful mansion was located nearby (*see pages 228-229*).

The founders of the gardens aimed to create a scientific association that would resemble the Royal Zoological Institute in Amsterdam. The gardens were to promote the pursuit of botany, zoology, agriculture, horticulture and animal husbandry and also enable the people of Batavia to enjoy pleasant social gatherings.[58]

The early decades of the gardens were marked by steady progress. This was partly attributed to the increase in steamship traffic to the Indies which followed the opening of the Suez Canal in 1869; visiting ship captains to Batavia frequently brought to the gardens important plant specimens and animals. Indeed, many apparently "considered it an honour" to do so.[59] The association would also make purchases to add to their collection, and a memo dated 3 November 1874 notes: "Request for purchase: A few young tigers."[60] By 1883, there were three commissioners for the plant division and one for the animal division.

The gardens also had a concert hall where selections from operas were often presented. Balls, dances, charity events and concerts of popular music including waltzes and polkas by Strauss and Weber were held there. However, in 1882 a letter to the editor of a Batavia newspaper complained that the gardens might not be the most suitable venue for charity dances because: "the gardens are so far away, which of course will influence the number of visitors, especially those who do not possess a carriage",[61] and that the Harmonie Society was a preferred venue "as it is situated in the centre of Batavia".[62]

Towards the end of the 19th century, the zoo seems to have entered a period of decline. The author of a guidebook from 1891 was unimpressed by the small number of animals:

> At a short distance from the remarkable house of Raden Saleh are the Botanical Gardens and Zoo which the foreigner could visit by paying one guilder. The small restaurant there gave the opportunity for having some refreshments. The garden and the building connected to it where now and then drama and other performances are presented, thanked its foundation and arrangement also to the above mentioned Javanese artist. Besides a few monkeys, birds and other animals, the zoo contained very little in the way of zoological curiosities. Three orang-utans, however, earned our attention. The park with its beautiful trees, including several remarkable species, offered an agreeable and cool walk, which should better be carried out early in the morning or in the late afternoon hours. On Sunday mornings from 7.00 a.m. until 9.00 a.m., music performances are presented in the garden. The association which owns the gardens is nowadays in a somewhat languishing condition.[63]

In the late 19th century or early 20th century, the zoo was closed and animals were no longer kept at the gardens.

Nevertheless, the gardens remained popular for many years for family picnics, balls, parties, exhibitions and other social functions. Sporting amenities for tennis and swimming were also added. The zoo reopened in the 1930s with the return of animals. In the late 1960s, the gardens became "Taman Ismail Marzuki", which still exists today. In this photograph, we can see the main entrance of the concert hall on the right surrounded by the spacious grounds. The concert hall has long since been demolished.

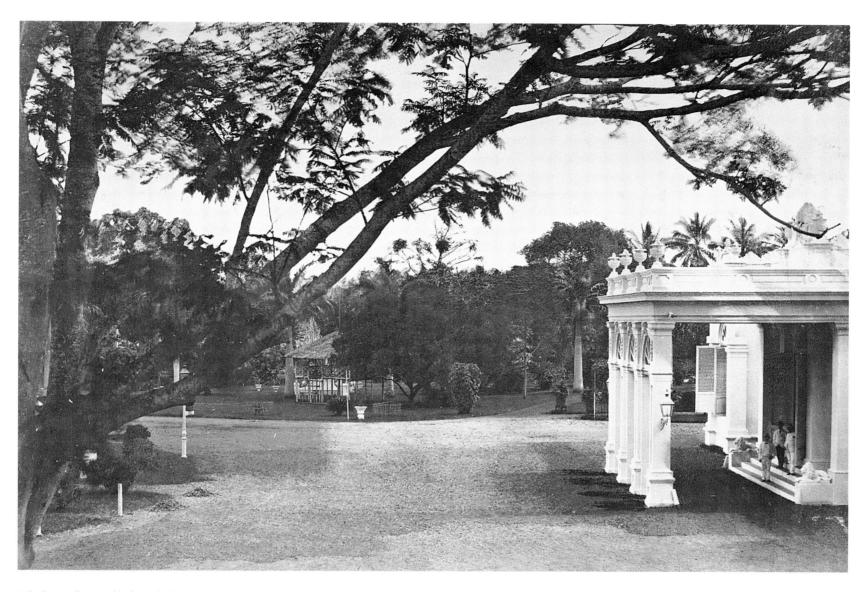

124. Photographer: possibly the **Netherlands Indies Topographic Bureau**, 1870s ■ albumen print ■ size: 20.8 x 30.2 cm ■ collection of the author, Melbourne.

The Gymnasium Willem III

Opportunities to pursue an education in the Netherlands Indies were very limited during the VOC era (which ended in 1799) and also during the first half of the 19th century. European men generally sent their sons to Holland for schooling if they could afford to do so because a European education was usually the path to the higher echelons of society for those men who chose to return to the Indies. Education for girls was not considered to be a priority, although various short-lived attempts to operate schools for girls were made in the 18th and 19th centuries.

For the sons of Eurasians and Europeans of lesser financial means in the 19th century, the lack of access to an education in Europe immediately limited their career prospects to low-ranking civil service positions or as clerks in private firms with little hope of advancement.

In 1859, as an attempt to improve educational opportunities in Batavia, it was decided to establish the Gymnasium Willem III (often known as the "KW III School"), which would give a much wider spectrum of youth in the Indies the chance to obtain a secondary education.

The Gymnasium Willem III was officially opened in 1860 by the governor-general in a large European house in Salemba that had been converted into a school. Regarded for many years as a "Eurasian" school, the Gymnasium Willem III was an important step towards the emancipation of Eurasians in Batavia and thus helped them to rise further in society.

However, in the early years of the school not everyone was convinced that it would succeed. One visitor to Batavia in 1862 noted that:

> Many people cherish great expectations about it [Gymnasium Willem III], and a new and spacious building has just been completed for the institute. I have to explain, however, that I belong to those people who think that real good and a complete education for European children in the Indies cannot be given. The reasons, are in my opinion, firstly the climate, and secondly the environment of the children. I have visited many schools in the Netherlands Indies, but often I have observed that the climate has a stupefying influence on the teaching staff. This cannot be otherwise; as the incessant heat fatigues the teachers.[64]

The school building which can be seen in this photograph is now part of the National Library in Jalan Salemba.

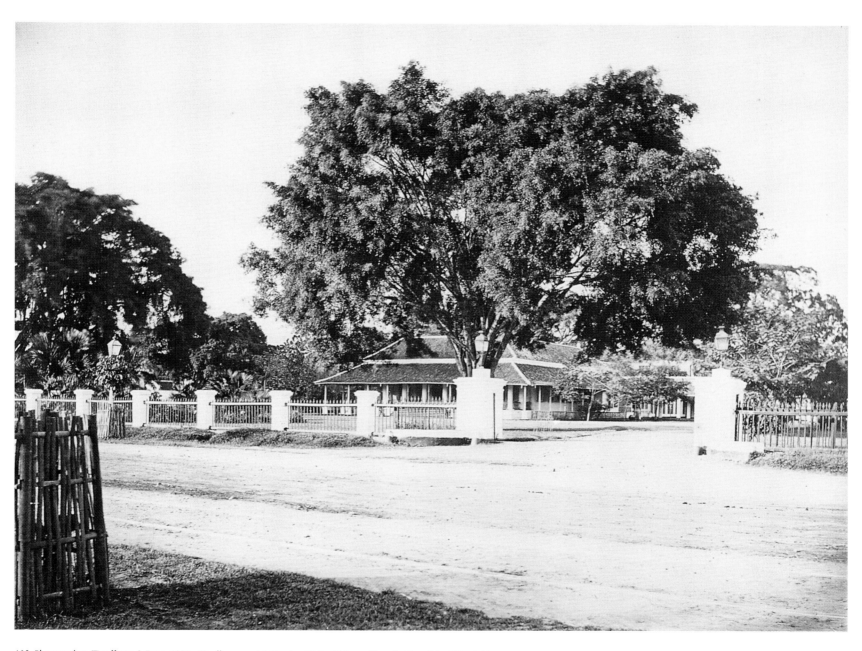

125. Photographer: **Woodbury & Page**, 1870s ▨ albumen print ▨ size: 18.5 x 24.0 cm ▨ collection of the KITLV, Leiden.

Looking north along Matraman

This photograph looks north from a point on the road which is now Jalan Matraman Raya continuing on to Jalan Salemba Raya and Jalan Kramat Raya. If heading north along this road, a traveller would eventually have come to the Kramat Bridge seen on page 216 and the Pasar Senen market. If heading south, he would arrive at Meester Cornelis (now Jatinegara) and then further on to Buitenzorg (now Bogor).

Note the tram lines on the right which led to Meester Cornelis and the telegraph lines on the left which connected Batavia with Buitenzorg. This telegraph connection was the first to be established in the Netherlands Indies (in 1856) and was of particular importance because it enabled the governors-general, who traditionally spent most of their time in the cooler mountain climate of Buitenzorg, to communicate with Batavia.

In August 1811, Dutch-French forces under Governor-General Jan Willem Janssens (governor-general 1811) retreated south along this road to Meester Cornelis in the face of the British invasion of Batavia under the command of Lieutenant-General Sir Samuel Auchmuty. After a battle at Meester Cornelis on 26 August 1811, the British troops achieved total victory and the surrender of Janssens' forces was to usher in the five-year British interregnum from 1811 to 1816, under Lieutenant-Governor Thomas Stamford Raffles.

126. Photographer: **Woodbury & Page**, 1870s ■ albumen print ■ size: 15.5 x 22.5 cm ■ collection of the KITLV, Leiden.

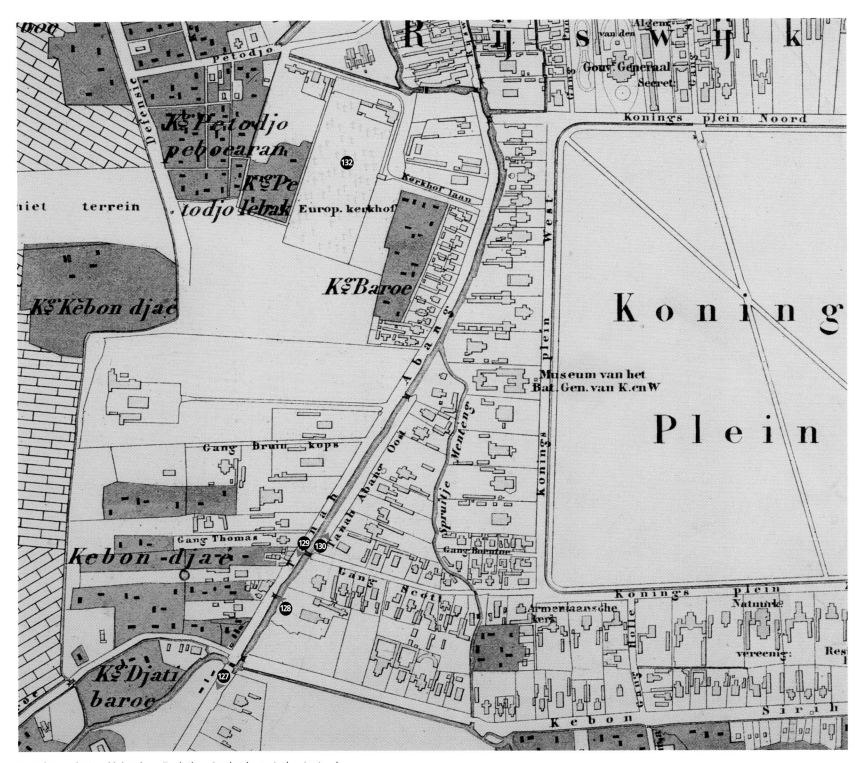

236

Note: Photograph 131 is likely to be on Tanah Abang Oost but the precise location is unknown.

TANAH ABANG

Tanah Abang has a long history. According to legend, troops belonging to Sultan Agung of the Mataram kingdom in Central Java were camped in the Tanah Abang area prior to their unsuccessful attack on the young Dutch city of Batavia in 1628. The troops noticed the red earth (*tanah abang* in Javanese) around them, and thus the name was given.[65]

Tanah Abang became an important source of supplies, including agricultural produce, for Batavia after the digging of the Molenvliet canal in 1648, because sugar, teakwood, ginger and peanuts could be transported along the canal from Tanah Abang to the walled city of Batavia in the north. Some of the street names in and around Tanah Abang today, such as Kebon Jati ("Teak Garden"), Kebon Jahe ("Ginger Garden") and Kebon Kacang ("Peanut Garden"), still remind us of those early activities in the area.

However, Tanah Abang is generally best known for its large market which was established by Justinus Vinck in 1735 and still exists today. In the same year, Vinck also opened the Pasar Senen market on the famous Weltevreden estate he acquired in 1733, in addition to building the roads that are now Jalan Prapatan and Jalan Wahid Hasyim in order to connect the two markets. Initially, the Tanah Abang market was permitted to open only on Saturdays but from 1745, it was also allowed to open on Tuesdays and Wednesdays. In 1801, trading days were limited to just Wednesdays and Saturdays.[66]

The Tanah Abang market was burnt down during the infamous Chinese massacre of October 1740, a tragedy from which the area took many years to fully recover.

Looking south along Tanah Abang West

This photograph looks in a south-westerly direction along the southern end of Tanah Abang West (Jalan Abdul Muis). It was taken just beyond the southern corner of what are today Jalan Kebon Sirih and Jalan Abdul Muis near the front of the Millennium Hotel. In the distance on the right we can see two of the four houses that comprised a large landhuis ("country seat") originally dating back to the mid-18th century.

In 1875, this estate was inherited by Pieter Albert de Nijs Bik from an uncle, Jannus Theodorus Bik (1796-1875), who acquired it in 1863 but died childless. De Nijs Bik sold the larger two houses in 1918 before his death in 1920, with the smaller two staying in his family until 1948. From the late 1950s through to the 1970s, the four houses were demolished to enable the expansion of the Tanah Abang market.

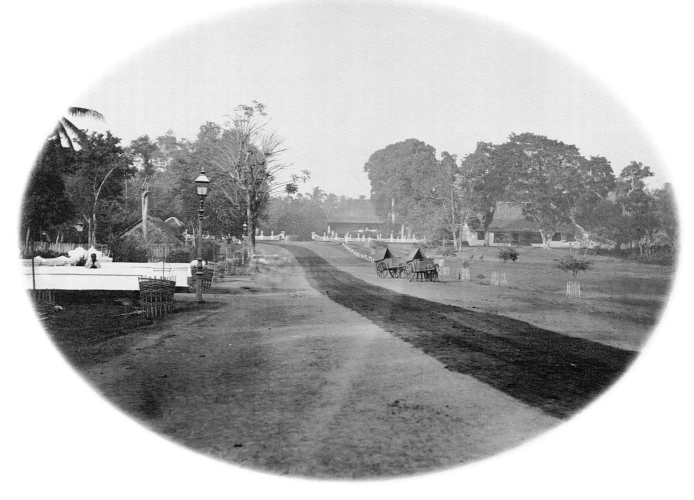

127. Photographer: **Jacobus Anthonie Meessen**, c. September 1867 ■ albumen print ■ size: 16.0 x 21.2 cm ■ collection of the Royal Library, The Hague.

Canal scene at Tanah Abang

This very early view of Tanah Abang by Woodbury & Page is one of only three salt prints known to exist showing topographical views of Batavia. The other two can be seen on pages 152 and 155. All three probably date back to the period between December 1858 and late May 1859 when Woodbury & Page operated a photographic studio next to the premises of Leroux & Co. on Rijswijkstraat (Jalan Majapahit).

This photograph was taken from one of the bridges which span the Tanah Abang canal that runs along what is now Jalan Abdul Muis (previously known as Tanah Abang West) not far from the corner with Jalan Kebon Sirih. We are looking in a northerly direction across the canal towards Tanah Abang West where a mosque is visible in the centre with a Chinese shop or residence on its right.

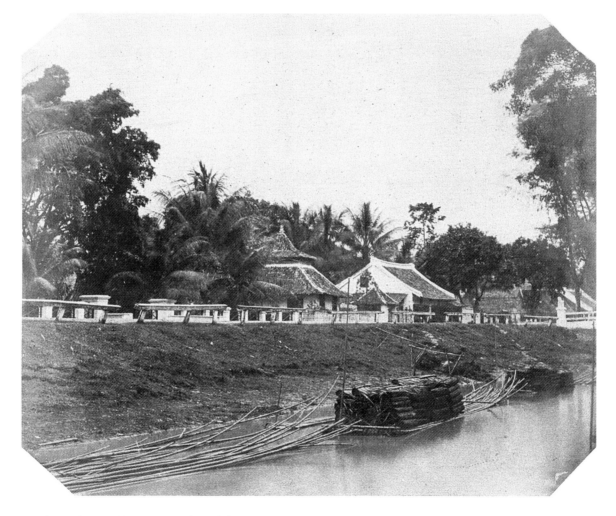

128. Photographer: **Woodbury & Page**, c. first half of 1859 ▦ varnished salt print ▦ size: 19.3 x 22.2 cm ▦ collection of the Royal Photographic Society, Bath.

Scene at Tanah Abang

Here we are looking in a south-westerly direction along Tanah Abang West (Jalan Abdul Muis) with the canal on the left. The photographer would have been standing near the corner of Gang Scott (Jalan Budi Kemuliaan) facing in the direction of Kebon Sirih (Jalan Kebon Sirih). The ethnic diversity that was a feature of Tanah Abang is evident in the variety of architectural styles along the street. The Chinese shop and mosque in the distance can be seen more clearly in the centre of the photograph on page 239. A mosque (the "Ar-Rohah" mosque) stands on the same site today.

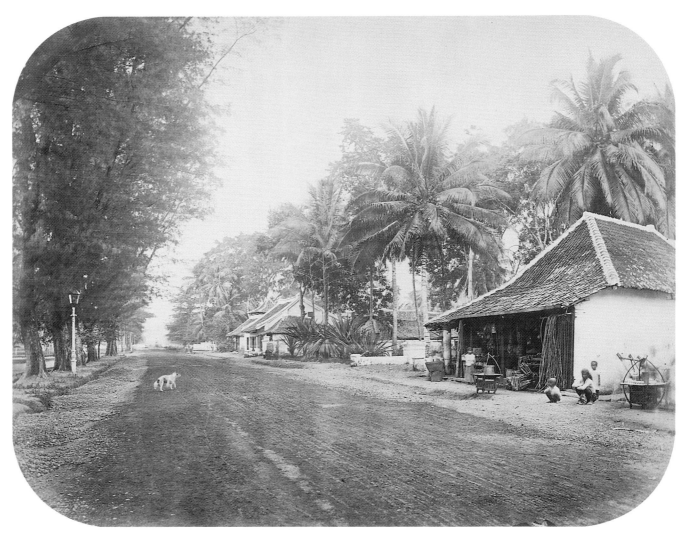

129. Photographer: **Woodbury & Page**, late 1860s ▨ albumen print ▨ size: 18.9 x 23.8 cm ▨ collection of the author, Melbourne.

The canal at Tanah Abang

This photograph was probably taken looking north from the bridge at the western end of Gang Scott (Jalan Budi Kemuliaan) which crossed over the Tanah Abang canal between Tanah Abang West (Jalan Abdul Muis) on the left and Tanah Abang Oost (Jalan Tanah Abang Timur) on the right. In the second half of the 19th century, this was a fashionable residential district for Europeans. On both sides of the canal we can see the front fences of luxury European homes. A modern visitor would find that this scene has totally changed. The canal has been narrowed to a width of barely a few metres to enable Jalan Abdul Muis to accommodate four lanes of traffic while commercial premises now dominate this area.

130. Photographer: **Woodbury & Page**, c. 1865 ■ albumen print ■ size: 19.2 x 24.4 cm ■ collection of the author, Melbourne.

The residence of Mr Martinus Petrus Pels

Mr Martinus Petrus Pels was first listed as a resident of Batavia in 1859 and was an active member of Batavia's social and business circles. He was the honorary vice-consul in Batavia for the United States of America from 1862 until 1864 or 1865. In 1867, he was the honorary consul for the German Grand Duchy of Mecklenburg. He was also listed as a member of Batavia's Association of Industry and Agriculture in 1865, and a member of its council in 1866.

Mr Pels was secretary of the Batavian Musical Society in 1864 and 1865 and a commissioner of the prestigious Harmonie Society (*see pages 122-125*) from 1868 to 1870. From 10 June 1869, he was also a second lieutenant in the infantry of the "Schutterijen", which was a part-time civilian defence force.

Mr Pels probably spent most of his career in Batavia working for Dummler & Co., which was a trading firm and a shipping and insurance agent. He was the head of the firm from 1870 until 1872. He may have been involved with the establishment of Batavia's first horse-drawn tramways, because in 1867 it was Dummler & Co. that obtained the first tramway concession in Batavia.

Mr Pels left Batavia temporarily sometime after March 1865, and his name does not appear in the official name list of European residents in 1866. However, he does appear again in 1867, which suggests he had returned to Batavia in the second half of 1866, certainly before 3 September 1866 when he became a member of Batavia's Chamber of Commerce and Industry. In the approximately one and a half years he was absent from Batavia, he may have taken leave (perhaps to Europe) or he may have been transferred to work in another part of the Indies.

Prior to Mr Pels' temporary departure from Batavia, his household belongings were auctioned at his home on Wednesday, 29 March 1865.[67] His address at the time was given as "Te Tanah Abang Oostzijde, weg naar Gang Scott" (on the east side of Tanah Abang, on the road to Gang Scott), which in modern terms would be on Jalan Tanah Abang Timur near the corner of Jalan Budi Kemuliaan.

Where Mr Pels lived after he returned to Batavia in 1866 is not known, but the house in this scene could certainly have been on Tanah Abang Oost (now Jalan Tanah Abang Timur). This photograph is from a large album that contains only nine photographs of Batavia (including this one), but of which two are views of Tanah Abang and another is a view of Gang Scott and, therefore, in the immediate neighbourhood of where Mr Pels was living until March 1865. Perhaps the album belonged to the Pels family. It is highly likely to be Mr Pels and his family who can be seen standing on the front verandah of the house.

This photograph is rare, and was probably commissioned by Mr Pels himself. It does not appear to have been available in the inventory of Batavia views that Woodbury & Page carried for general sale at their studio.

There is no record of Mr Pels after 1872. However, a relative seemed to follow him at Dummler & Co. given that a Mr P. F. W. Pels was joint head of Dummler & Co. from 1877 until 1879, and then sole head from 1880 until 1884. Dummler & Co. disappeared after 1884, possibly a victim of the economic crisis that hit the Netherlands Indies in the mid-1880s following the collapse of sugar prices.

131. Photographer: **Woodbury & Page**, c. 1865 ■ albumen print ■ size: 17.9 x 24.4 cm ■ collection of the author, Melbourne.

The European cemetery

The European cemetery in Tanah Abang was established on land either donated or sold to the Dutch authorities in 1795 by W. V. Helvetius van Riemsdijk, the son of Governor-General Jeremias van Riemsdijk (governor-general 1775-7), for the purpose of building a burial ground for Christians. The cemetery is located on Kerkhof Laan (Jalan Tanah Abang I). Since 1977, the remaining part of it has been a museum known as Taman Prasasti ("Park of Memorial Stones").

The cemetery was originally at least five and a half hectares in size, but in recent decades much of the land has been taken over for civic purposes, including the construction of the Central Jakarta mayoralty office on the cemetery's southern side. Only a little over a hectare of the original grounds remain. The white portico at the entrance dates back to 1844.

An interesting feature of the cemetery is that it contains tombstones from the 17th and 18th centuries that predate the cemetery's opening. This is because tombstones that had been located in churches or churchyards in the old city of Batavia in the north were brought to the "new" cemetery in Tanah Abang when those churches were demolished or destroyed. Two such churches were the "New Dutch Church" that stood from 1736 to 1808 on Binnen Nieuwpoort Straat (Jalan Pintu Besar Utara) and the Portuguese Binnen Kerk ("Portuguese Church Inside the Walls") that was located, until it was destroyed by fire also in 1808, on the northern corner of Kali Besar West (Jalan Kali Besar Barat) and Utrechtsche Straat (Jalan Kopi).

The "New Dutch Church" and its predecessor ("Old Dutch Church"), which stood on the same site from 1640 until 1732, were prominent institutions during VOC days and many senior officials, including numerous governors-general and their families, were buried there. Some of their tombstones are now in Taman Prasasti (marked "HK" for Hollandsche Kerk or "Dutch Church"), while others can still be seen in the Wayang Museum that stands on part of the site where the New Dutch Church was located on Jalan Pintu Besar Utara.

If we visit Taman Prasasti today, we can still find two of the tombstones visible in this photograph. However, they are no longer in the same close proximity to each other and are examples of the large number of tombstones that were relocated to other parts of the cemetery as large areas of the original grounds were gradually taken over to be used for different purposes. It is not clear which of these tombstones (if either) is still in its original location and, therefore, whether they are still standing above the coffins that were once buried beneath them.

The first of these tombstones is the elaborate cast iron Gothic style monument of the far left of the photograph (partly obscured by the trees) that was erected in 1855 to honour Major General Perie (or Perje), Commander of the Military Division of Java, who was born in Tilburg, Holland, on 31 May 1788 and who died in Batavia in 1853. The General was a holder of the "Order of the Netherlands Lion".

The second is the tall white pointed tombstone on the far right surrounded by the neat cast iron railings that was erected to the memory of L. Launy, a Dane born in Copenhagen on 28 February 1797 and who died in Batavia on 29 July 1849. Mr Launy was a senior finance official with the government in Batavia and was also a holder of the "Order of the Netherlands Lion" in addition to a Danish order. He must have been a popular man given that this tombstone was "erected by his friends with the consent of his family". His friends also had inscribed on the tombstone that "his memory remains blessed with happy reminiscences."

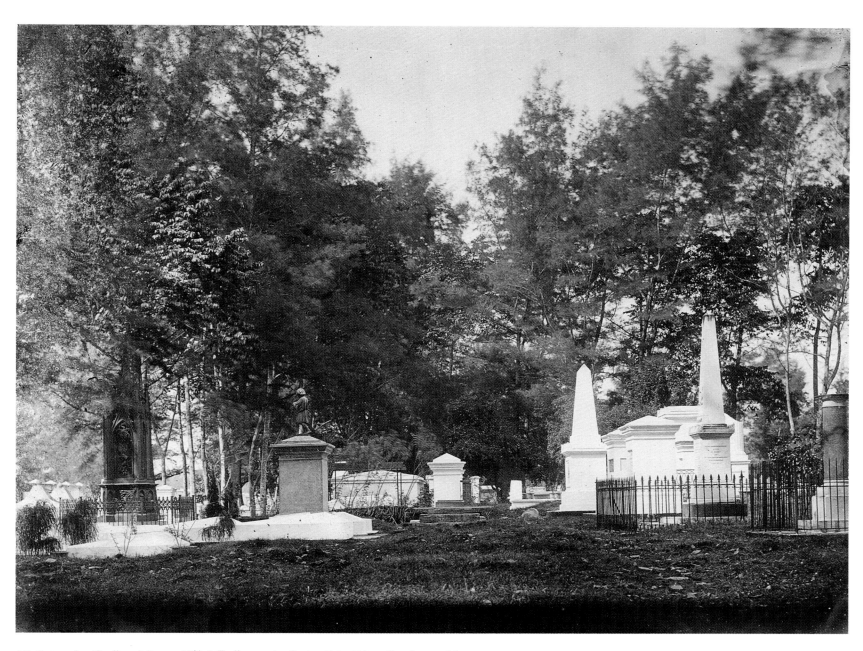

245. Photographer: **Woodbury & Page**, c. 1864–5 ■ albumen print ■ size: 18.3 x 24.4 cm ■ collection of the Tropen Museum, Amsterdam.

TANJUNG PRIOK

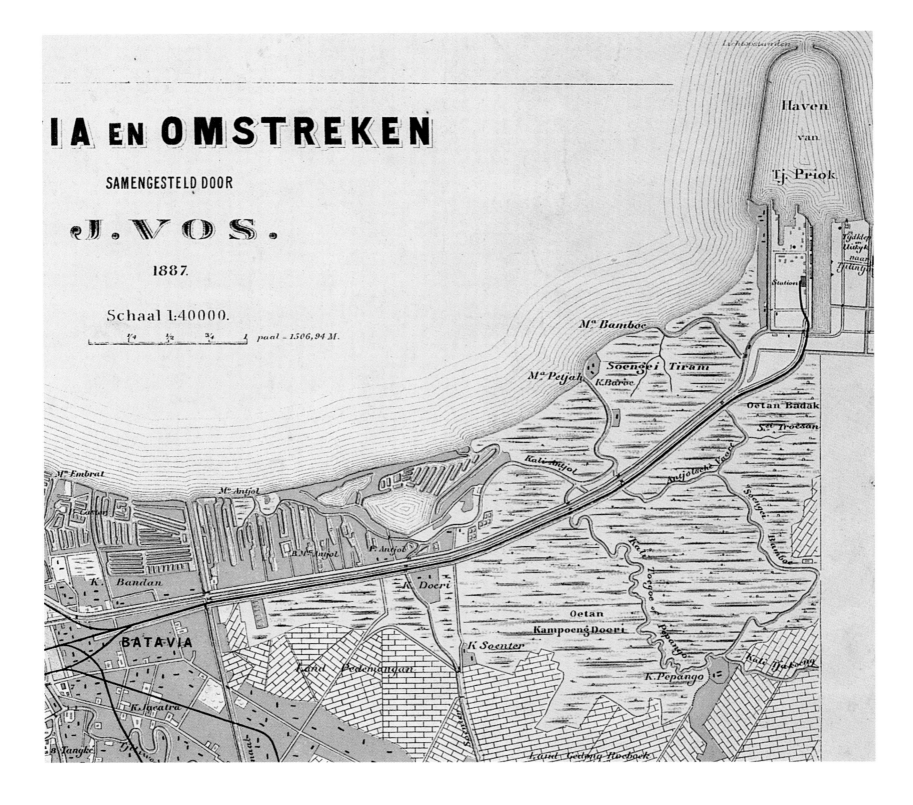

IA EN OMSTREKEN

SAMENGESTELD DOOR

J. VOS.

1887.

Schaal 1:40000.

¼ ½ ¾ 1 paal = 1506,94 M.

TANJUNG PRIOK

The shortcomings of harbour facilities at the old port of Batavia had been a frequent source of frustration and complaint since the 17th century, almost from the very beginning of Batavia itself in 1619. The site for the original port of Batavia, which is now the area known as Sunda Kelapa, was chosen because it lay at the mouth of the Ciliwung River. In Batavia's earliest days, small vessels could sail along the Ciliwung transporting goods to and fro between the ships anchored at sea and the warehouses located at and nearby Kali Besar.

Even by the mid-1630s, silting of the Ciliwung had become a problem. The solution was to build a dyke (or canal) extending some 800 metres out to sea that would be regularly dredged to ensure a smooth passage to and from the river. The situation was made worse by an earthquake in January 1699 that caused large amounts of mud and silt to be deposited in the dyke and resulted in silting levels increasing in subsequent years. Sand and silt continued to accumulate at the mouth of the dyke, which meant that its length frequently had to be extended. By 1827, the northern end of the dyke was 1,350 metres from the river mouth and maintaining an adequate depth of water in the dyke was a never-ending headache. Crude dredging methods were employed from time to time, but a permanent solution to the problem was never really found, not even by the 19th century.

The implications for shipping were very unfavourable. With each extension of the dyke, ships had to anchor further and further out at sea. Cargo had to be transported longer distances between the ships and Batavia's warehouses by small boats with a shallow draft called "lighters". This was not only time-consuming but was often treacherous in the wet season. It was also expensive, and the lighter business was known to be a very profitable one.

Facilities at Batavia's old port had been far from satisfactory for too long, and calls for improvement were continually made. By the 1860s, a decision on how to proceed could no longer be delayed. The imminent opening of the Suez Canal in November 1869 became a major catalyst for action. The canal would dramatically reduce the travelling time between Europe and Batavia and, therefore, lead to an increase in shipping traffic. The gradual replacing of sailing ships by steamships during the 19th century also made the upgrading of Batavia's port facilities essential. Steamships were usually larger and required a faster turnaround time than sailing vessels. In addition, the Dutch authorities could not avoid the need for Batavia to be able to compete effectively for trade with the then British port of Singapore.

The area of Tanjung Priok, nine kilometres east of the old port, was identified as a suitable location for a modern new deep-water harbour. Construction started in May 1877 and was completed by the end of 1885. A railway was also built to link Tanjung Priok with both the old city of Batavia and the newer districts in the south. Tanjung Priok remains to this day the major port of Jakarta for all large shipping traffic.

Survey work at Tanjung Priok

Extensive survey work was carried out in the Tanjung Priok area in 1867, as can be seen in the photograph below. Many members of Batavia's business community strongly opposed the development of this area because they feared that the long-established commercial district around Kali Besar would become deserted if a new centre grew up around Tanjung Priok. Instead, they favoured the building of a new harbour closer to the existing one. To resolve the matter, an independent commission was appointed to be the final arbitrator and eventually decided in favour of Tanjung Priok.

133. Photographer: **Woodbury & Page**, 1867 ■ albumen print ■ size: 17.5 x 22.5 cm ■ collection of the KITLV, Leiden.

Port of Tanjung Priok under construction

After much delay, construction of the new port of Tanjung Priok finally commenced in May 1877, some seven and a half years after the opening of the Suez Canal. It was clearly well underway when the photograph below was taken. By 1883, most of the work had been completed, with the final phases being finished by the end of 1885. As it happened, the business community around Kali Besar need not have worried about Tanjung Priok because no major township grew up around the new port. Tanjung Priok quickly came to be regarded as a malaria-infested and generally unhealthy place to live and work, which meant the trading houses and insurance companies remained in the old town nine kilometres away.

134. Photographer: **Woodbury & Page**, c. 1880 ■ albumen print ■ size: 19.8 x 24.9 cm ■ collection of the Museum of Ethnology, Rotterdam.

The *S. S. Swaerdecroon* at Tanjung Priok

Shipping traffic at the new port of Tanjung Priok increased steadily, although perhaps not as rapidly as was originally expected. In 1885, 487 steamships and 47 sailing ships entered the port. Between 1886 and 1890, this rose to an average of 587 and 56 per annum respectively. Between 1891 and 1897, the averages were 797 and 48 while in 1913, 1,636 steamships and 31 sailing ships arrived at the port.[1]

The steam ship docked at Tanjung Priok in this photograph is the *S. S. Swaerdecroon*, which measured 641 gross tons and was launched in 1890. It was part of the fleet of the KPM or Koninklijke Paketvaart Maatschappij ("Royal Packet Navigation Company"), which was the leading shipping line in the Netherlands Indies from 1891 until the end of the colonial period.

During the last quarter of the 19th century, the operation of mail and passenger shipping services in the Indies was in the hands of private companies that worked under contracts awarded by the government.

For the 15-year period from 1876 to 1890, the contract was held by the Netherlands India Steam Navigation Company. In 1888, the government awarded the contract for the next 15-year period (1891–1905) to three Dutchmen, who

on 12 August 1888 formed the KPM.

The new company then proceeded to have 13 steamers built in Holland, one of which would have been the *S. S. Swaerdecroon*, which came from the De Maas shipyard at Rotterdam. In July 1890, the KPM also opened an office in the Kali Besar district of Batavia in preparation for the commencement of the contract period on 1 January 1891. From that date, the KPM operated thirteen routes throughout the Netherlands Indies, six of which departed regularly from Tanjung Priok. The KPM covered the entire archipelago, including Sumatra, Borneo, the Moluccas, Sulawesi and Irian Jaya.

The *S. S. Swaerdecroon* was sold to new owners in Japan in 1906, and its name was changed to "*Kimigayo Maru*". It continued to operate under a Japanese flag until 23 May 1945 when it hit a mine and sank not far from Shanghai, China.

The *S. S. Swaerdecroon* took its original name from Hendrik Zwaardecroon, who was governor-general of the VOC from 1718 to 1725. There appears to be several variations of the spelling of his name, but on his tombstone, which can still be found at the old Portuguese church on Jalan Pangeran Jayakarta (*see pages 72–73*), the spelling is "Henric Zwaardecroon".

135. Photographer: **Woodbury & Page**, early 1890s ■ albumen print ■ size: 19.0 x 24.2 cm ■ collection of the author, Melbourne.

APPENDIX ONE

TOWARDS THE EARLIEST TOPOGRAPHICAL PHOTOGRAPHY IN BATAVIA

When was the earliest photograph of a building or a landmark or a street scene taken in Batavia? Perhaps an impossible question to answer with any certainty. The earliest views that could be found for this book date back to circa the first half of 1859. However, it is clear that topographical photography of Batavia was not a priority for the Netherlands Indies' colonial government which was the early sponsor of photographic work in the 1840s, nor for the pioneering private commercial photographers who either lived in or passed through Batavia in the 1850s and early 1860s.

The colonial government saw photography as a means of recording Javanese antiquities and natural history, while commercial photographers, who obviously needed to earn a living, took advantage of the lucrative demand for photographic portraits. Photography was still an expensive undertaking in its early decades and professionals in the field needed to take views that they could readily sell. There was apparently little early demand for views of Batavia, and hence the lack of them until the late 1850s and early 1860s.

The first photographer known to have arrived in Batavia was Jurriaan Munnich (1817-65), a medical officer, who was commissioned by the Dutch Ministry of Colonies in 1840 to travel through Central Java in order to "collect photographic representations of the principal views, etc. and also of plants and other natural objects".[1] This was only a year after Louis Daguerre's invention of photography had been announced in France in August 1839, and showed how quickly the Dutch government sensed photography's potential.

Munnich arrived in Batavia in 1841 and made 64 Daguerreotypes during his travels in Java. However, they were a disappointment and reflected his lack of understanding of the impact of tropical heat and humidity on the sensitive Daguerreotype process.

Two years later in 1843, the Dutch government accepted a proposal from Adolph Schaefer, a German-born professional Daguerreotypist living in The Hague, to work as a photographer in the Netherlands Indies. Schaefer was loaned money to buy photographic equipment in Europe and make the trip to the Indies on the understanding he would repay the loan with photographs to be commissioned from him. The government believed it would be useful to have a professional photographer in the Indies to assist the archaeological research being undertaken on Javanese antiquities and also to enable Dutch citizens to have their portraits taken.

Schaefer arrived in Batavia in June 1844, but was apparently in no hurry to honour his commitments to the government. Instead, he established what was probably the first photographic studio to operate in Batavia. An account in the *Javasche Courant* on 22 February 1845 noted of Schaefer that:

> So far he has mostly occupied himself with making portraits; a large number of which he has produced with best results; and those portraits give ample evidence of his talent. However, now he has stopped his work and he is busy preparing himself to make Daguerreotypes of the stone statues which decorate the archeological cabinets of the Batavian Society of Arts and Sciences, as well as the statues recently bought by the Society, depicting characters of the Balinese *wayang*.

In the same article, the journalist noted the striking realism that was achieved with a photographic portrait. Perhaps it was the first time he had seen one:

> He who likes to be flattered will never want a Daguerreotype portrait; for there is no flattery here; it is the mirror which reflects the deficiencies as well as the beauty.

The government was soon frustrated by Schaefer's tardy attitude and also by his extravagant demands for prices for his photographs that were approximately ten times higher than prices prevailing in Europe at the time.[2] Finally in April 1845, Schaefer was ordered to make Daguerreotypes of some of the collections of the Batavian Society of Arts and Sciences in Batavia. Later in the same year, he was sent to Central Java to make Daguerreotypes of the bas-reliefs of the Borobudur temple. He produced at least 58 successful images of Borobudur, and it is for this work that he is best known today.

After its frustrations with Munnich and Schaefer in the 1840s, the colonial government appeared to abandon any further thought of utilizing photography for scientific or archeological purposes. It wasn't until the early 1860s that it tried again.

If the 1840s were characterized by government sponsorship of photography for scientific pursuits, then the dominant features of the 1850s were the emergence of private commercial photographers and the popularity of photographic portraits.

In late January 1853, the itinerant photographer L. Saurman was in Batavia and operating "Saurmans Daguerrian Gallery" from the Marine Hotel (*see pages 112-113*). His advertisements make it clear that he was only offering portraits.

Java Bode, 22 and 26 January 1853

In May 1855, Saurman was in Singapore making portraits from a studio at the London Hotel.[3]

Another itinerant photographer, C. Düben, was in Batavia in July and August 1854 offering "New Daguereotype" portraits from a studio "opposite the house of Mr Humme on Molenvliet".[4] Düben was quite a traveller. In May 1853, he was working as a Daguerreotypist in Hong Kong, where he also invited people to examine "specimens" he had made in Shanghai, Macao and Manila.[5] In April 1854, he was offering his services as a photographer in Singapore.[6] By mid-1857, he was back in Batavia operating his "Nieuwe Photographische Galerij"

from the Hotel der Nederlanden (*see pages 130-131*).[7]

Java Bode, 5 and 9 August 1854

The last known advertisement for Daguerreotypes in Batavia appeared in the *Java Bode* on 23 December 1854 when an unknown photographer announced: "The Studio for Daguerreotype Portraits, on Molenvliet, opposite Gang Ketapang."

Java Bode, 23 December 1854

The first photographer in Batavia known to have offered photographs on glass and paper (rather than Daguerreotypes, which were made on silver-coated copper plates) was Antoine François Lecouteux, who worked from a studio in Noordwijk (now Jalan Juanda). Lecouteux's advertisements in the *Java Bode*

on 6 and 9 September 1854 suggest that he was familiar with making ambrotypes on glass as well as albumen paper prints from wet collodion glass negatives, processes which were still very new at that time, having only been developed in the early 1850s. Lecouteux offered to make portraits and photographs of paintings and engravings.

PHOTOGRAPHIE
sur Verre et sur Papier.
Portraits et Groupe de Famille ; reproduction de Tableaux à l'huile ; Gravures, etc.
Point de vues de la grandeur de 40 centimètres sur 50.
(1324) Chez A. LECOUTEUX , à Noordwijk.

Java Bode, 6 and 9 September 1854

In May and June 1855, Lecouteux teamed up with the Belgian-born portrait painter and theatre personality, Isadore van Kinsbergen (1821-1905) in an arrangement whereby Lecouteux took photographs that were then coloured or retouched by van Kinsbergen.[8] Their partnership appeared to have been short-lived because in 1856, Lecouteux was operating alone again.[9] Van Kinsbergen later achieved recognition as a photographer in the 1860s and 1870s with his superb views of Javanese antiquities.[10, 11]

In July 1857, Lecouteux was advertising himself as the Groot Photographisch Atelier van A. Lecouteux ("Great Photographic Studio of A. Lecouteux") and offering "Photography of every kind on glass and on paper", but the emphasis still appeared to be on portraits.[12]

GROOT PHOTOGRAPHISCH ATELIER
van
A. LECOUTEUX,
Noordwijk naast den Toko MUIJSENBERG.
Photographie in alle soorten op glas en op papier.
Portretten op papier à ƒ 10.— en ƒ 15.— voor goede uitvoering wordt ingestaan.
Nota. Personen die mijne nieuwe proeven verlangen te zien wordt daartoe elken morgen van 8 tot 10 ure , des Zaturdags uitgezonderd , de gelegenheid aangeboden.
(1867) A. LECOUTEUX.

Java Bode, 1 July 1857

Lecouteux's advertisements spanned an almost three-year-long period from September 1854 until July 1857, although they appeared on only a rather intermittent basis. Nevertheless, he was probably the first photographer to operate a reasonably permanent photographic studio in Batavia as distinct from the itinerant photographers such as Saurman or Düben who spent no more than a few weeks or months in Batavia working from hotels.

Thus had been the development of photography in Batavia by the time Walter Bentley Woodbury and James Page arrived there from Melbourne, Australia in May 1857. Daguerreotypes had given way to albumen prints and ambrotypes, while the focus of photographic work had shifted from supporting archaeological research to making portraits.

The number of photographers in Batavia at the time was still small. In a letter to his mother on 9 June 1857, Woodbury somewhat immodestly noted that: "There are three other artists here only they all give me preference."

The "three other artists" would have been Lecouteux working from his studio on Noordwijk, the travelling photographer Düben with a temporary studio at the Hotel der Nederlanden (also on Noordwijk) and probably van Kinsbergen, who was active in photography at the time although his major interest was the theatre.

The newly established partnership of Woodbury & Page operated their first studio in Batavia between 5 June and 15 October 1857 and their focus was also portraits. Demand for these was strong, as Woodbury noted to his mother in a letter dated 9 June 1857: "I opened about a week ago and think that everything looks well. Every day we have had carriages at the door every ten minutes and have got engagements for the next week so the commencement has been good."

Prices for portraits were also high, as Woodbury observed in a separate letter to his mother on 2 September 1857 (*see page 258*). There is no record of any topographical images of Batavia being made during this period.

During most of 1858, Woodbury & Page worked as travelling photographers in Central and East Java, where Woodbury's letters show that he was aware of the commercial potential of photographs of "views" as opposed to "portraits". On 1 September 1858, Woodbury wrote to his mother from Surakarta (Central Java), noting that: ". . . we have also a lot of large views of the ruined temples of this place which the Government of Holland are very anxious to obtain, altogether we expect to get as much as £400 for the collection."

However, clearly Woodbury's "views" were of Javanese antiquities in which the colonial government had been interested since the 1840s. There is no hint that Woodbury was excited by the commercial possibilities of topographical images such as buildings, monuments or street scenes from Java's major cities.

Back in Batavia from at least 8 December 1858, Woodbury & Page opened a studio in Rijswijkstraat (Jalan Majapahit) where they remained until late May

1859. From this location, they again offered portraits to the public in their advertisements in the *Java Bode*.[13]

Java Bode, 8 and 11 December 1858

It was probably also during this short six-month period that the three salt prints on pages 152, 155 and 239 that are potentially the earliest surviving topographical photographs of Batavia were taken. However, it is unlikely that they were made for commercial purposes. Albumen prints would have given richer tonal qualities than salt prints and, therefore, have been more easily saleable, as Woodbury & Page would certainly have known at that time. It is more likely that the salt prints were experiments with different papers in Java's high humidity, or perhaps Woodbury & Page had temporarily run out of albumen paper.

It is also possible that they were just amusing themselves by taking the salt prints during a slow period in their portrait business. Between 2 February and 6 May 1859, Woodbury & Page's studio was temporarily closed pending the arrival from Europe of a new supply of frames and cases that were needed to sell ambrotype portraits.[14] Both men would have had ample leisure during that period. The fact that the only known copies of these three salt prints are to be found in an album that was once the personal possession of Walter Woodbury himself further suggests that they were not taken for commercial sale.

It would not be until more than two years later that Walter Woodbury would first advertise *gezigten van Batavia* ("views of Batavia") for sale at his studio in Rijswijk, in two separate advertisements in the *Java Bode*, both on 28 August 1861. In one of the advertisements, "Woodbury's Photographic Warehouse" offered *Groote gezigten van Batavia* ("Large views of Batavia") which were presumably albumen prints. In the second one, Woodbury offered stereotypes that "had just been received by the mail steamer". These were the earliest known occasions that advertisements specifically mentioning topographical photographs of Batavia ever appeared in the Indies press. Perhaps Walter Woodbury sensed that demand for such views already existed.

One of the albumen prints that Woodbury probably had for sale at that time is the view looking along Molenvliet that can be seen on page 97. The stereotypes he had available almost certainly included the two Glodok Chinatown scenes on page 79 that were published by Negretti & Zambra in London from views that Woodbury & Page had most likely taken between early June and 15 July 1859.

Java Bode, 28 and 31 August 1861

Java Bode, 28 August 1861

It was almost another two years before the first known list of individual photographs of Batavia ever publicly offered for sale appeared in a Woodbury & Page advertisement in the *Java Bode* on 27 May 1863. On that occasion, 16 "newly taken" views of Batavia were offered for five guilders each. Further discussion of this list can be found in Appendix Three.

APPENDIX TWO

THE PHOTOGRAPHERS

Woodbury & Page

There can be no doubt that the most famous and important firm of commercial photographers in Batavia in the 19th century was Woodbury & Page. Without the magnificent photographs of this firm, the photographic record of 19th century Batavia would be so poor as to be almost negligible.

The firm was founded in 1857 by two Englishmen, Walter Bentley Woodbury (1834-85) and James Page (1833?-65), who first met each other on the goldfields of Victoria, Australia in the mid-1850s. They arrived in Batavia on 18 May 1857 and operated their first photographic studio between 5 June and 15 October 1857 from a private home on the south side of Koningsplein (Medan Merdeka), near the Armenian church (*see pages 164-165*) and probably not far from the house on page 169.

Throughout most of 1858, Woodbury and Page travelled extensively through Central and East Java before returning to Batavia towards the end of the year. An advertisement in the *Java Bode* of 8 December 1858 announced that Woodbury & Page had opened a photographic studio next to the firm of bakers, Leroux & Co. in Rijswijkstraat (*see pages 154-155*) and was offering portraits to the public. Woodbury & Page stayed at these premises until late May 1859, and it was probably during this period that they took the three salt prints on pages 152, 155 and 239 that are perhaps the earliest topographical views of Batavia to have survived to this day.

From Rijswijkstraat, Woodbury & Page moved to the Glodok Chinatown district in the north of Batavia where they operated a studio for approximately one and a half months until 15 July 1859. It was probably during this brief period that they took the two stereotypes that appear on page 79.

Woodbury and Page spent most of 1860 again travelling through Central and East Java together with Walter's brother, Henry James Woodbury (1836-73), who arrived in Batavia in April 1859. The return of the three men to Batavia in November 1860 would appear to mark the end of the relatively brief three-and-a-half year partnership between Walter Woodbury and James Page because they were never to work together again. The reason why they decided to go their separate ways is not known. Nevertheless, Page returned to England for a few months around the end of 1860 while Woodbury remained in Batavia to further develop his career as a commercial photographer, possibly with the assistance of his brother Henry.

On 18 March 1861, Walter Woodbury opened a photographic studio in Batavia adjoining a house he acquired from a Mr van Dorp. Woodbury called his studio the "Photographisch Atelier van Walter Woodbury" or "Atelier Woodbury", and it can be seen on the left-hand side of the photograph on the opposite page. These premises were located on the corner of Gang Secretarie (*see pages 174-175*) and Rijswijk, next to the Hotel der Nederlanden (*see pages 130-131*) and only two or three doors along from the official residence of the governor-general (*see pages 128-129*).

That a young photographer still in his 20s, who had very little money when he arrived in Batavia less than four years earlier, could afford to acquire such a prime property is evidence of how profitable photographic work must have been. Indeed, in his letters to his mother in England, Woodbury mentioned the prosperity he was enjoying:

We get very good prices for our portraits from 20 Rupees to 120. (Batavia, 2 September 1857)

At present we are doing a very good business, the average receipts a day since we have been in Surabaya have been about 120 Rupees. (Surabaya, 2 March 1858)

A Dutch visitor to Batavia in 1862 also noticed that photography was very lucrative:

For photographs, e.g. in the Indies money is earned in abundance, (in Batavia that industry is now found in the hands of an Englishman and a Belgian).[15]

136. THE STUDIO (ATELIER) AND HOME OF WALTER WOODBURY
Photographer: **Atelier Woodbury**, between 18 March 1861 and 31 December 1862 ■ albumen print ■ size: 22.6 x 29.3 cm ■ collection of the author, Melbourne.

This photograph shows the home and photographic studio of Walter Woodbury in Batavia during the period he operated as the "Photographisch Atelier van Walter Woodbury" or "Atelier Woodbury" between 18 March 1861 and 31 December 1862. These premises were located on the corner of Rijswijk (*see page 126*) and Gang Secretarie (*see pages 174–175*). The identities of the people seen here are not known but Miss Luanne Woodbury, a grand-

daughter of Albert Woodbury, has suggested that this photograph might have been taken on the wedding day of Walter Woodbury to Marie Sophia Olmeijer on 22 January 1863 although this cannot be confirmed. The studio was used by Woodbury & Page until 1908 but no longer exists. The site now forms part of the grounds of Bina Graha, the office of the President of the Republic of Indonesia.

It was from these premises that Walter Woodbury for the first time offered *gezigten van Batavia* ("views of Batavia") for sale in advertisements in the *Java Bode* on 28 August and 31 August 1861 (*see Appendix One*). These advertisements were the first known occasions that topographical photographs of Batavia were ever publicly offered for sale.

"Atelier Woodbury" was certainly the most important photographic establishment in Batavia in the early 1860s. It sold portraits, views of Java, stereotypes, cameras, lenses, photographic chemicals and "everything connected with the subject of photography".[16] Advertisements for the "Atelier" appeared in the local press on an almost weekly basis.

Walter Woodbury left Java for the last time to return to England in late January or early February 1863. He continued to be active in photography and perhaps became best known for his invention of the "Woodburytype", one of the first successful methods of photomechanical printing. However, despite his prosperity in Java, he died in relative poverty in England on 5 September 1885, leaving behind an estate valued at only £240.

From 1 January 1863, "Atelier Woodbury" again became "Woodbury & Page", but in the persons of James Page and Henry James Woodbury. They continued to operate from the same premises on Rijswijk. However, Page became seriously ill in 1864 and returned to England, where he died in January 1865. Before his return to England, the firm of Woodbury & Page was sold to a German named Carl Kruger in late August 1864. Henry James Woodbury returned to England in 1866 and died there in July 1873.

A third Woodbury brother, Albert Woodbury (1840-1900), bought out Kruger on 1 March 1870 to become the new proprietor of Woodbury & Page. He held the position for just over a decade until he sold the firm to Adolf Constantine Franz Groth in late 1881 or early 1882. He later returned to England, where he died in April 1900.

Woodbury & Page reached the peak of its success in the 1870s, when the firm was already famous throughout the Netherlands Indies. The 1870s also witnessed an increase in the number of visitors to Batavia following the opening of the Suez Canal in 1869 and the passing of the Agrarian Law in Holland in 1870, which paved the way for a larger role for private enterprise in the Indies. A highlight for Woodbury & Page came in 1879, when it was awarded the right to use the royal coat of arms of King Willem III of Holland.

From the early 1890s, Woodbury & Page went into decline. This was partly attributable to competition from the larger number of commercial photographers who were operating in Batavia by that time and also because improvements in technology had opened up photography to the mass market from the late 1880s. The firm was dissolved in 1908.

Many of the Woodbury & Page photographs in this book were taken while the proprietors of the firm were Carl Kruger (1864-70) and Albert Woodbury (1870-81 or 1882), but we do not know which photographs were taken by Kruger or Woodbury themselves and which were taken by their staff. A characteristic of Woodbury & Page throughout the history of the firm was that the individual photographers of each view were almost never identified and instead it was the firm's name that was given prominence. One of the few exceptions to this practice was during the "Atelier Woodbury" period between 18 March 1861 and 31 December 1862 when Walter Woodbury occasionally stamped the mounts of some of his photographs with "Photographed by Walter Woodbury, Java".

Very few surviving Woodbury & Page photographs of Batavia were actually taken by the firm's founders, Walter Woodbury or James Page. In this book, the only ones might be the salt prints on pages 152, 155 and 239, the two stereotypes on page 79 and the views described in Appendix Three. This is a reflection of the fact that the involvement of the founders lasted only a few short years and that their main focus was generally portraits.

Nevertheless, an enduring feature of Woodbury & Page was that the high-quality standards set by the founders were maintained, or even further improved, by the later proprietors of the firm. We can admire the attractive and often striking composition of many of their photographs and we can be impressed by the technical mastery they achieved in producing images of rich tonality and sharp clarity despite the difficult and humid conditions in which they had to operate in the Netherlands Indies. These features continue to be enjoyed today more than a century and a quarter after most of the photographs were taken and help to make the work of Woodbury & Page not only a great pleasure to view, but also very important from historical and topographical perspectives.[17]

137. THE INTERIOR OF THE WOODBURY & PAGE STUDIO
Photographer: **Woodbury & Page**, between 1879 and early 1882 ■ albumen print ■ size: 18.5 x 23.3 cm ■ collection of the author, Melbourne (acquired from the Woodbury family).

This beautiful photograph shows the interior of the Woodbury & Page studio in Batavia complete with three cameras and a variety of cabinet card portraits on the side tables. We are looking here from the rear of the studio towards the front doors. The door on the left leads to the house. The exterior of the studio can be seen on page 259.

This photograph was probably taken towards the end of Albert Woodbury's proprietorship of Woodbury & Page before he sold the firm late in 1881 or early 1882 and returned to England. On several of the cabinet cards we can see the coat of arms of the Dutch king that Woodbury & Page were permitted to use from 1879.

138. WOODBURY & PAGE ALBUM, MID-1860s

Size: 37.9 x 33.6 cm ■ collection of the author, Melbourne.

Interest in photographs of the Netherlands Indies and its people was high in the second half of the 19th century and Woodbury & Page, as the leading firm of commercial photographers in Batavia, was in a strong position to take advantage of the demand. They always maintained a stock of *gezigten* ("views") and *Indisch Typen* ("Native Types") for sale at their studio in Rijswijk and frequently advertised their photographs in local newspapers.

Customers of Woodbury & Page could buy photographs in specially embossed albums such as the one above or in Woodbury & Page presentation boxes, like the one on the opposite page, which would generally come with between 20 and 40 individually mounted views. They could also buy studio portraits of "native types" in great abundance. Amateur photography was not possible on a large scale until the late 1880s. People who wanted

photographs had no choice but to visit commercial firms such as Woodbury & Page.

It might seem strange that the titles on both the album and the presentation box are written in French whereas the Netherlands Indies was a Dutch colony and Walter Woodbury and James Page were both Englishmen. Nevertheless, in the second half of the 19th century almost everything French was very fashionable in Batavia, from French theatre, French food and wine, French shoes and fashions to French hairdressing styles and beauty treatments. The relatively small French population in Batavia played a disproportionately large role in the arts and social life of the city as well as in owning or running several of the major hotels and in operating many of the boutiques and retail stores. Newspaper advertisements in French were also not unusual.

139. WOODBURY & PAGE PRESENTATION BOX, 1870s

Size: 34.9 x 45.6 cm ■ collection of the author, Melbourne.

Jacobus Anthonie Meessen

Jacobus Anthonie Meessen was born in Utrecht, Holland, on 6 December 1836. He departed for the Netherlands Indies around 1860 to work as an architectural overseer or building inspector. He had clearly returned to Utrecht by 11 December 1862, given that he was married there on that date. He remained in Utrecht until at least April 1864, and then sometime thereafter returned to the Indies. Meessen advertised as a photographer in the *Sumatra Courant*, in Padang, West Sumatra, in May and June 1867.

From September until December 1867, Meessen was in Batavia. In the *Java Bode* on 18 September 1867 he advertised his "Atelier J. A. Meessen" (Studio of J. A. Meessen) offering *Diverse Typen en Gezigten* ("Diverse People and Landscapes") and announcing that his studio was open every day from 7.00 a.m. until 9.00 a.m., presumably to make portraits.

Meessen's stay in Batavia appeared to last no more than a few months, because on 20 December 1867 he auctioned his household belongings including a camera, a milk cow and calf, horses and wagons etc. on account of his impending departure from Batavia.[18] Meessen's whereabouts in the first half of 1868 are unknown, but from July 1868 until June 1869 he was back in Padang and again advertising as a photographer in the *Sumatra Courant*. By 24 October 1870, Meessen had returned to Utrecht accompanied by his wife and two daughters, both of whom were born in Batavia.

In February 1871, Meessen presented to the Dutch King a compilation of his photographs taken during his six years in the Netherlands Indies. The photographs were mounted in a magnificent album which bears the title:

Aan Z. M. Willem III, Koning der Nederlanden, Prins van Oranje Nassau, Groot Hertog van Luxemburg, wordt dit album, de vrucht van eene zesjarige reis door de Oost-Indische bezittingen, eerbiedig opgedragen door den vervaardiger. Utrecht, Februarij 1871. J. A. Meessen. Photographe. [To His Majesty Willem III, King of the Netherlands, Prince of Orange Nassau, Grand Duke of Luxembourg, this album, the fruit of a six-year journey to the East Indies colonies, is respectfully dedicated by the maker. Utrecht, February 1871. J. A. Meessen. Photographer.]

The album, now held at the Royal Library in The Hague, includes seventeen photographs of Batavia. Five of them are shown in this book plus a sixth one from a private collection. These views reveal Meessen's great skill. Not only did his technical mastery enable him to achieve images of rich tonality and sharp definition in the tropical climate of the Indies, but his work also displays an artist's feel for composition which imbues an atmosphere of considerable poignancy in many of the scenes he captured.

Photographs by Meessen were advertised for sale in Holland in *De Indische Letterbode* in March 1876. The advertisement offered 175 landscapes and 75 views of people by Meessen, taken throughout the Netherlands Indies (including Batavia). The price for the whole collection in a wooden presentation box or in four albums was 225 guilders. Individual landscapes were available for 1.25 guilders each. A detailed catalogue was available from J. H. de Bussy in Amsterdam. Response to this advertisement does not seem to have been strong given that photographs by Meessen are today extremely rare, suggesting that very few found their way into private hands.

Meessen died in Holland in 1885.[19]

140. KAMPONG KWITANG

Photographer: **Jacobus Anthonie Meessen**, c. September 1867 ▪ albumen print ▪ size: 16.0 x 21.0 cm ▪ collection of the Royal Library, The Hague.

This photograph of a European family's residence in the Kwitang area of Batavia was taken by Meessen, probably in the second half of 1867 and the caption reads *Kampong Kwitang* ("Kwitang Village"). It is a somewhat unusual image because photographers in the Indies at that time (including Meessen himself) usually took views of the grander residences of the Batavian elite (*see pages 179, 181, 221 and 223*) whereas the house in this photograph is somewhat more modest. Meessen was living in Kwitang in December 1867 and his address was *Kwitang, nabij de Brug van Parapattan* ("Kwitang, near the Prapatan Bridge").[20] It is tempting to think that this house was Meessen's own residence (or the one he was renting at the time), although there is no evidence to prove this conclusively even though part of a bridge is visible in the foreground.

The Netherlands Indies Topographic Bureau

Sixteen photographs in this book have been attributed as *possibly* being the work of the "Netherlands Indies Topographic Bureau". This is not a strong attribution, but is the best that can be concluded based on available information. All 16 are taken from a set of 35 photographs of *Batavia en omstreken* ("Batavia and its Environs") of which one is the office of the Netherlands Indies Topographic Bureau itself (*see the opposite page*). Early photographs of the the Bureau's office in Batavia are rare, and it might perhaps be regarded as unusual that such a photograph would be included in the set unless it was the Topographic Bureau itself that was responsible for producing it.

It can also be said that the theme of the photographs in the set is consistent with the type of images that a Topographic Bureau might logically produce, such as buildings, monuments, landmarks and street scenes. There are no portraits of indigenous aristocrats or views of tropical fruits or ruined temples that were so popular with commercial photographers in the Netherlands Indies in the second half of the 19th century.

It is also notable that the photographs in the set spanned a reasonably long period of time, from approximately the mid-1860s until the early 1880s. Woodbury & Page and Isadore van Kinsbergen were the only photographers or photographic firms known to have been continuously active in photography in Batavia during that period of almost two decades, but these images are unlikely to have been their work.

Furthermore, we know that the Netherlands Indies Topographic Bureau did occasionally publish photographs of Batavia. For example, in 1910 a set of 22 photographs (of which 21 depict views of Batavia) was issued by the Bureau in a leather-bound presentation box, the lid of which can be seen here. This set also includes two images of the Topographic Bureau's office in Batavia.

The development of the Netherlands Indies Topographic Bureau grew out of the desire of the Dutch colonial government to have reliable maps of the interior of the main islands of the Indies. From the early 1840s, the need for a defence plan for Java was the main motivation for initiating topographic surveying, and it was army surveyors who were predominantly responsible for the work. The first topographic survey on Java was carried out between 1849 and 1853 and covered the terrain between Batavia and Buitenzorg (Bogor). The surveying work was subsequently extended to include a topographic map of Batavia itself. In 1857, the number of surveying personnel was increased from one brigade to two, and then to four brigades in 1864.

On 25 February 1864, the surveyors were formally organized into a "Topographic Bureau", whereas before they had just been individual members of the corps of military engineers. Nevertheless, the Bureau still came firmly under the control of the army's engineering corps.

On 7 April 1874, the Topographic Bureau became an independent branch of the army general staff and its name became the Topographic "Dienst" ("Service"). Already at that time, a photographic studio existed as part of its facilities for the primary purpose of making photographic reproductions of topographic maps.

In 1901, the staff of the photographic studio at the Topographic Service comprised one photographer with the rank of civil servant or military supervisor, two assistant photographers from the ranks of non-commissioned officers and two indigenous assistants. Even as late as 1913, the photographic studio was still using wet collodion plates with a normal maximum size of 90 by 90 cm.

In 1907, the Topographic Service was separated from the army general staff and became the ninth division of the Ministry of War.

141. TOPOGRAPHIC SERVICE PRESENTATION BOX FOR PHOTOGRAPHS, 1910
Size: 38.8 x 45.7 cm ■ collection of the author, Melbourne.

142. THE OFFICE OF THE TOPOGRAPHIC BUREAU IN BATAVIA
Photographer: possibly the **Netherlands Indies Topographic Bureau**, between 1864 and 1874 ■ albumen print ■ size: 21.0 x 29.2 cm ■ collection of the author, Melbourne.

Given that this photograph shows the office of the Topographic "Bureau" (rather than the "Dienst" or "Service"), we can probably conclude that it was taken between February 1864 (when the surveyors were organized into a "Bureau") and April 1874 (when the "Bureau" became the "Service"). This office was located on the eastern side of Jalan Gunung Sahari, just opposite the eastern end of Sipaijers Weg (Jalan Dr Wahidin).

APPENDIX THREE

THE WOODBURY & PAGE LIST OF BATAVIA PHOTOGRAPHS FROM MAY 1863

The earliest known list of topographical photographs of Batavia ever offered for sale to the public was in an advertisement by Woodbury & Page which appeared in the *Java Bode* on 27 May 1863 offering 16 different views of Batavia for 5 guilders each (*see below*). A very similar advertisement offering the same list of 16 photographs appeared in the *Java Bode* three days later on 30 May 1863 and was repeated on 3, 6, 13, 20 and 24 June 1863 (*see next column*).

The answer might largely be found in one particular early Woodbury & Page album from the mid-1860s, which contains (among other views) 24 photographs of Batavia. The subjects of 12 of them quite precisely tie in with 12 of the 16 captions listed in the Woodbury & Page advertisements. This cannot be regarded as a coincidence because there would have been only a limited number of Woodbury & Page topographical views of Batavia available in the mid-1860s when this album was compiled. The album is entitled: *Vues De Java, Photographies Par Woodbury & Page, Batavia* and the album cover can be seen on page 262.

Verkrijgbaar bij **WOODBURY & PAGE**, de volgende pas genomen

PHOTOGRAPHIEN:

1. De kleine boom.
2. „ groote do.
3. Het stadhuis.
4. Hotel des Indes.
5. Molenvliet.
6. Marine Hotel.
7. Harmonie.
8. Gezigt op het Koningsplein, hoek Gang Scott.
9. Gang Scott, oostzijde.
10. „ „ westzijde.
11. Laan van Tanah-Abang.
12. Tanah-Abang.
13. Brug van Parapattan.
14. Raden Saleh's villa.
15. Goenong Sahari, uitzigt noord.
16. do. do. „ zuid.

Prijs per stuk *f* 5.—. 1935

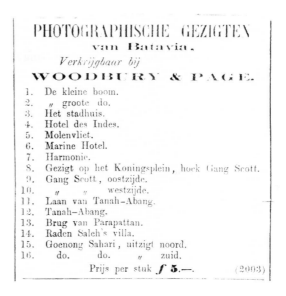

PHOTOGRAPHISCHE GEZIGTEN van Batavia.

Verkrijgbaar bij

WOODBURY & PAGE.

1. De kleine boom.
2. „ groote do.
3. Het stadhuis.
4. Hotel des Indes.
5. Molenvliet.
6. Marine Hotel.
7. Harmonie.
8. Gezigt op het Koningsplein, hoek Gang Scott.
9. Gang Scott, oostzijde.
10. „ „ westzijde.
11. Laan van Tanah-Abang.
12. Tanah-Abang.
13. Brug van Parapattan.
14. Raden Saleh's villa.
15. Goenong Sahari, uitzigt noord.
16. do. do. „ zuid.

Prijs per stuk *f* 5.—. (2003)

The obvious question is which 16 views of Batavia were Woodbury & Page offering for sale in these advertisements? This is not easy to answer because Woodbury & Page were not known to date their photographs. However, it is an important issue to resolve because if any of the images can be identified they will be among the earliest views of Batavia that can be reliably dated.

Of the remaining four photographs on the list but not in the above album, three can be determined by a process of elimination by comparison with other views of Batavia that Woodbury & Page were known to have taken in the 1860s. Therefore, only one of the photographs on the list (number 12) is difficult to identify with a reasonable level of certainty.

The 16 photographs were probably the inspiration of James Page, who was the only one of the Woodbury & Page principals in Batavia in May 1863, although whether it was Page himself or an assistant who took the images is unknown. Walter Woodbury had already returned to England around late January or early February 1863 while Henry James Woodbury was in Sumatra from 27 January until 30 May 1863 and did not arrive back in Batavia until 3 June 1863.[21]

The key role James Page played in promoting these photographs can also perhaps be gauged from the fact that the list last appeared in the *Java Bode* on 24 June 1863, only three days before Page departed for Cirebon on 27 June 1863 on the ship "*Esperanza*".[22]

In the first of the advertisements on 27 May 1863, Woodbury & Page announced that the photographs were *pas genomen* ("just taken" or "newly taken") which clearly suggests that they were made in May 1863 or shortly beforehand. Certainly, the existence of gas street lamps in many of the views confirms that they would have been taken after 1 October 1862 from which date street lamps were installed on Batavia's public roads by L. J. Enthoven & Co. and its successor, the Netherlands Indies Gas Company.

From a critical perspective, the composition of some of these 16 photographs is not of an aesthetically high quality. For example, the view of Koningsplein West (photograph 8) and the two views of Gang Scott (numbers 9 and 10) are essentially just empty streets with no buildings visible and without any particularly notable features that make them stand out as having been taken in Batavia. The relatively long exposure times required in the early 1860s might explain why there are no people in these photographs, but this does not explain why the views are devoid of any architectural features that would have made them more compelling and more distinctly representative of Batavia.

The photograph of the Marine Hotel (photograph 6) is unsatisfying because the tree blocks our ability to enjoy the form of the hotel that is the intended subject of the scene. The slightly later view of the Marine Hotel on page 113 is a considerable improvement in this regard.

In the view of the Harmonie Society building (photograph 7), the photographer seemed to have wanted to also include as much as possible of Rijswijk (Jalan Veteran) in the image, which thereby detracts from our ability to appreciate the fine features of the Harmonie building itself. In a similar view on page 123, taken six to eight years later, the photographer concentrates more closely on his subject and the result is a far superior image.

The view of Tanah Abang (photograph 11) also runs the risk of being called just another featureless and empty street. The great scope to improve such a scene is very evident from the image on page 240 of the same street, but taken a few metres further north and several years later. In that view, Batavia's ethnic diversity is highlighted by the different architectural styles visible, while the photograph's appeal is enhanced by the scene of the shop on the right-hand side and people squatting nearby.

The Prapatan Bridge (photograph 13) is an extraordinarily poorly composed image and it is baffling to know what the photographer had in mind when it was taken and why Woodbury & Page felt it was sufficiently interesting to be sold commercially.

Finally, the photograph of Raden Saleh's villa (photograph 14) seems flat and two-dimensional because it was taken directly in front of the villa itself. Another image of this villa on page 229, which was made only a few years later, was taken just slightly off to the side rather than from the front and is a much more striking and revealing view.

Nevertheless, the 16 views offered in these advertisements represent a stage in the evolution of topographical photography in Batavia and are important historically for being very early. It can perhaps be said that many of the images of Batavia which followed in the second half of the 1860s and in the 1870s were an improvement over the 16 which were offered in May 1863. We can, therefore, perhaps conclude that the photographers in the employ of Woodbury & Page who came after the founders learned from the short-comings of earlier efforts, particularly with regard to developing a finer appreciation of the composition of topographical views.

The 16 views discussed in the order they appear on the list are as follows:

1. De Kleine Boom

The view below of the Kleine Boom and the Stads Herberg is perhaps three or four years earlier than the very similar photograph which appears on page 29. Note that in this earlier view, the awning around the front of the Stads Herberg has not yet been put up. Furthermore, the "Marine Stores" sign of J. Parker's ship supplies business, which we can see above the awning on the northern side of the Stads Herberg in the view on page 29, was not yet in place when this photograph was taken around May 1863.

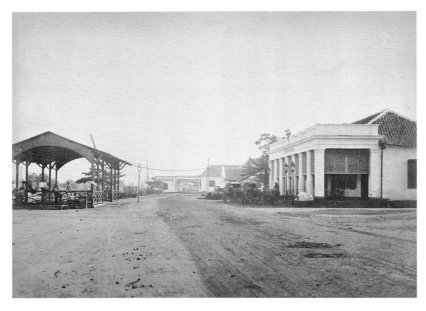

143. THE KLEINE BOOM (SMALL CUSTOMS POST)
Photographer: **Woodbury & Page**, c. May 1863 ■ albumen print ■ size: 17.9 x 23.9 cm
■ collection of the author, Melbourne.

2. De Groote Boom

The particular image of the Groote Boom which Woodbury & Page were offering for sale in May 1863 was almost certainly the photograph on page 33. This was the only view of the Groote Boom that Woodbury & Page are known ever to have had in their stock, and it could easily date back to the first half of the 1860s. The same photograph was still available at Woodbury & Page's studio as late as October 1879.[23]

3. Het Stadhuis

This view below of the Stadhuis or town hall is probably six to eight years earlier than the one on page 45 which dates from around the early 1870s.

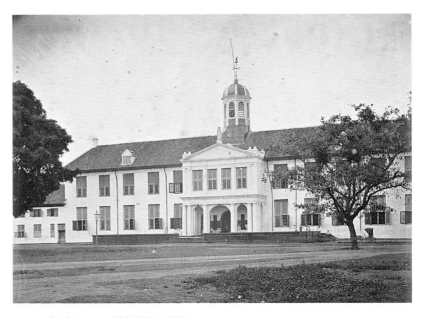

144. HET STADHUIS (TOWN HALL)
Photographer: **Woodbury & Page**, c. May 1863 ■ albumen print ■ size: 17.7 x 23.8 cm
■ collection of the author, Melbourne.

4. Hotel des Indes

Most likely to be the photograph on page 107 looking north along Molenvliet West (Jalan Gajah Mada) with the front buildings of the hotel visible on the left.

5. Molenvliet

Most likely to be the photograph on page 103 looking south along Molenvliet West (Jalan Gajah Mada) with the Harmonie Society and Oger Freres buildings visible in the distance.

6. Marine Hotel

In the following view of the Marine Hotel, the thick foliage of the large tree in the front courtyard obstructs the view of the hotel building. In the more satisfying photograph on page 113, the tree is taller after several years of further growth, thus making the hotel more easily visible.

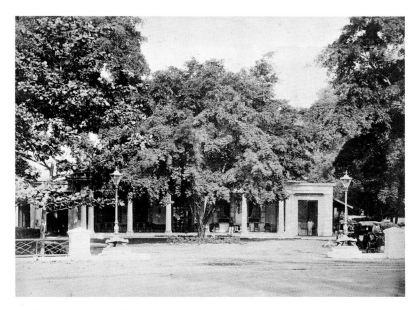

145. THE MARINE HOTEL
Photographer: **Woodbury & Page**, c. May 1863 ■ albumen print ■ size: 20.2 x 27.1 cm
■ collection of the author, Melbourne.

7. Harmonie

In this photograph, we are looking east across the front of the Harmonie Society building and along into Rijswijk. This view is probably six to eight years earlier than the one on page 123, which dates from the early 1870s.

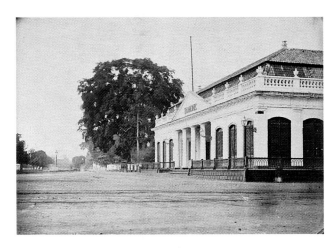

146. THE HARMONIE SOCIETY BUILDING
Photographer: **Woodbury & Page**, c. May 1863 ■ albumen print ■ size: 17.4 x 23.9 cm
■ collection of the author, Melbourne.

8. Gezigt op het Koningsplein, hoek Gang Scott

The photograph below is probably the "View of the Koningsplein, corner of Gang Scott", that Woodbury & Page were offering in May 1863. It looks north along Koningsplein West (Jalan Medan Merdeka Barat) and would have been taken from the near the corner of Gang Scott (Jalan Budi Kemuliaan). It could also quite possibly date from 1863. There is no other similar image fitting this description known from the first half of the 1860s.

147. LOOKING NORTH ALONG KONINGSPLEIN WEST
Photographer: **Woodbury & Page**, c. May 1863 ■ albumen print ■ size: 18.6 x 23.3 cm
■ collection of the author, Melbourne.

9. Gang Scott, Oostzijde

Most likely to be the photograph of Gang Scott (Jalan Budi Kemuliaan) on page 166 which almost certainly shows the *oostzijde* ("east side") or the eastern end of Gang Scott looking in a westerly direction. There is no other known view of the eastern end of Gang Scott from the same period. Despite being a somewhat featureless view of an empty street, this photograph must have been popular because it is frequently found in early albums.

10. Gang Scott, Westzijde

The photograph below is likely to be the view of the west side of Gang Scott (Jalan Budi Kemuliaan) that Woodbury & Page were advertising in May 1863, although another similar view is known to exist which could also date from around the mid-1860s. The western end of Gang Scott connected with Tanah Abang Oost (Jalan Tanah Abang Timur), which would have been just behind the photographer when he captured this view.

It is odd that two different views of Gang Scott would appear among the 16 photographs which Woodbury & Page were offering in May 1863. Neither seems particularly interesting to a modern audience, showing as they do empty tree-lined streets completely lacking in architectural features such as houses or other buildings. Gang Scott was an elite European residential area in the second half of the 19th century and many potential customers for Woodbury & Page would have lived there. However, these photographs could presumably have been made much more interesting (and therefore more saleable) by including some of the fine houses that no doubt existed along Gang Scott at the time.

It is therefore ironic that similar views of Gang Scott frequently appear in 19th century photo albums. This type of scene must clearly have had a particular attraction for people at that time.

148. GANG SCOTT, WEST SIDE
Photographer: **Woodbury & Page**, c. May 1863 ■ albumen print ■ size: 22.0 x 19.1 cm ■ collection of the author, Melbourne.

11. Laan van Tanah-Abang

Tanah Abang was very frequently photographed in the 1860s, presumably because it was a popular residential area for Europeans who were potential customers for Woodbury & Page. Unfortunately, none of these photographs were precisely dated. However, the image below is contained in the same mid-1860s album which contains 11 other photographs that tie in with the May 1863 Woodbury & Page advertisement and it is the only scene of Tanah Abang that appears in that album. It may therefore have been this view which Woodbury & Page were offering with the description *Laan van Tanah Abang* ("Lane in Tanah Abang") in May 1863. Here we are looking in a south-westerly direction along Tanah Abang West (Jalan Abdul Muis). A similar, but more striking view taken a few years later and from slightly further north along the same street can be seen on page 240.

149. LANE IN TANAH ABANG
Photographer: **Woodbury & Page**, c. May 1863 ■ albumen print ■ size: 24.0 x 28.6 cm ■ collection of the author, Melbourne.

12. Tanah-Abang

As mentioned above, there were many photographs taken of the Tanah Abang area in the 1860s. The caption here "Tanah Abang" is too general to give any

clear indication of which particular view of Tanah Abang that Woodbury & page were offering in their May 1863 advertisements. Accordingly, we cannot identify the specific photograph with any certainty.

13. Brug van Parapattan

The following photograph is probably what Woodbury & Page were offering in their advertisements with the title *Brug van Parapattan* ("Prapatan Bridge"). It could certainly have been taken in the first half of the 1860s and there is no known photograph from the period that more closely matches the description. This view can be regarded as uninteresting in the extreme. The composition is poor and there is no apparent subject. We can see the railings of the bridge as well as a section of the river together with a variety of tropical vegetation. It is not at all clear what aspects of this image captured the photographer's attention, and even less obvious why Woodbury & Page felt that this photograph would be commercially successful.

150. VIEW FROM THE PRAPATAN BRIDGE
Photographer: **Woodbury & Page**, c. May 1863 ■ albumen print ■ size: 20.0 x 25.2 cm ■ collection of the author, Melbourne.

14. Raden Saleh's Villa

This is likely to be the photograph of Radeh Saleh's villa or mansion from

Woodbury & Page's May 1863 advertisements. It was probably taken only two or three years before the similar but superior photograph that appears on page 229.

An obvious weakness with this view is that it was taken directly in front of its subject, therefore making the house seem somewhat two-dimensional and many of the architectural details appear to run into each other. The same mistake was not made when the photograph on page 229 was taken because on that occasion, the photographer stood slightly off to the right-hand side and took the view from an angle. This helped capture an image that accentuates the many extraordinary features of Raden Saleh's beautiful residence.

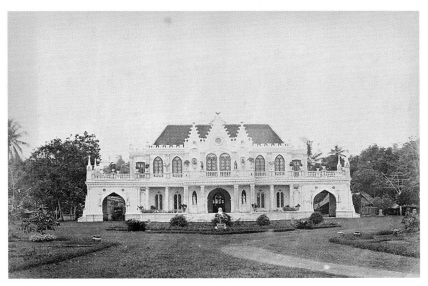

151. RADEN SALEH'S VILLA
Photographer: **Woodbury & Page**, c. May 1863 ■ albumen print ■ size: 17.5 x 26.1 cm ■ collection of the author, Melbourne.

15. Goenong Sahari, Uitzigt Noord

The *uitzigt noord* ("northern view") of Gunung Sahari that Woodbury & Page offered in May 1863 is likely to have been the following photograph. This view certainly dates from the 1860s, and there is no other similar view known from the same period. It shows what was probably a northern section of the Gunung Sahari canal. In the 19th century, this part of Gunung Sahari was not as developed as the more residential areas further south.

152. GUNUNG SAHARI, NORTHERN VIEW
Photographer: **Woodbury & Page**, c. May 1863 ■ albumen print ■ size: 18.3 x 23.5 cm
■ collection of the author, Melbourne.

153. GUNUNG SAHARI, SOUTHERN VIEW
Photographer: **Woodbury & Page**, c. May 1863 ■ albumen print ■ size: 18.5 x 23.4 cm
■ collection of the author, Melbourne.

16. Goenong Sahari, Uitzigt Zuid

The *uitzigt zuid* ("southern view") of Gunung Sahari that Woodbury & Page were offering in May 1863 is likely to have been one of the two photographs shown here which are almost identical and would have been taken just a few minutes apart. The only clear difference between the two is that in the top one there is a man sitting under the tree on the western bank (the right-hand side) of the Gunung Sahari canal whereas the photograph below is almost devoid of people. However, in the view below we can faintly see the back of a horse-drawn carriage heading south along the eastern side of the Gunung Sahari road and there is also a blurred view of something moving on the western side of the road behind the lamp post.

These two photographs were taken perhaps a decade before the view on page 213, but from a location only a few metres away. Note in the later view the infrastructural improvements that had been made to the western side of the canal by the 1870s.

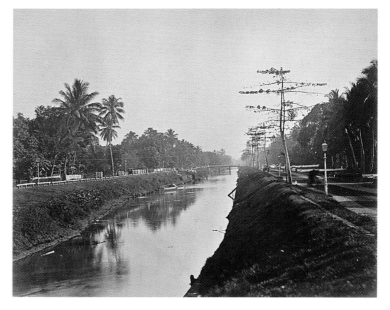

154. GUNUNG SAHARI, SOUTHERN VIEW
Photographer: **Woodbury & Page**, c. May 1863 ■ albumen print ■ size: 21.7 x 26.9 cm
■ collection of the author, Melbourne.

NOTES TO THE TEXT

FOREWORD AND INTRODUCTION

1. Quoted in Davis, Keith, *Desire Charnay: Expeditionary Photographer*, Albuquerque, University of New Mexico Press, 1981, p. 2.
2. See in particular Groeneveld, Anneke, et al., *Toekang Potret: 100 Jaar Fotografie in Nederlands Indie 1839–1939*, Amsterdam, Fragment Uitgeverij, 1989 and Reed, Jane Levy, editor, *Toward Independence: A Century of Indonesia Photographed*, San Francisco, The Friends of Photography, 1991.
3. Raffles, Thomas Stamford, *The History of Java*, London, 1817, reprinted Oxford University Press, Kuala Lumpur, 1965, p. 246.
4. Deynoot, Gevers, *Herinneringen Eener Reis Naar Nederlandsch Indie In 1862*, 's-Gravenhage, Martinus Nijhoff, 1864, pp. 28–29.
5. Weitzel, A. W. P., *Batavia in 1858: Schetsen en Beelden uit de Hoofdstad*, Gorinchem, J. Noorduijn & Zoon, 1860, pp. 11–12.
6. *Ibid.*, p. 14.
7. Deynoot, *op. cit.*, p. 30.
8. Buys, M., Batavia, *Buitenzorg en de Preanger: Gids voor Bezoekers en Touristen*, Batavia, G. Kolff & Co., 1891, p. 2.
9. Weitzel, *op. cit.*, p. 21.
10. *Ibid.*
11. Bemmelen, J. F. van and Hooyer, G. B., *Guide Through Netherlands India; Compiled by Order of the Koninklijke Paketvaart Maatschappij (Royal Packet Navigation Company)*, London, Thos. Cook & Son, 1903 & Amsterdam, J. H. de Bussy, 1903, p. 25.
12. *Ibid.*
13. *Nederlandsch Indie Oud & Nieuw*, Batavia, March 1924, p. 330.
14. *Ibid.*, p. 331.
15. *Ibid.*, p. 331-333.

PART ONE: DOWNTOWN BATAVIA — THE OLD CITY OF THE NORTH

1. Deynoot, *op. cit.*, pp. 25–26.
2. *Ibid.*, p. 25.
3. Bickmore, Albert S., *Travels in the East Indian Archipelago*, New York, D. Appleton and Company, 1869, reprinted by Oxford University Press, Singapore, 1991, p. 27.
4. *Ibid.*
5. Gent, L. F. van, *Logementen en Herbergen van Oud-Batavia*, Weltevreden, N. V. Boekhandel Visser & Co., 1925, p. 48.
6. Weitzel, *op. cit.*, p. 6.
7. Loos-Haaxman, J. de, *Johannes Rach en Zijn Werk*, Batavia, G. Kolff & Co., 1928. See page 101 for a view looking south towards the Amsterdam Gate from inside the old castle and page 107 for a view looking north from outside the castle.
8. Deynoot, *op. cit.*, pp. 26–27.
9. Fryke, Christopher and Schweitzer, Christopher, *Voyages to the East Indies*, reprinted London, Cassell and Company Ltd., 1929, first published 1700, p. 188.
10. *Batavia als Handels-, Industrie- en Woonstad*, Batavia, G. Kolff & Co., 1937, p. 250.
11. Macmillan, Allister, *Seaports of the Far East*, London, W. H. & L. Collingridge, 1925, p. 290.
12. Berg, N. P. van den, *The Financial and Economical Condition of Netherlands India since 1870 and the Effect of the Present Currency System*, The Hague, Netherlands Economical and Statistical Society, third edition, 1895, reprinted as *Currency and the Economy of Netherlands India, 1870-95*, Canberra, Research School of Pacific Studies, Australian National University, 1996, p. 115.
13. Wright, Arnold, editor, *Twentieth Century Impressions of Netherlands India*, London, Lloyd's Greater Britain Publishing Company, 1909, p. 352.
14. Berg, van den, *op. cit.*, p. 109.
15. Courtesy of Drs Henry Th. Cox of Amersfoort, Holland, great-grandson of Willem Hendrik Cox.
16. Wright, *op. cit.*, p. 454.
17. Haan, F. de, *Oud Batavia*, Bandoeng, A. C. Nix & Co., second edition, 1935, p. 341.
18. *Ibid.*
19. *Ibid.*, p. 342.
20. Heuken, Adolf, *Historical Sights of Jakarta*, Singapore, Times Books International, third edition, 1989, p. 84.
21. Wachlin, Steven, *Woodbury & Page: Photographers Java*, with contributions from Fluitsma, Marianne and Knaap, Gerrit, Leiden, KITLV Press, 1994, p. 15.
22. Mace, O. Henry, *Collector's Guide to Early Photographs*, Pennsylvania, Wallace-Homestead Book Company, 1990, p. 152.
23. Why Woodbury & Page did not date their topographical photographs is unclear. Certainly, Walter Woodbury was aware of the benefit of dating portraits for the purpose of observing how a person's features change over time. In a letter to his mother on 2 September 1857 Woodbury wrote: "The portrait I send has the date marked on it and in future I shall always date them so that you can see if I improve in appearance or otherwise." However, a possible reason for not including dates on topographical views might have been that it quickly made them seem out-of-date only a few months or a few years after they were taken and thus more difficult to sell. Clearly from the perspective of a firm of commercial photographers like Woodbury & Page, which held a stock of views for sale, the longer the same image could be sold, the greater the profit that could be made from it. It was, therefore, perhaps preferable not to write or print a date on the topographical views they sold. An example of the same photograph serving the firm for many years is the view of the "Groote Boom" (see page 33) which Woodbury & Page first advertised for sale in the *Java Bode* on 27 May 1863 (see also "Photograph 2" in APPENDIX THREE). This is the only view of the "Groote Boom" that Woodbury & Page were known to have made and it was, therefore, almost certainly the identical photograph which they offered again as item "17" in the *Java Bode* on 18 October 1879 almost sixteen and a half years later!
24. The titles of the seven Batavia stereotypes in the Negretti & Zambra catalogue are: "3979, River in Chinese camp" (which is shown on page 79), "3980, Pintu Cuchill" (the spelling is clearly incorrect and should be "Pintu Kecil"), "3981, Hut in Chinese cemetery", "3982, Private residences", "3983, Chinese camp" (which is shown on page 79), "3984, Tomb of Major Chinaman" and "3985, Chinese cemetery". Six of these seven views are Chinatown or Chinese related. The seventh, which depicts "Private residences", is unusual because it is a view of a rather ordinary European house rather than any building or landmark that was distinctly representative of Batavia and which could, therefore, presumably have been more commercially saleable. The copy of the Negretti & Zambra catalogue was kindly made available by Ms Mattie Boom, curator of the Rijksmuseum Print Room in Amsterdam.
25. Valentijn, Francois, *Oud en Nieuw Oost Indien*, Amsterdam, 1724–1726 as quoted in Kalff, S., Mongoolsch

Batavia, an article in *Nederlandsch Indie Oud & Nieuw*, Batavia, July 1919, pp. 67–68.

26. Haan, F. de, *op. cit.*, p. 300.

27. For more information on the "Jin De Yuan" temple, see Heuken, Adolf, *Historical Sights of Jakarta*, *op. cit.*, Chapter VIII.

28. Lohanda, Mona, *The Kapitan Cina of Batavia 1837 1942*, Jakarta, Penerbit Djambatan, 1996, pp. 114–115.

PART TWO: MOLENVLIET

1. Abeyasekere, Susan, *Jakarta: A History*, Singapore, Oxford University Press, 1990, p. 53.

2. Nieuwenhuys, Rob, *Baren en Oudgasten*, Amsterdam, Querido, 1981, pp. 44–45.

3. Deynoot, *op. cit.*, p. 27.

4. Nieuwenhuys, *op. cit.*, p. 48.

5. See photograph titled "Woonhuis aan Molenvliet" (page not numbered) in Nieuwenhuys, Rob, *Batavia: Koningin van het Oosten*, 's-Gravenhage, 1977.

6. Haks, Leo and Maris, Guus, *Lexicon of Foreign Artists Who Visualized Indonesia (1600–1950)*, Utrecht, Gert Jan Bestebreurtje, 1995, p. 33.

7. Gelink, J. M. B., *50 Jaar N. V. Hotel des Indes Batavia*, Batavia, Koninklijke Drukkerij De Unie, 1948, p. 28.

8. Willekes Macdonald, P. J., and Treslong Prins, P. C. Bloys van, *Beknopte Geschiedenis der Oude Gebouwen op het erf van Hotel des Indes*, Batavia, Koninklijke Drukkerij De Unie, 1948, p. 28.

9. Gelink, *op. cit.*, p. 37.

10. *Ibid.*, pp. 37–40.

11. Kinloch, Charles Walter, *Rambles in Java and the Straits in 1852*, Simpkin Marshall and Co., 1853, reprinted Oxford University Press, Singapore, 1987, p. 31.

12. Gelink, *op. cit.*, pp. 40–41.

13. *Java Bode*, 12 December 1866.

14. Quoted in Gelink, *op. cit.*, pp. 29–36.

15. *Ibid.*, p. 32.

16. *Ibid.*, p. 48.

17. Schulze, Fedor, *West-Java Traveller's Guide for Batavia and from Batavia to the Preanger Regencies and Tjilatjap*, Batavia, Visser & Co., 1894, no page number.

18. Gelink, *op. cit.*, p. 29.

19. *Ibid.*, p. 32.

20. *Java Bode*, 22 and 26 January 1853.

21. Wright, *op. cit.*, p. 463.

22. Maurik, Justus van, *Indrukken van een "Totok"*, Amsterdam, Van Holkema & Warendorf, second edition, 1898, p. 119.

23. *Ibid.*, pp. 119–120.

24. *Ibid.*, pp. 192–193.

PART THREE: UPTOWN BATAVIA — THE NEW CITY OF THE SOUTH

1. Weitzel, *op. cit.*, p. 37.

2. *De Jonge Jaren van de Harmonie 1815–1940*, Private Publication, 1940, pp. 26–27.

3. *Ibid.*, p. 27.

4. Wright, *op. cit.*, p. 451.

5. Weitzel, *op. cit.*, p. 37.

6. Deynoot, *op. cit.*, p. 31.

7. Scidmore, E. R., *Java: The Garden of the East*, New York, The Century Co., 1899, reprinted Oxford University Press, Singapore, 1986, pp. 26 & 29.

8. Joustra, M., *Het Batavia van Heden*, in *Indie*, Leiden & Haarlem, 28 May 1919.

9. Maurik, *op. cit.*, p. 192.

10. Wright, *op. cit.*, p. 473.

11. Haan, F. de, *op. cit.*, p. 305.

12. Schulze, *op. cit.*, no page number.

13. Wright, *op. cit.*, p. 466.

14. Macmillan, *op. cit.*, pp. 310–311.

15. Wright, *op. cit.*, p. 470.

16. Deynoot, *op. cit.*, p. 43.

17. Macmillan, *op. cit.*, p. 334.

18. Wright, *op. cit.*, p. 468.

19. Weitzel, *op. cit.*, pp. 28–29.

20. Cox, Henry Th., *The Family Cox: Biographies 1585–2000*, Unpublished Draft, p. 34.

21. Deynoot, *op. cit.*, p. 30.

22. *Official Guide to Eastern Asia; Vol. 5: East Indies*, Tokyo, Imperial Government Railways of Japan, 1917, p. 387.

23. Information on the Armenian Church in Batavia was derived from: Paulus, G., *Short History of the Armenian Community in Netherlands India*, Batavia, Publisher Unknown, 1935. Other information was very generously supplied by Archbishop Mesrob Mutafyan and Mihran Aroian of the Armenian community of the United States and Archbishop Aghan Baliozian of Sydney.

24. Haan, F. de, *op. cit.*, p. 322.

25. *Ibid.*

26. *Ibid.*, p. 306.

27. Nieuwenhuys, Rob, *Komen en Blijven*, Amsterdam, Querido, 1982, p. 20.

28. *Ibid.*

29. *Ibid.*

30. see KITLV catalogue numbers 3357 and 3358.

31. Deynoot, *op. cit.*, p. 34.

32. Buys, *op. cit.*, p. 28.

33. Tio Tek Hong, *Kenang-Kenangan: Riwayat-Hidup Saya dan Keadaan di Djakarta dari Tahun 1882 Sampai Sekarang*, Jakarta, Tio Tek Hong, 1959, p. 51.

34. Deynoot, *op. cit.*, p. 31.

35. The young English photographer Walter Woodbury writing to his mother from Batavia on 26 May 1857 noted in a somewhat disdainful manner that: "a European here if he wants to go next door must have a carriage" and "I should like to take a walk but it is not fashionable."

36. Johan Olivier quoted in: Wall, V. I. van de, *Geschiedenis der Militaire Societeit "Concordia" te Batavia*, Batavia, G. Kolff & Co., 1933, pp. 9–10.

37. Haan, F. de, *op. cit.*, p. 320.

38. Deynoot, *op. cit.*, p. 32.

39. Wall, V. I. van de, *op. cit.*, p. 3.

40. *Ibid.*, p. 14.

41. *Ibid.*, pp. 18–19.

42. *Ibid.*, p. 29.

43. *Ibid.*

44. *Ibid.*, p. 26.

45. *Ibid.*, p. 27.

46. *Ibid.*, Preface.

47. Maurik, *op. cit.*, pp. 107–108.

48. As quoted in Kalff, S., "Bij 'T Eeuwfeest van den Bataviaschen Schouwburg", an article in *Nederlandsch Indie Oud & Nieuw*, Batavia, December 1921, p. 233.

49. Haan, F. de, *op. cit.*, p. 343.

50. *Ibid.*, p. 313.

51. *Ibid.*, p. 317.

52. *Ibid.*

53. Deynoot, *op. cit.*, p. 34.

54. Weitzel, *op. cit.*, p. 23.

55. Keen, A. T., *The British Church: Batavia*, Weltevreden, G. Kolff & Co., 1928, p. 31.

56. Bickmore, *op. cit.*, pp. 37–38.

57. *Ibid.*, pp. 38–39.
58. Godee Molsbergen, C. E., *Gedenkboek "Planten en Dierentuin" te Batavia 1864–1924*, Weltevreden, G. Kolff & Co., 1924, p. 5.
59. *Ibid.*, p. 9.
60. *Ibid.*
61. *Ibid.*, p. 16.
62. *Ibid.*
63. Buys, M., *op. cit.*, p. 22.
64. Deynoot, *op. cit.*, p. 53.
65. *Batavia: Kisah Jakarta Tempo Doeloe*, compilation of articles from Intisari magazine 1963–1988, Jakarta, 1988, p. 80.
66. Haan, F. de, *op. cit.*, p. 317.
67. *Java Bode*, 25 March, 1865.

PART FOUR: TANJUNG PRIOK

1. *Encyclopaedia van Nederlandsch Oost-Indie*, 's Gravenhage, Nijhoff, 1918, Volume II, p. 70.

APPENDICES

1. Groeneveld, et al., *op. cit.*, p. 16.
2. Reed, *op. cit.*, p. 22.
3. Falconer, J., *A Vision of the Past*, Singapore, Times Editions, 1987, p. 12.
4. *Java Bode*, 5 and 9 August 1854.
5. *Picturing Hong Kong: Photography 1855–1910*, New York, Asia Society Galleries & George Braziller, Inc., 1997, p. 51.
6. Falconer, *op. cit.*, p. 13.
7. Wachlin, *op. cit.*, p. 11 and Groeneveld, et al., *op. cit.*, p. 180.
8. *Java Bode,* 16 June 1855.
9. *Java Bode*, 7, 21 and 31 May 1856.
10. Reed, *op. cit.*, pp. 36–43.
11. Van Kinsbergen also operated a photographic studio in the Pasar Baru area of Batavia for at least 30 years from the early 1870s and which may have survived his death in 1905. It was presumably located on "Gang van Kinsbergen" ("Van Kinsbergen Lane") which was named after him.
12. *Java Bode*, 1 July 1857.
13. *Java Bode*, 8 and 11 December 1858
14. Wachlin, *op. cit.*, p. 195.
15. Deynoot, *op. cit.*, p. 43. The "Englishman" to whom Deynoot referred was obviously Walter Woodbury, while the Belgian was probably Isadore van Kinsbergen (1821–1905).
16. *Java Bode*, 9 and 13 March 1861.
17. The standard work on the history of Woodbury & Page is: Wachlin, *op. cit.*
18. *Java Bode*, 14 and 18 December 1867.
19. Information on J. A. Meessen was generously provided by Steven Wachlin of Utrecht.
20. *Java Bode*, 14 and 18 December 1867.
21. Wachlin, *op. cit.*, p. 196.
22. *Ibid.*
23. *Ibid.*, p. 201.

ACKNOWLEDGEMENTS

1. *Nederlandsch Indie Oud & Nieuw*, Batavia, November 1923, p. 224.

BIBLIOGRAPHY

Abeyasekere, Susan, *Jakarta: A History,* Singapore, Oxford University Press, 1990.

Agung, Ide Anak Agung Gde, *Bali in the 19ᵗʰ Century,* Jakarta, Yayasan Obor Indonesia, 1991.

Bastin, John and Brommer, Bea, *Nineteenth Century Prints and Illustrated Books of Indonesia,* Utrecht, Het Spectrum, 1979.

Batavia als Handels-, Industrie- en Woonstad, Batavia, G. Kolff & Co., 1937.

Batavia: Kisah Jakarta Tempo Doeloe, Compilation of articles from *Intisari* magazine 1963–1988, Jakarta, 1988.

Bataviaasch Nieuwsblad, 50 Jaren: 1885–1935, Batavia, G. Kolff & Co. 1935.

Bataviasche Planten- en Dierentuin 1864–1939, Batavia, Drukkerij 'T Kasteel van Aemstel, 1939.

Beekman, E. M., *Troubled Pleasures: Dutch Colonial Literature from the East Indies 1600–1950,* Oxford, Clarendon Press, 1996.

Bemmelen, J. F. van and Hooyer, G. B., *Guide Through Netherlands India; Compiled by Order of the Koninklijke Paketvaart Maatschappij (Royal Packet Navigation Company),* London, Thos. Cook & Son, 1903 & Amsterdam, J. H. de Bussy, 1903.

Berg, N. P. van den, *The Financial and Economical Condition of Netherlands India since 1870 and the Effect of the Present Currency System,* The Hague, Netherlands Economical and Statistical Society, third edition, 1895, reprinted as *Currency and the Economy of Netherlands India, 1870–95,* Canberra, Research School of Pacific Studies, Australian National University, 1996.

Bickmore, Albert S., *Travels in the East Indian Archipelago,* New York, D. Appleton and Company, 1869, reprinted by Oxford University Press, Singapore, 1991.

Brakel, Koos van, et al., *Indie Omlijst: Vier Eeuwen Schilderkunst in Nederlands-Indie,* Amsterdam, Tropenmuseum & Pictures Publishers, 1998.

Brommer, Bea, *Historische Plattegronden van Nederlandsche Steden; Volume 4: Batavia,* Holland, Canaletto Alphen and den Rijn, 1992.

Buys, M., *Batavia, Buitenzorg en de Preanger: Gids voor Bezoekers en Touristen,* Batavia, G. Kolff & Co., 1891.

Cox, Henry Th., *The Family Cox: Biographies 1585–2000,* Unpublished Draft.

Davis, Keith, *Desire Charnay: Expeditionary Photographer,* Albuquerque, University of New Mexico Press, 1981.

Day, Clive, *The Dutch in Java,* New York, Macmillan, 1904.

Deeleman, C. T., *Bataviaasch Album,* Batavia, G. Kolff & Co., 1859.

De Jonge Jaren van de Harmonie 1815–1940, Private Publication, 1940.

De Koloniale Roeping van Nederland (Holland's Colonial Call), The Hague, Dutch-British Publishing Company, 1929.

De Topographische Dienst in Nederlandsch-Indie, Amsterdam, 1913.

De Topografische Dienst in Nederlandsch-Indie 1874–1924, Weltevreden, 1924.

Deynoot, Gevers, *Herinneringen Eener Reis Naar Nederlandsch Indie In 1862,* 's-Gravenhage, Martinus Nijhoff, 1864.

Diessen, J. R. van, *Jakarta/Batavia,* de Bilt, Cantecleer, 1989.

Diessen, J. R. van, and Voskuil, R. P. G. A., *Boven Indie,* Purmerend, Asia Maior, 1993.

Door Tyd en Vlyt; Gedenkboek Uitgegeven ter Gelegenheid het Honderdjarig Bestaan van de N. V. Koninklijke Boekhandel en Drukkerij G. Kolff & Co., Batavia, G. Kolff & Co., 1948.

Duparc, H. J. A., *Trams en Tramlijnen: De Elektrische Stadstrams op Java,* Rotterdam, Uitgevers WYT, 1972.

Eggink, E. J., *Gemeente Batavia 1905–1930,* Batavia, 1930.

Encyclopaedia van Nederlandsch Oost-Indie, 's-Gravenhage, Nijhoff, 1918, Volume II.

Fabian, Rainer and Adam, Hans-Christian, *Masters of Early Travel Photography,* London, Thames & Hudson, 1983.

Falconer, John, *A Vision of the Past,* Singapore, Times Editions, 1995.

Fryke, Christopher and Schweitzer, Christopher, *Voyages to the East Indies,* reprinted London, Cassell and Company Ltd., 1929, first published 1700.

Gedenkboek der Willems-Kerk te Batavia, Parapattan, 1840.

Gedenkboek Nederlandsch-Indische Gas-Maatschappij 1863–1913, Private Publication, 1913.

Gedenkboek Nederlandsch-Indische Gas-Maatschappij 1863–1938, Rotterdam, N. V. Drukkerij M. Wyt & Zonen, 1938.

Gedenkboek van de Vrijmetselarij in Nederlandsch Oost Indie 1767–1917, Private Publication, 1917.

Gedenkboek voor Nederlandsch-Indie ter Gelegenheid van het Regeeringsjubileum van H. M. de Koningin 1898–1923, Batavia, G. Kolff & Co., 1923.

Gedung Balai Kota Jakarta, Jakarta, Pemerintah Daerah Khusus Ibu Kota Jakarta, 1996.

Gelink, J. M. B., *50 Jaar N. V. Hotel des Indes Batavia,* Batavia, Koninklijke Drukkerij De Unie, 1948.

Gent, L. F. van, *Logementen en Herbergen van Oud-Batavia,*

Weltevreden, N. V. Boekhandel Visser & Co., 1925.

Gernsheim, Helmut, *The History of Photography,* London, Oxford University Press, 1955.

Godee Molsbergen, C. E., *Gedenkboek "Planten en Dierentuin" te Batavia 1864–1924,* Weltevreden, G. Kolff & Co., 1924.

Groeneveld, Anneke, et al., *Toekang Potret: 100 Jaar Fotografie in Nederlands Indie 1839–1939,* Amsterdam, Fragment Uitgeverij, 1989.

Haan, F. de, *Oud Batavia,* Bandoeng, A. C. Nix & Co., second edition, 1935.

Haberhausen, Romana, *Sejarah Suster Ursulin Biara Noordwyk-Juanda Tahun 1856-1986,* Surabaya, Unpublished Manuscript, 1989.

Haks, Leo and Maris, Guus, *Lexicon of Foreign Artists Who Visualized Indonesia (1600–1950),* Utrecht, Gert Jan Bestebreurtje, 1995.

Haks, Leo and Zach, Paul, *Indonesia: Images from the Past,* Singapore, Times Editions, 1987.

Het Indische Stadsbeeld: Vorheen en Thans, Private Publication, circa 1939.

Heuken, Adolf, *Historical Sights of Jakarta,* Singapore, Times Books International, third edition, 1989.

_____, *Tempat-Tempat Bersejarah di Jakarta,* Jakarta, Yayasan Cipta Loka Caraka, 1997.

Holtorf, Gunter W., *Jakarta Street Atlas & Names Index,* Jakarta, FALK-Verlag, ninth edition, 1991.

_____, *Jakarta Jabotabek: Street Atlas & Names Index,* Jakarta, FALK-Verlag, eleventh edition, 1997.

Indie, Leiden & Haarlem (weekly journal), various editions 1919.

Istana Presiden Indonesia, Jakarta, Sekretariat Negara Republik Indonesia, 1979.

Jong, Michiel van Ballegoijen de, *Spoorwegstations Op Java,* Amsterdam, De Bataafsche Leeuw, 1993.

Kartiwa, Suwati, editor, *Treasures of the National Museum,* Jakarta, Buku Antar Bangsa, 1997.

Keen, A. T., *The British Church: Batavia,* Weltevreden, G. Kolff & Co., 1928.

Kinloch, Charles Walter, *Rambles in Java and the Straits in 1852,* Simpkin Marshall and Co., 1853, reprinted Oxford University Press, Singapore, 1987.

Kline, M. Franklin, *Official Shippers Guide 1930–1931,* Osaka, Osaka Shosen Kaisha, 1930.

Kurris, R., *Sejarah Seputar Katedral Jakarta,* Jakarta, Penerbit Obor, 1992.

Lindeboom, Lucas, *Oude K.P.M.-schepen van 'Tempo Doeloe',*

Bilthoven, Maritime Stichting, 1990.

Lohanda, Mona, *The Kapitan Cina of Batavia 1837–1942,* Jakarta, Penerbit Djambatan, 1996.

Loos-Haaxman, J. de, *Johannes Rach en Zijn Werk,* Batavia, G. Kolff & Co., 1928.

Mace, O. Henry, *Collector's Guide To Early Photographs,* Pennsylvania, Wallace-Homestead Book Company, 1990.

Macmillan, Allister, *Seaports of the Far East,* London, W. H. & L. Collingridge, 1925.

Maurik, Justus van, *Indrukken van een "Totok",* Amsterdam, Van Holkema & Warendorf, second edition, 1898.

Naamlijst der Europesche Inwoners van het Mannelijk Geslacht in Nederlandsch-Indie en Opgaven omtrent hun Burgerlijken Stand, Batavia, Landsdrukkerij, 1845–1900.

Nederlandsch Indie Oud & Nieuw, Batavia, monthly journal published continuously from 1916 until November 1933.

Newhall, Beaumont, *The History of Photography,* New York, The Museum of Modern Art, fifth edition, 1997.

Nieuwenhuys, Rob (E. Breton de Nijs), *Tempo Doeloe: Fotografische Documenten Uit Het Oude Indie,* Amsterdam, Querido, 1961.

_____, *Batavia: Koningin van het Oosten,* 's-Gravenhage, Thomas & Eras, 1977.

_____, *Baren en Oudgasten,* Amsterdam, Querido, 1981.

_____, *Komen en Blijven,* Amsterdam, Querido, 1982.

Official Guide to Eastern Asia; Vol. 5: East Indies, Tokyo, Imperial Government Railways of Japan, 1917.

Oldham, J. T., *Christ Church Surabaya,* Private Publication, 1960.

Overzicht van de Organisatie en de Werkwijze van den Topographischen Dienst in Nederlandsch-Indie, Batavia, Topographisch Bureau te Batavia, 1901.

Paulus, G., *Short History of the Armenian Community in Netherlands India,* Batavia, Publisher Unknown, 1935.

Picturing Hong Kong: Photography 1855–1910, New York, Asia Society Galleries & George Braziller, Inc., 1997.

Raffles, Thomas Stamford, *The History of Java,* London, 1817, reprinted Oxford University Press, Kuala Lumpur, 1965.

Reed, Jane Levy, editor, *Toward Independence: A Century of Indonesia Photographed,* San Francisco, The Friends of Photography, 1991.

Regerings-Almanak voor Nederlandsch-Indie, Batavia, Landsdrukkerij, 1845–1900.

Ricklefs, M. C., *A History of Modern Indonesia,* London, Macmillan, 1991.

Schama, Simon, *Patriots and Liberators: Revolution in the Netherlands 1780–1813,* New York, Random House, 1992.

Schulze, Fedor, *West-Java Traveller's Guide for Batavia and from Batavia to the Preanger Regencies and Tjilatjap,* Batavia, Visser & Co., 1894.

Scidmore, E. R., *Java: The Garden of the East,* New York, The Century Co., 1899, reprinted Oxford University Press, Singapore, 1986.

Seabad Biara Sancta Ursula, Jakarta, Private Publication, 1959.

Sejarah Pos dan Telekomunikasi di Indonesia; Volume 1: Masa Pra Republik, Jakarta, Direktorat Jenderal Pas dan Telekomunikasi, 1980.

Seratus Tahun Berdirinja Tarekat-Ursulin, Jakarta, Private Publication, 1956.

Taylor, Jean Gelman, *The Social World of Batavia,* Wisconsin, University of Wisconsin Press, 1983.

Telefoongids Batavia, Weltevreden, G. Kolff & Co., September 1936.

Thorn, William, *The Conquest of Java,* London, T. Egerton, 1815, reprinted Singapore, Periplus Editions, 1993.

Tio Tek Hong, *Kenang-Kenangan: Riwayat-Hidup Saya dan Keadaan di Djakarta dari Tahun 1882 Sampai Sekarang,* Jakarta, Tio Tek Hong, 1959.

Trade Directory of Indonesia 1949, Batavia, Department of Economic Affairs & Foreign Trade; Information Service of the Bureau of Commerce-Batavia, 1949.

Ursulinenklooster: Weltevreden Batavia, 1859–1934, Batavia, Private Publication, 1934.

Vletter, M. E. de and Voskuil, R. P. G. A. and Diessen, J. R. van, et al., *Batavia/Djakarta/Jakarta: Beeld van een Metamorfose,* Purmerend, Asia Maior, 1997.

Voskuil, R. P. G. A., *Batavia: Beeld van een Stad,* Purmerend, Asia Maior, 1993.

Vries, H. M. de, *The Importance of Java Seen from the Air,* Batavia, H. M. de Vries, 1928.

Vries, J. J. de, *Jaarboek van Batavia en Omstreken 1927,* Weltevreden, G. Kolff & Co., 1927.

Wachlin, Steven, *Woodbury & Page: Photographers Java,* with contributions from Fluitsma, Marianne and Knaap, Gerrit, Leiden, KITLV Press, 1994.

Wall, V. I. van de, *Geschiedenis der Militaire Societeit "Concordia" te Batavia,* Batavia, G. Kolff & Co., 1933.

Weitzel, A. W. P., *Batavia in 1858: Schetsen en Beelden uit de Hoofdstad,* Gorinchem, J. Noorduijn & Zoon, 1860.

White, Stephen, *John Thomson: A Window to the Orient,* Albuquerque, University of New Mexico Press, 1989.

Willekes Macdonald, P. J., *Batavia's Bovenstad,* in *Tijdschrift voor Indische Taal-, Land-en Volkenkunde*, Part LXXVII, Number 1, Batavia, Koninklijk Bataviaasch Genootschap van Kunsten en Wetenschappen, 1937.

Willekes Macdonald, P. J., and Treslong Prins, P. C. Bloys van, *Beknopte Geschiedenis der Oude Gebouwen op het erf van Hotel des Indes,* Batavia, Koninklijke Drukkerij De Unie, 1948.

Wright, Arnold, editor, *Twentieth Century Impressions of Netherlands India,* London, Lloyd's Greater Britain Publishing Company, 1909.

INDEX

ACKNOWLEDGEMENTS

This book was the result of more than six years work and research undertaken on a part-time basis and I was very fortunate to receive generous assistance from a large number of people who made valuable contributions in many ways.

First and foremost, I owe a large debt of gratitude to my great friend and mentor, Leo Haks of Amsterdam. Leo first guided me as a collector but then in June 1994, planted in my mind the idea that my research into 19th century photographs of Batavia could be developed into a book that might be enjoyed by a wider audience. Leo was always available to offer advice and encouragement and share with me his wisdom gained from many years of experience as a writer, collector and dealer. Without his influence and guiding spirit, this book would never have been possible.

I also wish to extend my deepest thanks to Father Adolf Heuken SJ, of Jakarta and Steven Wachlin of Utrecht. Father Heuken, one of the world's foremost authorities on the history of Jakarta, very kindly proofread the text for historical accuracy and made many suggestions for corrections and revisions. He also opened up his extensive library from where I was able to find numerous rare reference works. Steven Wachlin generously made available materials from his own outstanding library on the history of early photography in Indonesia and gave me valuable leads that took my research in important new directions. Furthermore, Steven's own research into the firm of Woodbury & Page was of enormous value for dating many of the earliest photographs.

As far as I could determine, the two finest collections in the world of 19th century photographs of Batavia are held at the Koninklijk Instituut Voor De Tropen (the Tropen Museum) in Amsterdam and the Koninklijk Instituut Voor Taal-, Land- en Volkenkunde (the KITLV) in Leiden. I was indeed fortunate to receive friendly assistance from both institutes and I would particularly like to thank Steven Vink, Anouk Mansfeld and Ingeborg Eggink of the Tropen Museum and Marianne Fluitsma and Lam Ngo of the KITLV.

I am also indebted to Anneke Groeneveld, Renee Cress and Heleen Bijl of the Museum Voor Volkenkunde in Rotterdam, Pam Roberts and Debbie Ireland of the Royal Photographic Society in Bath, Mattie Boom of the Rijkspretenkabinet in Amsterdam, Marieke van Delft of the Koninklijke Bibliotheek in The Hague, Christine Barthe of the Musee De L'Homme's Phototheque in Paris and the staff of the Algemeen Rijksarchief in The Hague.

I would also like to thank Wim van Keulen of Amsterdam who kindly made available rare stereotypes from his magnificent collection and who enthusiastically shared his great knowledge on the history of early stereotypes.

I must note that every photograph in this book was sourced from outside of Indonesia as I was sadly unable to identify any significant institutional or private collections of 19th century photographs of Batavia within Indonesia itself. Such collections may exist but I could not find them nor even pick up any leads on their existence. Nevertheless, I am grateful to Soedarmadji Damais, the former Director of the Jakarta History Museum for allowing me to view his outstanding collection of pre-independence 20th century photographs of Batavia and also for his very knowledgeable comments on some of the early photographs of the Glodok district of Jakarta.

I also wish to thank Sister Helena of the Ursulin Sisters in Jakarta who kindly made available unpublished material from her convent's archives, Reverend George Thomas of All Saints' Anglican Church in Jakarta, Archbishop Mesrob Mutafyan and Mihran Aroian of the Armenian community of the United States, Archbishop Aghan Baliozian of the Armenian community of Sydney, Henry Th. Cox of Amersfoort, Bapak Rachmat of the Dewan Kerajinan Nasional Indonesia in Jakarta, Shirley Walker of the State Library of New South Wales in Sydney and the staff of the National Library of Indonesia in Jakarta.

Thanks are also due to Stephen Grant, formerly of Jakarta (now in El Salvador), for his wisdom and guidance, Geoff Edwards, Hery Soesanto, David & Elizabeth Dawborn in Jakarta and Ken & Jenny Jacobson in London for their support and encouragement and to Mrs. Ediati Kamil in Jakarta for her tireless translation work.

Warmest thanks also to Didier Millet and all of his colleagues at *Editions Didier Millet*, in Singapore especially Charles Orwin, Goh Geok Yian, Edmund Lam, Tan Seok Lui, Tim Auger and Nelani Jinadasa who made production of this book a reality. I am very grateful to Didier for his confidence in this project from its early stages even though he knew nothing about me when Leo Haks first told him that I was working on this book.

Acknowledgements must also be made to a man no longer alive to receive them; namely Dr. F. de Haan (1863-1938), who was the state archivist in Batavia from 1905 until 1922, and whose monumental piece of scholarship, *Oud Batavia* (I have used the second, revised edition from 1935) is undoubtedly the standard reference work on the history of Batavia, (particularly of the 17th and 18th centuries), and is a constant companion for anyone researching Jakarta's history. A book review published in November 1923, made the following observation regarding de Haan's first edition of *Oud Batavia*.

de Haan's "Oud Batavia" will for a long time remain *the* work about Batavia, the beautiful and trustworthy book where a solid scholar, the only man who could write it, in a lively and entertaining way talks about a subject that is dear to his heart. One will learn from it and also enjoy it.[1]

These words remain just as true today as they were when written over three-quarters of a century ago.

To the outstanding firm of commercial photographers, "Woodbury & Page", which operated in various forms from 1857 until 1908, and which was responsible for approximately two-thirds of the photographs in this book, enormous gratitude is owed because without their magnificent photographic work, our ability today to appreciate and understand Batavia as it was in the second half of the 19th century, would be so poor as to be almost negligible. I would also like to extend special thanks to Miss Luanne Woodbury of London, granddaughter of Albert Woodbury, for her support and enthusiasm and whose remarkable energy is an inspiration to us all.

Responsibility for any errors and omissions is mine alone.

Finally, my dearest thanks to my wonderful wife, Theresia and to my two little assistants, Maxi and Nicole, for their love and support and for their understanding of all of the hours that this book required.

SCOTT MERRILLEES
Melbourne, Australia
June 2000